Upstairs and Downstairs

Upstairs and Downstairs

British Costume Drama Television from The Forsyte Saga *to* Downton Abbey

Edited by
James Leggott
Julie Anne Taddeo

ROWMAN & LITTLEFIELD
Lanham • Boulder • New York • London

Published by Rowman & Littlefield
A wholly owned subsidiary of The Rowman & Littlefield Publishing Group, Inc.
4501 Forbes Boulevard, Suite 200, Lanham, Maryland 20706
www.rowman.com

16 Carlisle Street, London W1D 3BT, United Kingdom

British Library Cataloguing in Publication Information Available

Library of Congress Cataloging-in-Publication Data

Upstairs and downstairs : British costume drama television from The Forsyte saga to Downton Abbey
/ edited by James Leggott, Julie Anne Taddeo.
pages cm
Includes bibliographical references and index.
ISBN 978-1-4422-4482-5 (cloth : alk. paper) – ISBN 978-1-4422-4483-2 (ebook)
1. Historical television programs–Great Britain–History and criticism. 2. Clothing and dress on
television. 3. Television series–Great Britain. I. Leggott, James, editor. II. Taddeo, Julie Anne, editor.
PN1992.8.H56U68 2015
791.45'65841–dc23
2014031795

∞™ The paper used in this publication meets the minimum requirements of American
National Standard for Information Sciences Permanence of Paper for Printed Library
Materials, ANSI/NISO Z39.48-1992.

Printed in the United States of America

Contents

Foreword

Jerome de Groot

In an acid comment upon the heritage process, James Bond destroys his country home in *Skyfall* (Sam Mendes, 2012) as a way of becoming un-British, an international postmodern orphan, and therefore the perfect assassin. He leaves the period-drama setting for pastures new, spectacularly severing ties with the old country. It slows him down. Maybe the costume drama is a form that expresses something we want, really, to destroy: the heritage-lite of remembered Sunday evenings. We don't really want to revisit too much but are compelled to do so. As the Bond episode suggests, there is an argument that costume drama is the most British of all television genres. It is certainly one of the most exported. While other countries developed and sustained excellent television in other exciting areas, the costume drama has been regularly on British screens in various manifestations for decades. It has had regular moments of renaissance, from *The Forsyte Saga* (BBC, 1967) and *Brideshead Revisited* (Granada, 1981) to *Pride and Prejudice* (BBC, 1995) and *Downton Abbey* (ITV, 2010–). It intertwines with British national identity in multiple complex and subtle ways, from the adaptation of great national writers (Dickens, Brontë, and Austen) to the use of the landscapes and houses throughout the country as backdrops and locations. Regardless of whether we agree with the version of Britishness that is being presented, it is inarguably important and influential.

Furthermore, British costume drama is used to present a particular sense of this British identity throughout the world. *The Forsyte Saga*—an epic twenty-six episodes—was made in conjunction with MGM television and was the first BBC show to be sold to the USSR; recently, the chancellor of the exchequer, George Osborne, has sparked controversy by hoping that the huge number of Chinese viewers of *Downton Abbey* might translate into a boost for the UK tourist economy.[1] Costume drama intertwines with heri-

tage; it is part of a peculiarly British vernacular that has international impact. Shows are developed with an eye to the export market and form part of a complex fiction-heritage aesthetic that contributes a great deal to the domestic economy. A good example of how this itself has become part of the cultural imagination is seen in the film *Austenland* (Jerusha Hess, 2013), in which an impressionable American fan spends her life savings traveling to the immersive theme park Austenland in the UK. It is clear that the "Austen" she and her fellow tourists are chasing is largely that created by serial adaptation (basically, Colin Firth).

Throughout the 1980s the unstoppable rise of period drama seemed inarguable. This was mainly through the huge success of certain films, and the relationship between British film industry and British television industry in this area needs further investigation. Suddenly a particular kind of Britishness was being articulated, and a way of considering oneself in relation to the past came into vogue. Costume drama became almost fashionable, certainly a key way of conceptualizing contemporary identity. This is well satirized in Alan Hollinghurst's novel about the conservative 1980s, *The Line of Beauty*:

> Martine slightly surprised him by saying, "I think it's so boring now, everything takes part in the past."
> "Oh . . . I see. You mean all these costume dramas . . . "
> "Costume dramas. All of this period stuff. Don't the English actors get fed up with it—they are all the time in evening dress."[2]

"Period stuff" is so regular as to be worthy of complaining about, something so very 1980s that it would form part of the background of a historical novel. Hollinghurst's exquisite joke is that the protagonist Nick and his lover are planning a version of Henry James's *Spoils of Poynton*. The suggestion is that this adaptation comes nowhere near the original; indeed, even attempting it is a kind of joke on the vulgar culture that might allow or demand such a thing.

Costume drama during the 1980s became something that would export British values of some kind around the world and suggest something about the way that British culture conceptualized itself historiographically. Scholarship took on the rise in heritage/costume drama, and a number of key interventions were made in the 1980s and early 1990s by writers such as Patrick Wright, Andrew Higson, Alison Light, David Lowenthal, Robert Hewison, and Raphael Samuel. They intervened regarding what Samuel termed "Thatcherism in period dress."[3] Costume drama, they recognized, is never just a genre but always a site of contention about memory, national identity, and nostalgia. It is produced by a set of cultural institutions (e.g., Granada, ITV, and BBC) with their own agendas, by writers (Andrew Davies, Julian Fellowes, etc.) with particular biases, and for a set of markets

(e.g., Sunday teatime, American Masterpiece presentation, and Chinese export) with particular tastes and desires. Costume drama presents us with a serious canon of fictional production of the past. Often dismissed as something trite, conservative, and dull, costume drama demonstrates to us throughout its history the multiple ways that television might dramatize and enact relationships between the past and the present, illustrate a way of conceptualizing and idealizing the past, and resource the contemporary historical imagination.

The intervention of Davies into the classical adaptation must be appreciated here, in shifting (from 1995 onward) the focus of the form. In a similar fashion, the massive worldwide success of Fellowes's *Downton Abbey* will warp and shift the landscape of future production in a way that we cannot at present fathom. Certainly after *Pride and Prejudice* it became more difficult to dismiss the cutesy adaptation, or to ignore the complexity of the text. Post-2000 it might be argued that a head of steam has been building in costume drama in a way hitherto unimagined. New markets, new forms, hybrid genres, and new models have led the mode into exciting and hitherto unforeseen areas. Costume drama became self-aware, bullish, and confident. Formal experiments, such as the thirty-minute episodes of *Bleak House* (BBC, 2005), demonstrated a genre at ease with itself. New genres—crime, comedy, horror, and medical—became part of the canon. This intervention of the costume drama into multiple new subgenres is something to be celebrated, from *The Bletchley Circle* (ITV, 2012–2014) through *Call the Midwife* (BBC, 2012–) to *Hunderby* (Sky, 2012).

Of course, one of the key issues here is the articulation of "Britishness" through a genre that in many ways is as English as possible, projecting through the focus on a small group of characters an entire nation. We might wonder at the way that the form has insulated itself somehow, rarely challenged by external forces but calmly annexing new areas. Its core aesthetic and representational values rarely shift, but it increasingly looks to colonize new subgenres. Does the costume drama close down discussion about Britishness by presenting a dominant version without nuance? Is it something that reflects the centrality of metropolitan, English discourse in the definition of national identity within a global context? This argument has been part of the scholarship on the field for decades, but in the increasing global contexts for consumption of the genre the arguments become more compelling. Similarly, we need to look at the ways that Britain is figured in the genre—through the country house, the landscape, and social relationships—to wonder about how this feeds back into our way of conceptualizing our relationship with nation and the past.

With a new generation of work, and a new perspective on the achievements of older texts, comes a reassessment of the form as a whole. This book looks for the first time at a wide range of texts from the 1960s onward. It is to

be commended for its generic diversity and breadth of reference, and in this lies its key intervention. It is time to critique the form but also to recognize its huge contribution to the British (and international) imaginative economy over decades. We may recognize its conservative impetus, worry at the nostalgic way it represents the past, or wish that it chose a few more interesting writers to adapt, but we should also recognize that it is something worth investigating for its longevity, its influence, and its adaptability as a mode. These chapters open up a multiplicity of readings that look to establish a more secure foundation for work on the field in the future. If we are to understand the complex ways that we as a society engage with the past, and how this past-fictional representational aesthetic contributes to our historiographical imagination, we need to take the costume drama very seriously indeed.

NOTES

1. Tom Chivers, "George Osborne Thinks 160m Chinese Watch Downton," *Telegraph Blogs, Telegraph,* 14 October 2013, accessed 5 June 2014, http://blogs.telegraph.co.uk/news/tomchiversscience/100241196/george-osborne-thinks-160m-chinese-watch-downton-shouldnt-the-chancellor-have-a-good-head-for-figures.

2. Alan Hollinghurst, *The Line of Beauty* (London: Picador, 2005), 214.

3. Raphael Samuel, *Theatres of Memory*, vol. 1, *Past and Present in Contemporary Culture* (London: Verso, 1996), 290.

Acknowledgments

First and foremost, we would like to thank our editor, Stephen Ryan, and the entire production team at Rowman & Littlefield, for supporting this project and providing guidance while also trusting our judgment. Many thanks also to our contributors, whose speed, enthusiasm, and fine scholarship have made editing this book such a pleasure. A special thank you goes to Cynthia J. Miller for her generous assistance with our screen grabs. James gives thanks to his coeditor for a smooth and rewarding transatlantic working relationship (and she, likewise, gives thanks to him). And to the dearest people in his life, he offers apologies. To Karen, for indulging his obsession with *Mr. Selfridge*; to his parents, for arriving unannounced at their house and forcing them to miss the final episode of a repeat run of *The Pallisers*; and lastly to Toby, for producing a book that has nothing whatsoever to do with fish or dinosaurs. Julie would like to thank her mother for sharing with her many memorable Sunday-night viewings of *Masterpiece Theatre*, and Paulo and Ava, who have allowed her to continue this tradition in relative peace and quiet. Lastly, we thank the makers of the period costume drama who have afforded us such enjoyment and academic motivation.

Introduction

James Leggott and Julie Anne Taddeo

In November 1972, the British press reported on a most unusual event that had just concluded at the National Film Theatre in London. According to the *Guardian* newspaper, "Blinking like surfacing potholers and stifling yawns, 60 triumphant filmgoers emerged from the gloom [of the cinema] . . . after surviving" a twenty-four-hour showing of all twenty-six episodes of the BBC's 1967 serial *The Forsyte Saga*.[1] Rescreened as part of a celebratory series commemorating the BBC's fiftieth anniversary, the show had quickly been recognized as important and influential. In 1986, episodes were repeated on British television in celebration of BBC television's own fiftieth anniversary, and in the summer of 1989, the National Film Theatre again ran the series in its entirety, this time spread across two days. But the mocking, superior tone of the *Guardian*'s coverage of that experimental 1972 marathon suggests how *The Forsyte Saga*—like the costume-drama format more generally—would simultaneously elicit popular affection, institutional canonization, and critical snobbery.

Widely recognized as a foundational work for the development of a very British strain of the costume-drama television, *The Forsyte Saga*—based on a cycle of novels by John Galsworthy about the tempestuous lives of an aristocratic family between 1879 and 1926—had been first broadcast in 1967, initially as an enticement for viewers to retune their boxes to the new BBC Two channel. However, it only really became a cultural phenomenon when repeated the next year on Sunday nights on BBC One, and legends now abound of pubs and churches standing empty during its run.[2] Furthermore, the show's marital rape sequence (in the "Decisions" episode)—one of the earliest depictions of rape on British television—is remembered as generating a national outcry on a scale that even *Downton Abbey* (2010–), arguably the program's contemporary equivalent, would not be able to match when its

writer, Julian Fellowes, introduced a story line about sexual violence.[3] In turn, in the United States, *The Forsyte Saga* would be cited not only as a cornerstone work of the *Masterpiece Theatre* strand but also as being responsible for its very inception.[4] And in addition, the show's exclusive focus on aristocratic characters—in tandem with its exploitation of the longer format—ultimately resulted in the genesis of the equally popular and influential *Upstairs, Downstairs* (1971–1975), in which its creators Eileen Atkins and Jean Marsh deliberately redressed the class balance via interwoven story lines about the aristocracy and their servants.[5] In turn, *Downton Abbey* would use the same conceit of mapping early twentieth-century political and social change through the fortunes of a single family, as well as deploying an "open" narrative, not constrained by the narrative limits imposed by a literary source (as had been the case with *The Forsyte Saga*).

According to *The Guardian* report of the 1972 screening of *The Forsyte Saga*, only a hard core of sixty Galsworthy enthusiasts stayed to witness the charismatic antihero Soames (Eric Porter) finally expire after saving the life of his contrite daughter Fleur (Susan Hampshire); for others, "the almost endless stream of tear-jerking episodes proved too much."[6] One of the "survivors"—reported to be a "prospective Conservative candidate"—acknowledged that only constant nudges by his wife had kept him awake, but a lady identified only as "Mrs. Tony Townes, of Pimlico" described the experience as "magnificent." The *Forsyte Saga* may have been groundbreaking in its attention to literary detail, and in its budget (an unprecedented £10,000 per episode),[7] but the association of costume drama with "soapy" melodrama, and thus with a predominantly female reception, was already entrenched. Of course, the skeptical (and unnamed) author of the *Guardian* piece could not possibly have appreciated the significance of the marathon screening as a precursor, of a kind, to the "binging" pleasures that would later be available to audiences via DVD box sets and streaming services. In the early twenty-first century, *Downton Abbey*'s occasional capacity to captivate and shock initial viewers with unexpected plot twists could be deemed proof of the format's continuing power as a communal experience, although it could also be regarded as an anomaly in an increasingly fragmented broadcasting landscape.

One of the central aims of this book is to trace the pathways of British "costume" drama (sometimes referred to as "period" drama) between the original *Forsyte Saga* and *Upstairs, Downstairs* (both were subject to twenty-first-century remakes) and contemporary equivalents such as *Downton Abbey*. There is no escaping the fact that the phenomenal international success of the latter has led audiences, and indeed scholars, to revisit earlier examples produced for television since the 1960s. Inevitably, the mighty triumvirate of these three mutually influential shows stands in danger of obscuring what is actually a nuanced and varied history of popular historical-

ly set dramas. In the 1970s and 1980s, the *Forsyte* template was used for similarly long-form, and sometimes multiseries, adaptations of prestigious literary works such as *War and Peace* (1972), *The Pallisers* (1974), *Poldark* (1975–1977), and *I, Claudius* (1976), but another key strand of costume drama was war-set drama such as *Colditz* (1972–1974), *Secret Army* (1977–1979), *Tenko* (1981–1984), *Wish Me Luck* (1987–1990), and *Fortunes of War* (1987). The BBC's *House of Eliott* (1991–1994), devised by the creators of *Upstairs, Downstairs*, and spanning thirty-four episodes across three series, would prove to be a swan song for the hitherto standard format of multicamera video production, and also—for a while anyway—the long-running, open-ended costume drama.

In the early 1980s, the domestic and international success of *Brideshead Revisited* (1981) and *The Jewel in the Crown* (1984) began a trend for "quality" over "quantity," with producers favoring slow-paced but cinematic-looking adaptations of prestigious or popular sources; their high budget necessitated rarity, which in turn rendered them as highly promotable "events."

In the even more risk-averse 1990s, the main British broadcasters prioritized feature-length (i.e., stand-alone) adaptations of popular genre fiction by the likes of Patrick Cornwall, Agatha Christie, P. G. Wodehouse, and Catherine Cookson. Meanwhile, the literary adaptation was given a famous shot in the arm with the BBC's rollicking, self-consciously modern *Pride and Prejudice* (1995), which brought about a wave of "sexed-up," politically aware adaptations of classic literature by Austen, Dickens, Trollope, and others. Aside from the occasional experiment with soap-like formats (e.g., the Dickens adaptation *Bleak House* [2005], which was broadcast twice weekly in the UK in the manner associated with contemporary soaps such as *Coronation Street* [1960–]), these "heritage" adaptations are obviously very different from—albeit generically related and critically bracketed with—the very recent cycle of open-ended serials written newly for television.

Few would doubt the significance of the upstairs/downstairs drama *Downton Abbey*, first broadcast in 2010, in emboldening producers to return to the *Forsyte/Upstairs, Downstairs* template of long-running and populist (it was hoped) serials balancing historical fascination with appealing characters and plots. *The Paradise* (2012–2014) and *Mr. Selfridge* (2013–) exchanged *Downton*'s grand estate setting for prototypes of the modern department store but retained the panoramic sweep and symbolically loaded historical backdrop, while *Call the Midwife* (2012–) was—depending on your point of view—either nostalgic fluff or one of the most quietly feminist dramas ever devised (or indeed both). *Downton*'s careful address to international audiences was also mirrored by genre-driven serials such as the crime dramas *Ripper Street* (2012– ; coproduction between BBC and BBC America) and *Peaky Blinders* (2013–), set respectively in Victorian London and the Midlands of the early twentieth century.

The success of *Downton Abbey* generated numerous journalistic and critical speculations about its "winning" formula. As with the gently paced *Lark Rise to Candleford* (2008–2011), chronicling the everyday lives and relationships between inhabitants of the titular hamlet and market town in Oxfordshire in the late-Victorian period, *Downton* certainly had a nostalgic pull. But a detailed article in *Time* magazine by Graeme McMillan cited various alchemic factors that include its "occasionally hilarious melodrama," its self-aware borrowing from soap opera, and a multinarrative, multilevel pacing associated with "quality" US drama such as *The West Wing* (1999–2006) and *NYPD Blue* (1993–2005).[8] As proved by the quick cancellation and critical panning of the BBC's "dour" 2011–2012 remake of *Upstairs, Downstairs*, merely having a similar setting and historical framework with *Downton* was not sufficient, and neither was the canonical status of the original. Some commentators argued that the strictly stratified, ordered world of *Downton* was a fortuitous tonic for audiences in "austerity" Britain, alive to prominent debates about economic difficulty, social disorder, and stoicism in the face of adversity.[9] Others saw it as the harbinger of a cycle of "warm bath" television: cheerful programs with a "feel-good rosy glow" appropriate for the economic climate and long winter nights.[10]

Downton's success in the United States was in some places interpreted in terms of its cultural exoticism, but some argued for a greater analogy between the "fairy-tale" class system of Edwardian England and the obsessions and desires of contemporary Americans. For example, Theodore Dalrymple, in the *Wall Street Journal*, identified the program as a "guilty passion" satisfying a "secret or vicarious longing for elegance without imposing the hard work that's necessary to achieve it in reality."[11] Similarly, Nicoletta Gullace observed the ambivalent appeal for female viewers seeing characters with only slowly developing independence yet retaining a "certain gentility and graciousness of living."[12]

Although some of these programs, and some of this generic history, has received critical attention, this has often been within the context of the practicalities and politics of literary or historical adaptation, or from a historical perspective; as we have already established, not all costume drama is derived from a literary source or from historical fact, while some may be written directly for television yet have a complex relationship with factual or literary events and characters.[13]

The shows under discussion in this book are mostly examples that are either newly written or based on literary sources that they "eclipse" or subsume; in other words, unlike short-form or one-off adaptations of canonical literature by the likes of Dickens and Austen, they are not always defined, or confined, by their relationship to an original text. However, as already indicated in relation to *Downton Abbey*, it is nearly impossible to analyze UK costume drama without acknowledgment of the wider critical and popular

debates around British "heritage" culture. Scholars and observers of British media and political culture have carefully scrutinized the relevance of re-creations and reenactments of a historical past—whether real or imagined—for contemporary citizens and consumers.[14]

Within the specific arena of British film studies, the so-called heritage debate around films such as *A Room with a View* (1985) and *Elizabeth* (1998) was chiefly concerned with their perceived representational conservatism (or otherwise) and their appeal to particular audience groups and fans.[15] Although mostly dealing with cinematic examples, this scholarship opens up paradigms of great use when thinking about TV costume drama, as they point to the genre's potential for transgression, and the way in which it can provide a lens through which to examine the class and gender politics of both the past and the present, as well as notions of historical "authenticity."

It is true that traditions of costume drama on television have—until recently—received comparatively scant attention, despite their continuing popularity with audiences, and the easy availability of canonical titles via syndication, box sets, and online streaming. This is partly to do with the relative infancy of television studies as a disciplinary field, but the dearth of close textual analysis of costume drama may be as much to do with practicality as snobbery; quite simply, longer-form examples of the genre require patience and time to interpret and contextualize.

Indeed, there have been ongoing debates within television studies of late around the interrelationship of seriality and "quality." Now acknowledged as a loaded and problematic term, "quality" TV has tended to be associated with densely plotted US serials such as *The Sopranos* (1999–2007) and *The Wire* (2002–2008).[16] The transatlantic, and indeed international, distribution and reception of some UK costume drama adds a further complication to any assessment (should one wish to make one) of the genre's claims to quality. In the case of our much-cited examples of *The Forsyte Saga*, *Upstairs, Downstairs*, and *Downton Abbey*, all were produced by mainstream public service broadcasters in the UK, although the latter two were made for the commercial station ITV (although, confusingly, the remakes of *The Forsyte Saga* and *Upstairs, Downstairs* were broadcast on ITV and BBC respectively). This may seem irrelevant to non-UK readers of this volume, but the evolution of the costume drama is tightly bound with the shifting attitudes and competitive strategies of the two main UK terrestrial broadcasters. However, for US viewers, such nuance is likely to have little bearing on the reception of programs extrapolated from their original broadcasting context, most likely into the long-running *Masterpiece Theatre* series, which has its own framing devices and context, or more recently into niche channels such as BBC America.

Just as US imports have often had connotations of professionalism for British viewers by dint of their comparatively glossy production values, so

UK shows with populist impulses and specific political/cultural meaning to indigenous audiences can take on cult appeal, and a host of different readings, beyond their national context. And as our initial discussion of the *Forsyte* marathon reminds us, it is necessary to acknowledge the more active, complex scenarios of consumption and participation by viewers, both contemporary and historical.

THE SCOPE OF THE COLLECTION

A volume of this size cannot possibly cover all TV costume dramas, but we have selected those we see as most representative of the genre and that afford opportunities for multiple readings. The book begins with a series of chapters that represent the broad range of possible conceptual approaches to the British costume drama. Part I surveys trends in programming, narrative techniques, and the hybridization of genres that, while of interest in their own right as part of the history of the costume drama on TV, also highlight the larger social and cultural contexts of production and reception, and viewers' changing tastes and desires.

Claire Monk establishes the crucial importance of the 1970s, a decade of TV programming often overlooked in favor of the more lavish heritage productions of the eighties, in order to lay the cultural, generic, and institutional ground for the British period drama as it is understood and academically framed today. The year 1971 marked the beginning of the *Masterpiece Theatre*/WGBH coproduction and distribution relationship between the US public-service channel WGBH Boston and the BBC (and, later, ITV). Through this relationship, prestigious and popular British period TV dramas found appreciative transatlantic audiences, and this association remains central to the US visibility of British TV drama as a "brand" and to the formation of "Anglophilic" taste among US audiences today. Monk also considers the programs of the 1970s as more daring and politicized, but also more populist, in subject matter than such recent hits as *Downton Abbey*. She examines such series as the suffragette-themed *Shoulder to Shoulder* (1974) and those with a significant working-class, feminine, class-mobile, or regional focus that epitomized "the cult of Sunday night," from *Upstairs, Downstairs* to *The Duchess of Duke Street* (1976–1977) and *Poldark*. The unprecedented thematic interest in class and gender emancipation in such popular dramas both articulated and appealed to wider democratizing impulses that had come to the fore in 1970s British society, in a decade of unprecedented socioeconomic equality that would decline consistently from the Thatcher-era 1980s onward.

Though often marginalized by scholars, the 1970s, as Tom Bragg also reminds us, was the "Golden Age" of British television costume drama, and

while *Downton Abbey* owes a significant thematic debt to earlier programs such as *Upstairs, Downstairs*, key technical differences still exist, highlighting evolving production methods and their impact on the content of the costume drama. In particular, a recognized and cherished feature of programs like *Upstairs, Downstairs*, as well as *Poldark*, was the studio-based mise-en-scène; filmed mostly indoors within boxy artificial studio sets, 1970s costume dramas had to rely on innovative narrative techniques in lieu of big budgets and "visitable" places (such as *Downton*'s Highclere Castle). As in the nineteenth-century historical novel, the costume drama's historical narrative is composed within spaces that can be easily manipulated—such as the studio mock-up of a coach's interior or the claustrophobic servants' bedrooms of 165 Eaton Place, inviting viewers to its make-believe enclosed spaces—and thereby evoking intimacy. Bragg concludes that, despite, or perhaps because of, their self-conscious theatricality and playfulness, Golden Age costume dramas are not necessarily "historically accurate" but nevertheless bring the past alive as they depict the space of history as something other than a realistically achieved mimetic space.

The evolution of the British costume drama since the 1970s has been paralleled by an equally notable tradition of historical-based comedy, whether in the form of sketch-show skits or longer-running sitcoms and serial comedy-dramas. James Leggott surveys some of the key contributions to the canon of period comedy, from *Sesame Street*'s parodic "Monsterpiece Theater" to the most recent spoofs of *Downton Abbey* (*Uptown Downstairs Abbey*, 2011), making the case for the symbiosis of historical and comic forms as one of the distinctive characteristics of British media culture. While Britain's rich literary tradition is easy fodder for satire (for example, *The Bleak Old Shop of Stuff* [2011–2012] spoofs producers' overreliance on Dickens for "quality" TV programming), making light of specific historical events, such as the First World War, has inevitably stirred up controversy, as in the case of the *Blackadder Goes Forth* (1989) series; not only did the series become British TV's most popular war program, but also many viewers, to the ire of conservative politicians and historians, believe this parody to be actual history. These developments in British television comedy clearly reveal shifting attitudes to the reenactment and consumption of history.

Just as the historical-based comedy is so dependent on the costume drama for much of its content and style, it is not always easy to pinpoint just what makes the costume drama a distinct genre. Producers of costume dramas are very quick to distance their programs from the less critically respected genre of the soap opera. Yet as Marc Napolitano points out, even "prestige" programs, such as adaptations of Dickens's novels for TV, have elements of the soap opera, and he adds, it is this very hybridization that makes the serial drama so similar to the nineteenth-century novel that incorporated several of the melodramatic plot devices of the penny dreadful. Napolitano compares

such series as *Upstairs, Downstairs*, *The Forsyte Saga*, *The Duchess of Duke Street*, and *Downton Abbey* to differentiate narrative approaches and concludes that borrowing elements from the open-ended serialized soap opera ultimately allows for greater experimentation and improvisation (as well as responsiveness to viewers' reactions).

Benjamin Poore further considers the viability of such a production model and some of the tensions created by this hybrid of classic-novel adaptation and soap opera in his discussion of the BBC's *The Paradise*. A loose adaptation of an Émile Zola novel, *Au Bonheur des Dames* (1883), *The Paradise*—as indicated by its second season, which has drastically departed from Zola's ending—has the potential to substantially expand upon its source material. Mostly set in a large department store in 1870s Newcastle upon Tyne, where most of the characters both work and live, the series borders on soap opera, with its accent on human relations, romantic tension, and workplace drama, but also reflects a new production model of "composite sets" built for filming that almost harkens back to the studio mise en scène described by Bragg. Some of these techniques undoubtedly reflect budgetary concerns as the lavish "one-off" costume-drama production has become financially unsustainable, but as Poore argues, the generic indeterminacy of *The Paradise* is part of its appeal to audiences, whose appetite may be whetted by the possibility of a "never-ending story."

The costume drama's writer is of pivotal significance, as we see with Julian Fellowes's total authorial control over *Downton Abbey*, but even those who adapt a nineteenth-century novel for the small screen can still achieve great technical and narrative innovation, despite the "closed arc" of the original source text. Perhaps the most subversive writer to examine, Ellen Moody argues, is Andrew Davies, whose two BBC adaptations of Anthony Trollope's novels *He Knew He Was Right* (2004) and *The Way We Live Now* (2001) offer a liberal feminist interpretation of Victorian domesticity and masculinity. Moody closely analyzes Davies's televisual techniques of filmic epistolary sequences, montage, flashbacks, and voice-over, critiquing and shedding light on the relationship between the original source texts and their adaptations. Davies not only undercuts the conservatism of these novels while exploiting conservative tendencies in heritage films but also freely adapts Trollope's male characters' psychological experience as they cope with the demands the characters make upon themselves while they attempt to enact sexual ideals of manliness and achieve financial and social success.

One form of innovation often overlooked by viewers and critics alike, who look for authenticity in the costume drama's interior furnishings and clothing, involves music, but as Karen Beth Strovas and Scott M. Strovas demonstrate, music (and notable musical absences) transcends its role as supplementary to a scene's action and emotional content. Their chapter examines the function of music in *The Forsyte Saga* (2002–2003), *Upstairs,*

Downstairs, and *Downton Abbey*, not just for establishing the period settings of the dramas but also for the ways in which all three programs exploit music as a tool to define and intensify the conflicts of class and gender central to their narratives. Of the three, only *The Forsyte Saga* consistently features music that would have been heard and performed within its London setting; *Upstairs, Downstairs* uses music of an early 1900s British character, albeit newly composed, and *Downton Abbey* features a contemporary orchestral soundtrack. Strovas and Strovas look at the title music as well as specific scenes from each series, for example, Soames's rape of Irene in *The Forsyte Saga*; Sarah's provocative music-hall-style performances in *Upstairs, Downstairs*; and the scene where Matthew and Mary dance along to the gramophone as Matthew's fiancée lay upstairs dying of influenza in *Downton Abbey*. They demonstrate how music deepens characterization, differentiates between the upstairs and downstairs ways of life, and defines and intensifies other potential class and sexual conflicts.

In the case of *Downton Abbey*, the use of specific musical references adds further layers to the program's already complex relationship to the so-called heritage tradition of representation that is deemed so important to British visual and literary representation. Strovas and Strovas include in their chapter some analysis of the controversial rape story line initiated in the third episode of the fourth series. Some aficionados of UK costume drama may well have been struck by the episode's juxtaposition of the "downstairs" sexual assault of housemaid Anna with an "upstairs" concert performance of "O Mio Babbino Caro" by Dame Nellie Melba. Here, not only was the real-life Australian soprano played by the well-known opera star Dame Kiri Te Kanawa, but also Kanawa was singing the same music that had been used as the opening credits for Merchant Ivory's *A Room with a View*, arguably one of the quintessential British "heritage" texts of the 1980s. The subsequent debate—in the press and among fans—was mostly concerned with perceptions of taste and precedent, but the choice of a highly coded piece of music for this pivotal scene was evidently deliberate and certainly readable as an act of provocation by the creative team.

The chapters in part II expand on the ongoing debate about what constitutes a "heritage" production, as well as how "historically accurate" such productions are and why such labels are more limiting than productive for textual analysis. Critics have been too hasty in their view of the costume drama as a purveyor of nostalgia, a conservative and superficial rendering of a myth of "Britishness." In fact, as Jerome de Groot has argued, the TV costume drama is "flexible and innovative" and can "invoke complex models of historical subjectivity, confound expectations, and consider key political issues of the past in order to educate the viewer."[17] As this collection demonstrates, series as diverse in content and style as *Upstairs, Downstairs* and

Ripper Street equally allow for a critique of understandings of past traditions, including gender and class roles, and challenge models of the past.

The popular success of programs such as *Downton Abbey* seem to suggest a viewer preference for dramas set in the recent past, that is, the late nineteenth and early twentieth century. However, as Andrew B. R. Elliott argues, dramas set in the medieval period demand our critical attention as they frequently harness those same values and ideas that characterize the more familiar kinds of period dramas. Surveying programs produced from the 1950s to the present day that center on the historical (and sometimes ahistorical/fantasy) topics of Robin Hood, King Arthur, and the Crusades, Elliott traces how the costume drama has evolved from a formulaic narrative into a more cynical critique of the British past, allowing a more introspective turn in its critiques of national founding myths and revealing anxieties about national identity, multiculturalism, and masculinity.

Not all of the costume dramas set in the medieval and early modern past focus on notable men of history. Sabrina Alcorn Baron compares Elizabethans' interactions with their "Virgin Queen"—a person placed at the head of the political and social order—with the costume drama's determination to transform her into "every woman." While the essence of Queen Elizabeth I was manipulated in her lifetime to ensure that she transcended her femaleness to be a successful public political figure in an overtly patriarchal office and culture, twentieth- and now twenty-first-century television has reshaped Elizabeth I into a sexualized female stereotype who failed at love and motherhood, and thus did little else of consequence. In most television portrayals, in fact those touted as the most genuine, historically-based portrayals, Queen Elizabeth I, one of the most powerful women in the history of the world, is portrayed as a woman just like any other: weak, feeble, and in need of male guidance and support.

The defeat of the Spanish Armada during Elizabeth I's reign has long been held as one of England's greatest military achievements. And, as Mark Fryers notes, the Armada was something of a turning point, marking the beginning of a cultural fascination with both maritime success as being vital to the wealth and security of the British nation and the idea of "difference" and "exceptionalism." Re-creating another period ruled by a mighty queen, *The Onedin Line* (1971–1980) depicts Britain's Victorian empire protected by its Merchant Navy and the unique character of the men who sailed in it. While the series evokes Britain's heritage of landscape, and particularly maritime painting and nautical romance, it more significantly presents the sea as a masculine frontier, typified by a national mythology allied to strong and silent men made tough by the landscape. *The Onedin Line*'s cancellation, after a decade of international success, pointed to an overall declining interest in the navy since the 1970s. Indeed, when a ship does feature in TV

costume dramas such as *Downton Abbey*, it is mainly to kill off an inconvenient character on the *Titanic*.

As does Fryers, A. Bowdoin Van Riper looks at male-centric costume dramas that place war and work squarely in the dramatic foreground and in the process subvert the genre. Rather than simply use war as an excuse for romance, the Second World War–themed series *Danger UXB* (1979) and *Piece of Cake* (1988) take place on the de facto front lines at particular, clearly identified moments within the war. The men at the center of the action are not of the elite leisured class who typically populate costume dramas; in fact, such men are depicted as buffoons and out of touch with the changing nature of modern warfare. The defense of Britain in 1940–1941 was led, both series suggest, by men who had little connection with, and often less regard for, the prewar order of things. They are men who laud the values of work and technology and win the war through mastery of machines. Though apolitical, they are presented as heroic because they embody the distinctly Thatcherite virtues of the 1980s.

In the updated version of *Upstairs, Downstairs* (2010–2012), the Second World War still looms on the horizon. The First World War dominated series 4 of its 1970s predecessor, leaving the upstairs son, James Bellamy, physically and emotionally damaged. The new master of 165 Eaton Place, Sir Hallam Holland, seems, according to Giselle Bastin's chapter, just as weak as James Bellamy, an equivocator in his domestic affairs in ways that mirror the Chamberlain government's confused dealings with the German leadership throughout the late 1930s. Although facing Hitler's bombs by series' end, Eaton Place is already a house in ruin, one where the sandbags gathered at the house's entrance are as indicative of the threats from within (a fascistic sister-in-law and Holland's own adultery) as from without. On a larger level, *Upstairs, Downstairs* engages in a dialogue with historiographical representations of the 1930s and also with developments in period drama itself; it offers a number of self-reflexive strategies to indicate just how intertwined the narratives of the past are with some of the wider concerns of the period genre.

While Bastin regards the 2010–2012 *Upstairs, Downstairs* representation of the past as more nuanced and creative than its 1970s predecessor, Katherine Byrne, in her discussion of *Downton Abbey*, is keenly aware of the negative criticism that often accompanies the costume drama's engagement with the history it claims to authentically re-create. No one can deny that *Downton Abbey* is faithful to the period details or the latest twentieth-century technologies transforming the large estate inside and out, but critics of the first two seasons of the series have faulted it for its nostalgic, conservative worship of the aristocratic lifestyle, reminiscent of the heritage costume dramas of the 1980s. In response to such criticism, the series' creator and writer, Julian Fellowes, has complicated in the third and fourth seasons his original

fantasy of a gentle, paternalistic order in which harmony largely exists within and between the upstairs and downstairs worlds. Death and rape now cast a pall on the abbey, and although the killing off of beloved characters such as Lady Sybil and Matthew Crawley, and the turning of fan favorites like Anna into victims of sexual violence, have angered many fans, Byrne suggests that such developments seem inevitable as the series moves through the twentieth century and closer to the modern world. The cost of a movement away from the conventional, nostalgic heritage drama is that the world offered instead is less comforting and more disturbing, and one wonders if viewers will be as willing to return for more seasons of a "downer" *Downton Abbey.*

Experimenting with the heritage formula may win the approval of critics, but this does seem to occur at the expense of fans' tastes and desires, and this is certainly the case with Tom Stoppard's 2012 production of Ford Madox Ford's *Parade's End.* Although it has some of the visual pleasures typical of the costume drama, Stella Hockenhull describes the innovative camera work and editing, inventive and melodramatic imagery, and depiction of women as independent and sexually promiscuous, which mark this production as "high end" and "postheritage." From its opening sequence that compacts four years into seven minutes and ends with a close-up of a copulating couple, we know that this will not be a traditional classic adaptation. Fidelity to the source text is not Stoppard's intention, but he does stay true to Madox Ford's fractured style, capturing the breakdown of English society in the wake of the First World War and its aftermath. Lastly, Hockenhull notes that *Parade's End*'s attempt to appeal to a less elitist and more populist audience ultimately failed to win over viewers in either the UK or United States who overwhelmingly preferred its rival, the less experimental *Downton Abbey.*

Even when the costume drama does not take technical risks, it can still be quite transgressive (within limits) in its approach to the sexual and class politics of the past, as the chapters in part III illustrate. Appealing—it is often said—largely to middle-class women,[18] costume dramas address issues, usually of a domestic nature, that speak to historical specificity but also transcend time and relate intimately to viewers' own lives. The role of fans in shaping the content and reception of these dramas is especially relevant in this age of online message boards and fan fiction, but as the example of the "survivors" of the 1972 *Forsyte Saga* marathon demonstrate, fans have always engaged with the TV costume drama on an intensely personal and emotional, if less technological, level.

The writers and producers of these series have had to acknowledge this formidable force, as Julie Anne Taddeo's chapter on the 1970s BBC series *Poldark* suggests. Depicting such taboo topics as rape and domestic abuse, *Poldark* clearly courted a predominantly female audience, but the more practical considerations of the BBC production team and the responses of fans who mythologized the character of Captain Ross Poldark (and the actor

portraying him) often clashed with *Poldark*-creator Winston Graham's feminist intentions. The influence of fans—described by some critics as a "Cult of Poldark"—has since been bolstered by the series' afterlife on video and DVD, as well as the Poldark Appreciation Society and message boards whose members continue to debate the sexual politics of the *Poldark* novels and TV series. This type of interaction with the costume drama also disrupts any notion (as typically perpetuated by critics) of the female fan as a mindless viewer of "fluff."

The intellectual and emotional engagement of fans with the costume drama is further illustrated by the rise of online fan fiction, which has rapidly become a genre in its own right. As Andrea Schmidt demonstrates, Internet fan fiction sites based on *Downton Abbey* both respond to and potentially influence the series itself. The conservative impulse at the heart of the series, and the aristocratic posturing of its creator and writer, Julian Fellowes, especially come under harsh criticism from fan fiction writers. On websites such as Fanfiction.net, contributors publish their own version of events, alternative love stories (especially of the homoerotic variety), and parodies, and engage with other readers of the site; ultimately, the *Downton* fan fiction boards provide an important space for viewers to work through and challenge what they consider a portrayal of history and gender, as well as class and race, in need of serious revision. As Schmidt demonstrates, fan fiction has the potential, if not to solve, at least to bring attention to, problematic depictions of the past perpetuated by Fellowes in *Downton* (and assign the series' female characters greater sexual agency and narrative depth in the process).

That *Downton Abbey* has fueled such an online wealth of fiction by fans speaks to the enormous cultural influence of this series. Fellowes's meticulous attention to period detail has also stirred up a longing by fans to "own" a piece of the past he has imagined on the small screen, a longing that has easily been satisfied by marketing *Downton*-themed and -branded beauty products, jewelry and accessories, and excursions to Highclere Castle. The displays of opulence and pleasures of consumerism associated with *Downton Abbey* are also a prominent feature of the two recent department-store-themed series, *The Paradise* and *Mr. Selfridge* (the latter another Andrew Davies creation), and as Andrea Wright explains in her chapter, spectacle and shopping are also bound up with gender representation, class structures, and social change. Comparing the two series in which the ambitious owners and managers of the department store are all male with their closest predecessor, *The House of Eliott* (1991–1994), about the developing couture business of two genteel and independent sisters, Wright observes that, while familiar in some respects, the earlier series offered much more exciting and transgressive representations of femininity. Even as the salesgirls in *The Paradise* and *Mr. Selfridge* struggle to rise up the stores' hierarchy, they are constantly faced with a choice of love versus financial independence, and the women all

pay much higher prices for their sexual transgressions—probably more historically accurate but also much more disappointing for twenty-first-century viewers.

The competitive spirit of the department store in *Mr. Selfridge* and *The Paradise* infects all of its employees, including the female clerks, who compete with each other not only for commissions but also for the attentions of the men with or for whom they work. Therefore it is refreshing to see a true sisterhood at work in *Call the Midwife*, what Louise FitzGerald calls a rare paradigm in a postfeminist culture that encourages female misogyny. Based on Jenny Lee's memoirs of her experiences as a midwife in a prefeminist era, *Call the Midwife* does not shy away from such controversial issues as domestic abuse, rape, incest, and abortion, but conflicts are too easily resolved, and the program's superficial treatment of race and class in London's East End of the 1950s further problematizes the recent impulse by journalists and other scholars to read *Call the Midwife* as feminist TV. *Call the Midwife*, FitzGerald suggests, might seem radical in its cultural presentation of women, but its feminism is safe and contained within the past.

When another taboo topic, homosexuality, is tackled by the costume drama, the immediate context of the program's production and viewer reception must also be taken into account. Lucy Brown compares the fates of two footmen, both homosexual, in the 1970s version of *Upstairs, Downstairs* and the more recent series, *Downton Abbey*. The staff and upstairs family at 165 Eaton Place cannot even bring themselves to utter the word "homosexual," and Albert's trajectory, from illicit lover of an aristocratic household guest to executed murderer of another male lover, was quite daring for 1970s television, even as it reinforced both Edwardian and late twentieth-century prejudices about the homosexual as a deviant type. Meanwhile, *Downton Abbey*'s gay footman, Thomas, while often hated by viewers, is disliked not because of his sexual orientation but for his scheming ways that often hurt his more kindly coworkers and employers. Thomas does exist within the confines of the criminalization of homosexuality (and barely escapes arrest in series 3), but the twenty-first-century mindset of *Downton Abbey*'s writer and viewers does not allow for the same ending for Thomas as that which befell Alfred forty years earlier on *Upstairs, Downstairs*.

Alfred's violent crime is never shown on camera, and the costume drama as a whole has tended to shy away from graphic depictions of violence; not so, however, with the recent police costume drama *Ripper Street*, whose weekly body count seems to keep growing. However, it would be foolish to read this series about lawmen, themselves of dubious morals, fighting crimes (and having a lot of sex with prostitutes) in the post-Ripper Whitechapel slums as a continuation of the misogynistic, violent "new lad" tradition that dominated 1990s British cinema and TV. Elke Weissmann looks at this BBC–BBC America coproduction as a way to understand how a transnation-

al mix of a distinctly British costume-drama genre with the American crime drama and Western leads to a more complicated and fractured depiction of masculinity and heroism. The lawmen at the center of the series, while undeniably quick with a gun (and fists and knives), are traumatized by violence, inadequate at yet often yearning for domesticity, and very relatable to twenty-first-century viewers. Its popular success also suggests a possible template for the future development of the UK costume drama.

Ripper Street's self-conscious grittiness and its reimagining of late-Victorian London as a steampunked Wild West seems, on the surface, to place it outside the mainstream of a tradition of British costume drama most obviously represented by the likes of *Upstairs, Downstairs* and *Downton Abbey*. Indeed, it is difficult to imagine what those marathon viewers of *The Forsyte Saga* would have made of *Ripper Street*, or even *Downton* for that matter. But in ranging across a broad (and yet far from exhaustive) assortment of examples, the contributors to this volume identify sufficient commonalities and continuities to justify and demand further scrutiny of the British costume drama. This is a history of popular television that has tended to be critically overlooked, or dismissed in oversimplistic terms; one might cite here, for example, the historian Simon Schama's judgment of *Downton Abbey*, and the British period drama more generally, as "servicing the instincts of cultural necrophilia."[19] The chapters in this volume hopefully go some way to addressing the social and political contexts that have shaped the genre (if it indeed can be recognized as one), as well as the changing geohistorical contexts in which programs are re-viewed and reinterpreted by a thriving twenty-first-century global fan culture. In so doing, *Upstairs and Downstairs* is both an interdisciplinary intervention within the expanding, exciting field of television studies and an argument for the value of television texts in the understanding of broader cultural, political, and industrial trends.

NOTES

1. "The Longest Picture Show," *Guardian*, 6 November 1972, 28.
2. See Joe Moran, *Armchair Nation: An Intimate History of Britain in Front of the TV* (London: Profile Books, 2013), 174–77. For an example of a citation of the legendary status of *Forsyte*'s impact on viewers, see Richard and Judy, "Life Below Stairs Was Very Tough in the Downton Era," *Express*, 12 October 2013, accessed 20 January 2014, http://www.express.co.uk/comment/columnists/richard-and-judy). Moran gives a nuanced account and slight debunking of the "legend" that the success of the "Sunday night period drama," as represented by *The Forsyte Saga*, hastened the decline of church attendance. He quotes Ronald Blythe's comment that the "demise of Evensong" was due to "the best television of the week, plus, I used to suspect, some connivance by the clergy to rid themselves of this service." Ronald Blythe, *The Bookman's Tale* (Norwich, UK: Canterbury Press, 2009), 88.
3. For an account of the *Downton Abbey* controversy, see, for example, Sabrina Sweeney, "Downton Abbey creator Julian Fellowes defends story line," *BBC News*, 8 October 2013, accessed 20 January 2014, http://www.bbc.co.uk/.

4. For a detailed account of the genesis of *Masterpiece Theatre*, see Rebecca Eaton, *Making Masterpiece: 25 Years behind the Scenes at Masterpiece Theatre and Mystery! On PBS* (New York: Viking, 2013).

5. For an account of the origins of *Upstairs, Downstairs*, see Deirdre O'Brien, "'I Always Wanted to Be the Maid, Not the Lady': Upstairs Downstairs Creator and star Jean Marsh on Revival of the Classic Costume Drama," *Sunday Mirror*, 9 February 2012, 19.

6. "The Longest Picture Show," 28.

7. Sergio Angelini, "*The Forsyte Saga*," ScreenOnline, accessed 20 January 2014, http://www.screenonline.org.uk/.

8. Graeme McMillan, "'I Must Have Said It Wrong': Decoding *Downton Abbey*'s Television DNA," *Time*, 4 January 2013, accessed 21 January 2014, http://time.com/entertainment.

9. See, for example, "Downton, a Remedy for Our Chaotic Lives: Women Delight in Being Transported to a More Orderly Time," *Mail Online*, 13 September 2013, accessed 21 January 2014, http://www.dailymail.co.uk/.

10. Vicky Frost, "Less Grit Please: The Rise of 'Warm Bath' Television: Feelgood Dramas Are Spreading beyond Their Sunday Night Slots," *Guardian*, 19 January 2013, 17.

11. Theodore Dalrymple, "The Secret Appeal of 'Downton Abbey,'" *Wall Street Journal*, 4 February 2012, accessed 21 January 2014, http://online.wsj.com/.

12. Nicoletta Gullace, quoted in "UNH British Historian Explains Appeal of Downton Abbey," 13 December 2012, accessed 21 January 2014, http://www.unh.edu/.

13. Some examples of scholarship dealing with the interrelationship of history and television are Ann Gray and Erin Bell, *History on Television* (London: Routledge, 2012); Helen Wheatley, "Rooms within Rooms: *Upstairs Downstairs* and the Studio Costume Drama of the 1970s," in *ITV Cultures: Independent Television over Fifty Years*, ed. C. Johnson and R. Turnock, 143–58 (Maidenhead, UK: Open University Press, 2005); and Rachel Moseley, "'It's a Wild Country, Wild . . . Passionate . . . Strange': *Poldark* and the Place-Image of Cornwall," *Visual Culture in Britain* 14, no. 2 (2013): 218–37.

14. See, for example, Jerome de Groot, *Consuming History: Historians and Heritage in Contemporary Popular Culture* (London: Routledge, 2009); Amy Sargeant, "Making and Selling Heritage Culture: Style and Authenticity in Historical Film and Television," in *British Cinema, Past and Present*, ed. Justine Ashby and Andrew Higson (London: Routledge, 2000); and Andrew Higson, *English Heritage, English Cinema: Costume Drama since 1980* (Oxford: Oxford University Press, 2003).

15. See, for example, Claire Monk, *Heritage Film Audiences: Period Films and Contemporary Audiences in the UK* (Edinburgh, UK: Edinburgh University Press, 2011).

16. See, for example, Janet McCabe and Kim Akass, eds., *Quality TV: Contemporary American Television and Beyond* (London: Tauris, 2007); Mark Jancovich and James Lyons, eds., *Quality Popular Television: Cult TV, the Industry and Fans* (London: British Film Institute, 2003); and Michael Z. Newman and Elana Levine, *Legitimating Television* (London: Routledge, 2011).

17. De Groot, *Consuming History*, 184.

18. Ibid.

19. Simon Schama, "Why Americans Have Fallen for Snobby 'Downton Abbey,'" *Newsweek*, 16 January 2012, accessed 21 January 2014, http://www.newsweek.com/.

Part I

Approaches to the Costume Drama

Chapter One

Pageantry and Populism, Democratization and Dissent

The Forgotten 1970s

Claire Monk

The familiar historiographic narratives we are told (or tell ourselves) about the "rise" of period costume dramas on British television and their export worldwide—as shaped by TV critics and the wider media but also in academic accounts—often seem to inhabit a perpetual present, preoccupied with identifying, analyzing, celebrating, or decrying the (presumed) latest trends and recent successes. However, this tendency toward neophilia—fascination with the (apparently) new—can mask amnesia about the trends, radical innovations, and achievements of the surprisingly recent past. The global success of the major British-made costume-soap phenomenon of the early twenty-first century, ITV's *Downton Abbey* (which debuted in the UK in September 2010), is beyond dispute. *Downton Abbey* has been credited with tripling the ITV network's profits from advertising revenue (and, by some accounts, saving ITV as a company) in its first season;[1] earned its writer/creator Julian Fellowes a Conservative peerage in the British House of Lords; and brought the PBS network its highest ratings in years.[2]

Faced with such benchmarks of success, it becomes easy to overlook the far greater longevity of the British TV period drama across all its familiar subgenres—literary, historical, and popular—and the striking variety of productions, cycles, and subtrends within this longer history. In terms of dominant critical framings, the impact of *Downton Abbey* was preceded by an intense preoccupation—from adaptation scholars to the mainstream media—with the 1990s, widely claimed as marking both the "renaissance"[3] of the period literary adaptation or "classic serial" and the birth of Austen-mania

(following the wave of media and audience excitement around the BBC's 1995 *Pride and Prejudice* and subsequent US studio-backed feature films such as Ang Lee's 1996 *Sense and Sensibility*). However, empirical attention makes clear that rather than being something "new," the high-profile, much-discussed "event" costume dramas of the 1990s onward belong to a far longer continuum of popular, critically acclaimed, profitable, and/or exportable period-drama successes.

What *is* new about post-1990 developments in British TV period drama is that these have been shaped, institutionally, by the arrival of a deregulated, commercially focused commissioning and production culture even within the BBC; the complex fragmentation and specialization of TV audiences; and the increasingly slick and efficient commercialism of the twenty-first-century globalized entertainment industry, in which culturally and financially British period dramas (for many decades, stereotyped as the preserve of a "discerning," culturally conservative niche audience) are marketed and sold as aggressively as any other genre worldwide. This new climate has undoubtedly seen the adoption of (self-consciously) new aesthetic, generic, and popularizing strategies, partly in response to the rising tide, since the 1980s, of critical, scholarly, and popular scorn for "heritage" television, "fidelity" adaptation, and the "*Masterpiece*" aesthetic but centrally designed to capture new audiences and appeal to diversified markets.

But, despite such shifts, the story sources and generic models shaping post-1990s period-drama successes remain recognizably close to those of earlier decades, while the ideological and aesthetic questions these contemporary dramas raise for debate can be only partially understood without a sense of what preceded them. Thus, for example, the (above-and-below-stairs, period soap opera) genre model adopted by the ideologically and aesthetically contested *Downton Abbey* has clear affinities with its hugely popular 1970s precursor *Upstairs, Downstairs* (LWT, 1971–1975), which, like *Downton Abbey*, was produced by commercial television rather than the BBC and spearheaded a much-debated cycle of Edwardian TV dramas in its own decade. Yet as this chapter will show, closer empirical attention to the *full* "cycle" of Edwardian dramas produced by British television in the 1970s (and, in fact, extending back into the 1960s) reveals a far wider (but only selectively remembered) spectrum of texts that defy the unity imposed in even the best of the established scholarly analyses, revisiting the Edwardian past in some cases to ambivalent ideological effect,[4] but in others for overtly interrogatory or progressive purposes.[5] The 1980s, identified by classic-serial scholars Robert Giddings and Keith Selby as the decade of the British costume-drama "blockbuster,"[6] was also the era of Margaret Thatcher's Conservative government. This gave it suggestive political similarities to the "*Downton* moment," which coincided with the 2010 election to Parliament of David Cameron's Conservative coalition government, and was of some rele-

vance to the debates around the ideological functions and appeal of *Downton Abbey* in a period of (contested) austerity politics. Furthermore, the 1990s' "irrepressible tide of Jane Austen revivalism" looks less distinctive to that decade once we realize that the BBC's first *television* adaptation of *Pride and Prejudice* was broadcast as early as 1938.[7]

As Giddings and Selby themselves document, however, the "classic serial" format originated still earlier, on BBC radio, which broadcast its first serialized readings of classic novels in the 1920s (with a notable emphasis, by the 1930s–1940s, on the works of Charles Dickens, alongside more adventurous choices).[8] The very first BBC televised dramas of the 1930s (transmitted live, and dogged by cumbersome equipment, poor picture quality, and continuity problems) soon included period dramatizations of novels and stage plays, both of which multiplied in the post–Second World War period.[9] By the 1930s, the emphasis on theatrical source material already extended far beyond Shakespeare to encompass modernist works on historical subjects such as T. S. Eliot's 1935 *Murder in the Cathedral* (broadcast live in 1936 on BBC TV) and popular theater hits concerned with the more recent past such as R. C. Sheriff's 1928 First World War play *Journey's End* (broadcast on Armistice Day 1937 on BBC TV).[10] And, alongside this theatrical strand, the novels of an array of nineteenth- to twentieth-century English authors who have remained mainstays of the TV costume drama as we know it today (Jane Austen, Thomas Hardy, George Eliot, Elizabeth Gaskell, the Brontës) were popular choices for radio—and later television—serialization from the outset.[11] Such antecedents alert us to the cyclical aspects of the history of British period TV drama but also to what becomes lost if we permit our historiography or interpretive work to succumb to short-termist amnesia. (Indeed, the uneven selectivity of popular, critical, and institutional memory in relation to this history, and the forces shaping these, are subjects of some interest in themselves.)

Many past decades were moments of historical/costume-drama innovation. The terrain of British television period drama in the 1970s, however, is of special interest: for its simultaneous closeness to and distance from the present; and for the ways in which it developed in some directions that recognizably prefigure trends familiar since the 1990s, at the same time as pursuing others that have not endured, are poorly remembered, or often both. Yet perhaps in line with the wider neglect and dismissal of 1970s British culture and film culture,[12] and the dominant framing of 1970s Britain in social, economic, and political historiography as a decade of crisis, the British TV period dramas of the 1970s have suffered both critical and scholarly neglect, and extreme cultural marginalization, relative to those of more recent decades.

Moreover, most of the scholarship that has engaged with the 1970s at all has done so within a consideration of two important, but narrow and overlap-

ping, phenomena across a longer time frame, rather than considering the broader field of period drama specifically within the 1970s. This work has been concerned centrally with developments in the TV classic serial on the one hand. [13] On the other hand, it has looked at the intersecting set of productions distributed, branded, marketed, and mediated to a "discerning" Anglophilic North American audience under the *Masterpiece Theatre* banner. This banner was instigated in 1971 as a distribution and coproduction relationship between the public-service TV channel WGBH Boston and the BBC (joined, two years later, by the ITV network via *Upstairs, Downstairs*) and was underwritten from 1971 until 2004 by the Texan oil corporation Mobil (now ExxonMobil). [14] In both cases, the existing scholarship has emphasized literary costume dramas more than historical stories from nonliterary sources; "quality" rather than popular/mass-market literary adaptations; and often case studies (and textual readings of them) that align neatly with notions of "heritage" television and (gendered) journalistic and academic prejudices against the audiences for such dramas, presumed to be "elite," traditionalist, and uncritically Anglophile.

Thus Giddings and Selby, in their chapter on the 1970s in their study of the "classic serial," dismiss an untenably broad sweep of both literary and nonliterary 1970s productions as "Edwardian period nostalgia." [15] Such stereotypes of British TV period dramas and their audiences are, of course, perpetuated more widely in the existing literature but are paradoxical and need to be challenged for two reasons. First, they disregard the actual aesthetic, thematic, and ideological variety even within restricted subfields such as dramas set in the Edwardian period made and screened during the 1970s. Second, this variety and nuance have, at times, been more fully acknowledged and understood by past commentators—not only by earlier scholars but also even in the contemporary British press during the 1970s. [16] In contrast, Nancy West and Karen E. Laird, writing in 2011, insist that—right up until its "radical relaunching" in 2008—*Masterpiece Theatre* clung to "an aesthetic that kept the camera excruciatingly still [to] . . . fit the sluggish metabolism of middle age" in a format "designed for an older cultural elite who did not watch television . . . [a format whose] survival has depended on the twin comforts of familiarity and old-fashionedness." [17]

Such discourses are—precisely—more discourse than empirical fact, but the discourse is nonetheless a persistent one. Such claims ignore the consciously revisionist, postheritage, period literary adaptations of the 1990s and beyond, including those explored by Sarah Cardwell as the central case studies in her monograph *Adaptation Revisited*. Examples include the BBC's gritty *The Fortunes and Misfortunes of Moll Flanders* (1996) and its groundbreaking but institutionally controversial 1996 version of Anne Brontë's *The Tenant of Wildfell Hall*, with its cold natural lighting and scenes of marital abuse and the (unfaked) medical use of live leeches—which were screened in

the United States by *Masterpiece* in its 1996–1997 and 1997–1998 seasons respectively.

The larger point, however, is that a variety of subjects and styles—including programs or scenes that departed radically, even disturbingly, from the supposedly cozy *Masterpiece* mode—were at least as commonplace in the British TV period-drama mix of the 1970s as in more recent decades. As Simone Knox accurately observes, while "it is tempting" to impose an explanatory narrative of "linear historical development" in which *Masterpiece*'s acquisitions policy "changed over time, widening to allow for more textual diversity"—and equally on British TV period-drama productions themselves, whose thematic, aesthetic, and representational choices are presumed to develop in increasingly daring *and* sociopolitically progressive or inclusive directions—this model does not match the empirical reality. "A closer look at the programme history of *Masterpiece Theatre* suggests that, *from the early years* [my italics], it showed programmes that do not comfortably fit into [a] 'best of the past' heritage shorthand."[18]

With these issues in mind, this chapter seeks to provide a broader appraisal of the field of the British period television drama during the 1970s and a necessary account of significant developments and production trends in a distinctive—but incompletely analyzed and poorly remembered—decade. My account is guided by the following emphases. First, it argues for the importance of the popular (even populist) and historical—as well as literary—strands of period TV drama, within the 1970s and beyond. Second—and more distinctive to the 1970s—it acknowledges and reinstates the accepted place of radical political dramas within the TV period-drama mix (inflected by the wider radical, formally experimental, and iconoclastic trends that flourished during the 1960s–1970s "Golden Age" of British television drama),[19] alongside the widespread adaptation (in English) of classics of European, Russian, and American (as well as English) literature. Third, it establishes the significance of 1970s developments in laying the cultural, generic, and institutional foundations for the British television period drama as it is understood by audiences and framed academically today. But, fourth, I also argue for the crucial importance of studying the 1970s to remind us of rich paths and possibilities that the dominant period-drama trends of later decades ultimately did *not* take.

INSTITUTIONAL MARGINALIZATION AND TECHNOLOGICAL LIMITATIONS

This "lost" history is exacerbated by institutional marginalization. Numerous 1960s–1970s British TV drama productions recorded on video have been lost to the archive because the tapes were junked. Also, many key 1970s produc-

tions (including dramas that do survive in the archives) have never been
released on VHS or DVD, ranging from the BBC's thirteen-part dramatiza-
tion of Jean-Paul Sartre's *Roads to Freedom* trilogy (1970) to the unprece-
dented, explicitly feminist, committed women's history of *Shoulder to Shoul-
der* (BBC, 1974), which explored the struggles, strategies, and key players of
the post-1900 Women's Suffrage Movement (centrally, the militancy of the
Women's Social and Political Union) across six interlinked seventy-five-
minute television plays.

The nonavailability and "organized forgetting" of such dramas has per-
sisted in the face of twenty-first-century Amazon customer campaigns and—
in the case of *Shoulder to Shoulder*—feminist campaigns; the efforts of ac-
tress Patricia Quinn (who played Christabel Pankhurst in the series and en-
joys influence with an international fan base via her role as Magenta in the
1975 cult film *The Rocky Horror Picture Show*); and, in 2014, a cast and
crew reunion and symposium at Birkbeck, University of London, to com-
memorate the series' fortieth anniversary—where *Shoulder to Shoulder*'s
production manager, Graham Benson, declared that the 2014 BBC regime
literally "haven't heard of it."[20] Yet the fate of these series stands in (perhaps
revealing) contrast with another milestone of 1970s TV political-history dra-
ma: *Days of Hope* (BBC, 1975), a socialist, working-class history of the
British Labour movement from the First World War to the 1926 General
Strike, written by Jim Allen, produced by Tony Garnett, and directed by Ken
Loach, which was both widely debated at the time and has remained visible
in the scholarly literature.[21]

The institutional and technological foundations upon which British TV
period drama would flourish and develop in the 1970s—the launch of the
BBC's second television channel, BBC Two; the general adoption of the new
videotape technology for the recording of dramas (rather than live transmis-
sion); and the (initially, partial) launch of color television—were actually
laid in the 1960s. Further innovation would come in the later 1970s: *The
Mayor of Casterbridge* (BBC/Time Life Films, 1978)—adapted by Dennis
Potter from Thomas Hardy's 1886 novel and starring Alan Bates as Michael
Henchard, the tragic protagonist whose decision to sell his wife at a fair
brings about his downfall twenty years later—became the first drama serial
to be shot entirely on lightweight outside-broadcast cameras.[22] Giddings and
Selby are scathing about the technically flawed result—ameliorated by the
psychological depth of Potter's distinctly auteurist adaptation and the superb
performances. Prior to *The Mayor of Casterbridge*, British period TV dramas
were shot predominantly on sets and recorded on videotape—initially, often
edited live during filming, as postproduction editing of early video was ex-
tremely difficult—punctuated by outdoor location sequences shot on film.
While the aesthetic differences between videotaped interior sequences and
filmed location work are apparent when we re-view such dramas (indeed,

Figure 1.1. Emily Wilding Davison (Sheila Ballantine), women's suffrage activist and heroine, contemplates the final militant action that would lead to her death when she was trampled in a collision with King George V's horse at the Epsom Derby on the 4 June 1913 (*Shoulder to Shoulder*, episode five).

contemporary critics did not always welcome the latter),[23] this approach was so much the norm in the 1970s that it did not deter large audiences. Moreover, the technological limitations of 1970s TV drama were often belied by the quality and boldness of writing and performance, and forms of thematic expansion and dramatic development, that the production economics and narrative economies of twenty-first-century television rarely permit today.

THE BBC AND THE PERIOD BLOCKBUSTER

BBC Two was launched in April 1964. Within a wider ethos of mixing highbrow and popular programming, one of its core strategies to attract viewers was an ambitious approach to quality period drama, concentrated in the classic literature, historical, and political range of the spectrum.[24] During the late 1960s and 1970s (and beyond), such productions would typically premiere on BBC Two, supported by a fanfare of full-color publicity in *Radio Times* (which at that period exclusively covered only the BBC's, not ITV's, schedules and programs), followed—in selected, successful cases—by repeats on the mass-audience channel BBC One. Classic serials were immediately allocated a new Saturday-evening slot on the new BBC Two, allowing for "a more sophisticated and sometimes daring choice of novel and a more adult treatment in longer episodes" compared to the established teatime or early evening slots in which family classics (such as *Tom Brown's School-*

days [1971] or *David Copperfield* [1966 and 1974]) were traditionally scheduled.[25]

The year 1967, pivotally, was the year of the BBC's first (and enduringly most famous) great period-drama blockbuster, *The Forsyte Saga*—which was simultaneously "a landmark in the change-over from live drama transmission to monochrome videorecording" and the last lavish period-drama series to be made and shown in black and white, since 1967 was also the year of the UK's first color broadcasts.[26] Adapted from a cycle of novels by John Galsworthy that were published between 1906 and 1922 but set in the late 1870s onward, *The Forsyte Saga* dramatized the tensions, conflicting values, loves, and feuds across two branches of a wealthy business family—deeply conscious of their status as "new money" rather than members of the old aristocracy. Starting in January 1967, *The Forsyte Saga* ran for twenty-six fifty-minute episodes. It starred Eric Porter as the stolidly materialistic "man of property" Soames Forsyte, Kenneth More as his (relatively) unconventional artist cousin and antithesis "young" Jolyon Forsyte, and Nyree Dawn Porter as the beautiful, enigmatic Irene, over whom both men battle. The series drew more than eighteen million UK viewers per episode (at a date when the UK population was fifty-five million, British television comprised only three terrestrial channels, and viewer tastes remained conditioned by classed attitudes to popular culture).[27]

The Forsyte Saga established a template for the production of period "event television" dramas on a vast multiepisodic scale that would remain prevalent throughout the "long" 1970s. This extended to the sale of such BBC (and, later, ITV) serials/series—and, more commonly, shorter miniseries—to North America, where *The Forsyte Saga* debuted on the United States' National Educational Television (NET) in 1969. It went on to be sold and screened worldwide, where it was ultimately seen by around 160 million viewers.[28] In October 1970, however, NET was superseded by PBS. NET's distribution of *The Forsyte Saga* can thus justifiably be viewed as the precursor of the transatlantic *Masterpiece Theatre* relationship between PBS/ WGBH and the BBC that would be formalized the following year.

The BBC's "full" color service was launched (at first exclusively on BBC Two) on Saturday, 2 December 1967 (following color coverage of the summer 1967 Wimbledon tennis championships), with a six-part adaptation of William Makepeace Thackeray's satirical 1840s novel *Vanity Fair*—starring Susan Hampshire, *The Forsyte Saga*'s Fleur, as Thackeray's social-climbing antiheroine Becky Sharp. As the first British classic-novel adaptation to be produced in color, *Vanity Fair* was notable for a lavish production design that broadcast both the appeal of color television (and of investing in a color TV set) and its special merits for the display of historical sets and costumes. As Giddings and Selby explain, it was "an elaborate undertaking, with 60

speaking parts . . . and conscientiously historical design by Spencer Chap-
man," while Hampshire was given thirty costume changes.[29]

MASTERPIECE THEATRE AND
TRANSNATIONAL PARTNERSHIPS

Masterpiece Theatre made its debut on PBS on 10 January 1971, establishing
the institutional model for the transnational funding and circulation of cultu-
rally British period television drama that remains most prominent today.
Despite *Masterpiece*'s self-presentation to its US audiences as a drama series
in its own right—by 2014, "the longest-running primetime drama in
American television"[30]—it was and is more accurately understood as a distri-
bution, marketing, and (less often) production funding partnership between
the Boston-based public-service broadcaster WGBH and British television
drama producers (initially, the BBC).

 Masterpiece fast became the most visible brand under which British peri-
od TV dramas, serials/series, and miniseries—prestigious and popular
alike—would be packaged for and received by transatlantic audiences; it was
thus central to the US profile of British television drama as itself a quality
"brand" and to the formation of Anglophilic taste among sections of the US
television audience.[31] Three important qualifications must be added, howev-
er.

 First, the time lag between the UK television debuts of these dramas and
their US television premieres as part of *Masterpiece Theatre* was variable
and could stretch to several years. Indeed, almost half of *Masterpiece*'s debut
1971–1972 season was filled by dramas that had been made and screened by
the BBC in the late 1960s, such as Stella Gibbons's 1932 rural-romance
parody *Cold Comfort Farm* (1968). There were also a cluster of 1968–1969
adaptations from the heavyweights of nineteenth-century European literature,
all exploring themes of social stratification, division, and upheaval attuned to
the late-1960s sociopolitical zeitgeist: Tolstoy's *Resurrection*, Balzac's *Père
Goriot*, and Dostoyevsky's *The Gambler* and *The Possessed*; meanwhile the
BBC's 1967 *Vanity Fair* did not reach US audiences until *Masterpiece*'s
1972–1973 season. For consistency, this chapter cites original UK (rather
than US) TV broadcast years throughout.

 Second, *Masterpiece* was not the only new international—or transatlan-
tic—partnership to make its mark on 1970s British television drama. In BBC
Two's early years, several of its largest-scale prestige series were co-
produced by Time Life Films, then (typically) broadcast on NBC. These
included Jacob Bronowski's famous twelve-part factual series *The Ascent of
Man* (1973) and the decade's most expansive—indeed, to many of its critics,
unwieldy—classic-novel blockbuster, Tolstoy's *War and Peace* (1972),

adapted in twenty forty-five-minute episodes by Jack Pulman and starring the young Anthony Hopkins as Count Pierre Bezukhov. Benefiting from co-production funding from the Belgrade-based Yugoslav Films as well as Time Life, *War and Peace* was three years in production. It combined location filming in Yugoslavia with the most expensive (£30,000) TV drama set of its time and featured around two hundred speaking roles plus the Yugoslav Territorial Army as extras.[32]

However, the 1970s also brought other ambitious BBC/Time Life collaborations that have been all but forgotten. *The Search for the Nile* (1971) was a six-part docu-dramatization of the explorer, geographer, and orientalist Sir Richard Burton's 1856–1860 expedition, filmed on location by the esteemed cinematographer Brian Tufano (who, two decades later, would collaborate with Danny Boyle on *Trainspotting*, among many other credits), and starring Kenneth Haigh as Burton. Glowing audience reviews (or, more precisely, memories) posted on IMDb attest to *The Search for the Nile*'s high visual and dramatic quality and the appropriately complex characterization of Burton (including positive comparisons to David Lean's 1962 *Lawrence of Arabia*);[33] but, despite an Emmy Award and Golden Globe nomination, it has never been released on VHS or DVD—in contrast with the DVD availability of both *War and Peace* and the BBC Shakespeare (see below).

Last, while the British dramas broadcast in the United States by *Masterpiece* during its first decade (and beyond) were more diverse than is always acknowledged, it is vital to understand that a far larger, and still more strikingly varied, field of British period TV dramas were made and screened domestically in the UK during the 1970s—by both the BBC (including its regional studios) and the ITV companies—without US involvement or distribution. This domestic UK period-drama output—of which only a relatively small part was distributed transatlantically and seen by US audiences, and much of which is lost to British archives—was extremely prolific during the 1970s and reached domestic UK audiences under more than one programming strand.

PLAY OF THE MONTH: DIVERSITY AND RADICALISM

In addition to the BBC "classic serial"—across both strands of its dual strategy: the teatime/family-oriented and BBC Two evening/adult variants—and its ITV comparators, more than eighty further single (and, predominantly, *period*) dramas were packaged and broadcast between 1969–1970 and 1978–1979 under BBC One's *Play of the Month* strand (which ran from 1965 until 1983). Led from 1966 to 1977 by the South African–born producer Cedric Messina, *Play of the Month* predominantly screened (or adapted) classical and contemporary stage plays, as well as some novel adaptations.

The strand went into hiatus in the late 1970s (then ceased altogether) after Messina was charged with producing the most ambitious of the BBC/Time Life collaborations: the BBC Shakespeare, launched in 1978, which brought classically cast and staged productions of twelve of Shakespeare's plays to television in 1978–1980 alone.

While *Play of the Month* itself included some significant Shakespeare productions, its wider period-drama output during the 1970s was, by twenty-first-century standards, staggeringly broad. It thus stands as one of several indexes of the unruly diversity of 1970s British TV period drama across all its intersecting generic, programming, and institutional fields. This diversity can also be traced via the astonishingly varied credits of individual talents, such as the directors Moira Armstrong (*The Shadow of the Tower* [1972], *Shoulder to Shoulder*, and *Testament of Youth* [1979]), Waris Hussein (*Shoulder to Shoulder*, *Notorious Woman* [1974], and *Edward and Mrs Simpson* [1978]), or James Cellan Jones (*The Forsyte Saga, Roads to Freedom, Jennie: Lady Randolph Churchill* [1974], and much of the Henry James cycle discussed below).[34]

The 1970s saw *Play of the Month* productions of works by Chekhov, Ibsen, and Molière; English Jacobean tragedies and Restoration comedies; but also no less than nine plays by George Bernard Shaw, including *Candida* (1971), *Don Juan in Hell* (1971), *Mrs. Warren's Profession* (1972)—written in 1894 but initially banned by the Lord Chamberlain's Office (Britain's theatrical censor, disbanded in 1968) because of its argument that social inequalities made female prostitution a rational choice—and *Pygmalion* (1973). And, in keeping with Shaw's popularity throughout the twentieth century, the *Plays of the Month* were far from 1970s British television's only Shavian offerings. The end of the decade brought a more populist, romantic treatment of Shaw in Granada TV's six-part ITV adaptation of his novel *Love among the Artists* (1979), alongside a BBC production of *Saint Joan* (1979).

Shaw himself was a renowned socialist and activist, but the 1970s *Play of the Month* also televised less familiar and (still) more radical works. These included versions of Georg Büchner's play *Danton's Death* (1978)—adapted and directed by Alan Clarke, one of the greatest British dramatists and directors of his generation in his own right—and Sartre's meditation around the Regency actor-manager (Edmund) *Kean* (1978), starring Anthony Hopkins.[35] They also included two uncompromising plays from the 1900s written in the early 1900s by Shaw's junior, the actor-manager Harley Granville-Barker; production choices that (like Shaw's own works and other examples noted in this chapter) powerfully challenge the persistent equation of Edwardian period drama with a sepia-tinted nostalgia for "the glorious lingering sunset" of an imperialist class society steeped in hierarchy and deference.[36] Granville-Barker's *The Voysey Inheritance* (1979), starring a pre-*Brideshead*

Jeremy Irons, exposes the corrupt foundations of a family business built on fraud and financial speculation. His less-performed *Waste* (1977), initially banned for many years, charts an Edwardian politician's fall from grace after his mistress dies of a botched abortion, and was directed for television by Don Taylor, best known for his 1960s collaborations with the radical dramatist David Mercer.

Taylor's other 1970s credits included (as writer-director) *The Roses of Eyam* (BBC Birmingham, 1973), an excellent case study illustrating how original TV period drama during the 1970s embraced history from below alongside the spectacular pleasures of biographical dramas and royal pageantry. The one-off drama told a harrowing true tale of the courage of ordinary people in the village of Eyam in Derbyshire during the 1665–1666 Great Plague after a box of clothing sent from London brought plague to their village. In common with the higher-profile 1970s radical history blockbusters like *Days of Hope* or *Shoulder to Shoulder*, *The Roses of Eyam* dramatized, rather than effaced, the processes of debate and conflict, collective decision making, and dissent; the village's brave decision to put itself in isolation to halt the local spread of the disease and save the lives of others (in which half the population of Eyam died) was shown to be hard won and not fully obeyed.

HENRY JAMES AND TRANSATLANTIC APPEAL

An examination of decade-specific 1970s trends in the adaptation of classic novels similarly yields some surprises. While one trend was an almost bewildering proliferation of adaptations from Henry James, the decade was equally distinctive for its absences—most startlingly, a hiatus in TV Jane Austen adaptations between 1972 and 1980—and its forgotten cycles. In the light of E. M. Forster's oft-cited resistance to screen adaptations of his novels (which included refusing Satyajit Ray's request to film *A Passage to India*) and the near-universal critical framing of film adaptations of his work as a phenomenon distinct to 1980s to 1990s "heritage cinema," it is almost perplexing to find that Forster's four best-known completed novels were all adapted as BBC One *Play of the Month* productions (three of them—just about—during his lifetime), beginning with *A Passage to India* in 1965 and ending in 1973 with *A Room with a View*.

The BBC's "1970s" James cycle is likewise best understood as stretching from 1965's *Ambassadors* to 1979's *Wings of the Dove*. Between these two productions, the BBC alone broadcast a further six adaptations from James: three single dramas (two of which, *The Heiress* [1969] and *The Ambassadors* [1977] starring the American actresses Gayle Hunnicutt and Lee Remick, were *Play of the Month* productions) and three classic serials: *The Portrait of*

a Lady (1968), *The Spoils of Poynton* (1970), and *The Golden Bowl* (1972), which recast Hunnicutt as Charlotte Stant, alongside the US-born but British-based Jill Townsend (who would later be cast in *Poldark* as Ross's infuriating patrician first love Elizabeth) as Maggie Verver. In addition, the ITV company London Weekend Television (LWT) televised thirteen of James's novels or stories during the 1970s as one-off dramas in its anthology series *Affairs of the Heart*, titled under the female protagonists' names—including (both 1975) *Milly* (*The Wings of the Dove*), with Rosalind Ayres as Milly Theale, and Georgina Hale as *Daisy* (*Daisy Miller*).

Here, one particular appeal of James for the BBC in the first decade of the transatlantic *Masterpiece* relationship becomes evident. As Giddings and Selby note, "It is a self-evident truth that Henry James's fiction is greatly concerned with barely concealed tensions between the New World and the Old," frequently explored via the trope of "young American women, fascinated on visiting Europe . . . coming into conflict with Europeans."[37] (James reversed this trope in his 1878 "sketch" *The Europeans*, an exploration of clashing morals and mores in 1850s New England that in 1979 provided the American director James Ivory and Merchant Ivory Productions with the first of their art-cinema literary "greatest hits," paving the way for the greater crossover success of their 1985–1992 trio of cinematic Forster adaptations.)

The BBC's 1970s James adaptations (unlike LWT's) maximized this transatlantic appeal by casting American actresses.[38] Moreover, transatlantic relations, relationships, and marriage formed a wider (if less Jamesian) thematic trend that extended to some of the decade's popular biographical period-drama series, where it was characteristically coupled with (Churchillian or royal) subjects of presumed appeal to US audiences, treated with a strong emphasis on love affairs and scandal. Key to this trend were two seven-part series produced by ITV's Thames Television: *Jennie: Lady Randolph Churchill*, starring Remick as Winston Churchill's US-born mother, Jennie Jerome, which chronicled her "controversial" marriage into the Churchill family but also her infidelity and multiple remarriages; and *Edward and Mrs. Simpson*, which dramatized the constitutionally problematic relationship of future King Edward VIII (Edward Fox) with the married American socialite Wallis Simpson (Cynthia Harris) and the consequent 1930s British abdication crisis. *Edward and Mrs. Simpson* was also part of a minicycle of 1970s late-Victorian to early twentieth-century royal drama series (intersecting with the wider field of Edwardian dramas), and stands in counterpoint to its precursor, ATV's thirteen-part *Edward the Seventh* (US title *Edward the King*, 1975). The latter was a sympathetic treatment of the youth and rise to the throne of Queen Victoria's son Bertie, the eventual Edward VII, featuring Annette Crosbie as Queen Victoria, Timothy West as Bertie, John Gielgud as the Victorian prime minister Benjamin Disraeli, and Francesca Annis as

Lillie Langtry, one of Bertie's numerous mistresses (who also included Jennie Jerome).

Although respect for the monarchy remained the norm during the 1970s, the rumblings of Republican dissent within British politics became louder toward the decade's end. By 1978, *Edward and Mrs. Simpson*, based on Frances Donaldson's 1974 study *Edward VIII: Road to Abdication* (which had exposed Edward's German sympathies during the rise of National Socialism) marked a turn toward a (necessarily) less reverential approach. The same year also brought two spin-offs from ATV's *Edward the Seventh* team, both shifting nonroyal supporting characters from the earlier series to the center of dramatic attention. The miniseries *Disraeli: Portrait of a Romantic* starred Ian McShane, fresh from his appearance as Christopher Marlowe to Tim Curry's *Will Shakespeare* in John Mortimer's "rumbustuous" and "image-shattering" six-part life of "the bawdy bard," also for ATV, earlier the same year.[39] The thirteen-part *Lillie* expanded Annis's earlier performance as the late-Victorian "Professional Beauty," actress, and royal mistress Lillie Langtry into a tale of female social (and geographical) mobility via men—a trope more widely evident in the decade's popular period dramas. *Lillie* celebrated rather than decried the Jersey-born Langtry's astute self-advancement to the heights of London society via self-exploitation and a succession of wealthy lovers.

ADAPTATIONS OF EUROPEAN LITERATURE

The trend most distinctive to the "long" 1970s was undoubtedly the vogue for classic serial adaptations from European literature, which arrived with the early years of color but (coincidentally or not) tailed off as location filming—greatly enhancing the opportunities for costume dramas to exploit real British landscapes and heritage locations for the international market—became the norm. The Europeanizing trend coincided with the period in which Britain debated and (on 1 January 1973) joined the European Union (as well as the democratization of continental European travel across all social classes). However, the "adult" choices of text—in which sexuality and sensation, including adultery and polyamory as well as betrayal and tragedy, were prominent attractions, but with female dissatisfaction and desire as a recurrent theme—may be more compellingly understood as the costume drama's response to the social transformations of the 1960s in a decade culturally shaped by a wider, unprecedented "crisis of [sexual] permission in British society."[40] This strand encompassed classic serial adaptations such as Guy de Maupassant's *Bel Ami* (1971) and Gustave Flaubert's *Madame Bovary* (1975, again starring Annis) as well as *Vienna 1900* (1973), a sophisticated six-part dramatization, with a vast cast, interconnected short stories by Ar-

thur Schnitzler exploring erotic and familial psychology. ITV's mass-audience take on the European costume drama could be seen in examples such as *The Strauss Family* (ATV, 1972), which dramatized in eight episodes the live, loves, and career rivalries of the nineteenth-century Viennese dynasty of composers across eighty-five years. Also noteworthy in this context is the seven-part BBC/WGBH original drama *Notorious Woman*, which won Rosemary Harris a 1976 Emmy and a Golden Globe nomination for her portrayal of the (female) bohemian, nineteenth-century Parisian writer, lover of Chopin, and occasional cross-dresser George Sand.

BBC Two's five-part *Bel Ami*, indicatively, exhibited the sexual attitudes of its time in its makers' insistence that the story of the penniless opportunist Georges Duroy (Robin Ellis)—a social outsider in Parisian society who ruthlessly uses sex to pursue his ambitions—as "basically a comedy . . . with the charms of a fantasy world." *Radio Times'* publicity reported that Ellis (who had appeared as Robert Devereaux, Earl of Essex, in *Elizabeth R* [1971] only a few weeks earlier) "was partly chosen for the role on the recommendation of a very informal panel of women, who decided . . . that he had the sex appeal appropriate to a great lover."[41] Their taste was vindicated a few years later when BBC One's hugely successful Sunday-night eighteenth-century Cornish tin-mining saga *Poldark* (1975–1977) promoted Ellis to international heartthrob (and according to one banner headline in the British tabloid newspaper *The Sun*, "THE SEXIEST MAN ON TELLY") as the egalitarian hero Ross Poldark.

PAGEANTRY AND THE CULT OF SUNDAY NIGHT

The casting of Ellis leads us neatly, in conclusion, to the two remaining important strands within 1970s British TV period drama that, between them, encapsulate (although, in this varied decade, far from exclusively) the distinctive traits expressed in this chapter's title. On the one hand, there is the pageantry of the iconic BBC Tudor-history blockbusters *The Six Wives of Henry VIII* (1970) and *Elizabeth R*: all-round critical, domestic audience and export triumphs that opened the (post-*Forsyte*) decade in such grand style that the British Radio Manufacturers' Association held them responsible for a 61 percent year-on-year increase in color-TV-set sales.[42] Both series spawned big-screen spin-offs for their stars—but also a less-remembered thirteen-part TV prequel, *The Shadow of the Tower*, focusing on Henry VII's efforts to secure the Tudor dynasty against a dramatic backdrop that included religious dissent and peasant protest.

On the other hand, the decade's popular, mass-audience, multiseason period blockbusters—the serials, upstairs-downstairs narratives, and family sagas—decisively established what the BBC would later celebrate in

retrospect, from the less "golden" twenty-first-century age of marketized media and fragmented audiences, as "the cult of Sunday night."[43] Scheduled on peak-time BBC One or ITV, the benchmark examples included LWT's "grand soap opera" *Upstairs, Downstairs*,[44] which ran for five seasons and sixty-six episodes (1971–1975 in the UK) and became (prior to *Downton Abbey*) "the most successful series that British television ever exported";[45] its BBC One comparator and successor *The Duchess of Duke Street* (two seasons, 1976–1977), inspired by the career of the real-life working-class cockney "Duchess of Jermyn Street" Rosa Lewis, a talented cook turned high-class hotelier; *Poldark*; and *When the Boat Comes In* (four seasons, 1976–1981), James Mitchell's extremely popular epic of working-class industrial and political life in impoverished Northeast England after the First World War (which was exported to some northern European countries but not the United States). Many of these serials were based on original scripts; others (such as *Poldark*, adapted from the novels of Winston Graham) on popular fiction; but in all cases they embraced popular narrative modes. Above all, they were popular in *both* senses: they appealed to wide audiences (as their twenty-first-century successors continue to do), but their subject matter and sensibility, too, were diversely democratizing and egalitarian in ways that seemed second nature in the 1970s but that in the early twenty-first century have become remote from televisual norms and societal expectations alike.

CONCLUSION

In the working-class, feminine, class-mobile, and regional focuses of 1970s British television's mass-audience period-drama serials, we can see the populist echoes of both the politicized labor, working-class, and feminist-history strands of serious 1970s period drama, and of comparable themes explored in the decade's unprecedented (and perhaps unrepeatable) diversity of period dramas adapted from theater and literature. Distinctions of ideology and nuance must, of course, be drawn: between the Marxism of *Days of Hope* and *Poldark*'s late eighteenth-century egalitarian outrage; between the latter and (in another common 1970s trope) *Poldark*'s eroticization of (patriarchal, heterosexual) class difference; and between the socialist feminism of *Shoulder to Shoulder* and *The Duchess of Duke Street*'s proto-Thatcherite narrative of upwardly mobile female enterprise. The unprecedented thematic interest in class, gender, and (hetero)sexual emancipation in such popular and "event" period television dramas of the 1970s—and across the wider terrain discussed in this chapter—nonetheless appealed, and testifies, to wider democratizing impulses that had come to the fore in 1970s British society, alongside continuing unresolved struggles around gender and sexual rela-

tions. As D. L. LeMahieu pinpoints, what made *Upstairs, Downstairs* a breakthrough was "the active presence of three-dimensional working-class people in the first place" in a series that the actresses Jean Marsh and Eileen Atkins had conceived expressly because Marsh's own mother had worked as a parlormaid (while Atkins's mother worked in a factory by day and as a barmaid by night) and because both "wanted to provide servants with a voice of their own in historical dramas." If these new voices sometimes "proved less revolutionary than the New Left hoped, at least the silence had been broken."[46]

However, these gains were made in a decade of unprecedented socio-economic equality in the UK that would decline consistently from the Thatcher-era 1980s onward, and at a moment of equally unprecedented working-class cultural legitimacy that the politics and media culture of later decades would all but erase. How far such voices can still be heard in period television drama today, or exercise creative agency in its production, remain questions for continuing debate.

NOTES

1. "ITV Profits Triple as Ad Revenue Grows Thanks to *Downton* and *The X Factor*," *Broadcast*, 2 March 2011, accessed 31 October 2013, http://www.broadcastnow.co.uk/.

2. Jake Kanter, "*Downton Abbey* Helps PBS to Ratings High," *Broadcast*, 24 February 2012, accessed 31 October 2013, http://www.broadcastnow.co.uk/.

3. Robert Giddings and Keith Selby, *The Classic Serial on Television and Radio* (Basingstoke, UK: Palgrave, 2001), 80.

4. See, for instance, *Upstairs, Downstairs*, or the proto-Thatcherite *Duchess of Duke Street* (BBC One, 1976–1977). One of the first and best-known analyses of these ambivalences can be found in D. L. LeMahieu, "Imagined Contemporaries: Cinematic and Televised Dramas About the Edwardians in Great Britain and the United States, 1967–1985," *Historical Journal of Film, Radio and Television* 10, no. 3 (1990): 243–56. However, his analysis is limited by a focus on only the best known of the British 1970s Edwardian TV dramas broadcast by *Masterpiece* in the United States, alongside disparate cinematic examples, and by an approach that conflates the two media.

5. Examples include the (at the time) high-profile women's-history drama series *Shoulder to Shoulder* (1974) and the multi-award-winning *Testament of Youth* (1979), adapted from the feminist, pacifist, and social reformer Vera Brittain's best-selling 1933 personal memoir of the First World War.

6. Giddings and Selby, *Classic Serial*, 54.

7. Ibid., 117.

8. Ibid., 9–14.

9. Ibid., 14–22.

10. Ibid., 15–16.

11. Ibid., 13.

12. Sue Harper and Justin Smith, *British Film Culture in the 1970s: The Boundaries of Pleasure* (Edinburgh, UK: Edinburgh University Press, 2012), 1–4.

13. See, centrally, Giddings and Selby, *Classic Serial*. Sarah Cardwell's important revisionist study, *Adaptation Revisited: Television and the Classic Novel* (Manchester, UK: Manchester University Press, 2002), is concerned centrally with adaptations produced in the 1990s and makes no reference to the period before 1980.

14. On *Masterpiece Theatre*, see, especially, Timothy Brennan, *"Masterpiece Theatre* and the Uses of Tradition," *Social Text* 12 (autumn 1985): 102–12; and Laurence A. Jarvik, *Masterpiece Theatre and the Politics of Quality* (Lanham, MD: Scarecrow, 1999). Regarding the ideological and corporate value to Mobil of its sponsorship of *Masterpiece*, see LeMahieu, "Imagined Contemporaries," 244; and Simone Knox, *"Masterpiece Theatre* and British Drama Imports on US Television: Discourses of Tension," *Critical Studies in Television* 7, no. 1 (2012): 29–48.

15. Giddings and Selby, *Classic Serial*, 28.

16. LeMahieu, "Imagined Contemporaries."

17. Nancy West and Karen E. Laird, "Prequels, Sequels and Pop Stars: *Masterpiece* and the New Culture of Classic Adaptation," *Literature/Film Quarterly* 39, no. 4 (2011): 306.

18. Knox, *"Masterpiece Theatre,"* 31–32.

19. As Giddings and Selby explain, for many commentators, the 1963 appointment of the Canadian Sydney Newman (from the commercial channel ABC, later Thames Television) as the new head of BBC Television Drama marked "the beginning of the Golden Age of *BBC* television drama" (*Classic Serial*, 25; my italics). For authoritative broader accounts of "Golden Age" British television drama, see John Caughie, *Television Drama: Realism, Modernism, and British Culture* (Oxford: Oxford University Press, 2000); and Jonathan Bignell and Stephen Lacey, eds., *British Television Drama: Past, Present and Future*, 2nd ed. (Basingstoke, UK: Palgrave Macmillan, 2014).

20. "*Shoulder to Shoulder*: Female Suffrage, Second-Wave Feminism and Feminist TV Drama in the 1970s," Birkbeck Institute for the Humanities, University of London, 15 May 2013 (cast and crew reunion panel) and 16 May 2013 (symposium), accessed 25 June 2014, http://www.bbk.ac.uk/.

21. Running to almost seven hours of drama across four episodes, *Days of Hope* fast became a focal text in 1970s theory debates around the politics of film and television form, specifically around whether mainstream realist styles and forms were adequate to the needs of radical political drama. See Colin McArthur, "*Days of Hope*," *Screen* 26, no. 4 (1975): 139–44; and Colin MacCabe, "*Days of Hope*: A Response to Colin McArthur," *Screen* 17, no. 1 (1976): 98–101. Such debates did not, however, broaden to consider equally radical feminist texts such as *Shoulder to Shoulder*. Indeed, Giddings and Selby (disappointingly) elide the latter with a "craze" for Edwardian "romantic nostalgia"—in the face of its dramatic debate of difficult questions of strategy and militancy and deeply harrowing scenes of the state-sanctioned prison force-feeding of suffragettes—while misattributing the whole of *Shoulder to Shoulder* to one of its male scriptwriters instead of its female creators, Midge Mackenzie, Verity Lambert, and Georgia Brown (*Classic Serial*, 27–28).

22. Giddings and Selby, *Classic Serial*, 32–33.

23. Writing in 1971, the critic John Carey proposed, "A medium which is enclosed, rapid and shinily colored naturally manages better with urban material. When television decides to be countrified, it's hard to forget that there's a mass of technological joinery between you and the grass." Carey, "John Carey discusses 'Bel Ami,'" *Listener*, 17 June 1971.

24. Robin Scott, BBC Two's controller from 1968 to 1974 (succeeding the channel's launch controller David Attenborough), explicitly described BBC Two's first historical drama hit of the 1970s—*The Six Wives of Henry VIII*, starring Keith Michell, which debuted on 1 January 1970—as "an inducement to acquire viewers to BBC2." Quoted in Asa Briggs, *The History of Broadcasting in the United Kingdom*, vol. 5, *Competition, 1955–1974* (Oxford: Oxford University Press, 1995), 937.

25. Giddings and Selby, *Classic Serial*, 26.

26. Ibid., 27.

27. For the viewing figure, see ibid., 26.

28. Kenneth Passingham, *The Guinness Book of TV Facts and Feats* (London: Guinness Superlatives, 1984), 227–28.

29. Giddings and Selby, *Classic Serial*, 30.

30. WGBH Educational Foundation, "About *Masterpiece*," *Masterpiece*, accessed 29 June 2014, http://www.pbs.org/.

31. In more recent decades, the specific forms of this Anglophilia have evolved alongside *Masterpiece*'s branding and programming themselves. From January 2008, *Masterpiece* introduced "a new look, new scheduling," and new hosts calculated to appeal to younger, diversified audiences; dropped the word "Theatre"; and subdivided *Masterpiece*'s programming into three distinct "seasons": Masterpiece Classic, Masterpiece Mystery! and Masterpiece Contemporary. WGBH Educational Foundation, "Masterpiece Theatre Introduces Masterpiece Classic, Masterpiece Mystery!, and Masterpiece Contemporary," *Masterpiece*, 2007, accessed 29 June 2014, http://www.pbs.org/.

32. Giddings and Selby, *Classic Serial*, 35–36.

33. IMDb, user reviews for *The Search for the Nile* (1971), accessed 9 July 2014, http://www.imdb.com/.

34. Here are two further case studies: Scriptwriter Jack Pulman's prolific credits for the BBC during the "long" 1970s included two Henry James serializations; *War and Peace*; the entirety of the acclaimed, but famously sexual and violent, twelve-episode Roman drama *I, Claudius* (1976), adapted from the novels of Robert Graves; and four of the sixteen episodes of series 1 of *Poldark* (1975). The 1970s TV drama credits of Ian McKellen—as one of the preeminent stage actors of his generation—were mainly theatrical and Shakespearean but also included season 1 of Granada TV's popular *Country Matters* (1972–1973), produced by future *Brideshead Revisited* producer Derek Granger, which anthologized stories focusing on the harsher aspects of Edwardian English rural life. McKellen's other 1970s credits are of interest for the inclusion of two canonic queer roles just three years after the 1967 decriminalization of homosexuality in the UK, and many years before McKellen came out as gay to the general public. In 1970, for the BBC, McKellen both starred as T. E. Lawrence (Lawrence of Arabia), in a now-lost *Play of the Month* production of Terence Rattigan's 1960 play *Ross*, and repeated his title role in the Prospect Theatre Company's production of Marlowe's *Edward II*.

35. *Kean* was one of very few BBC *Play of the Month* works to be screened by *Masterpiece* in the United States.

36. Giddings and Selby, *Classic Serial*, 28.

37. Ibid., 39.

38. Ivory, ironically, was one of the beneficiaries: his 1979 *The Europeans* recast both Lee Remick and Lisa Eichhorn, and was widely credited with making a star of the latter.

39. John Mortimer, "The Bawdy Bard," *TV Times*, 10–16 June 1978, and front cover text.

40. Harper and Smith, *British Film Culture*, 4.

41. Dan Yergin, "Love in Maupassant's Paris," *Radio Times*, 8 May–5 June 1971.

42. "Boom in Colour TV," *Daily Mail*, 22 May 1971, 3.

43. The label was coined by the BBC for the purpose of the celebratory series *The Cult of . . . Sunday Night*. See the episode guide at BBC Four, "Sunday Night," *The Cult of . . .*, 2008, accessed 18 July 2014, http://www.bbc.co.uk/.

44. Paul Gray, "Goodbye to All That," *Time*, 9 May 1977, 74.

45. LeMahieu, "Imagined Contemporaries," 246.

46. Ibid., 248.

Chapter Two

History's Drama

Narrative Space in "Golden Age"
British Television Drama

Tom Bragg

The success of ITV's drama *Downton Abbey* (2010–) has drawn inevitable comparisons to the similar success of LWT's *Upstairs, Downstairs* (1971–1975). Both programs drew wide viewerships in Great Britain and America, have become critical successes, and investigate contemporary issues, themes, and conflicts via engagement with the same fictionalized historical setting. By purporting to depict the households of prominent Edwardian families, both series explore class, gender, nationalism, and sexuality within and without their historical settings, while also supplying enough period costume, décor, and manners to satisfy viewers' most nostalgic urges. But although the premise of *Downton Abbey* may evoke déjà vu from viewers with longer memories, the two programs actually "feel" nothing alike.

Despite similarities in subject matter and approach, one crucial difference between the two programs (and between Golden Age British television drama[1] and more recent productions) is their respective spatial techniques. While *Downton Abbey* has followed common practice since the 1980s by shooting extensively in and around heritage locations, *Upstairs, Downstairs* was videotaped almost entirely in studios, seldom making use of outdoor filming. The set-bound quality of early British television drama may have had budget more than aesthetics in mind, but it is nevertheless a recognized and even cherished feature of such landmark dramas as *The Duchess of Duke Street* (1976–1977), *I, Claudius* (1976), and *Poldark* (1975–1977). Critics such as Helen Wheatley, Peter Hutchings, and Rachel Moseley have recently challenged the notion that such programs should be conceptualized in terms

of their limitations but suggest instead that they should be studied for the unique quasi-modal opportunities and techniques they bring to their narratives.[2]

As critics, we should find it interesting that these different moods, methods, and even historical visions produce similar enthusiasm for British tourism,[3] particularly as regards the space/narrative dynamics of these television dramas. While it seems obvious that *Downton Abbey* should promote visits to Highclere Castle, its primary shooting location, it is less intuitive that *Upstairs, Downstairs'* boxy and reverberant sets should encourage visits to London, or that Cornwall should become a popular tourist destination via *Poldark*, a program that actually featured less location filming than viewers remember.[4] In fact, the different spatial approaches revive questions of authenticity, technique, and narrativity at least as old as the nineteenth-century historical novel, that fact-fiction blend dependent on spatial description and heavily peppered with scenic emphasis. The set-bound serial dramas of British television make us wonder how artificial spaces can contribute to period dramas that nevertheless remain relevant and authentically historical, commenting insightfully on their time periods in the manner of the best historical fiction. How does *I, Claudius* convey meaning about ancient Rome without ever showing Rome? How does *Upstairs, Downstairs* interrogate Edwardian society from a studio? How can *Poldark* show the viewer anything about Cornish life without filming Cornwall's distinctive terrain much more than it does? More basically, what do the spaces in Golden Age period dramas do that similar stories filmed in and around actual heritage sites do not?

Engaging in these many questions is beyond the scope of this chapter, which takes up a matter nevertheless germane to them all. While the dominant spaces of series such as *Upstairs, Downstairs* may seek to achieve some degree of mimesis through its "rigorous accuracy of presentation"[5] and painstaking re-creation of "the elegant drawing rooms of a vanished elite,"[6] their essential qualities are less set bound than set *liberated*—that is, free to engage historical *chronotopoi*,[7] processes, and meanings more considerately via patently artificial spaces. By so doing, their spaces are consistent with the practices of the British historical novel, especially in its classic nineteenth-century manifestations. Following Helen Wheatley's invitation to "begin to think about the meaningful and expressive uses of studio-based *mise en scene* in the 1970s,"[8] this chapter will consider two tendencies of the spatial narrative dynamic present in these Golden Age dramas that demonstrate this greater freedom: they repeatedly draw attention to themselves as sets, emphasizing their unrealistic qualities; and they engage viewer interaction with the camera's exploration. Although this discussion could easily reference a range of applicable programs, my analysis will be confined to *Upstairs, Downstairs* and *Poldark*—the former as a representative of the canonical

historical novel tradition that draws upon the recent past, the latter as a representative of the more fanciful historical romance variety.

LITERARY PRECEDENTS

The literary antecedent of *Upstairs, Downstairs, Poldark*, or *I, Claudius* is the historical novel in its many varieties; to the spaces and places of this genre we must look to understand the spatial-narratorial practices examined within this chapter. An acquaintance with criticism's investigation into historical novel space therefore seems warranted.

Always considered a hybrid form since its nineteenth-century popularization by Walter Scott, the historical novel has been largely viewed after Georg Lukacs as a subcategory of the realistic novel, one that focuses on the recent past and finds in history evidence of dialectical process at work.[9] At odds with this privileging of a more realistic historical novel is the functioning of space within historical fiction at large. While Lukacs had little to say about space in the historical novel, critics have since been divided on the matter. For instance, James Reed found space and place in Scott's *Waverley* (1814) to be accurate and authentic, more "recording" than inventing,[10] while Saree Makdisi found *Waverley*'s spaces to be "fluid" and fanciful, a fantasy land divorced from the reality of Scottish experience.[11] Franco Moretti geographically plots the space of the British historical novel as being "away from the center" of England and "in the proximity of major natural barriers" like forests, remote coastlines, wide territorial expanses, "and especially mountains"—implying that historical novel space is without history and is rather the liminal, unvisitable space where history is in flux.[12] While such spatial fluidity is palpably evident within the serious historical novel, I argue that it is also readily available in the historical romance, whose geographical location may be in the center of England (Scott's *Ivanhoe* [1819] and *Kenilworth* [1821]) and even in populous city spaces (W. H. Ainsworth's *Tower of London* [1839], Charles Dickens's *Barnaby Rudge* (1843), and Charles Kingsley's *Hypatia* [1853]). The geographic space, and even the ratio of wild to urban space, depends more on the generic aims of the author and the uses to which history is put. What remains typical of spaces across the different varieties of historical fiction, however, is that space is fluid and changeable—not unlike theatrical scenery and props—in its ability to shift, convey complex ideas with very little representation, and metonymize.

Spatial and narrative dynamics as they pertain to the British historical novel[13] are equally relevant to the space/place techniques used in period serial dramas on British television. As Wheatley notes, histories of television drama in the 1970s tend to conceptualize the studio "as a problem or a handicap, with studio drama identified as being produced within a compro-

mised dramatic space."[14] In rebuttal, Wheatley cites Raymond Williams's remarks (from a 1989 speech) about the room as an expressive space "permeated with meaning" and alleges that the room of *Upstairs, Downstairs* "asks to be read and understood as a meaningful space . . . more than a neutral backdrop, but which acts as a shaping and defining structure within the drama at hand."[15] The concept of space as an active and shaping force rather than a mere backdrop tallies well with the spatial narrative dynamic at the heart of the classic British historical novel, whose spaces are indeed "compromised," but in a way that provides narrative flexibility and opportunity.

About these two series it should be noted, *Upstairs, Downstairs* almost immediately won acclaim for its authenticity and historical acumen; *Poldark*, on the other hand, was just as quickly criticized for its clichéd adherence to historical romance. Yet both programs' shooting methods were similar: filmed mostly indoors, within boxy, artificial studio sets. We should not conclude from this fact that spaces do not matter in period television dramas but that flexible and artificial spaces—the stage space, in other words, but explored by the narrating camera in a manner quite unavailable to conventional theater—were de rigueur for period drama during British television's Golden Age. Given the praise and enthusiasm that *Upstairs, Downstairs* garnered for depicting authentic spaces, we might further conclude that the very plasticity of space in these dramas lends itself to their highly literary nature; *Upstairs, Downstairs*' tone is realistic while *Poldark*'s is romantic, but equally their fluid, theatrical spaces enable both programs to achieve their tonal or modal ends. In each case, the sets—design, lighting, and décor—and the camera's narrator-like exploration of those sets allowed for different historical visions to be enacted.

However similar the spaces of these very different series might have been, critical pronouncements about the success of one or the failure of the other reveal the close connection between them and the historical novel. Recalling Williams's argument that the television play "was the ultimate realisation of the original naturalist convention: the drama of the small enclosed room, in which a few characters lived out their private experience of an unseen public world," Carl Freedman remarks that "though Williams never even mentions 'Upstairs, Downstairs,' few televisional texts better illustrate his point."[16] For Freedman, the series' superior evocation of the past relies on its "overwhelmingly literary" form, one that "constructs its myth of Englishness largely through verbal, intellectual signifiers, which enable a high degree of historical specificity."[17] That degree of specificity could be granted to many Golden Age period programs like *The Duchess of Duke Street* (1976–1977) and *The Forsyte Saga* (1967) that made up in art and set decoration what they could not represent in historical location shooting.

What specifically troubles Freedman's identification is that the naturalist convention of which Williams writes depends upon an apparently realistic depiction of life under the proscenium and that the spaces of British period television dramas from this classic period, though ingenious, are also quite obviously studio sets: "small enclosed rooms," certainly, but rooms limited from achieving mimesis by their physical qualities. But—given their literary precedent—these limitations are not detrimental to the programs' effectiveness as historical fiction. Limited location shooting and the exigencies of the studio led producers, directors, designers, and other collective "authors" of these programs to create a flexible dramatic space that both well suited the needs of the fabulae and tallied with the fluid, active spaces of literary historical fiction.[18] What follows here are some brief examples of spaces in these two programs to illustrate some common features of what we might call Golden Age period drama space.

I should first note that what is sometimes mistaken for authentic spaces might be properly called authentic décor—period costume, antique furniture, and other props—more evocative of the historical era via metonymic and referential qualities than verisimilitude. A museum space may recall a historical epoch without being in any way reconstructive of spatial practices or "lived spaces" of the past. Further, the accumulation of period objects in the visual frame, perhaps analogous to the overdetailed descriptions of costume often indulged in by historical romancers, may only contribute to an impression of foregrounded research—of an overt attempt to refer to the past by the "author" and thus a narratorial intrusion. The question should be not whether the objects within view in the period television dramas are convincingly authentic but whether the spaces themselves depict historical spatial practice in a naturalistic or realistic way—in other words, whether the spaces of historical period dramas emerge as real "places" to the viewer. This they assuredly do not during the Golden Age.

SPACES EXTERIOR

As emphasized above, the dramas of this period avoid shooting at historic locations or even outdoors. While British television producers during this era were indeed, as D. L. LeMahieu notes, combining "the efficiencies of videotape interiors with the stunning visual effects of filmed locations," exterior scenes are yet few and limited, and when filmed, often retain a formal, pantomimic quality.[19] The opening sequence of the first *Upstairs, Downstairs* episode, "On Trial," provides a good example. As Sarah Moffat first arrives at the Bellamy residence, her attempts to enter at the front door and Hudson's irate redirection all happen wordlessly; no dialogue gets delivered until Sarah arrives at the servant's entrance. The brief scene is clever and

informative, acquainting the viewer with both Sarah's iconoclasm and Hudson's rigid conformity, and hinting at the social mores of the chronotope. But its wordlessness is unnatural and, actually, out of character for Sarah. A garrulous character, she explodes with dialogue and even complains about being sent away from the front entrance, but not until she appears at the back door, in a studio scene. Despite its reputed picturesqueness, the BBC series *Poldark* opens similarly. The first shot of a series much associated with rugged Cornwall scenery is an exterior one, of a coach managing rough, muddy roads. The very next shot, however, is a studio mock-up of the coach's interior, shot against a projection screen. As we are introduced to the protagonist, Ross Poldark, the actors are bounced around in evident studio comfort.

The formal quality of these similar openings to two dissimilar period dramas reveals the common function of exterior shots as establishing devices; both opening scenes might be easily replaced with title cards. Again, such choices are probably not aesthetic but logistical, having more to do with budget than artistic statement. But these scenes nevertheless make it clear that in both series, the authentic place—the elegant London street and the rough Cornish road—will be the exception and that the viewer will be made to participate in and experience the chronotope via other means than the pictorial or cinematographic.[20] Instead, as in the nineteenth-century historical novel, the historical narrative will be composed within spaces that can be easily manipulated. In the historical novel, that meant the wild space: rural landscapes and wilderness, like the "pass of peril" in Scott's *Waverley* or the sylvan locations of Sherwood Forest in *Ivanhoe*. For the British period dramas of the 1970s, it is the studio—quasi-theatrical, a "performative" space for acting yet still a "narrative" space for action.[21]

SPACES INTERIOR: CROWDING THE FOREGROUND

One ubiquitous spatial manipulation is to crowd the foreground, so that the camera regards the relatively shallow sets through some seeming obstruction in the fourth wall, implying enclosure; this is only one of many frequently employed tricks to imply space that does not exist in a way that attracts rather than deflects attention. *Poldark* uses this technique rather well: in interior scenes to express introspection, for instance, as when Ross is viewed through the fireplace in episode 1:6. Moseley notes that this scene "makes the most of the studio's potential for intimacy and immersion," pointing out that the flames distort Ross's image while his own thoughts and comfort are disturbed by "the lot of the Cornish poor."[22] But the same trick is employed to convey energy and confusion in an important exterior scene in episode 1:2, when Ross meets future wife Demelza in an apparently crowded market-

place. Here the camera weaves between posts, barrels, market stalls, and dangling goods to bring a cluttered and bustling mood to what is essentially a courtyard.

That crowding the studio spaces can be put to important rhetorical use has been demonstrated by Wheatley, who finds the crowded spaces of *Upstairs, Downstairs* declarative of Lady Marjorie Bellamy's struggle against containment and powerlessness—a characterization consistent with first-wave feminist concerns but at odds with Lady Marjorie's apparently antifeminist actions and dialogue. Unless we read Lady Marjorie spatially, Wheatley argues, we will miss the character's "continual frustration at the displacement of [real] power."[23] While persuasive, the sustained spatial argument of *Upstairs, Downstairs*' crowded spaces seems to have less to do with feminism than with class. The visual claustrophobia of spaces "upstairs" works against the ambience of elegance and wealth often taken for granted by viewers and critics alike. Adequate living space—that so important commodity whose absence in poor spaces was agonized over by social reformers—seems conspicuously lacking among Edwardians like the Bellamys, whose world-historical affairs upstairs seem confined to three or four overcrowded rooms. Meanwhile, the spaces of the servant's hall are spacious, tidy, and uncomplicated. While Hudson fusses over "a place for everything, and everything in its place," the camera's eye regards servant meals at the foot of a long table—a frequent downstairs scene more familial and functional than most family gatherings upstairs.

SPACES INTERIOR: IMPLIED AND LIMINAL

In *Upstairs, Downstairs*, the servants' living quarters, especially Rose Buck's bedroom, also become spaces for intimacy, coziness, and comfort, an impression aided considerably by other spatial manipulations like false ceilings and the use of windows and artificial light. Rose and Sarah's sleeping space at the beginning of *Upstairs, Downstairs* is a small bed tucked snugly between a wall, a fireplace, and a sloping ceiling that features a vaguely lit window. Far from appearing squalid as might be expected from a series with so populist a social conscience, this is a space of both domesticity and luxurious abandonment—the trappings about the room appear fine but discarded, like attic treasures. Here in episode 1:2, "The Mistress and the Maids," Rose is seen reading Yonge's *Dove in the Eagle's Nest*, a Victorian historical novel about an unassailable castle perched high in the Alps, a neat intertextual comment on Rose's own seemingly impregnable privacy high in the house's space—even more "upstairs" than the Bellamys! Such intimate space also allows for a languid female homoeroticism, both apparent and inferred, in the same episode. When avant-garde painter Scone depicts Rose and Sarah

in seminudity within this imagined space, his bohemian interpretation is exhibited with a formal portrait of Lady Marjorie, creating a great scandal, as well as accusations that the maids have allowed Scone into their bedroom. The episode comments deftly on the Bellamys' inability to discern either space or art and, with its contrasting paintings, also contrasts the stiff unreality of life "upstairs" with the genuine, sensual life of the servants. (Indeed, the title of the episode seems to echo that of the series.)

Poldark uses similar implied spaces for rather a different effect: that of visually "insisting" that depicted spaces are real, that they are not sets. Cameras are frequently angled high enough to catch ceiling moldings, cornices, archways, and other architectural elements. As with other camera-conscious shots like shooting through the fireplace, however, the net effect is less realistic than attention seeking. The very technicality of these shots becomes the focal point.

We can see the prevalence of such spatial use in period dramas of the 1970s by considering the liminal space: openings to other implied spaces, especially windows. As *Upstairs, Downstairs* did, *Poldark* often composes interior scenes so that the camera looks through rooms into other apparent rooms, thus creating depth and scope in otherwise shallow set spaces. But *Poldark* also makes a great effort to include windows in interior shots, often at the expense of credibility to the fabula. For instance, in episode 1:7, Ross and Demelza Poldark attempt to help murderer Mark Daniel escape pursuing soldiers. Although a fugitive from Captain McNeil, who threatens to close in on the house momentarily, Mark stands in front of a large, darkened window throughout the ten-minute scene. No one present closes the drapes or even looks out, although the conversation makes it very clear that Mark has been fleeing the authorities all day.

Although its actors do not treat windows realistically, *Poldark* makes a point of displaying windows in many episodes either to show authentic scenery outside (a sloping hill outside Captain Blamey's cottage, in episode 1:7; a horse in other episodes) or to reveal clever but false exterior details such as shrubbery, moody lighting, or simulated rain. Again, the technicality of the effect is the focal point; *Poldark* demonstrates via its windows either that the episode is shot on location (the scenery is real) or that pains have been taken to arrange "exterior" details outside the window.

To see why this matters, we should note that realistic dramatic spaces, spaces that appear to be actual places, will typically be granted by a viewer. The viewer's attention has not been drawn by an unrealistic effect, so his or her suspension of disbelief has not therefore been solicited. On film, a realistically achieved rain shower outside the window will not be congratulated by the viewer as a convincing effect; it will simply be assumed to be actual weather. On stage, the same effect draws attention to itself by its technical success. A less convincing effect will also draw attention, causing annoyance

or amusement in the viewer, or perhaps willing suspension of disbelief and therefore an implicit agreement to participate in the fabula.

NOOKS AND CRANNIES: SPACES INTERIOR

It is this sort of willing complicity, this virtual interactivity, that the spatial "tricks" of 1970s period dramas seem to court most often. A similar reader complicity was often elicited by British historical novelists in their picturesque descriptions of landscapes and scenery full of "pockets," enclosures, hollows contrived to conceal characters, entrances, and exits hidden away like so many stage trapdoors. Any tapestry present must have a door, an alcove, or a listening nook behind it. A Scott exterior scene, or the castle and dungeon scenes of Ainsworth, is a scene pregnant with possibility, eliciting wonder and expectation in nature both picturesque and sublime. Like the Gothic landscape or interior space, these are scenes that conceal possibility and evoke speculation.

Already inviting viewers to its make-believe enclosed spaces—and thereby evoking intimacy, claustrophobia, or whatever else the narrative may require—the space of *Upstairs, Downstairs* and *Poldark* invites viewers to explore these pockets and recesses via the portability of the camera. While the purely theatrical space cannot achieve this kind of narrative flexibility, the television studio set may do so with the camera's directing eye.

This willingness to explore the narrative spaces of the set can be seen in the remarkable episode 1:8 of *Upstairs, Downstairs*, "I Dies from Love." At the beginning of the episode, kitchen maid Emily is seen daydreaming while gazing through the area window; she is even joined by other servants, who appear not unlike theatergoers peering upward as they watch the wealthy Mrs. Van Groeben and her handsome footman William arrive. Later, when Emily and William begin an ill-fated affair, the couple is depicted holding hands at the table in a kitchen space where an area window can just be glimpsed in the upper-right corner of the screen. At the end of the scene, the camera executes a slow zoom out to regard the couple through the steel bars of the area window.

Here is a brilliant instance of not a realistic space but a stage space explored with a narrating eye. The viewer has watched characters view other characters in a diegetic space "beyond the area window," then two characters in a space with a visible area window, and finally the same characters "from" the area, through the same window. The exploration of these theatrical nooks and crannies has also allowed the spaces to comment on the story. We have seen Emily go from wistful would-be lover to actual lover and to (via the enclosing bars) doomed lover.

Figure 2.1. Viewing a "downstairs" romance through the area window (*Up-stairs, Downstairs*, episode 1:8).

Poldark also makes use of this kind of narrative exploration via the camera, as noted by Moseley, who remarks on the camera's "positioning [that] places the viewer as an observer *within* a scene: at the side of a character, peering from behind them as in Mark Daniel's murder of his adulterous wife; at a horse's shoulder; watching a scene playing out from halfway up an internal or external staircase."[24] For Moseley, such camera work participates in an "ethnographic" tourist gaze, "the viewpoint of an involved outsider."[25] Yet the camera in *Poldark*'s interior scenes explores places and takes perspectives to which no outsider could be privy—inside a forgotten section of the Wheal Grace mine in episode 1:13, watching Francis Poldark "discover" it; focusing on Henshawe's face in episode 1:15, at the exact moment he dies in a mine explosion; and, later in the same episode, leaning close enough to witness Captain McNeil whispering indecencies to Demelza in the middle of a party. This is no touristic gaze but a privileged third-person, omniscient narration, achieved through the camera's fluid exploration of space.

WATCHING THE WATCHERS: REFLECTIVE MOMENTS

It should be noted that Golden Age period-drama spaces are often most artificial when they specifically reference the theatrical. This is particularly true for *Upstairs, Downstairs*. For instance, in episode 1:7, "Magic Casements," Lady Marjorie Bellamy attends a performance of *Tristan und Isolde* with her soon-to-be lover, Captain Charles Hammond. An episode whose

title and script repeatedly invoke Keats's magic windows for viewing a remote "faery land" past finds the two lovers in the act of viewing a theater stage, a one-angle shot in which the actors seem to be looking into an off-camera spotlight, and occasionally reacting to a recording of the opera's climax. While the actors watch a legendary and doomed love affair through their "magic casement," the viewer watches another pair of doomed lovers through the television's casement in a scene that, although minimally decorated and lit, achieves verisimilitude sufficient to sustain the fabula. Thirty-five seconds into the scene, however, the actors applaud the end of the opera while the stage curtain supposedly rapidly rises and falls, twice within twenty seconds. The shadow effect on-screen appears less like a stage curtain than a drawn window shade obscuring a single spotlight.

A mood that might easily have been achieved with dimming lights is instead apparently bungled by an unconvincing effect, one whose artificiality, like *Poldark*'s windows, nevertheless demands viewer attention. Yet, though unrealistic, the effect echoes the magic portal theme of the episode, spatially creating a reflective act of viewing. While the lovers watch the opera's narrative within its "casement," they are simultaneously framed for the viewer by light and shadows from the "stage." The narrative moment is complicated and synchronous; the characters' object of focalization intrudes upon the viewer's—the opera stage becomes the viewer's object of focalization, in fact, but only by a nonrealistic stage effect.

A similarly self-reflective moment associated with the theatrical occurs in episode 1:13, "For Love of Love," again involving the trappings of the theater. The viewer becomes dramatically reacquainted with former maid Sarah Moffat via a scene of her performing a bawdy music-hall number. Although laughter and applause are heard, the viewer never sees any member of Sarah's audience, and she appears throughout to be playing the scene to the television viewer; indeed, she looks directly into the camera several times, appealing with the viewer to become involved in the burlesque. Alternating with these shots are two brief, nearly identical shots from the wings: a stage-hand is seen watching the performance from behind a gauzy, transparent curtain, the only person the viewer sees actually watching the performance.

Certainly we should avoid confusing aesthetic choice with logistical necessity; other reasons aside, these theater scenes do not explicitly show an audience because that additional cast would have affected budget and shooting schedules. But accounting for pragmatic factors does not alter the self-conscious artificiality of the scenes. The opera box might easily have been simulated without the unrealistic window-shade effect; Sarah's performance might have been filmed entirely from the wings or simply heard from her dressing room to which she rushes when the number finishes. Instead, the sequence risks disbelief in order to conflate the viewer first with the music-hall's offscreen audience—the patrons whom Sarah eyes flirtatiously while

singing her bawdy song—and then with the voyeuristic stagehand. As the opera scene had self-consciously referenced its episode title, so Sarah's music-hall number references the program itself; her song is the program's theme song, with slightly indecent lyrics added.

Poldark also features an extended in-the-round theatrical scene in episode 1:5, in which actors and spectators overlap as miner Mark Daniel is dazzled by his future wife, traveling player Keren. But perhaps a more interesting self-referential scene occurs in episode 1:14, when Caroline Penvenen eavesdrops on a confrontation between Demelza Poldark and Elizabeth Poldark, her sister-in-law and rival for Ross's affections. While Demelza and Elizabeth argue, the camera regards Caroline witnessing the contretemps in the reflection of a large, ornate mirror above the fireplace. As Caroline's placid but voyeuristic expression is mirrored for the viewer (and, perhaps, mirrors the viewer's own interest in the scene), the mirror's similarity to a proscenium arch—the area surrounding the stage opening in a theater, and built to be especially decorative during the eighteenth century, *Poldark*'s setting— emphasizes the scene's self-referentiality. The viewer watches as Caroline watches a virtual stage, peering up at the "performance" between the series' two female leads.

Self-referential but also explicitly theatrical scenes like these are not typical in *Upstairs, Downstairs* or *Poldark*, but they represent most prominently the spatial playfulness generally evident in Golden Age historical dramas such as I have indicated. Like the stage-ready scenery evident in nineteenth-century historical novels, where spectacle combined with scenic depth, and natural landscapes combined with convenient architectural features—trees forming natural arches, streams descending natural steps, and caverns making natural amphitheaters[26]—these spaces are less historical than historically themed, interested in depicting the space of history as something other than a realistically achieved mimetic space. The acknowledged theatricality of such scenes thus empowers and encourages the viewer to participate in this historical flavor. But most scenes in similar programs of this era revel in the opportunities afforded by their theatrical spaces, thereby making history seem cozy, nostalgic, and even—with the help of an exploratory camera— interactive.

Regarding the historical novel, more than a century of criticism took such deliberate staginess for ineptitude and clumsiness; readers may recall E. M. Forster's complaints about Scott's "scooped out and carefully ruined" glens and abbeys,[27] or Mark Twain's mockery of Fenimore Cooper's unreal rivers in *The Deerslayer*.[28] But if, as Franco Moretti observes, "each genre possesses its own space, then—*and each space its own genre*," it seems clear that the more *literary* historical space remains flexible and theatrical in nature.[29] Similarly, the spaces of the highly literary Golden Age British historical drama are not monumental—not the verifiable, "visitable" space like High-

clere Castle, a space that by design, architecture, or remnants makes evident some historical epoch. Rather, these dramas employed spaces whose evident unreality and self-conscious theatricality supplied the narrative spark needed to resurrect the dead past.

NOTES

1. The "Golden Age" of British television drama typically refers to a period from the 1960s to the early 1980s, incorporating historical series and serials such as *The Forsyte Saga* (1967), *Upstairs, Downstairs*, and *Brideshead Revisited* (1981), and the exportation of such programming to the United States on programs like *Masterpiece Theatre*. See Jonathan Bignell and Stephen Lacey, eds., *British Television Drama: Past, Present and Future* (New York: Palgrave Macmillan, 2001).

2. Peter Hutchings, "Dangerous Spaces: Studios, Video and the 1970s Psychological Thriller," keynote address, "Spaces of Television" conference, Leicester University, April 2011; Rachel Moseley, "'It's a Wild Country, Wild . . . Passionate . . . Strange': *Poldark* and the Place-Image of Cornwall," *Visual Culture in Britain* 14, no. 2 (2013): 218–37; Helen Wheatley, "Rooms within Rooms: *Upstairs Downstairs* and the Studio Costume Drama of the 1970s," in *ITV Cultures: Independent Television over Fifty Years*, ed. C. Johnson and R. Turnock, 143–58 (Maidenhead, UK: Open University Press, 2005).

3. D. H. LeMahieu, "Imagined Contemporaries: Cinematic and Televised Dramas About the Edwardians in Great Britain and the United States, 1967–1985," *Historical Journal of Film, Radio and Television* 10, no. 3 (1990): 245.

4. Moseley, "It's a Wild Country," 221.

5. Carl Freedman, "England as Ideology: From 'Upstairs, Downstairs' to *A Room with a View*," *Cultural Critique* 17 (winter 1990–1991): 81.

6. LeMahieu, "Imagined Contemporaries," 249.

7. "Time-space," a literary term denoting the configuration of time and space as represented in a literary work. The setting of historical fiction is often understood as a "chronotope."

8. Wheatley, "Rooms within Rooms," 145.

9. Georg Lukacs, *The Historical Novel*, 1937, trans. Hannah Mitchell and Stanley Mitchell (Boston: Beacon, 1962).

10. James Reed, *Sir Walter Scott: Landscape and Locality* (London: Athlone, 1980).

11. Saree Makdisi, *Romantic Imperialism: Universal Empire and the Culture of Modernity* (Chicago: University of Chicago Press, 1998), 76.

12. Franco Moretti, *Atlas of the European Novel 1800–1900* (London: Verso, 1998), 34.

13. I address this in a forthcoming work, *Space and Narrative in the Historical Novel: Scott, Ainsworth, Bulwer-Lytton* (Farnham, UK: Ashgate).

14. Wheatley, "Rooms within Rooms," 145.

15. Ibid., 145–46.

16. Freedman, "England as Ideology," 85.

17. Ibid., 101.

18. "Fabulae" is the plural form of the narratological term "fabula," denoting the raw material of the story. See Peter Verstraten, *Film Narratology* (Toronto: University of Toronto Press, 2009).

19. LeMahieu, "Imagined Contemporaries," 245.

20. *Poldark* did make more use of location filming than did *Upstairs, Downstairs* and many other period dramas of the period, but exterior scenes were filmed under very limited conditions, with one camera rather than the four commonly provided in the studio. Robin Ellis, *Making Poldark: Memoir of a BBC/Masterpiece Theatre Actor* (Palo Alto, CA: Brady New Media Publishing, 2012), Kindle edition.

21. John Caughie, *Television Drama: Realism, Modernism, and British Culture* (Oxford: Oxford University Press, 2000), 77.

22. Moseley, "It's a Wild Country," 230.

23. Wheatley, "Rooms within Rooms," 155.

24. Moseley, "It's a Wild Country," 228. Original emphasis.

25. Ibid.

26. It should be born in mind that historical novels were among the most common subjects for stage adaptation, in the form of either melodrama or opera. More than a hundred operas were based on the works of Walter Scott, for instance, with *Ivanhoe* alone inspiring eponymous opera by Puccini, Rossini, and Arthur Sullivan, as well as Nicolai's *Il Templario*. The fame and potential compensation of such adaptations might have explained why historical novelists and romancers frequently devised such "stage-ready" scenery in their novels.

27. E. M. Forster, *Aspects of the Novel* (New York: Harcourt, 1955), 30.

28. Mark Twain, "Fenimore Cooper's Literary Offenses," 1895, in *How to Tell a Story and Other Essays* (London: Harper and Brothers, 1900), 78–96.

29. Moretti, *Atlas*, 135. Original emphasis.

Chapter Three

"It's not clever, it's not funny, and it's not period!"

Costume Comedy and British Television

James Leggott

In March 2011, as part of its biannual *Comic Relief* (1985–) telethon fund-raising event for charity, the BBC broadcast a short, two-part parody titled *Uptown Downstairs Abbey*. Part of a global industry of broadcast and online spoofs and mash-ups of the most successful costume drama of its era, this sketch was particularly star laden and stood directly in the *Comic Relief* tradition of one-off parodies, crossover, or special versions of popular contemporary shows involving the cream of UK comedians, actors, and celebrities. Written by the well-known comic performers Jennifer Saunders and Adrian Edmondson, and using genuine exterior shots and musical cues from its target, the skit was in many respects characteristic of the incisive yet anachronistic approach to parody developed by the well-known double act Dawn French and Jennifer Saunders across their various series for the BBC. In typical French and Saunders style, there is exaggerated mimicry of character; mockery of visual and narrative conventions (such as the dominance of the musical score, and the emphasis on montages of glances: "Have we done all our looks?"); and actors breaking out of character to pass comment on the show and their place on it. In a continuation of a long-running French and Saunders gag, the veteran actress Joanna Lumley appears as "herself," complaining that her aristocratic bearing makes her unsuited to a "Mrs. Danvers" serving role. *Uptown Downstairs Abbey* also took potshots at *Downton Abbey*'s awkward references to traumatic historical events; its tendency toward soap opera (the show's miscarriage-via-dropped-soap plotline is described as "worse than *Emmerdale*," a long-running, critically unloved UK soap, and

the final credits describe the show as ultimately endless); the auteur status of Julian Fellowes; and the necessity of filming the "downstairs" scenes many miles away from those at Downton itself—which requires refills of tea to be sent via bus from Ealing. The title itself is a barbed comment on *Downton Abbey*'s clear debt to the original *Upstairs, Downstairs*, as well as the BBC's seemingly opportunistic reboot of the 1970s program. The casting of the reality television "cleaning" star Kim Woodburn and the flamboyant quiz-show host and presenter Dale Winton (in the role of the scheming footman Thomas) also implicitly conveyed the populist aspirations of *Downton Abbey*.

In various ways, then, *Uptown Downstairs Abbey* requires a rather sophisticated knowledge of British comedy and visual culture to fully unpick. This density of reference is neatly summed up by a throwaway comment made by a character played by the performer and writer Victoria Wood: "Don't I know you from *Lark Pies to Cranchesterford?*" This gag is an allusion to a sketch in one of Wood's own BBC shows, in which she affectionately pastiched the language, characterization, costumes, and performance styles of contemporary costume dramas such as *Lark Rise to Candleford* (2008–2011), *Little Dorrit* (2008), and *Cranford* (2007–2009); in Wood's version, the poor teenage Araminty leaves her rural hamlet for a job in the Post and Potato Office in the busy town of Cranchesterford.

Indeed, the evolution of the British costume drama since the 1970s has been paralleled by an equally notable tradition of historical-based comedy, whether in the form of sketch-show skits or longer-running sitcoms and serial comedy-dramas. This chapter will consider some of the key contributions to the canon of period comedy and in doing so support a case for this symbiosis of historical and comic forms as one of the distinctive characteristics of British media culture. While some comedies and comedians have sought to directly parody particular programs, or the costume genre more generally, others have used "heritage" re-creations to exploit, mock, or solicit identification with historical incidents, people, and settings. In this way, a survey of period television comedy not only offers a kind of alternative, critical history of the "straight" period drama, and a reflection on developments in British television comedy more generally, but also reveals something about shifting attitudes to the reenactment and consumption of history.

THE 1960S AND 1970S: UPSTAIRS, DOWNSTAGE

Although the importance of *Upstairs, Downstairs* as a foundational work of the British period serial is generally acknowledged, one can easily find proof of its significance, reach, and afterlife in the traces left in popular culture in both the UK and the United States, not least in comedy. While *Sesame Street*

(1969–) spoofed the show and its place within the *Masterpiece Theatre* (here *Monsterpiece Theater*) series—via Alistair Cookie (the Cookie Monster, obviously) introducing a segment featuring Grover literally running upstairs and downstairs—there were some more sustained parodies. *Carry on Laughing* (1975), the spin-off TV show of the *Carry On . . .* movie series of ensemble farces, included two episodes of *Upstairs, Downstairs* spoofs, while *Keep It Up Downstairs* (1976)—an otherwise undistinguished contribution to the cycle of sex comedies that came to define the declining British film industry of the 1970s—featured an opportunistic period plot about randy masters and servants involved in the rescue of the grand Cockshute Castle. Another example is the comedian Stanley Baxter, well known in the UK for his impressions of celebrities, who played a total of seven characters in a virtuosic and technically tricky parody titled "Upstage Downstage" in a 1974 episode of his show for ITV. As is typical of television vehicles for impressionists, the parody is primarily a means for Baxter to display his mimicry skills, but alongside the opportunity for the sort of tame sexual innuendo associated with British populist comedy of the era (talk of "old queens," a "delicious pair," etc.), the script's main conceit is that the respective "downstairs" and "upstairs" casts are envious of being upstaged by the other. In the kitchen, Mrs. Bridges rails against the casting of distinguished guest stars and, when she learns she is about to be replaced by Glenda Jackson, despairs that her only future will be in the much-derided soap opera *Crossroads* (1964–1988). In the drawing room above, servants are chastised for not knowing their place as "supporting players," although Hudson notes with glee that the TV listings guide has revealed that the upstairs cast will shortly depart for a luxury cruise, which happens to be aboard the ill-fated *Lusitania*. As with the *Uptown Downstairs Abbey* parody, which featured analogous gags about soap opera and about "downstairs" actors escaping lower-class stereotyping, the deployment of what appears to the casual viewer to be the actual set of the program being satirized gives the comedy a degree of verisimilitude but also of official sanction. Baxter's skit was made by the same broadcaster as *Upstairs, Downstairs*, so it is quite possible that the real costumes and sets were used; either way, it could be argued that this synchronicity, together with the emphasis upon mocking the actors as much as the show itself, rather limits the satire.

The late 1960s and early 1970s saw not only the emergence of the long-form period serial drama, with the likes of *The Forsyte Saga* (1967) and *Upstairs, Downstairs* (1971–1975) but also the evolution of the period comedy. The best known (in the UK at least) of these is undoubtedly Jimmy Perry and David Croft's *Dad's Army* (1968–1977), following the exploits of a gang of Home Guard volunteers in the Second World War. Still frequently broadcast and remembered in the UK, with its characters and catchphrases firmly rooted in the popular imagination, *Dad's Army* now has a nostalgic, whimsi-

cal appeal for viewers that is as much about its production in a perceived "golden age" of family-friendly British comedy as its evocation of (male) community and parochialism. Ironically, as with other period comedies from the time, it may indeed be the historical setting that has assisted the show's longevity, as contemporary references and styles are sometimes deemed to disenfranchise modern viewers. In keeping with one of the recurrent themes of both the British sitcom and period drama, *Dad's Army* is alive to hierarchies and dynamics of class, most notably through the tension between the pompous middle-class Captain Mainwaring (a bank manager) and the languid, upper-class Sergeant Wilson. However, despite the suggestion of entrapment and "class anxiety" through the "restless dynamics of the platoon's internal relationships," *Dad's Army*, as Simon Morgan-Russell notes, "never seeks to challenge what it treats as the 'natural order' of the British class system."[1] The program's emphasis on male experience also befits Frances Gray's judgment of the general role of women in British sitcom as a "backdrop": "their absence is existentially liberating, their presence a reminder of the 'norms' which help the viewer identify the source of comic incongruity."[2]

The writers of *Dad's Army*, Croft and Perry, would go on to specialize in sitcoms with a period setting: *It Ain't Half Hot Mum* (1974–1981) was another war-set comedy, this time about a Royal Artillery Concert Party in India and Burma, *Hi-de-Hi!* (1980–1988) was about a Butlins-esque holiday camp in the late 1950s, and *You Rang, M'Lord?* (1988–1993) evoked memories of *Upstairs, Downstairs* with its interwar story of aristocrats and servants in a London house. While the Croft/Perry shows aspired, in the main, toward authenticity, the ribald *Up Pompeii!* (1969–1991) used its ancient Roman setting primarily as a vehicle for the double entendres, asides, and anachronistic commentary of the comedian Frankie Howerd, who played the slave Lurcio; Howerd also appeared in the similarly fanciful spin-off shows *Whoops Baghdad* (1973), set in medieval times, and the pilot-only *Touch of the Casanovas* (1975). The era's other most notable intervention in historical representation came from the Monty Python team, whose cinematic releases *Monty Python and the Holy Grail* (1975) and *The Life of Brian* (1979) were as surrealistically deconstructive as their television sketch show and yet were also incisive parodies of filmic and artistic representations of the Arthurian and biblical eras. A similar balance of incongruity and authentic re-creation was found in Michael Palin and Terry Jones's *Ripping Yarns* (1976–1979), an anthology series primarily poking fun at the propagandistic, "stiff upper lip" attitudes and stereotypes promoted by Victorian and Edwardian juvenile literature; targets include the ridiculous rituals of the English public school ("Tomkinson's Schooldays"), plucky explorers ("Across the Andes by Frog"), and the mores of colonial rulers ("Roger of the Raj").

THE 1980S: GOING OVER THE TOP?

A ubiquitous concept in discussions of British politics and popular culture of the 1980s is that of "heritage." In response to developments in the British film and television industry of the era, some commentators have identified a strain of conservative, reassuring, yet internationally exportable historical drama that was in some respects compatible with Thatcherite ideology; examples include the patriotic *Chariots of Fire* (1981), the films of Merchant Ivory, and the prestigious literary TV dramas *Brideshead Revisited* (1981) and *The Jewel in the Crown* (1984). However, readings of such texts as straightforwardly nostalgic have been queried by some British film scholars, who have challenged the use of the "heritage" title as an umbrella term for costume dramas with different styles and aspirations; identified elements of social critique beneath the detailed period décor; and unpicked the nuanced appeal of costume dramas for audiences of different gender, sexuality, age, and nationality. Unsurprisingly, perhaps, the most impactful TV period comedies of the era—such as *Blackadder* (1983–1989), *Brass* (1983–1990), and *Allo Allo* (1982–1992)—were those that took a playful, sometimes antiestablishment approach to historical representation, but in doing so, they also risked accusations of stereotyping and mythmaking.

The farcical *Allo Allo*, about the exploits of the French resistance in the Second World War, was initially conceived as a specific parody of the stern, humorless *Secret Army* (1977–1979) about the Belgian resistance movement, but the show quickly transcended—even overwhelmed—memories of its source, as it accumulated running jokes and catchphrases. In contrast, the ITV sitcom *Brass*, set in a fictitious 1930s Lancashire mining town called Utterley, did not have a specific target but was a sustained "send up of everything that has ever been written, painted or filmed about the North of England."[3] Across three seasons (and a total of thirty-two episodes), Timothy West played the mine owner Bradley Hardacre, continually scheming for efficiency, despite the efforts of militant socialists stirring the downtrodden workers to revolt. The show's point of departure was clearly the "grim up north" stereotypes of working-class period dramas, such as *When the Boat Comes In* (1976–1981) and ITV's own version of *Hard Times* (1977), in which West had also appeared. The language, characterization, costumes, plots, and iconography of such shows are exaggerated to the point of melodramatic absurdity; the performance styles are consciously overwrought and theatrical, the colloquial dialogue convoluted and cliché-ridden. In one typical exchange, the working-class matriarch and socialist agitator "Red" Agnes Fairchild lambasts her son Jack for daring to consider a job above his station. "There's never an honest working-class lad climbs out of that gutter but he treads on the prostrate forms, aye, and the prostrate glands of his hapless comrades," she chides him. She goes on to snatch his flat cap—a symbol of

working-class identity much mocked in the show—and declare, "You've renounced your birth-rate . . . you'll never wear this cap again!" The show cast a rather broad satirical net, implicitly or explicitly making reference to a broad canon of "northern" literature and visual culture, including D. H. Lawrence, L. S. Lowry, J. B. Priestly, Walter Greenwood, Catherine Cookson, *Hobson's Choice* (1954), the various iterations of *Hindle Wakes*, the "kitchen-sink" realist novels and films of the 1960s, and the long-running soap opera *Coronation Street* (1960–). But there were also visual clues in the opening titles, which happened to be reminiscent of *Dallas* (1978–1991), that *Brass* was also a humorous riposte to developments in US soap opera, and in particular that era-defining saga of wealthy, "super-capitalist" tycoons and feuding families. As a satirical comment on UK politics, however, *Brass* is rather more limited, and for all its apparent swipes at Thatcherite ideology, one might query its historically confined, pantomime-like treatment of class struggle and industrial unrest in an era when Thatcher's defeat of the miner's strike (1984–1985) marked a turning point in industrial relations and the effective destruction of the trade union movement. As Dave Russell observes, in relation to *Brass* and similar treatments of the industrial north, parody is a highly complex mode. On the one hand, it is capable of a complimentary, witty, and affectionate response to the popularity of its target, but at the same time the "reinforcement of long-standing attitudes towards the North" can run the risk of "perpetuating old mentalities rather than simply having fun with them."[4]

Beyond issues of representation, however, *Brass* can be recognized retrospectively as rather innovatory in form. Although conceived and performed as a mainstream sitcom, it was not filmed before a live studio audience and also lacked a laughter track. This gave scope for more thoughtful direction than the traditional sitcom format would permit and for the dense dialogue to be performed more naturalistically and consistently; on first glance, the casual viewer might easily have mistaken *Brass* for a particularly hammy example of the straight period drama. As West describes in his autobiography, this hybrid form was unsettling to channel bosses, as it potentially placed the program in a no-man's-land between Granada Television's "light entertainment" and its "drama" departments.[5] From this point onward, a distinction was often drawn between historical sitcoms that adhered to the basic expectations of the comedy genre (such as performers delivering to a studio audience) and programs that were historical "comedy-dramas": works that partially drew from comedic forms, or were based on "comic" or light literature but otherwise used narrative structures more akin to straightforward period drama. As we shall see, however, such distinctions have often been challenged, with numerous programs occupying a more complex position in the supposed continuum between pure "comedy" and pure "drama."

Although not as formally adventurous, *Blackadder* (broadcast between 1983 and 1989 and later followed by a number of "specials") has been canonized as one of the most popular British comedies. Its creative personnel were part of a new wave of iconoclastic performers and writers who emerged in the late 1970s and were often prone to antiestablishment satire; an emblematic example is the *Comic Strip* 1950s-set spoof "Five Go Mad in Dorset" (1982), which targeted the racist and sexist attitudes of Enid Blyton's novels and era. Across its four main series, the *Blackadder* chronicles followed the declining fortunes of the Edmund Blackadder character (played by Rowan Atkinson) in, respectively, the late medieval, Elizabethan, Georgian, and First World War periods. A consensus has emerged, not least among the show's creators, that the first series was less comically effective—partly because of the characterization of Blackadder as a buffoon, rather than as the shrewd, world-weary plotter he would subsequently become. However, it has been recognized that it was this series—set in an "alternative" history in which Richard III had not been defeated at Bosworth but accidentally killed (by his grandson Edmund), leading to the succession of the fictitious Richard IV—that was the most "sustained attempt at an authentic period setting" and that made the most "explicit (albeit not serious) claims to be history."[6] With its extensive use of elaborate sets, location shooting (on film stock), and large cast (both reduced in future series as the result of budget constraints by the BBC), *Blackadder* is visually reminiscent of the BBC's studio-based Shakespearean adaptations (particularly the history plays), an impression furthered by the frequent use of cod-Shakespearean proclamations, typically deflated through rather prosaic embellishments. Katherine J. Lewis argues that the show's representation of fifteenth-century England is made up of tropes that "derive partly from certain ideas about the medieval past and the ways in which medieval history has been written, but which is also shaped by the conventions of sitcom and historical film."[7] The show thus speaks of some of the popular perceptions of the later Middle Ages, in particular of "approaches which regard it with a sense of superiority, condescension and, crucially, as something intrinsically laughable."[8]

As Eckart Voigts-Virchow observes, the first *Blackadder* series, in falling somewhere between the high production values of the "classic" drama and the sitcom's "focus on verbal and farcical interaction," achieved a "welcome alienation effect from the routine surface 'pastness' of the genre."[9] In contrast, the subsequent three *Blackadder* series were filmed according to the prevailing sitcom orthodoxies and thus opened up a more obvious gap between their static camera work, cheap-looking sets, and unsophisticated video imagery, and the glossy, expensive style expected of historical drama. To this end, *Blackadder* can be read as a polemicism against the heritage drama's tasteful, periodically accurate, and visually splendid re-creation of history. This generic gap is even more marked in the fourth series, set amid

the trenches of the First World War, where the sitcom format's "studio interiority" and domestic associations clash with the "grand audiovisual narratives of history."[10]

Unsurprisingly, *Blackadder* has received considerable attention from historical scholars, who have registered its contribution to a "postmodern, metahistoric social construction of history."[11] However, there has been faint alarm that the show's place in the British collective imagination is such that it was mistaken for real history; for example, a 2011 poll of Britons concluded that "one in five" believed the Blackadder character to have been real.[12] The fourth series in particular, despite offering only mildly exaggerated versions of historically accounted incidents of military absurdity, quickly became not just British television's most popular war program but also an "established part of Britain's modern memory of the First World War" that "resonated with truth about Britain's war experience."[13] An oft-cited reference by cultural and military historians used to demonstrate the show's mythmaking is its mention of the strategic imperative of "inching Field Marshal Douglas Haig's drinks cabinet closer to Berlin"; for many, *Blackadder* now apparently encapsulates essential truth about Haig and the battles on the Western Front. On the eve of the centenary of the First World War, the show was denounced by the British education secretary, Michael Gove, as part of a "leftist" and unpatriotic tendency by academics and writers to portray the Great War as a "misbegotten shambles—a series of catastrophic mistakes perpetrated by an out-of-touch elite." Quickly incurring the wrath of many historians—and also some of the creators of *Blackadder* itself—Gove argued, "Our understanding of the war has been overlaid by misunderstandings, and misrepresentations which reflect an, at best, ambiguous attitude to this country and, at worst, an unhappy compulsion on the part of some to denigrate virtues such as patriotism, honour and courage."[14] The paradox of *Blackadder* is that it has been recognized both as a useful teaching and critical tool for the understanding of history, and as a cynical presentation of history as a "repetitive pattern of lunacy, reinforcing but also debunking the cultural heritage of a country which has both more history and more comedians than others."[15] In a further twist, *Blackadder*'s seemingly untouchable status within the canon of UK comedy was itself the subject of satire by Harry Enfield and Paul Whitehouse in their one-off mockumentary *Harry and Paul's Story of the Twos* (2014), which featured skits of many well-known programs first broadcast by the BBC Two channel. In addition to a lampooning of the static camera compositions and wordy dialogue of *The Forsyte Saga*, and the declamatory acting styles and salacious subject matter of *I, Claudius* (1976), the show imagined a "Blackadder" take on the Edward VIII and Mrs. Simpson affair, replete with exaggeratedly comic "noises" and characteristically convoluted wordplay.

Blackadder's balance of informed commentary and flippancy proved highly influential. *Chelmsford 123* (1988–1990) went further back in time to the year AD 123 and concerned the games of deceit and one-upmanship between a Roman governor and a wily chieftain. Where *Blackadder* deployed heightened delivery styles and intricate plots, *Chelmsford 123* took a more conversational, digressive approach, while elaborating further on *Blackadder*'s anachronistic humor: characters refer to as-yet-uninvented technology and display modern attitudes; there are allusions to the identities of the actors; and in the first episode there is even a brief cameo appearance for the time traveler of *Doctor Who* (1963–). And *Blackadder*'s simultaneous appeal to children and adults, responding on different levels to its pantomime and deconstructive elements, proved influential for gleefully "postmodern" historical comedies for children such as the gender-bending drama *Maid Marian and Her Merry Men* (1989–1994) and the sketch-show *Horrible Histories* (2009–2013), which used contemporary idioms and music to convey "true facts" about some of the more gory or extreme incidents and characters of international history. Geared squarely at adults, however, was the provocative sketch show *Psychobitches* (2012–2013), in which a stream of famous and infamous women from history undergo modern therapy: patients included Sylvia Plath, Bette Davis, and Audrey Hepburn, but in an acknowledgment of the hard limits of comedic handlings of recent history, the late Diana, princess of Wales, is dismissed for arriving "too soon" for her appointment.

THE 1990S: PLOTS AND PROPOSALS

The subsequent decade was as much a transitional era for the British period drama as it was more generally for British television, now increasingly commercially oriented following deregulation that would ultimately bring about the proliferation of satellite, cable, and later digital television. With the continuing serial format that had characterized period drama in its 1970s heyday going into decline, costume productions now tended to be genre-based one-offs or miniseries (examples are the popular adaptations of the detective fiction of Agatha Christie, the swashbucklers of Bernard Cornwell, and the social histories of Catherine Cookson) or shorter-running works of classic literature (Jane Austen, George Eliot, Charles Dickens, and such). The BBC's phenomenally popular 1995 version of Austen's social comedy *Pride and Prejudice*, which made effective use of exterior and location filming, quickly became a template for productions that were prestigiously literary yet nimbly paced and more cinematic in style. This shift from the studio-based serial format to the literary heritage production—and from the slow paced and wordy to the frantic and visually excessive—was naturally noted by

television satirists. One of the last hurrahs for the studio serial was *The House of Eliott* (1991–1994), about two sisters finding success in 1920s London as haute couture designers; the show happened to be devised by Jean Marsh and Eileen Atkins, who had also been involved in the creation of *Upstairs, Downstairs*. The show was reimagined by the comedic duo French and Saunders in their BBC sketch-show series as *House of Idiot*, which made gleeful sport of the limitations of the studio style: the action is stiltedly framed to foreground objets d'art and is punctuated by a repetitious, cheap-looking exterior shot showing the same extras milling down a terraced street; and characters travel from room to room, or location to location, in a way that is transparent padding for a thin plotline about "missing buttons." At the end of the skit, the real actors from *The House of Eliott* appear on set and chastise the comedians for daring to produce a parody that is "not clever," "not funny," and—above all—"not period!"

However, the vogue for literary transfers quickly gave satirists new ammunition. Victoria Wood's "Plots and Proposals" skit on Austen adaptations—broadcast as part of her 2000 sketch show—was as sumptuously filmed, high budgeted, and starrily cast as the productions under gentle mockery. The cameo appearances of television celebrities associated with "light entertainment" formats in minor roles—such as the television cook Delia Smith and the "makeover" gardening expert Alan Titchmarsh—carried an implicit accusation that the new wave of period dramas were not only strategically populist but also offering similar pleasures to "lifestyle" programs about transforming landscapes, homes, or personal fashion. In the twenty-first century, costume-drama spoofing would become de rigueur for comedy sketch shows such as *That Mitchell and Webb Look* (2006–), *Armstrong and Miller* (2007–), and *Watson and Oliver* (2012–2013). There was also an entire four-part series, *The Bleak Old Shop of Stuff* (2011–2012), a sustained pastiche of the language, characters, and intricate plots of Charles Dickens, featuring characters such as Jedrington Secret-Past (owner of the Old Shop of Stuff), the evil lawyer Malifax Skulkingworm, The Artful Codger, and the dastardly Harmwell Grimstone, who at one point pauses mid-cackle to declare, "I really must grow a moustache to twirl." In keeping with the period comedy tradition, the pleasures were as much linguistic as visual—not least because of the program's origins in the long-running radio series *Bleak Expectations* (2007–)—but also because *The Bleak Old Shop* made prominent use of CGI effects and backgrounds to push Dickensian clichés to surreal levels, such as the Jolliforth Jollington character, whose head expands and deflates in response to positive and negative experiences.

One of the defining characteristics of 1990s period comedy was formal hybridity, a blurring of the lines between "straight" and comic drama. The "upstairs downstairs" comedy *You Rang, M'Lord?*, set in a 1920s townhouse, adhered in some respects to the traditional sitcom format, in being

filmed before a live studio audience, minimizing exterior/location shooting, and retaining the same basic premise, location, and characters across four series. But there were significant deviations that nudged the show generically toward more traditional drama, not least the running time for each episode of fifty minutes (rather than the conventional thirty); the serial narrative that followed various story strands across twenty-six episodes; the attention to period detail; and a tendency toward more nuanced (and often unsympathetic) characterization than typically associated with the sitcom. Plotlines typically concerned Alf, the shifty butler to the Meldrum family, plotting to swindle his employers. The show's relatively darker hue is conveyed from the start of its first episode, which incorporates a flashback of its key characters meeting in the trenches of the First World War, and quickly establishes, as Simon Morgan-Russell observes, "the dynamics that structure [the show] . . . : the attitude of distrust and antagonism that defines the relationship between the dishonest Alf and the upstanding, rather sanctimonious James; the class resentment felt by Alf towards his social 'betters' compare with James's willingness, even enthusiasm, to serve; the absurd privilege of the British aristocracy and their attitudes to the lower class."[16] The show's writers, Perry and Croft, may have been determined to give *You Rang, M'Lord?* a "classy air," but the show generally received less popular and critical acclaim than their more crowd-pleasing sitcoms of previous decades such as *Dad's Army* and *Hi-de-Hi!* Mark Lewisohn judges that the combination of "production values and darker characterisation seemed to work against the series, the normally loud and broad humour of such sensible romps was uncomfortable in the surroundings."[17]

There was also a tonal confusion to *Goodnight Sweetheart* (1993–1999), a long-running serial sitcom about a television repairman, Gary Sparrow, who discovers a portal to 1940s, wartime London. Sparrow continues to lead a double life, acting out a fantasy as a Blitz-era lothario and man of mystery that is far more preferable than his contemporary life where he is unable to meet the expectations of his career-driven wife. The story concludes with his decision to remain in the past, where his knowledge of future events has allowed him to become a war hero, underlining the idea that there he is "more of a man than he ever was before in the 1990s."[18] In this way, the show "carried a nostalgic idea of the past, in which the hardships of life were evened out by a simpler, more social existence."[19] As with other "postmodern" or "high-concept" dramas and comedies with a time-traveling or anachronistic conceit—such as *Lost in Austen* (2008)—*Goodnight Sweetheart* also incorporates a strand of reflection on the popular appeal and consumption of "heritage"; at one point Sparrow becomes a modern-day entrepreneur by selling the items of ephemera (newspapers, etc.) he has purloined from his travels in a 1940s-theme shop, which leads to a discussion about the ethics of exploiting historical artifacts for profit. Although the program features a

laughter track, the dialogue is delivered quite naturalistically (without catch-phrases or theatrical mannerisms), and there are numerous plot-driven scenes that lack a comic element; the pace is at times closer to that of a conventional studio-bound drama, and many episodes and scenes have a rather downbeat, melancholy quality that matches Sparrow's increasing alienation from the present.

While *Goodnight Sweetheart* and *You Rang, M'Lord?* used the serial format for the purpose of more thoughtful characterization and plotting, there were a number of nostalgic drama productions, translated from the lighter end of the spectrum of classic literature, which offered pleasures of comic incident and casting. For example, *Jeeves and Wooster* (1990–1993) was a polished adaptation of P. G. Wodehouse's stories about the twittish aristocrat Wooster and his far more intelligent manservant Jeeves, played respectively by the established comedic double act Hugh Laurie and Stephen Fry. *The Darling Buds of May* (1991–1993), following the lives, loves, and appetites of the Larkin family in the 1950s, may not have been marketed as a comedy, but its sunny, romanticized vision of rural life and plenitude proved highly seductive to audiences at a time of economic recession. The casting of David Jason, best known for his work in television sitcoms, as the ebullient Pop Larkin was also significant for the classification of the show as a comedy-drama. Indeed, the fusion and conflation of the comedic and dramatic forms in programs of the era was paralleled by the deployment of actors associated with (or with an early career in) comedy within period film and television: for example, the aforementioned Fry and Laurie found "serious" roles, re-spectively, in the biopic *Wilde* (1997) and *Sense and Sensibility* (1995), while Victoria Wood would balance comedy work with sensitive fact-based historical dramas like *Housewife, 49* (2006) and *Loving Miss Hatto* (2012) and documentaries about British colonial history and trade. Wood was also involved in the creation of *Eric'n'Ernie* (2011), an emblematic contribution to an interesting cycle of one-off period docudramas broadcast on UK televi-sion in more recent years about the lives and struggles of famous British comedians such as Tony Hancock, Kenneth Williams, the Monty Python team, and (in the case of *Eric'n'Ernie*) the formative years of the much-loved double act Morecambe and Wise. Just as comedians and sitcoms would take opportunities to go "straight," so British comedy history itself would become increasingly subject to re-creation and—through the prestige of the docudra-ma format, usually reserved for "great" figures and major events—a form of cultural legitimizing too.

INTO THE TWENTY-FIRST CENTURY:
SUFFRAGETTES AND CHICKENS

One might cite a number of reasons for the relative scarcity of long-running or impactful period comedies in the last couple of decades, not least a vogue in British comedy since *The Royle Family* (1998–) and *The Office* (2001–2003) for naturalistic and sometimes "dark" excavations of the everyday spaces and experiences of modern life, but also the forbidding presence of genre "classics" such as *Dad's Army* and *Blackadder* upon new comic writers and performers. The 2004 series *Directors Commentary*, in which footage of genuine archival dramas, such as the 1970s period drama *Flambards* (1979), was overlaid with a fictitious and amusingly mundane "commentary" from their supposed director Peter De Lane, took the formula of historical comedy into such realms of postmodernity that one may have feared for its future. The tradition was far from broken, though, with examples including the French Revolution–set *Let Them Eat Cake* (1999), and Graham Linehan and Arthur Matthews's *Paris* (1994) and *Hippies* (1999). However, there have recently been signs that the cyclical tendency of British-comedy history—which has seen a succession of waves of creative talent rejecting or responding to former styles and subject matter—has led to some writers consciously kicking against a perceived orthodoxy for realistically inclined and contemporary-set comedy. The results have been richly varied and illustrative of the many creative strategies available for period comedy.

As Hannu Salmi observes, within historical comedies, it is necessary to draw a distinction between "comedy, being comedic and being comic"; in other words, between invitations to laugh *at* the past and invitations to laugh at stories told about the past, whether through their incongruities or their exposure of the codes and conventions of their genre.[20] It is, of course, a truism that historical representations have as much to say about the present as the past, in giving us the "freedom to move backward and forward in time and to transcend barriers between eras."[21] Some of the examples broadcast on British television during the last decade may not necessarily be for the ages, yet taken together they demonstrate how historical comedy can "grant us an opportunity to perceive the past as something more than a predetermined and prefabricated entity."[22] For example, two comedy series first broadcast in 2013 took the early twentieth century as their setting but with a very different attitude to style and gender politics. Jessica Hynes's *Up the Women* was a "deliberately retro" studio sitcom about a women's craft circle in 1910 debating whether to commit to the suffrage movement. Hynes has described how the project began life as a serious drama about militant suffragettes but evolved into a low-key and "gentle comic insight into the lives of ordinary women living at an extraordinary time," yet *Up the Women* invites its audience to reflect upon the differences and similarities between the suf-

frage and modern feminist movements.[23] In contrast, *Chickens*, with its modern swearing and teenage vernacular, takes a far more youthful and anachronistic approach to its story about a group of conscientious objectors and army rejects during the First World War. Written and starring two of the performers of the scatological rite-of-passage sitcom *The Inbetweeners* (2008–2010), which had explored the pains and sexual adventures of a group of teenage boys, *Chickens* was less a historically accurate account and more an extension of *The Inbetweeners'* sex comedy scenario of young men as social outcasts and sexual inferiors; the first episode concludes with all of the women of the village collaborating to burn an effigy of the least popular of the three "cowards." Julia Davies's gothic *Hunderby* (2012), on the other hand, was a consciously cult affair, of niche appeal to fans of previous black comedies by Davies and former collaborators such as Chris Morris. Set in 1830s Cornwall, this visually arresting tale of a young shipwreck survivor's marriage to a widowed parson being sabotaged by a vengeful housekeeper who knows of terrible family secrets was a surrealistic take on the novels and film adaptations of Daphne du Maurier, particularly *Rebecca* (1939). The same source had already been parodied by French and Saunders in their drama "Conseula" (1986) for the *Comic Strip* anthology series, but Davies's version deployed the *Rebecca* template as merely the basis for an individualistic, eccentric vision of cruelty and sexual disgust, delivered by its cast in a style that is neither naturalistic nor theatrical but consistently deadpan and via a language system that is not so much anachronistic as its own unique system. Eschewing jokes per se, the dialogue is consistently scatological and excessive yet delivered with the formal, polite cadences of heritage-drama conversation. Of the sexual organs of his current and former wives, the pastor notes, "Arabella was smooth as ham, nature did not busy her broken mound with such a black and forceful brush." When his new wife is obliged to produce an heir to save the family home, the bizarre housekeeper Dorothy holds up a bloodied sheet and declares that "Satan's jam hath once again burst her bristled bun." Such linguistic excess is matched by a high number of sex scenes, the occasional "gross-out" moment involving bodily fluids, and the final plot revelations about incestuous relationships.

Not quite parody, not exactly laugh-out-loud amusing, evocative of certain sources, but far from historically authentic either, *Hunderby* was still recognizable as part of a vigorous tradition of British period comedy continually tilting at notions of taste, finding new hybrid forms, and inviting audiences to reflect on their attitude to history, and to representations of history. Why Britain has been such fertile soil for comedies about the past is a question beyond the scope of this chapter, and one that would need to be also addressed by way of its literary and filmic heritage—from the Monty Python movies to *The Private Life of Henry VIII* (1933) and Terry Deary's *Horrible Histories* books—as much as its rich and varied televisual history. But one

might argue that this is the inevitable result of a nation taking its history as seriously as its comedy: quite simply, the past is too important not to laugh at.

NOTES

1. Simon Morgan-Russell, *Jimmy Perry and David Croft* (Manchester, UK: Manchester University Press, 2004), 63.

2. Frances Gray, *Women and Laughter* (Charlottesville: University of Virginia Press, 1994), 82.

3. Timothy West, *A Moment Towards the End of the Play* (London: Nick Hern, 2001), 240.

4. Dave Russell, *Looking North* (Manchester, UK: Manchester University Press, 2004), 201–2.

5. West, *Moment Towards the End*, 240.

6. Katherine J. Lewis, "'Accident My Codlings': Sitcom, Cinema and the Re-writing of History in *The Blackadder*," in *Mass Market Medieval: Essays on the Middle Ages in Popular Culture*, ed. David W. Marshall (Jefferson, NC: McFarland, 2007), 114.

7. Ibid.

8. Ibid.

9. Eckart Voigts-Virchow, "History: The Sitcom, England; The Theme Park—*Blackadder*'s Retrovisions as Historiographic Meta-TV," in *Narrative Strategies in Television Series*, ed. Gaby Allrath and Marion Gymnich (Basingstoke, UK: Palgrave Macmillan, 2005), 226.

10. Ibid.

11. Ibid., 212.

12. See, for example, Pat Reichardt, "Blackadder Is Real Say Dumb Brits," *Daily Star*, 5 April 2011, accessed 24 February 2014, http://www.dailystar.co.uk/.

13. Emma Hanna, *The Great War on the Small Screen: Representing the First World War* (Edinburgh, UK: Edinburgh University Press, 2009), 22–23.

14. Jessica Elgot, "Michael Gove Attacked for 'Blackadder' Comments on 'Left-Wing' Whitewash of WW1 History," *Huffington Post UK*, 14 January 2014, accessed 24 February 2014, http://www.huffingtonpost.co.uk/.

15. Voigts-Virchow, "History," 226.

16. Morgan-Russell, *Jimmy Perry*, 130.

17. Mark Lewisohn, "You Rang, M'Lord?" BBC.co.uk Guide to Comedy, accessed 24 February 2014, http://web.archive.org/.

18. Rami Mähkä, "A Killer Joke? World War II in Post-War British Television and Film Comedy," in *Historical Comedy on Screen: Subverting History with Humour*, ed. Hannu Salmi (Bristol, UK: Intellect, 2011), 137.

19. Ibid.

20. Hannu Salmi, "Introduction: The Mad History of the World," in Salmi, *Historical Comedy on Screen*, 11.

21. Ibid., 29.

22. Ibid.

23. Jessica Hynes, "Jessica Hynes: It's OK to Poke Fun at Suffragettes," *Daily Telegraph*, 30 May 2013, accessed 24 February 2014, http://www.telegraph.co.uk/.

Chapter Four

"It is but a glimpse of the world of fashion"

British Costume Drama, Dickens, and Serialization

Marc Napolitano

In "A Family Festival"—the first installment of *The Forsyte Saga* (1967)—
Monty Dartie attempts to charm his future in-laws by quoting Charles Dick-
ens's *Nicholas Nickleby* (1838–1839). The allusion is wasted on James For-
syte, who decries Dickens as a deceased radical. It is an ironically humorous
moment, especially given that James and Monty epitomize the traits of char-
acters from the very novel that Monty has quoted. James's coldhearted capi-
talism, along with his more humanizing vulnerability regarding his legacy,
directly connects him to Ralph Nickleby, while Monty's sponging and phi-
landering, along with his melodramatic self-pity, strongly suggest Mr. Man-
talini. Moreover, there is an almost parodic quality to James's grumblings
given that a character in a sprawling serial set in the Victorian era is criticiz-
ing an author whose legacy is *defined* by sprawling serials set in the Victo-
rian era.

Although the Victorian setting and serialized narrative of *The Forsyte
Saga* are suggestive of the Dickens canon, its medium immediately connects
it to a less "respectable" entertainment genre: the soap opera.[1] When writers
of serial dramas seek to distinguish their works from the "common" soap
opera, they frequently turn to Dickens. Reflecting on the success of *Upstairs,
Downstairs* (1971–1975), cocreator Jean Marsh opined that "from time to
time I say to myself, 'It's just a middle of the road television series—what is
all the fuss about?' and then I realise that that is just a reaction to having had
too much praise. . . . I think television serials can be the modern day equiva-
lent of Dickens."[2] Similarly, *Upstairs, Downstairs* script editor Alfred

Shaughnessy "believed that television serials, written by installments, were just an extension of the way writers like Dickens . . . used to work."[3]

In the United States, *Upstairs, Downstairs* became a staple of *Masterpiece Theatre* (1971–), a program that has broadcast numerous adaptations of Dickens's novels, thus stressing the connection. In contrast to these "masterpieces," Marsh is wary of less sophisticated serial costume dramas that fail to achieve Dickensian transcendence and thus remain middlebrow soap operas. Reflecting on her subsequent creation, *The House of Eliott* (1991–1994), Marsh lamented that despite her initial conception, "*The House of Eliott* was a soap opera. I don't think it had to be. . . . I don't see why you can't have a serial which is entertaining and real."[4] Though British soaps are leagues removed from their American counterparts, these programs still cannot escape the somewhat pejorative connotation of "soap opera."[5]

Still, the efforts of writers and producers of serial costume dramas to elevate the soap opera as a genre through programs such as *Upstairs, Downstairs*, *The House of Eliott*, *The Forsyte Saga*, *The Pallisers* (1974), *The Duchess of Duke Street* (1976–1977), and *Downton Abbey* (2010–) seem ironically suggestive of Dickens's own attempt to elevate the serial novel. This chapter will examine the narrative technique of serialization in these disparate texts. Specific attention will be given to such issues as the function of individual episodes in relation to overarching narratives, as well as the adaptation of Dickens's novels for television. The conclusion will address the consolidation of serial installments into a composite object: in the case of a Dickens novel, an edited volume; in the case of a costume drama, a "complete series" DVD.[6]

GENRE AND RESPECTABILITY

The attempt to promote the decorum of entertainment genres by citing Dickens as an inspiration predates television; Sergei Eisenstein "all but enshrined Dickens as the forefather of cinematic narrative" in his landmark essay on Dickens and D. W. Griffith.[7] Nevertheless, skeptical scholars have accused critics of snapping up Eisenstein's assertions "as a way of arguing the cinema's respectability,"[8] and Kamilla Elliott has hinted that early filmmakers overemphasized the supposedly Dickensian components of film narrative.[9] The idea of alluding to Dickens as an inspiration is even more contentious regarding television narratives. Though Jennifer Hayward astutely notes that "the soap genre has recognizable themes and codes, most of which can be traced to . . . Dickensian techniques,"[10] these claims can be a source of frustration for Dickens scholars due to the "mechanized" mentality behind the product. Playing off the writings of John Ellis, Robin Nelson states that "the soap [opera] form, ongoing serial narrative, is television's distinctive

contribution to narrative form. A popular product with a seemingly limitless output made by an industrial process capable of three (or more) primetime episodes per week is a scheduler's dream."[11] In spite of the defensiveness of Dickensians, there is no denying that Dickens himself "was instrumental in developing mass-produced fiction, and thus became a kind of manufacturer of narrative for a vast and faceless public."[12] The production and consumption of his art was invariably shaped by the realities of a postindustrial society.[13]

More specifically, his methods of publishing, as informed by these economic/material realities, affected his narrative technique. Dickens broke new ground in establishing the monthly serial as both a financially viable and an artistically respectable method for publishing novels, and his ability to legitimize an ostensibly illegitimate method of telling a story was most apparent when he transitioned to weekly serials, the domain of the "penny dreadful." As a London *Times* columnist noted in a contemporary review of *Great Expectations* (1860–1861):

> Mr. Dickens led the way in making the experiment, and his enterprise was crowned with such success that most of the good novels now find their way to the public in the form of a monthly dole. . . . But what are we to say to the new experiment which is now being tried of publishing good novels week by week? Hitherto the weekly issue of fiction has been connected with publication of the lowest class—small penny and halfpenny serials that found in the multitude some compensation for the degradation of their readers. . . . Mr. Dickens has tried another experiment. The periodical which he conducts is addressed to a much higher class of readers than any which the penny journals would reach.[14]

If the costume drama provided a respectable improvement on the formula of the television soap, the Dickensian serial did likewise for the penny weekly. Nevertheless, it is impossible to deny that the writers of British costume dramas embraced many of the narrative conventions that defined the soap opera just as Dickens used several of the melodramatic plot devices of the penny dreadful. Still, the issue of whether a costume drama is actually just a soap opera in Dickensian clothing is a question not simply of respectability but also of narrativity.

CATEGORIZING COSTUME DRAMAS BY NARRATIVE

Serialization is the defining feature of the soap opera narrative, but it is inaccurate to categorize all costume dramas as "soap operas" simply because they too are serials. The label has been haphazardly applied to these works since *The Forsyte Saga*: "Many critics have asked, 'Isn't the *Saga* really a soap opera?' That's easy. Of course it was soap opera . . . a large number of

interrelated characters is set down in a constricted setting and things happen, with each episode containing glimpses of three or four continuing stories."[15] Though the preceding quotation alludes to several key traits, it ignores one of the most important qualities of the soap opera: its endlessness. "The most obvious structural feature of daytime serials is that they never begin and never end," write Muriel G. Cantor and Suzanne Pingree. "They are continuing stories, with competing and intertwining plotlines introduced as the serial progresses. Each plot on a given program develops at a different pace, thus preventing any clear resolution of conflict."[16] *The Forsyte Saga* was never open ended. It had a clear beginning, middle, and end, as established by its literary source. The same is true of the equally ambitious *Pallisers*, also produced by Donald Wilson. In both cases, the fact that the television programs were adapted from series of novels that had been brought to effective conclusions by their respective authors precluded the producers' embracing the "openness" described by Cantor and Pingree.

In contrast, Glen Creeber acknowledges that "the continuous or never-ending serial is frequently associated with the soap opera."[17] From this perspective, the other costume dramas mentioned above seem more analogous to soap operas on a basic narrative level. Of these programs, *Upstairs, Downstairs* and *The Duchess of Duke Street* are more episodic. When pitching *Upstairs, Downstairs*, Shaughnessy promoted a balance between the serial and series-based qualities of the program, though he clearly leaned toward the latter, noting that "we must have just the *minimum of background continuity*—mainly deriving from the relationships of the permanent characters— and in the foreground a series of strong, *self-contained stories which begin and end inside the episode*."[18] *Upstairs, Downstairs* producer John Hawkesworth adopted a similar approach for his later series, *The Duchess of Duke Street*.

The initial episodes of these programs are strikingly similar: both shows present a spunky cockney girl's entry into domestic service. "On Trial," the pilot episode of *Upstairs, Downstairs*, introduces Sarah as an outsider who joins an established community—165 Eaton Place—thus allowing the audience to acclimate to that community through her. When Sarah leaves service at the end of "Board Wages," the narrative does not go with her; the program is built around the daily experiences of characters within the house as opposed to the continuous adventures of someone outside of the house. Initially, *The Duchess of Duke Street* seems less episodic, as the first four installments form a continuous narrative tracking Louisa from her entry into domestic service to her elevation to royal paramour and her fiscal and physical collapse.[19] However, these installments basically serve as an extended pilot. Once Louisa settles in as manager of the Hotel Bentinck in "A Bed of Roses," the show adopts an episodic pattern based on the comings and goings of hotel guests. In the case of both *Upstairs, Downstairs* and *The Duchess of*

Duke Street, the confirmation of the setting and premise allows the narrative to ease into a routine.

Fundamentally, both programs seem more series than serial, though as Shaughnessy suggested, there is a basic level of continuity. Consider an installment from each program's first season. *Upstairs, Downstairs'* "The Path of Duty" tells a self-contained story about Elizabeth's return to Eaton Place. The episode can stand alone as a story about Elizabeth's societal debut, and yet the installment simultaneously affects the series' overarching narrative: a major character is introduced, and her actions will carry over to subsequent episodes. Elizabeth's liberal hypocrisy, along with her complex "friendship" with Rose, will evolve over the first season. Experiencing the prior episodes gives one a greater appreciation for the development of Elizabeth's character and her relationships with her family and servants. Furthermore, Elizabeth's rebelliousness thematically builds on Sarah's story arc, and their parallel story lines continue through the second season.[20]

The Duchess of Duke Street takes this episodic structure to the next level in "A Lady of Virtue." Here, too, continuity is a background issue, much as the series' main characters are relegated to the background: the plot revolves entirely around a love affair between MP George Duggan and Diane Strickland, two guest characters who never appear again. Still, Louisa's reactions to Diane's situation are best appreciated in the context of Louisa's prior experiences as the breadwinner in an unhappy marriage and as a participant in an affair with a powerful man. As in the case of *Upstairs, Downstairs*, continuity is grounded in character and theme, not story.

In contrast to *Upstairs, Downstairs* and *The Duchess of Duke Street*, *The House of Eliott* and *Downton Abbey* place greater emphasis on plot continuity to the extent that individual installments are less distinct. Episodes serve mainly to further existing story lines. As with *The Duchess of Duke Street*, the early episodes of *The House of Eliott* create something of an extended pilot, as the Eliott sisters overcome a series of setbacks before launching a fashion house in episode 7. However, the fact that this plot development occurs more than halfway into the season hints that it will not fundamentally restructure the program's narrative. Unlike the introduction of 165 Eaton Place or the establishment of the Hotel Bentinck, the founding of the House of Eliott does not result in the adoption of an episodic format. While individual episodes occasionally tell self-contained stories, these story lines develop in conjunction with larger, continuous arcs.

For example, Bea's unexpected reunion with her ex-lover Philip in season 1, episode 8, is a self-contained story, but this story progresses in conjunction with a multitude of prior issues, including the steady decline of Jack's business, Evie's burgeoning relationship with Sebastian, Lydia's continued attempts to reenter society, the Eliott sisters' growing conflict, and Penelope's increasing disillusionment. Furthermore, the episode does not "wrap up"

neatly with Bea and Philip's parting. Rather, it concludes with the sudden death of Sebastian, a plot point that will reverberate throughout subsequent episodes and widen the breach between Bea and Evie.

Downton Abbey adopts a similar pattern, as self-contained story lines in individual episodes form minor "arcs" in relation to sustained story lines. The opening scene of season 1, episode 4, hints that this installment will focus on a country fair, but the fair—a self-contained plot point—serves mainly as a backdrop against which standing story lines continue to unfold. Of the multitude of plot points that make up this episode, only four are self-contained: Mrs. Hughes's reunion with Joe, Sybil's purchase of a new dress, Anna's illness, and Isobel's treatment of Molesley. Furthermore, the latter two points are best appreciated in the context of Anna's kindness toward Bates in episode 1 and Isobel's conflict with Violet in episode 2, serving to further develop these two important relationships. The other plot points are either part of preexisting story lines (the fallout over Pamuk's death, Bates's conflict with Thomas, Thomas's mistreatment of William and Daisy, Matthew and Mary's growing rapport, the Crawleys' debate regarding the entail, and Gwen's pursuit of a secretarial position) or new developments that portend future conflicts (Carson's discovery that someone has been stealing wine and Branson's encouraging Sybil's nonconformity). In assessing *Downton Abbey* and *The House of Eliott*'s heavy emphasis on serialization, it is useful to consider that unlike *Upstairs, Downstairs* and *The Duchess of Duke Street*, episodes of *The House of Eliott* and *Downton Abbey* do not have individual titles—they are simply "parts" assigned numbers. This fact reinforces the notion that, in comparison to episodes of the previously discussed programs, the individual installments of *The House of Eliott* and *Downton Abbey* are best understood as sequential, continuous, yet undefined units of a larger, indefinite whole.

In light of these variations, the term "serial" seems too broad, though of the group of programs under consideration, only *The House of Eliott* and *Downton Abbey* fully adopt the narrative patterns of the soap opera.[21] *Upstairs, Downstairs* and *The Duchess of Duke Street* are too episodic, and individual installments feature not an "interweaving" of multiple story lines but a diversity of perspectives (Bellamys and servants; hotel staff and guests) on single-thread story lines. As for *The Forsyte Saga* and *The Pallisers*, their aforementioned lack of "openness" precludes their adopting the narrative format of the soap opera.

THE DICKENS COSTUME DRAMA PARADOX

Between his cinematic qualities and his narrative techniques, it is hardly surprising that Dickens has been used as a source for serialized costume

Costume drama categories based on narrative

Category	Programs	Narrative characteristics
Closed costume serial	*The Forsyte Saga* *The Pallisers*	• Set number of episodes with an overarching story line • "[T]he primary role of any episode-specific material . . . is to inform, complicate and/or progress the overarching story."[a]
Episodic costume serial	*Upstairs, Downstairs* *The Duchess of Duke Street*	• Open narrative • Episodes present self-contained plots; continuity emerges through character development, evolving relationships, and thematic issues.
Costume soap opera	*The House of Eliott* *Downton Abbey*	• Open narrative • Episodes alternate between a multitude of continuous story lines that commence and conclude at different points in the season.

[a] Trisha Dunleavy, *Television Drama: Form, Agency, Innovation* (New York: Palgrave Macmillan, 2009), 155.

dramas. Equally unsurprising is the fact that these televised Dickensian narratives are most comparable to *The Forsyte Saga* and *The Pallisers*, though *The Forsyte Saga* and *The Pallisers* were televised adaptations of series of books, while Dickensian costume dramas are televised adaptations of individual texts and are thus broken down into fewer episodes. The adaptation of Dickens's novels into serial costume dramas has further underscored the supposed connections between Dickensian serials and the contemporary soap opera. Recent series such as Andrew Davies's acclaimed versions of *Bleak House* (2005) and *Little Dorrit* (2008) were marketed as high-end soap operas and aired in half-hour installments like popular British television soaps such as *Coronation Street* (1960–), *Emmerdale* (1972–), and *EastEnders* (1985–).

Nevertheless, the Dickensian costume drama, like *The Forsyte Saga* and *The Pallisers*, is confined to various narrative parameters that, as previously noted, resist the soap opera label. While an adaptor has flexibility regarding the content of individual episodes and the tone of the overall adaptation (depending on how faithfully he or she wishes to adhere to the literary source), the narrative function of the installments is always the same: to move the overarching narrative toward its conclusion. Wilson did not intend to indefinitely continue the stories of Soames Forsyte and Plantagenet Palliser; similarly, Davies did not plan on tracing other Chancery lawsuits following the resolution of Jarndyce and Jarndyce, nor did he presume to track Arthur and Amy's relationship after their final departure from the Marshalsea. Even more experimental Dickensian costume dramas are confined to the

basic narrative boundaries of the closed serial. For example, the 1999 ITV *Oliver Twist* dramatized the novel's backstory by recounting the affair that led to Oliver's birth, while 1980's *Further Adventures of Oliver Twist* reunited Oliver and the Artful Dodger for future escapades. In spite of these audacious liberties, both series' narratives were bound up within a set number of episodes that would systematically and sequentially build toward an established conclusion.

Given their similar backgrounds as televised adaptations of literary texts, it seems fitting that the Dickensian costume drama and *The Forsyte Saga* would share the same "closed" narrative approach, yet ironically, Dickens's own approach to the process of telling a story in serial installments was quite different. *The Forsyte Saga* and *The Pallisers* were scripted, filmed, and then broadcast, precluding any variation. Conversely, Dickens refrained from writing out an entire novel before serializing it; indeed, he "never wrote more than four or five numbers before the first was published, and by the middle of the novel he was rarely more than one number ahead of his readers."[22] As will be discussed shortly, this approach allowed for experimentation and improvisation on the part of the author, who was ever mindful of the public's reaction to the monthly numbers. A television producer creating a "closed" serial adaptation of a Dickens novel could not duplicate this approach because the series would already have been filmed before it reached the public. Ironically, by remaining faithful to the source and using individual episodes to move the narrative toward Dickens's conclusion, the producers must reject his approach to serialization. Conversely, if they had adopted his approach to serialization, they would inevitably have deviated from the source by modifying the series based on unforeseen events/reactions during the serialization process.

TELEVISED AND DICKENSIAN HYBRID NARRATIVES

Dickens honed his ability to improvise early on in his career. Looking back on *The Pickwick Papers* (1836–1837), the serial that catapulted him to literary celebrity, Dickens reflected that "it was necessary—or it appeared so to the author—that every number should be, to a certain extent, complete in itself, and yet that the whole twenty numbers, when collected, should form one tolerably harmonious whole, each leading to the other by a gentle and not unnatural progress of adventure."[23] Here, Dickens characterizes *Pickwick* as what Robin Nelson would call a "flexi-narrative"[24] and what Michael Hammond refers to as a "hybrid":[25] a serial narrative with episodic installments that maintain a basic continuity. In comparison to the novels from Dickens's mature period, *Pickwick* obviously lacks in structure and coherence.[26] Still,

there were benefits to the "openness" of *Pickwick*, which left a wide gateway through which new readers could enter.

And enter they did. *Pickwick*'s runaway success following the introduction of Sam Weller in No. 4 is a testament to Dickens's comedic genius, but it is likewise a testament to the advantages of the young author's flexibility: "It may be assumed that as publication proceeded, Dickens watched the sales, that he noticed that they began to rise in July with the introduction of Sam Weller; certainly he took notice of William Jerdan's advice to 'develop' this character 'to the utmost.'"[27] Such improvisation would not have been possible had Dickens written out the entire novel before serializing it or committed himself to a complex, continuous plot. The flexi-narrative approach is apparent in other early works, particularly *Nicholas Nickleby* and *The Old Curiosity Shop* (1840–1841). Even *Oliver Twist* (1837–1839), arguably the most novelistic of the early texts besides *Barnaby Rudge* (1841), alternates between overarching plot points (Oliver's journey toward his middle-class birthright) and episodic adventures (Oliver's rapid movement between disconnected environments).

Tracing Dickens's maturation as a novelist oftentimes involves tracing the increasing sophistication of his plots, which grew more complex and coherent with the serialization of *Martin Chuzzlewit* (1843–1844) and *Dombey and Son* (1846–1848), transitional texts that anticipated masterworks such as *Bleak House* (1852–1853), *Little Dorrit* (1855–1857), *Great Expectations*, and *Our Mutual Friend* (1864–1865). Dickens himself perceived a connection between artistry and narrative control; in writing *Chuzzlewit*, he claimed to "have endeavoured in the progress of this Tale, to resist the temptation of the current Monthly Number, and to keep a steadier eye upon the general purpose and design. With this object in view, I have put a strong constraint upon myself from time to time, in many places; and I hope the story is the better for it, now."[28] He took this narrative "constraint" to the next level in *Dombey and Son*, which proved the testing ground for the numerical outlining processes that would define his narrative approach for the remainder of his career.[29]

The notion that a more tightly structured narrative is a *better* narrative seems reminiscent of scholarship on television genres, as several critics have cited the closed serial—with its firm narrative control—as the most sophisticated dramatic form.[30] Still, while the closed serial may seem the most inherently novelistic of the aforementioned categories of costume drama, Dickens's serial technique is actually more analogous to the methodology of programs such as *Upstairs, Downstairs*. Certainly, Sam Weller found his costume-drama doppelganger on *Upstairs, Downstairs*, as Sarah's cockney charm proved so captivating in the early episodes that the creative team rewrote the later scripts so as to bring her back into the narrative (an impossibility had *Upstairs, Downstairs* been conceived and executed as a "closed

serial").[31] More striking is the fact that Dickens's serial technique in the mature novels, like *Dombey and Son*, also runs parallel to the flexi-narrative strategies of *Upstairs, Downstairs*.

In a detailed letter to John Forster, Dickens outlined the plot to *Dombey*, tracing the interactions between Mr. Dombey and his two children, the perverse nature of Dombey's contempt for Florence, and the basic progression of the father-daughter relationship up through Dombey's downfall.[32] The letter presents a very effective summary of the text and reveals that Dickens clearly understood the centrality of the Dombey/Florence relationship from the very beginning. Still, though the letter reveals Dickens's clear vision for the story, it likewise alludes to an improvisational flexibility. Dickens informs Forster that he will "carry the [Dombey/Florence] story on, through all the branches and off-shoots and meanderings that come up; and through the decay and downfall of the house, and the bankruptcy of Dombey, and all the rest of it."[33] This sentence presents an odd mixture of certainty and ambiguity: Dickens knew that Paul would die in No. 4, and that the novel would build toward the collapse of Dombey's empire. However, the various "branches, offshoots, and meanderings" were far less defined, thus granting Dickens the power to improvise with the supporting characters and subplots: "Like contemporary soap opera producers, he 'tried out' characters and plot shifts."[34]

In his retrospective text on the making of *Upstairs, Downstairs*, Richard Marson describes a comparable technique, as Shaughnessy and the creative team would outline the major plot points of a season and then allow the episode writers to improvise upon this outline.[35] Looking back on the show's mixture of serialized preplanning and episodic extemporization, writer Jeremy Paul admitted that the narrative did not always develop based on "artistic decisions but on purely pragmatic ones. But in the end, this wonderful, massive, satisfying kind of television novel appeared."[36] Though Paul hints at a Pickwickian approach that promoted "pragmatic" improvisation over the "artistry" of the preplanned plot, Dickens's own work on *Dombey* indicates that he was willing to improvise and compromise based on practical realities even as he reached artistic maturity. In the case of *Dombey*, Dickens's initial plan was for Walter Gay to forge the path that would eventually be traveled by James Steerforth, Richard Carstone, Tom Gradgrind, and Tip Dorrit, the idle and dissolute young men of the middle novels who inevitably destroy themselves. However, he sacrificed this "artistic" vision for "pragmatic" concerns, and thus improvised a new story arc for Walter which ultimately allowed the boy to fulfill his fairy-tale fantasy of being Florence's hero.[37] The expansion of Nancy's role in *Oliver Twist*, the redemption of Miss Mowcher in *David Copperfield* (1849–1850), and the ambiguous ending to *Great Expectations* are all prominent examples of Dickens's extemporizing while serializing. In comparison to *The Forsyte Saga* and *The Pallisers*, the

flexible, hybrid structure of *Upstairs, Downstairs* ultimately seems more evocative of Dickens's ability to balance the complex coherence of a novel with the improvisational experimentation of a miscellany.

CONCLUSION: THE FINAL PRODUCT

Due to the fact that the soap opera inherently resists closure, the question of how to define a soap as a "total work" is complex: "Clearly one episode of a soap opera cannot be said to 'be' that soap any more than a page from the middle of a novel can be said to 'be' that novel. . . . Since any one episode . . . is built on all the episodes that have preceded it . . . then the only logical way to define a given soap opera is as the sum of all its episodes broadcast since its origination."[38] In spite of key narrative differences, it is likewise possible to view a Dickensian novel as the sum of its parts, especially given that Dickens knew his weekly or monthly numbers would be compiled and republished as complete texts. What is frustrating about single-volume compilations of Dickens's novels is that although they maintain the chapter divisions, they rarely indicate where the monthly or weekly numbers began and ended. Consuming a Dickens text in the manner that Dickens initially intended requires extra effort on the part of the reader, who must research the breakdown of the serial run. Naturally, Dickens's stories, characters, sentiments, and prosodies can be appreciated regardless of one's reading process. However, what is lost in translation is Dickens's fastidious attention to structural detail, both on a microlevel (within an individual installment) and on a macrolevel (the placement of the installments/breaks).

Ultimately, the "final product" of the costume drama—the complete-series DVD—proves to be the superior object for preserving the original method of narrative consumption. *The Forsyte Saga* and *The Pallisers* retain their episodic structures on DVD and can be viewed on an episode-by-episode basis. Though the viewer has the choice of watching countless episodes back to back, there is never any question about where individual installments begin and where they end, for the episodes retain their distinct identities on DVD. Ironically, one can experience, scrutinize, and appreciate the serial narrative structure of Davies's *Bleak House* on DVD more readily than one can experience, scrutinize, and appreciate the serial narrative structure of Dickens's *Bleak House* in novel form. A "DVD" is a "digital videodisk," and digitalization may prove to be the key to rectifying the aforementioned problems regarding the Dickensian composite text. E-text scans of Dickens's serials are becoming increasingly common within university digital collections. This trend may eventually extend to more general digital editions of Dickens's texts, which would allow the public to fully embrace the serial structure of the author's works.

NOTES

1. Though serialized storytelling has always been an integral part of the soap opera, several scholars have noted the increasing trend toward serialized storytelling in prime-time television dramas and a corresponding increase in quality; Sarah Kozloff alludes to an "increased tendency toward serialisation," while Glen Creeber traces "the increased serialisation and complexity of television drama." Finally, Trisha Dunleavy asserts that the "increasing narrative complexity in TV drama" is directly attributable to "increasing serialization." The reputation of television narrative has improved as a result of this increased use of serialized storytelling, a fact evocative of Dickens's own artistic maturation: as he refined and mastered the serial method of storytelling, the plots to his novels became more sophisticated and engrossing. See Sarah Kozloff, "Narrative Theory and Television," in *Channels of Discourse, Reassembled: Television and Contemporary Criticism*, ed. Robert C. Allen (Chapel Hill: University of North Carolina Press, 1992), 92; Glen Creeber, "The Miniseries," in *The Television Genre Book*, ed. Glen Creeber (London: British Film Institute, 2001), 35; Trisha Dunleavy, *Television Drama: Form, Agency, Innovation* (New York: Palgrave Macmillan, 2009), 217.

2. Richard Marson, *Inside Updown: The Story of Upstairs, Downstairs* (Bristol, UK: Kaleidoscope, 2001), 94.

3. Ibid.

4. Ibid., 100.

5. Marsh's linking *The House of Eliott*'s lack of realism to its status as a soap opera belies the fact that numerous scholars have cited the "gritty" realism of the British soap as its distinguishing characteristic in comparison to its American counterpart. Building on the writings of Dorothy Hobson, Anna McCarthy notes "a cultural recognition of social realism as an aesthetic strategy in British and Australian serial drama; often, they reflect a corresponding recognition of the setting and situations of American soap opera exports as hyperbolic and hence unrealistic." Enduring British soap operas such as *Coronation Street* and *EastEnders* are key examples of this trend. See Anna McCarthy, "Realism and Soap Opera," in Creeber, *The Television Genre Book*, 50.

6. Admittedly, the contemporary trend of streaming films will likely result in the extinction of the DVD. For the purposes of this chapter, it is appropriate to cite the DVD as the "final product" of the costume serial, not only because it is more analogous to the edited novel as a tangible compilation object, but also because several of these programs are not available through streaming media.

7. Brian McFarlane, *Novel to Film: An Introduction to the Theory of Adaptation* (Oxford: Oxford University Press, 1996), 105.

8. Ibid., 6.

9. Kamilla Elliott, *Rethinking the Novel/Film Debate* (Cambridge: Cambridge University Press, 2006), 122–23.

10. Jennifer Hayward, *Consuming Pleasures: Active Audiences and Serial Fictions from Dickens to Soap Opera* (Lexington: University Press of Kentucky, 1997), 148.

11. Robin Nelson, "Analysing TV Fiction: How to Study Television Drama," in *Tele-Visions: An Introduction to Studying Television*, ed. Glen Creeber (London: British Film Institute, 2006), 82.

12. Hayward, *Consuming Pleasures*, 39.

13. Bill Bell, "Fiction in the Marketplace: Towards a Study of the Victorian Serial," in *Serials and Their Readers: 1620–1914*, ed. Robin Myers and Michael Harris (New Castle, DE: Oak Knoll, 1997), 127.

14. "Review of *Great Expectations*," *Times* (London), 17 October 1861, 6.

15. James Michener, "A Hit in Any Language," *TV Guide*, 30 March 1970, 9.

16. Muriel G. Cantor and Suzanne Pingree, *The Soap Opera* (Beverly Hills, CA: Sage, 1983), 22.

17. Creeber, "The Miniseries," 35.

18. Catherine Itzin, "*Upstairs, Downstairs* Production History," *Theatre Quarterly* 2, no. 6 (April–June 1972): 30. Emphasis added.

19. The end credits for *The Duchess of Duke Street* include a card stating "*Serial* created by John Hawkesworth" (emphasis added). Conversely, the end credits for *Upstairs, Downstairs* include a card stating "*Series* created by Sagitta Productions Ltd." (emphasis added).

20. The finale of season 2, "A Family Gathering," would mark the final appearance of both characters.

21. I am basing this assertion on Dunleavy's definition of the soap opera; *Downton Abbey* and *The House of Eliott* meet all six of her requirements. Dunleavy, *Television Drama*, 97–98.

22. John Butt and Kathleen Tillotson, *Dickens at Work* (New York: Methuen, 1982), 14.

23. Charles Dickens, "Preface to the Original Edition, 1837," in *The Pickwick Papers* (New York: Penguin, 1986), 41.

24. Nelson uses the term "flexi-narrative" to describe a televised narrative that "maximises the pleasures of both regular viewers who watch from week to week . . . and the occasional viewers who happen to tune into one episode." Nelson, "Analysing TV Fiction," 82.

25. Michael Hammond, "Introduction: The Series/Serial Form," in *The Contemporary Television Series*, by Michael Hammond and Lucy Mazdon (Edinburgh, UK: Edinburgh University Press, 2005), 76.

26. Dickens acknowledged that, given the circumstances surrounding *Pickwick*'s publication, "no artfully interwoven or ingeniously complicated plot can with reason be expected." Dickens, "Preface," 41.

27. Butt and Tillotson, *Dickens at Work*, 66.

28. Quoted in ibid., 25.

29. Ibid.

30. Creeber, "The Miniseries," 38; Dunleavy, *Television Drama*, 22.

31. Marson, *Inside Updown*, 56. Sarah likewise eventually became the star of her own spin-off series, *Thomas and Sarah* (1979).

32. Charles Dickens, letter to John Forster, 25–26 July 1846, in *The Letters of Charles Dickens*, ed. Kathleen Tillotson, vol. 4 (New York: Oxford University Press, 1977), 589–90.

33. Ibid., 590.

34. Hayward, *Consuming Pleasures*, 58.

35. Marson's text indicates that initial series outlines changed significantly as the content of individual episodes changed. The outline for series 2 included a love affair between Rose and Thomas and an extended story line featuring Sarah's conflicts with Nanny. Series 3 was initially set during World War I, though this story line was postponed until series 4. On the whole, the episodic nature of *Upstairs, Downstairs*, along with the collaborative nature of the writing process, seems to have allowed for greater experimentation with continuity. See Marson, *Inside Updown*, 106–10, 172–78.

36. Ibid., 56.

37. See Dickens, letter to John Forster, 593.

38. Robin C. Allen, "*The Guiding Light*: Soap Opera as Economic Product and Cultural Document," in *Television: The Critical View*, ed. H. Newcomb, 4th ed. (New York: Oxford University Press, 1987), 148.

Chapter Five

Never-Ending Stories?

The Paradise *and the Period Drama Series*

Benjamin Poore

The BBC's costume drama *The Paradise*, which aired in the UK in late 2012 and returned for a second and final series in 2013, represents a relatively new departure in literary adaptation and period drama. *The Paradise* was a loose adaptation of an Émile Zola novel, *Au Bonheur des Dames* (1883), but it was an adaptation that, as with scriptwriter Bill Gallagher's previous success, *Lark Rise to Candleford* (2008–2011), substantially expanded upon its source material. *The Paradise*, *Lark Rise*, and other recent BBC period drama successes such as *Cranford* (2007–2009) and *Call the Midwife* (2012–) stand as examples of costume dramas that cross the line between drama serial and series, by incorporating elements of the soap opera. For example, *The Paradise* featured self-contained episodes and series climaxes but also a single main setting, a regular ensemble cast, and—or so it seemed—the prospect of an ending infinitely deferred.

This chapter considers the viability of such a production model and some of the tensions created by this hybrid of classic-novel adaptation and soap. The chapter argues that serials like *The Paradise* point to a way in which, in difficult financial times for the BBC, the corporation can monetize its cultural capital as a producer of classic-novel serializations by introducing economies of scale to the normally time-consuming, handcrafted, one-off model of the costume drama. In the case of *The Paradise*, an adaptation of a single novel yielded sixteen hours of television, and more could have been made had the viewing figures held up. I will consider the role of the lead writer in such series, informed by my interview with Kate Harwood, head of Drama for England at the BBC. In doing so, I build on the research of Simone Murray in her book *The Adaptation Industry* and hope that what follows will

contribute to what Murray calls "a *sociology* of adaptation," moving beyond the textual-analysis model inherited from English literature. [1]

WHY *THE PARADISE*?

The Paradise makes an interesting case study for such an investigation because, as suggested above, it had BBC costume-drama pedigree, having been created and written by Bill Gallagher, lead writer for *Lark Rise to Candleford*. It also featured actors such as Olivia Hallinan, Sarah Lancashire, Ruby Bentall, Matthew McNulty, and Peter Wight, who have appeared in *Lark Rise* (just as Claudie Blakley and Julia Sawalha from the cast of *Cranford* went on in turn to appear in *Lark Rise*). *The Paradise* took the period-drama-series formula further toward the soap opera, I argue, because it featured a range of female characters (albeit with the emphasis on the young shopgirls), as British soaps traditionally have, [2] and thus repeatedly appealed to "multiple identification," so that viewers were encouraged to see different characters' points of view. [3] Moreover, as with classic television costume dramas such as *Upstairs, Downstairs* (1971–1975) and *The Duchess of Duke Street* (1976–1977), and in common with the hugely successful *Downton Abbey* (2010–), *The Paradise* was mostly set in a workplace that is also where the majority of the characters live, here a large department store in 1870s Newcastle where shop assistants, according to the custom of the time, "live in." This allowed the "accent on human relations, domesticity, and daily life" that Ien Ang identified as being a key characteristic of soap opera to coexist with a workplace drama, since work and home constantly overlapped. [4]

CHOICE OF SOURCE TEXT

As Murray's study of adaptation focuses on the adaptation of contemporary fiction to the screen—and film in particular—this chapter borrows Murray's analytical framework to focus on a text that is considered a "classic" in France but is little known in the UK; hence, it is not one of those canonical works of English literature that have a long critical history and that are thus "freighted with cultural approbation and/or notoriety." [5] Rather, as with the other BBC series with which I classified *The Paradise* earlier, it was an adaptation of a lesser-known work with which the writer(s) and producers may have felt they had a greater degree of freedom. *Call the Midwife* was adapted from the memoir of Jennifer Worth (1935–2011); and *Lark Rise to Candleford*, the memoirs of Flora Thompson (1876–1947). *Cranford* was adapted chiefly from three Elizabeth Gaskell novellas, *Cranford*, *My Lady Ludlow*, and *Mr Harrison's Confessions* (later published together as a TV tie-in, *The Cranford Chronicles*). Series based on memoirs can be understood

as conveying an air of authenticity on the costume drama: the assertion that this is a factual document of what it was like to live in those times, not a romantic fiction. Nevertheless, the open-endedness of the series, by contrast the finite nature of the memoir, and the fact that both memoirists are dead mean that—even if the concept of memoir being unvarnished and authentic truth were not problematic in the first place—further stories would have to be invented by the show's writers. In the case of Gaskell and Zola, there is the kudos of a classic-novel adaptation but without the obligation to follow the source text particularly closely. That is, the writers can cut and alter without the scrutiny that would be attached to adaptations of Dickens or the Brontë sisters, the canonical nineteenth-century works that appear on British school syllabi and that featured in the landmark adaptations of the 1990s and 2000s (*Pride and Prejudice* [1995]; *Bleak House* [2005]).

Kate Harwood is open about the appeal of such open-ended source texts for the BBC. Where a Dickens adaptation's closed ending is "quite restrictive" in terms of what can be changed, Harwood regards *Lark Rise* as "very anecdotal. We were at one point just going to adapt the books, but it became more expanding on them. I mean, Twister [an elderly Lark Rise villager in the series], there's probably only a couple of pages on him in the books, and maybe only a paragraph on the protest march from Lark Rise to Candleford."[6] Series creator Bill Gallagher was therefore able to build whole episodes around quite small incidents alluded to in the source text and to construct recurring characters out of passing descriptions. With *Cranford*, Harwood remarks, "We could have kept on making [it], only there was a limit to the amount of time those actors were able to devote to doing series after series."[7] Thus, the star casting that initially made the program a hit (including Dame Eileen Atkins, Dame Judi Dench, and Sir Michael Gambon) prevented it from developing into a fully open-ended series.

PRODUCTION PRACTICES

In several ways, these series are symptomatic of how the BBC adapts, and how it presents, period drama now. First, they are filmed intensively, mainly in one or two locations (*The Paradise* was shot on the Lambton Estate, County Durham; *Lark Rise* was shot on a purpose-built site on a farm in Wiltshire; and the first two series of *Call the Midwife* were filmed at St. Joseph's Missionary College in Mill Hill and Chatham dockyard). If the series is recommissioned, more episodes can be shot relatively easily. By contrast, a Dickens or an Austen adaptation, as well as having, of course, a finite amount of "plot," also have bespoke sets and locations. Kate Harwood recalls,

I produced David Copperfield in 1999, and it [was] two nineties [ninety-minute episodes]. That probably cost, per hour, over a third more than we make period drama now. And part of that is there are just various savings, in terms of how we process making stuff. . . . When I made *Copperfield*, I shot that in London, Liverpool, Norfolk, Hampshire, Suffolk, Gloucestershire, and three weeks in the studio at Elstree. . . . You know, there was not much sense of savings being administrated. . . . We're now making period drama at around £1.1m an hour in 2013/14; I made David Copperfield in 1999 for £1.7m, so everything is much cheaper now, but I don't think the audience feel they've lost value.[8]

The series' content reflects the new production model. *The Paradise* and *Lark Rise* are centered on the comings and goings of the characters in a few locations: the post office, the Pratt sisters' shop, the Timminses' house, the ladieswear department, John Moray's office, and Edmund Lovett's shop. Both these series had "composite sets" built for their filming, which means that the shops, streets, and alleyways are all fully dressed to look "real," and hence that actors can be filmed in tracking shots coming out of a house and walking to another location, without the need to cut or adjust the camera angle to avoid breaking the illusion of a complete three-dimensional world. Of the BBC's *Three Musketeers*, being filmed at the time of our interview, Harwood stated, "There is a big build in the mix, but they're basically doing 90 percent of it in one place, really. And that's another big period show that's developed a precinct, really, the musketeers' garrison."[9]

This approach to filming—of the composite set and the precinct—has much in common with soap opera, which, of course, operates with considerable economies of scale, as soaps are broadcast several times a week and so must be recorded according to an intensive schedule. Christine Geraghty notes that British soaps establish narrative space "so that viewers know in a detailed and intimate way the layout of the setting in which the stories take place," calling this care taken over outside spaces in *EastEnders* and *Coronation Street* a "realist strategy" that asserts the soap's characters and locations as believable parts of contemporary London or Manchester, respectively.[10]

SERIAL TO SERIES

I have thus far used the term "series" to describe programs like *The Paradise*, rather than "drama serial," in order to differentiate these open-ended dramas from the classic, thirteen-part novel adaptation, as screened by the BBC in the 1970s in the early evening on Sundays.[11] I also adopt the distinction made by Geraghty between the serial and the series. Geraghty distinguished between the closed-ended drama and soaps, which Dorothy Hobson has described as "never-ending in form."[12] Even at the time of Geraghty's early work on soap opera, however, prime-time drama was borrowing formulae

Figure 5.1. Composite set: the street outside the department store in *The Paradise*.

from the soap, as Ien Ang notes in the case of *Dallas*.[13] Nevertheless, like *EastEnders* and *Coronation Street*, the recent crop of BBC costume-drama series could also be said to be asserting a social realist approach because of the composite sets and detailed locations, which assert a knowledge and understanding of what it was like to live day to day in that historical period. The "making of" featurettes—those behind-the-scenes minifilms, part documentary and part press-pack publicity, that come as extras on the series DVDs—offer evidence of the series makers' rhetoric of historical realism. *The Paradise* series 1 DVD, for example, includes the extra "Behind the Doors of the Paradise," which opens with actors David Hayman and Sarah Lancashire paying tribute to the production designers' craftsmanship, detail, and research expertise. Hence there is an inherent contradiction, in both a soap like *EastEnders* and a series like *The Paradise*, between an aesthetic that—however questionably—asserts the realism of the characters' surroundings and thus asserts the realistic nature of its portrayal of society—and the shows' heavily patterned content (what Hobson has called "recurrent catastasis," the regular spacing of peaks of dramatic action).[14] In their period setting and recurrent moments of character jeopardy, series like *Call the Midwife* and *The Paradise* mimic the narrative through-line of the classic realist novel, only to reestablish the status quo by the end of the episode. The writing out of a main character from the series, for example, Matthew Crawley's exit from *Downton Abbey* in 2012, is understood by audiences to be a result of the actor Dan Stevens's decision not to renew his contract. Hence, as Geraghty

notices with the soap, there is a "tightrope walking" between narrative strate-
gies that both engage and distance the audience, making them aware of the
external factors that have influenced the story development.[15] The "making
of" featurette, in the case of costume-drama series, can be said to fulfill a
similar function, highlighting the detail and richness of the televisual illusion
but nevertheless reminding viewers that it *is* an illusion.

"WARM BATH" TELEVISION

Despite this inevitable "oscillation between engagement and distance" in an
age where the media constantly report and anticipate developments on hit
shows,[16] these series have been identified as a television drama trend, some-
times called "warmhearted," or even, more critically, "warm bath" televi-
sion: programs for recessionary, uncertain times where viewers can immerse
themselves in the comfort of a familiar, settled community located in the
past.[17] Perhaps it is in response to this perceived criticism that Kate Harwood
seems to express a degree of ambivalence toward the BBC's history of suc-
cessful period dramas. She comments, "As for our reputation for period
drama, you know, it's great, [but] we can't live on our laurels," and notes that
American television makers seem in awe of British TV's ability to regularly
walk away with "Best Miniseries" Emmy Awards. "That is certainly what
people think of us in the US, it can be a kind of frustration as well. . . . [They]
assume that we] swan in with our period frocks and posh actors, but it's not
just that; there are so many other things that we do. . . . British drama is so
much richer than that, I think."[18] On a similar note, BBC One controller
Danny Cohen remarked, when announcing the cancellation of *Lark Rise to
Candleford*, that he hoped the new show being commissioned would "begin
to express the range and creative ambition we want BBC One drama to
capture in the coming years," which rather implies that *Lark Rise* belonged to
the corporation's past and lacked such "ambition."[19]

THE LEAD WRITER

However, the reason for the cancellation of *Lark Rise* was writer Bill Gal-
lagher's withdrawal from the series, whereupon he set about creating *The
Paradise*. Ben Stephenson, the BBC's controller of drama commissioning,
was quoted as saying, "I can't stress enough how important Bill Gallagher
was to the creative energy and drive of *Lark Rise*. With Bill moving on . . .
we therefore felt this was a natural point to bring it to an end."[20] Such a
decision brings into sharp relief the importance of lead writers to this kind of
period-drama series. The lead writer is often also an executive producer on
the show and the person who is usually credited in the opening titles: "Creat-

ed and Written by . . ." Examples of such writers at the BBC include, alongside Gallagher, Heidi Thomas, who created the revamped *Upstairs, Downstairs* (2010–2012) and *Call the Midwife*, and wrote several episodes of *Cranford*; Adrian Hodges, who adapted *David Copperfield* in 1999 and whose loose adaptation of *The Three Musketeers* airs in 2014; Sarah Phelps, who adapted *Oliver Twist* (2007) and *Great Expectations* (2011) and who is now lead writer on the original drama series *The Ark*; and also Richard Warlow, creator of *Ripper Street* (2012–). The lead writer is responsible for setting and maintaining the tone of the series and writing some entire episodes but also occasionally for writing scenes or additional dialogue. Harwood notes,

> I think one of the most elusive things in drama is tone, and if you can get the tone of something right, and then sustain that, then that's kind of what it all comes down to, I think. Because, you know, you get shows where the tone will fluctuate, or you'll get a show where they're trying for a very complex tone and it ends up a muddle, or you'll get a show where they're trying to keep it simple and it becomes bland.[21]

Harwood made a distinction between the lead writer and a US TV-style "show-runner," arguing that the showrunner has much greater autonomy; nevertheless, she conceded that Steven Moffat, current executive producer of *Doctor Who*, is as close as British television comes to this role: "I think Steven is closer to being a show-runner—well—I think Russell [T. Davies] was very close to being a show-runner." Harwood pointed out that from an executive's point of view, "if we're short of anything in British television we're short of writers. There's plenty of people who can do marketing, but what you really want is great big lead writers who can deliver the tone and story and characters through ten or twenty years, that's what we really need."[22] Such an observation goes a long way to explaining why Gallagher's departure from *Lark Rise* precipitated the cancellation of the series, which is hard to imagine happening if a cast member, or several cast members, decided to leave. If, as Murray suggests, the longstanding influence of auteur theory means that film is still considered a director's medium, with the screenwriter "systematically marginalised," and if, as Hobson asserts, a soap opera's producer is the "controlling, creative force," then in costume-drama series this power would seem to rest, unusually, in the writer's hands—or in the hands of a select group of sought-after writers, at least.[23]

BLEAK HOUSE: A HALFWAY HOUSE

A second major influence on the costume-drama trends under discussion in this chapter is the critical and ratings success of the most recent television

adaptation of *Bleak House* (BBC, 2005). As Geraghty points out in her illuminating book on that serial, the show was scheduled for weekday evenings after *EastEnders*, and the BBC's publicity emphasized the "soap treatment" that such a fast-paced, short-episode broadcast pattern implied, as well as the addictive qualities of the narrative and the refreshingly contemporary style of the show's direction and design.[24] As scholars from Geraghty all the way back to Giddings, Selby, and Wensley have argued, there are real problems in assuming that Dickens's serial-publication framework translates naturally and directly into soap, and in the often-made comment from TV adapters that "if Dickens was alive today, he'd be writing for *EastEnders*."[25] Nevertheless, it is notable that several of the lead writers mentioned in the previous section have made the transition from Dickens adaptations to the new open-ended style of costume drama. The BBC attempted to repeat *Bleak House*'s success with another short-episode, soap-style Andrew Davies adaptation, *Little Dorrit* (2008), which was slightly less well received by British critics and suffered falling audience numbers as the series progressed.[26] In the same year, the first series of *Cranford* and *Lark Rise* were aired, and the idea of drama series with the prestige and Emmy Award clout of *Bleak House* and *Little Dorrit* but that were open ended and thus appealing to international markets on a longer-term basis clearly appealed to the BBC's drama executives.[27] Kate Harwood observes:

> Period drama is just incredibly expensive, and we don't have that many international partners for it. We have more for the returning series. I think if we said we were going to do a third big serial version—if we said we were going to do *David Copperfield* or *Our Mutual Friend* again—it would be WGBH who came forward with probably a fraction of the budget, so we'd struggle through, and we'd make it, and it's wonderful. So it's partly evolution, partly cost, partly that . . . there's an inordinate amount of returning series, period drama—that has taken off, internationally, and with our audience, and that sort of squeezes [Dickens] out a bit.[28]

THE SPRINGBOARD ANALOGY

In describing the use of historical settings made by series that are not adaptations, like *Ripper Street*, Harwood referred to

> using history as a bit of a springboard for creating your own world and telling a certain kind of story, in a way that, I don't know—*Rome*, was certainly not Roman history; *Game of Thrones* is really not the Wars of the Roses; but it's using history as a springboard and using literature, sometimes, as a springboard. . . . I mean, the great thing about period [drama] is, you create your own world, it's like fantasy, or it's like mystery, you know, you can kind of say well *my* nineteenth-century London is *Ripper Street*'s London. It's an entire-

ly—it's a dark, gothic world, where the battle between good and evil is visceral and fought on the streets. Kind of *Gangs of New York* in London. But it's this license to be hyperreal, rather than slightly dull and historical. [29]

This "springboard" analogy, as Harwood implies, is as applicable to the BBC's recent adaptations as it is to original historical drama. By relocating Zola's novel to Victorian England, for example, Gallagher was able to play on all the associations that the period has for audiences familiar with the corporation's output of prestigious Victorian novel adaptations. *The Paradise* reflects much more of what viewers would recognize as positive "Victorian values," freighted with modern nostalgia toward the period, than does *Au Bonheur des Dames*. As Brian Nelson notes, Zola's setting for *Au Bonheur des Dames* is a century of "action and conquest" in which certainties were dissolving, and Zola adopted a "scientific view" of families and society that he termed naturalism in order to capture this. [30] Indeed, the whole Rougon-Maquart novel cycle, of which *Au Bonheur des Dames* is the fifth volume, was intended as an exposition of Zola's theory that inherited weaknesses were passed on to subsequent generations and informed their destinies and choices. [31] In *The Paradise*, by contrast, the emphasis is on individual agency and choice. The Paradise department store is initially seen through the eyes of lead character Denise Lovett, who arrives from Peebles in Scotland to enact the familiar transformation from country girl to confident, career-focused city worker, and from rags to riches. It is a Cinderella story in which the lowliest shopgirl marries the prince—the store owner, Moray—despite the machinations of wicked (yet occasionally tenderhearted) stepsister figures, coworkers Clara and Miss Audrey.

Similarly, as Lucinda Matthews-Jones points out, *The Paradise* emphasizes the idea of the store as one big family. [32] In episode 1:2, when Sam is accused of misbehaving with a customer, Miss Audrey says the staff should support him because he is "one of us." As in the case of the foundling taken in by the staff, and the errand boy Arthur, who was also born in The Paradise, the store "looks after its own." Moray, the store's charismatic owner (his name is Mouret in Zola's novel cycle), is prone to giving inspirational speeches to his staff that reiterate this point (contrast this with Mouret's pretended concern for the quality of the staff canteen food in Zola's novel). [33] And, crucially, Denise's uncle, who lives alone, welcomes Denise when she arrives in the city, where in Zola's novel he is reluctant to let her stay, and both characters are encumbered and financially drained by their families. In order to place a "warmhearted," sentimental glow around the idea of the family, then, Gallagher's adaptation not only had to take at face value Moray/Mouret's claims that the store is a family (and thus to remove the ruthless exploitation of his staff that is a key element of Mouret's modus operandi)

but also had to remove the actual family members whom old men like Lovett and young women like Denise were expected to support.

Therefore, I argue, *The Paradise* is as much a fantasy of the nineteenth century as is *Ripper Street*: it is the Victorian age viewed through the opposite structure of feeling. Where *Ripper Street* posits murder, violence, and grotesque villainy at every turn, *The Paradise* enacts a fantasy that in Victorian times, family and community existed for the most part without coercion, exploitation, or subjugation to others. Characters' actions can thus be discussed and judged by audiences as if they were figures in a modern soap, with a modern degree of personal agency. In making this argument, I imply no value judgment about Gallagher's changes but instead seek to demonstrate the process of adaptation in the sense developed by Linda Hutcheon, as analogous with natural selection: the text adapts to survive in its new environment.[34] This chapter has sought to map out that televisual environment in which *The Paradise* was developed in order, albeit briefly, to thrive.

CONCLUSION

I have argued that *The Paradise* is a key example and indicator of recent developments in costume drama and in adaptation. It can be interpreted as one way in which the BBC has responded to the success of *Downton Abbey* and also to the financial unsustainability of the one-off, classic-novel adaptation miniseries. Its hybrid form—more series than serial, somewhere between a soap and a "quality television" adaptation—creates a number of tensions and contradictions: between historical accuracy and contemporary appeal, between realism and excess, and between engagement and distanciation. There is also the tension between the conventional novel's focus on a single protagonist's experience (in this case, Denise) and soap's requirement of "multiple identification" as well as having an ensemble cast based around a key setting.[35] Moreover, the generic indeterminacy of *The Paradise* is arguably part of its appeal to audiences, who need to be culturally competent decoders of soap conventions as well as those of the classic novel in order to judge and anticipate what story elements will be resolved and what will remain open.

This model is, in all likelihood, the future of television adaptation in a digital age of fragmenting audiences. We would benefit from thinking about costume drama on television in terms of common production processes, rather than in discrete historical periods, as the academy is prone to do. Television adaptation is losing its one-to-one relationship with a source text, where each character and plot point is reproduced. To use the analogy of Sherlock Holmes adaptations, it seems unlikely—after the temporal, spatial, and generic relocations of the Holmes characters effected by the TV series *Sherlock*

(2010–) and *Elementary* (2012–), and the Guy Ritchie films *Sherlock Holmes* (2009) and *A Game of Shadows* (2011)—that television will return to the format of the Granada series (1984–1994) starring Jeremy Brett, where initially each story was adapted in turn in a way that proudly emphasized its fidelity to the source text. Perhaps, indeed, this one-to-one relationship between literary artifact and adaptation is now more prevalent in film, where recent versions of *Wuthering Heights* (Andrea Arnold, 2011), *Jane Eyre* (Cary Fukunaga, 2011), and *Anna Karenina* (Joe Wright, 2012) have offered unusual takes on nineteenth-century novels.

Even though the model is here to stay, individual series, as in the cases of *Lark Rise, Upstairs, Downstairs, Cranford*, and now *The Paradise*, lead a precarious existence in this new television landscape, prey to such factors as the vagaries of the international marketplace, star actors' shooting schedules, lead writers' willingness to continue, and, of course, weekly viewing figures. Like long-form American television (*The Sopranos* [1999–2007], *The Wire* [2002–2008], and *Breaking Bad* [2008–2013]), British costume drama must remain poised between the possibility of cancellation and tying up all the narrative strands quickly, or at the other extreme, extending a narrative conceived over a single season into something that continues to run for nearly a decade. As I have suggested, it is the raw material of soap opera that provides the narrative elasticity for this to happen.

NOTES

1. Simone Murray, *The Adaptation Industry: The Cultural Economy of Contemporary Literary Adaptation* (New York: Routledge, 2011), 4.
2. Christine Geraghty, *Women and Soap Opera: A Study of Prime Time Soaps* (Oxford, UK: Polity, 1991), 17.
3. Ien Ang, *Watching Dallas: Soap Opera and the Melodramatic Imagination* (London: Methuen, 1985), 76.
4. Ibid., 56.
5. Murray, *Adaptation Industry*, 21.
6. Kate Harwood, interview with author, 2 July 2013.
7. Ibid.
8. Ibid.
9. Ibid.
10. Geraghty, *Women and Soap Opera*, 14.
11. Robert Giddings, Keith Selby, and Chris Wensley, *Screening the Novel: The Theory and Practice of Literary Dramatization* (Basingstoke, UK: Macmillan, 1990).
12. Geraghty, *Women and Soap Opera*, 10; Dorothy Hobson, *Soap Opera* (Oxford, UK: Polity, 2002), 30.
13. Ang, *Watching Dallas*, 56–60.
14. Hobson, *Soap Opera*, 30.
15. Geraghty, *Women and Soap Opera*, 23.
16. Ibid., 24.
17. Vicky Frost, "Call the Midwife returns amid gentle rise of warm-hearted TV," *Guardian*, 18 January 2013, accessed 10 September 2013, http://www.theguardian.com/.
18. Harwood, interview.

19. Sarah Bull, "Lark Rise to Candleford Axed at the End of Current Series as Bosses Decide to 'Quit While We're Ahead,'" *Daily Mail*, 22 January 2011, accessed 10 September 2013, http://www.dailymail.co.uk/.

20. Michael Anderson, "Lark Rise Axed Because of Producer's Departure," On the Box, 28 February 2011, accessed 10 September 2013, http://channelhopping.onthebox.com/.

21. Harwood, interview.

22. Ibid.

23. Murray, *Adaptation Industry*, 132; Hobson, *Soap Opera*, 63.

24. Christine Geraghty, *Bleak House* (Basingstoke, UK: Palgrave Macmillan, 2012).

25. Geraghty, *Bleak House*, 15, 19–31; Giddings, Selby, and Wensley, *Screening the Novel*, 45–47.

26. James Walton, "Last Night on Television," *Daily Telegraph*, 11 December 2008, accessed 20 September 2013, http://www.telegraph.co.uk/.

27. *Little Dorrit* won seven Primetime Emmy Awards, having been nominated for eleven, and *Bleak House* was nominated for ten and won two.

28. Harwood, interview.

29. Harwood, interview.

30. Brian Nelson, *The Cambridge Companion to Zola* (Cambridge: Cambridge University Press, 2007); Émile Zola and Brian Nelson, *The Ladies' Paradise* (Oxford: Oxford University Press, 1995).

31. Nelson, *Cambridge Companion*.

32. Lucinda Matthews-Jones, "Review: The Paradise and Zola's The Ladies' Paradise," *Journal of Victorian Culture Online*, October 16, 2012, accessed 18 September 2013, http://myblogs.informa.com/jvc.

33. Zola and Nelson, *Ladies' Paradise*, 165.

34. Linda Hutcheon, *A Theory of Adaptation* (London: Routledge, 2006).

35. Ang, *Watching Dallas*, 76.

Chapter Six

Epistolarity and Masculinity in Andrew Davies's Trollope Adaptations

Ellen Moody

In this chapter I uncover and examine an aesthetic and thematic terrain that television screenwriter Andrew Davies shares with Victorian novelist Anthony Trollope. Throughout his novels Trollope reinforces and questions socially enforced ideals of manliness in his era. He dramatizes actuating conventional norms (which can differ considerably from ideals) and male goals in conflict with his sympathetic heroes' heterosexual impulses, and his stories tell the price paid by males who manage to dominate situations to their apparent advantage by exploiting unwritten social codes.[1] This is central terrain for Davies too, even in novels whose focus is not on ordeals of masculinity (e.g., his 1995 *Pride and Prejudice* and 1999 *Wives and Daughters*).

COSTUME DRAMA AND SUBVERSIONS OF TELE-NATURALISM

Both writers also persuasively endow their work with a deeply felt psychological interiority that the social scenes they write make manifest in drawing rooms, outdoors, and bedroom scenes alike. In Trollope's novels and Davies's scripts we see the realities of private selves displaying themselves whether they want to or not in the story's dramatized worlds. Both convey their stories centrally through naturalistic-seeming dialogue, itself psychologically and symbolically suggestive, dialogue that creates sympathy for all the characters, including those whose values we are to reprobate. Trollope's continuous use of a narrator to convey an impression of indwelling depths has often been discussed; less noticed is Trollope's unusual reliance on techniques of epistolarity to bring out his characters' subconscious motives. As

with Jane Austen's originally epistolary texts, Trollope's semiepistolary ones provide an aesthetic match for Davies's ways of deepening his TV adaptations through combined uses of filmic epistolarity, voice-over, montage, and televisual direct address.[2]

I focus on two four-hour miniseries (BBC/WGBH/Indigo productions) adapted from two classic novels somewhat outside the popular canon. Trollope's *He Knew He Was Right* (*HKHWR*; never adapted for film or TV before) and *The Way We Live Now* (*TWWLN*; adapted once only, by Simon Raven in 1969) enable Davies to freely adapt Trollope's male characters' psychological experience as they cope with the demands the characters make upon themselves while they attempt to enact sexual ideals of manliness and achieve financial and social success. The modernity and satiric stances of Trollope's outlook in these two books also enables Davies to undercut the conservatism of these novels while exploiting conservative tendencies in heritage films that make the genre feel appropriate for them: Davies's series draw viewers in with broadly alluring familial, pro-establishment, and romance tropes, and then examine and critique the norms actuating these tropes.[3]

Both series are distinctive and typical instances of costume drama. This is why for series whose sources are books thought to be very different, they are curiously alike. It's more than that they are the same typical length. One could take a secondary set of characters or story out of one series and place it in the other, so similar and effortlessly seamless does Davies's use of the filmic conventions feel. Most importantly, they both use a syntagmatic structure made up of parallel segments (matching stories) that can be moved about (and are by PBS when it rearranges a BBC production as it often does to fit its own time requirements).[4]

When discussed as novels in their own right, Trollope's *HKHWR* and *TWWLN* are most often treated as worlds apart in themes, art, and perspective. *TWWLN* is panoramic, political, and a "condition of England" novel with matter peculiarly relevant to our time: Trollope exposes financial speculation as dangerously devouring gambling, which has the potential to bankrupt many. He attacks the false promotions of a wholly commercialized literary marketplace as a parallel activity to that of selling worthless stocks. Arranged marriages are mostly hollow bargains over money. Elections are won by people whom the electorate admires merely for being rich; it matters not how ignorant Melmotte is of English life, customs, or laws. Personal emotional fulfillment yearned for by the younger characters is scorned by their older authority figures. The central story is of Augustus Melmotte, a Robert Maxwell–like speculator who pockets the funds he collects for stocks in a company said to be building a railroad in the southwest United States. The characters in the novel's other stories, be they writers, newspapermen, landowners or their children, merchants, or servants of all kinds, find them-

selves drawn to try to share in Melmotte's supposed wealth or position in town; exposure and bankruptcy for several principal characters at the novel's close end in suicide, exile, retreat, or emigration.

HKHWR, while having equally contemporary references to its era, the 1860s, is domestic romance: Trollope focuses on internal states of mind as these actuate inescapable conflicts in marriage stemming from suddenly discovered individual irritants, uncongenial personalities, and obsessive possessiveness where a weak male's sexual pride and anxiety are exacerbated by deliberately opaque sexualized social customs exploited by those around him. This book's central story depicts how Louis Trevelyan, tormented by sexual jealousy and his inability to dominate his wife, Emily, gradually destroys himself. From three to five secondary interwoven stories (depending which couples you count in) provide saturnine parodies, normative, tonic, and redemptive variations on the central couple's failure to negotiate the contradictory conflicts inherent in the way courtship and marriage were (and still partly are) conducted. Both novels dramatize the workings of law, but in *TWWLN*, Trollope's interest is in laws of inheritance, banking, and mostly commercial property; in *HKHWR*, Trollope shows the effects on people of laws about child custody and property in marriage.

Davies's treatment of these books enables us to see underlying preoccupations present throughout Trollope's oeuvre because Trollope's male characters and stories so readily lend themselves to Davies's changes in perspective whereby the matter of both novels becomes a filmic story of a male ordeal brought on by need for money and status and (at the same time) by a relationship with a strong woman. At the same time, in both series Davies transfers Trollope's textual epistolarity into an inventive use of the techniques of filmic epistolarity: he will intertwine several voice-overs, flashbacks within flashbacks (which include other characters in voice-over), and montages of the letter reader's memories and imagined scenes as she or he reads. In so doing, Davies defies the still strong prejudices in filmmaking and criticism against voice-over narration and long intertwined flashbacks. He has argued, "All the best television drama transcends or subverts tele-naturalism." He would presumably have defended his use of direct address and subverting of genre expectations in *Moll Flanders* (Granada/WGBH, 1996) on the grounds that he found his naturalistic *Wives and Daughters* (BBC, 1999) dissatisfying: the conventional "stately naturalistic" film was "two steps backwards," implying it lacked stimulating playfulness and, most important, did not induce "a more reflective mode of engagement."[5]

HE KNEW HE WAS RIGHT: THE USES OF FILMIC EPISTOLARITY AND MASCULINITY CONVENTIONS

What is striking about Davies's *He Knew He Was Right* is how Davies complicates his use of epistolarity techniques. He frequently takes advantage of TV's penchant for direct address by a speaker to the person in, say, his or her living room, thus distancing us from the story but making us experience directly, even aggressively, the inner consciousness of an imagined character who turns round to address us before, during, or after an epistolarity-montage sequence. Major characters—Louis and Emily, Hugh Stanbury and Bozzle, and Gibson—all do it, both defensively and meditatively. Some minor characters do too: Mr. Crump (James Bolam) brings the melodramatic rivalry of Arabella and Camilla over Mr. Gibson to an end by refusing to take Camilla's threats to "stab [Bella] to the heart" seriously; his concise remarks are refreshing because he is completely unimpressed by other people's emotions. We could not know that unless he tells us so.

One dual sequence of letter writing, reading, and interpretation begins with Louis (played by Oliver Dimsdale as psychologically vulnerable from the start) suddenly addressing us on scene in bewilderment: "How could she betray me with this man of all men . . . well at least I can save one part of my life [his son] from this sorry mess." We cut to his walking away from us up a darkened stairwell in Italy to which he fled and then back to England to his hired detective Bozzle (Ron Cook) talking to himself, worried about the turn events are taking. A dramatic scene of Colonel Osborne being denied access to Emily by her uncle (whom Louis makes her guardian), the Rev. Mr. Outhouse (John Alderton), is sandwiched between a continuous soft voice-over of Bozzle's commentary to Louis and Outhouse reading aloud in his own voice Louis's latest letter demanding custody of his son, little Louie. The sequence ends as Emily turns from Outhouse to quietly address us directly: "Would he really do such a thing—[speaking to herself as well]—to hurt me to hurt himself to hurt his little boy [soft poignant music]; this is what love becomes. I married a man who's kind and gentle; what have I done to him that he should treat me like this?"[6]

A repeated deliberate breakdown in the conventions of TV naturalism is also found in *The Way We Live Now*. We experience disjunctive rather than continuity editing; for example, there are sudden breaks in montage as we move from, say, a letter to what is imagined by its reader. The prologue to episode 1 includes rapid switching of perspectives on a large globe of the world being pushed into a front hall. Filmic epistolarity contributes to this subversion of steady verisimilitude. In the series's second episode, the heartless, cowardly shallow cad, Sir Felix Carbury (played with inimitable comic bravura by Matthew Macfadyen), arguably as central to the film *TWWLN* as is Melmotte (outstandingly acted by David Suchet), reads alternatively two

letters from two heroines in love with him (the actresses' voice-overs blend). Amidst the heard letter text of the country girl and servant, Ruby (Maxine Peake), we see her in a montage escaping her grandfather's savage beating, and amidst the heard text of the other, Melmotte's daughter, Marie (Shirley Henderson), we hear Melmotte's voice berating his wife ("You stupid woman; why can't you get one simple thing right?"). In both series, through this blend of interior and dramatic art, Davies subverts the frequent nostalgic elegiac mood of heritage drama, its faith in love's power to sustain someone, and its endorsement of family life as a sanctuary from larger society. [7]

In *HKHWR*, it is important that we take Louis seriously, see real cause for his anxiety, jealousy, and self-destructiveness, as well as for Emily's anger at him and eagerness for a relationship with Osborne. If we do not take their feelings seriously, the development of disquiet about the sources of love and demands of marriage, which both the book and TV adaptation examine and place against other thwarted, anguished, and successful relationships, is lost. [8] Trollope's readers have tended to exonerate Emily: she is seen as justifiably too proud to reassure an obsessively controlling husband and not at all attracted to Colonel Osborne; they dismiss and despise Louis and trivialize Osborne. [9] But Trollope's novel begins with a cycle of disturbing letters: accusatory challenges from Louis and Emily's vituperative retorts over her flirting and letters to Colonel Osborne. Emily and Osborne are disingenuous in presenting themselves as motivated by their desire to continue an avuncular relationship set up in years past, as there was none. Their claim their letters are needed for them to discuss Osborne's efforts in parliamentary committees to persuade people to call her father to the UK as a governor of the Mandarin Islands is transparently false. In the book we do not see any of Louis and Emily's bedroom scenes, only a sense of rocking hysteria afterward: at the close of the book we are told (the scene remains undramatized) the epithet Louis incensed Emily with repeatedly when they were in their bedroom together was "harlot." Her response is to refuse him access to her bedroom, in the book apparently permanently. Trollope, and Davies after him, are attempting to create sympathy for the kind of male often scorned as a cuckold: anxious, sensitive, and someone who does not excite his wife in the way a playful rake like Osborne might and thus distrusts, perhaps resents, her sexuality.

The first eight of the twelve scenes making up the series's first hour is an analogous thick mélange of filmic epistolarity, dramatic scene, direct address, and montage. [10] Davies's epistolary-montage sequences work to allow Davies to undercut the tendency of Trollope's text to marginalize the ironic but effective predatory nature of elderly rakish male bachelor—Colonel Osborne's threat (played convincingly by Bill Nighy) to Louis—and the attraction of Emily to him, as well as her boredom and irritation with her controlling husband, Louis, as gauche, unreasonable, and awkward. Davies wants us

to like Emily so he tones down Emily's scorn, removes all reference to how bored she is with Louis, and makes her a childlike social innocent; on the other hand, in the TV adaptation he adds scenes that make it clear Emily would have resumed a relationship with Osborne even after her son is abducted but that Lady Rowley does not let Emily's obfuscations pass and unanswerably insists (in the series Geraldine James plays Lady Rowley as the voice of calm reason) Osborne arranged what happened so that others would conclude he is acting the philanderer (with Emily).

The first mélange is prefaced by Louis's ominous remark to his best friend, Hugh Stanbury (Stephen Campbell Moore, in a Turkish bath scene added by Davies from one of Trollope's short stories and suggesting a homoerotic component in Louis), that "marriage isn't always a bed of roses, you know," and his remark to us: "My marriage could be a bed or roses were it not for Colonel Frederick Osborne . . . there I've said it." The scene dissolves to Louis standing by a window imagining or remembering (it's left unclear) Emily and Osborne teasing and laughing, their bodies close together. When he awkwardly tries to express his dismay to her in her bedroom, she is immediately defensive, and with much less apparent reason than in the book (there is no gross insult in the TV version), she declares, "If you insist on coming to my bed tonight, of course you must, it's your right, but if you permit it I should prefer to sleep upstairs." She seems simply to respond to his request by demanding he stay out of her bedroom. In the next scene she further ratchets up the quarrel by telling her sister, Nora (Christine Cole), who lives with them (and is in love with Hugh), that a letter on the breakfast table is "from the man [Louis] assumes to be my lover."[11]

The epistolary, montage, and soliloquy sequence is interrupted by an original dramatic scene in the park where we can view (as we could not in the book) Nighy as Osborne adept at interposing himself between the couple and uttering casual insinuating speech. The resulting hysterical fight between Louis and Emily might be understood as overreaction, except that immediately afterward Davies juxtaposes two scenes taken from letters in the novel and developed with the sensuality filmic art is capable of. First, Osborne writes in soft-focus yellow light murmuring to Emily as voice-over, "What was that about today . . . please write me a line." Then the soft focus moves to her (now in her bedchamber), and her softened voice-over to Osborne follows: "As far as I'm concerned I wish for no change except that people should be more reasonable." She writes Osborne that he can visit her at any time (which directly leads to his later visit to Nuncombe Putney and her acceptance of it in the allegorically named place Louis later tries to seclude her in). She then addresses us while walking down the stairs to put her letter in the house postbox: "If I send him away and refuse to receive him, it's as if I'm admitting there is something improper. I won't be put in the wrong, and I won't give up control of my life to a man that doesn't trust me." She puts the

letter down and begins to climb up, and looking within now, says, "No, this is a mistake," and runs down the stairs, but it is too late, Louis has seen it and has it mailed himself.[12]

In the latter half of the TV series these long epistolary and montage exchanges cease and then we are led to regard Emily as rightly treating Louis as someone ill from social isolation; Hugh sees him as pathetically maddened with yearning. Louis does lose all perspective and seeks isolation and death at the end of the series and book, but in the Rev. Mr. Gibson (played with inimitable comic panache yet troubled anguish by David Tennant) Davies offers us an apparently sane and self-interested male who combines aspects of Louis and Osborne. As in the book, in the series the story of Gibson and two rival sisters for his affection, Camilla (Claudie Blakey) and Arabella French (Fenella Woolgar), functions to highlight the believability of behavior both neurotic and salacious as just everyday goings-on. Davies adds scenes of letter composing by this anxious Lothario (the name is used for Gibson and Colonel Osborne too) as Gibson panics (and anachronistically chain-smokes) over the sisters' attempt to control his sexuality for their own advantage.[13] We are not to dismiss Louis and Emily's situation as irrelevant to common experience: Davies underlines what Trollope leaves implicit in a late failed encounter between the couple in a broken-down, isolated cottage in England (a scene often forgotten in discussions of the book). To her "Oh Louis, this is a terrible dream," he replies, "No . . . this is the reality of how it is with us. Of how it is with women and men, the other [ideal vision] was a dream . . . a foolish happy illusion." She looks at him with startling incomprehension, though she has implied much the same thing in a soliloquy preceding the abduction of little Louie.[14]

Davies uses dramatized and read-aloud letters to expand the roles of more minor males in the novel too, for example, the genteelly impoverished Rev. Mr. Outhouse, who emerges as a male who is willing to provide a home for his niece and her sister but finds himself frightened that the events that occur are hurting his reputation and therefore his clerical career. Davies builds far more respect for Bozzle than Trollope does: in the novel Bozzle remains a salacious-minded detective whom Louis Trevelyan hires to spy on his wife; Ron Cook as Bozzle has a conscience and respect for his occupation. In these mixed epistolary sequences, Davies explores masculinity bearing up under social duress, when the male's pride in his position in the world and career are threatened.

As a kind of warning prelude to the series' climactic scene of the abduction of little Louie, Davies begins with a voice-over of Louis, who has fled to Italy, writing a letter (from the novel) to Bozzle that gives Bozzle authority to claim the child, a letter Bozzle finishes reading aloud in his and his wife's London flat. Mrs. Bozzle (named Susan in the film, played strongly by Patsy Palmer) protests, "A child should be with its mother. You needn't think you

can bring it back here; I'm not getting mixed up in stealing another woman's child," at which Ron Cook as Bozzle turns round to reassure us, "She'll come round, she's got a very tender heart, Susan, despite appearances" (see figure 6.1).[15] Then we see a dissolve into a montage of Mrs. Outhouse (Lynn Farleigh) mothering the child at the table, which leads to several brief dramatic scenes, discussing the letter (previously read aloud) where Louis had made it clear he wanted custody of his son.

The sequence culminates in Mr. Outhouse deciding to disobey a law demanding he return Louis's child to Bozzle as Louis's representative. Mr. Outhouse uses the lack of a court order to put off the detective, telling him, "Mr. Bozzle, I believe you are a knave." Bozzle: "A knave, Mr. Outhouse?" Outhouse: "Yes, sir, a knave. No one who was not a knave would try to separate a little child from its mother." Outhouse threatens (and moves) to throw Bozzle out or, says he sarcastically, "I shall call a real policeman." A voice-over of Ron Cook begins, and the camera is now outside the house with Bozzle whose self-esteem has been hurt by the sneering reference to "a real policeman." We are to assume that Bozzle's letter we next see Louis reading, which he is composing aloud, is now fueled by his resentment against Outhouse. A dissolve moves into flashbacks of Emily playing with the child while Bozzle's words are still heard as a voice-over in the same letter to Louis (who is still reading). These warn us of the coming abduction: "It's a heavy step to take a child from its mother, sir. Mrs. Bozzle has had a lot to say about that. The boy would have to be snatched, a very heavy step indeed." As Bozzle's voice fades, the scene cuts to Louis's return to England to set up the kidnapping event; he is seen roaming in a UK train station, amid anonymous crowds, and a driving demonic nondiegetic music takes over.[16] In the TV series an ego clash between two secondary males has contributed centrally to the abduction.

He Knew He Was Right is a midcareer book for Trollope (serialized 1867–1868), emerging from that phase of his art where he blends psychologically revealing letters (parts and wholes) and his imagined readers' reactions to them with his narrator's overt continuous monologue (another consciousness in the text). It is stuffed with letters (eighty-six by my count) as is Davies's artful adaptation. *The Way We Live Now* (serialized 1874–1875) is rightly considered a late book where, although in Trollope's novellas one can sometimes follow the trajectory of Trollope's novels by moving from one letter to the next, or one chapter of correspondence to the next, there are fewer letters proportionally in a given book.

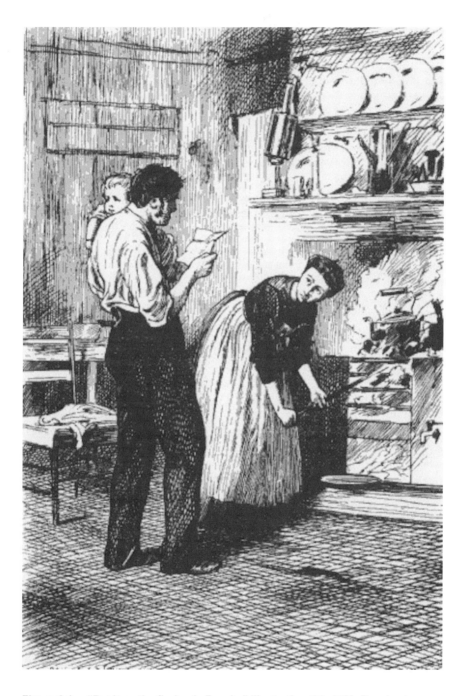

Figure 6.1. "Put it on the fireback, Bozzle." Illustration titled "Mr Bozzle at home," by Marcus Stone

REARRANGING THE BOOK TO DRAMATIZE INTERIORITY AND CAPITALIST BEHAVIOR

As a consequence, Davies's adaptation of *The Way We Live Now* has fewer specifically letter-writing and reading scenes. He still uses epistolarity techniques to achieve interiority and turns highly emotional dramatic scenes in Trollope's *TWWLN* into filmic letters where a voice-over extends over a montage; but, conversely too, Davies turns Trollope's later chapters of correspondence in the book into dramatic scenes of visceral aggressiveness (including one near rape) or poignant loss. [17] The emphasis is repeatedly on the use of montage and flashback extended outward from a character's subjective reverie sometimes authorized by letter writing or letter reading. Davies reworks Trollope's plot design to turn Trollope's primary story matter (the Carbury worlds, characters, and connections) into secondary matter whose turning points are contingent on Melmotte's story (who in Trollope's first plan was a secondary character and in the novel still dies about three-quarters of the way through the book). [18]

In his *TWWLN*, Davies adds scenes to dramatize the obstacles confronting men who want to act with integrity. New scenes include two in the western United States (during the present time of the novel, Montague never leaves England), where youthful hero, Paul Montague (Cillian Murphy), is confronted with the reality that the Melmotte company is cheating its stockholders: if he keeps silent, he will grow rich; if he tells, he loses his money. He needs money to marry the heroine, Hetta Carbury (Paloma Baeza). In the novel they marry by retreating to Carbury mansion with the book's ideal gentleman, Sir Roger Carbury (played in the series by Douglas Hodge), cousin to them both. In the series Davies makes Hetta into a proto-feminist who wants to work for her own living, wants to travel abroad, and finds the hypocrisies of high society distasteful. [19] Davies also dramatizes the social codes that pressure people into lying (e.g., as book reviewers) and prevent exposure of crooked stockbrokers, and cheaters at cards. Again Davies adds a scene where when Felix Carbury exposes the cardsharp Miles Grendall (Angus Wright), Grendall threatens to murder Felix through a duel; Felix is told by friends he is mortifying them and has become socially unacceptable because he was not "a sport." [20]

Like Trollope, Davies creates a continuum of male types. He follows his text and so uses Lady Carbury (in Trollope's scathing view, a marketplace "female literary charlatan") as salonière around whom these men congregate. Paul Montague represents a new kind of hero; with Hamilton K. Fiske (Michael Riley), who at the series' close is going to use the money they have wrongly managed to hold onto to build a railway in the southwestern United States. Both are entrepreneurial businessmen and engineers. Suchet as Melmotte is a composite figure intended to allude to contemporary ruthlessly

amoral campaigning politicians, CEOs, bankers, financiers, and corrupt stockbrokers with Ponzi schemes, all rolled into one. Where both Trollope and Davies significantly differ is in Davies's stronger creation of empathy for this man when deserted by everyone else, as someone who was trying to embody what others said they admired but did not himself have funds to support. Old-style gentlemen are represented by Sir Roger Carbury, who inherits and takes care of his estate, tenants, patronage, and rents; and Sir Felix Carbury (a contrasting figure) is content to do nothing, someone who spends his life at his club (playing cards) and marries for money. There are the newsmen and reviewers at Lady Carbury's parties, most notably Mr. Broun (David Bradley), who enacts the traditional role of protective male toward Lady Carbury and has nothing against inaccurately describing her books as good ("it's what everyone does"). In Mr. Broun's eyes and ours, Davies's Lady Carbury is a mother exploited by her son, vulnerable, and intensely sensually attractive. Mr. Broun's colleague, Mr. Alf (Rob Bryon), is the honest newsman who attempts to defeat Melmotte in an election (and fails) but, with evidence given him by Paul Montague, tells the truth about Melmotte's company and stocks in his newspaper.

Davies exposes the new norm of ruthless, competitive capitalism as destructive of individuals and society, whose denizens seek to discard and scapegoat all who are socially unacceptable: the poor, Jews, males exposed as physical cowards, women exposed as unchaste, and crooks like Melmotte whom they follow as Pied Pipers until their empires of lies collapse. But Davies is also concerned to highlight what he considers the hypocrisy of an elite gentleman ideal.[21] By the series's close when Suchet as Melmotte realizes he will be humiliated and scapegoated, he behaves as madly (he barks like a dog at one point) as Trollope's and Dimsdale's Louis. Melmotte has overreached; he has tried to extend the uses of the money given him in too many ways in his quest to become an English gentleman, MP, and pirate profiteer. A single chapter of omniscient narrative in Trollope that dramatizes Melmotte's proud reaction to humiliation (including a possible prison sentence) is replaced by a long penultimate sequence of voice-over, montage, and highly theatrical scenes filmed in a blurred style with a handheld camera.[22] These function to replace the revelation of a subjective self (say, through letters) that Melmotte would never commit but Davies feels is called for in order to project an almost tragic hero at the series' end. The whole sequence, though, projects Melmotte's distress as much as his courage and undermines the norm of masculinity that requires self-repression and control of emotions even when the person is alone; Melmotte's emotional pain together with his insistence on holding his head high creates admiration as well as sympathy for Melmotte.

The sequence is long and begins with the voice-over of Croll (Allan Corduner), Melmotte's clerk, just then determined to leave Melmotte be-

cause Melmotte has forged his signature.[23] The camera cuts to a mostly invented scene between Hetta Carbury and Mrs. Hurtle, Paul's ex-mistress (Miranda Otto), which is arranged to end on a sneer at Roger Carbury (who loves Hetta) as useless in the contemporary world: "But what use is that . . . no passion, no spirit . . . he might as well be stuffed in a museum . . . Paul wants you to take a chance. It might not work out, but at least you'll have an interesting ride." Davies sets up a contrast between Roger Carbury as this supposed conventionally moral and therefore boring male, and Melmotte as the romantic Byronic figure, as the camera switches to watch Suchet—in a magnificent wine-colored robe—drinking, bent over, and wandering around his house. He then goes once more to the House of Commons (the scene emphasized by Trollope), where a dreamlike montage of the men in Parliament is interspersed with London streets accompanied by loud train-tunnel sounds, quickly changing shots, and heard jeering voices that accompany him to the Tory bench. As in Trollope's novel, Melmotte falls, his hand stretched out to hold onto his high hat. He's retrieved himself into a standing posture and, with a sudden wide swing of his body, twirls his garments out with grotesque gestures reminiscent of Charles Laughton's memorable enactment of Quasimodo in RKO's 1939 *Hunchback of Notre Dame*.[24]

The aggressive, pounding nondiegetic music turns elegiac as Melmotte walks through dark, wet streets into his house, up the familiar stairs (we have seen so many characters flee up and down) to his study once more. The music then turns dissonant (staccato) as we see Melmotte in a series of facial close-ups: he takes a vial, drinks dark red wine, and smokes cigar after cigar

Figure 6.2. Melmotte stands defiant (*TWWLN*, episode 4).

(jump cut to jump cut). His last moments include contemplating and laughing wildly at the painting he had made of himself as a country gentleman with dog and gun, standing in front of the screen with country estate, curtain, and pillar. Suchet never speaks but relies wholly on gesture, expression, and nonverbal sounds. All turns quiet (the music fades) as we see a long, empty, grey-blue corridor gradually lightening with morning light. The sequence ends with the quiet voice-over of Marie as one of three people called to look down at the suicide: "What a life it has been. Now it's over."

The series is filled with original, creative, and subversive uses of interiority devices alternating with highly dramatic scenes, including close imitations of the original illustrations by Lionel Fawkes.[25] Much is wholly invented (there is no literal equivalent in Trollope), especially from episode 3 on. As those few who have written about the series have concentrated on its bizarre comedy, satire, burlesque, and grotesquerie, here we'll examine a seriously intended epistolarity sequence where Paul Montague enacts male behavior that Davies approves of. In the TV adaptation, Montague goes out to the western United States to try to start building a railway. Davies conveys this through dramatizing Hetta Carbury writing a letter while, with intense delight, she vicariously imagines herself with Paul, doing all he is doing. The montage is a soft focus or semiblurred series of dramatic scenes of Paul at work with a team of men, where her voice-over is at first louder than his. Paul's voice begins to dominate (and Hetta's presence falls away), as we hear his letter to Fiske, his American partner, whom Paul is still deluded enough to think will be turning up with funds from Melmotte: "The survey is finally underway. I've ordered equipment for blasting and tunneling and am preparing to enlist the work force . . . [spoken lower] payments have not yet come through, and I am paying the men out of my own pocket; this cannot continue." We watch Paul ride off into a sunny, dusty distance, as the voice-over becomes his words to Hetta (presumably in a letter in answer to hers): "This is a great country, this is great work we do, and history will thank us for it."

Then the screen seems to darken, and Melmotte's face emerges across the whole. A medium shot shows us we are in Melmotte's office in the city where a fretting Croll is informing Melmotte, "Another telegram from Mr. Montague." This is an ironic preface to a banquet scene that climaxes in a grandiloquent speech by Melmotte on how "profit" is a dominating motive in all we do and the "duty to make yourselves rich is the way to make the world a better place," a speech echoed a few scenes later in an election campaign where, seemingly prophetically (the series was made in 2001), Melmotte sounds like a CEO from just before the stock market meltdown of 2008. Unlike Trollope (who usually speaks of making money as the engine of progress), Davies is mounting a strong critique of uncontrolled capitalism through characters we recognize as male types from our own times, and he is

dramatizing the idea that producing things, socially useful products, is a real basis for a better world.[26]

WHAT THE COMPARATIVE APPROACH REVEALS

There is a strong tendency in recent adaptation studies to suggest the approach that compares the eponymous source texts and their authors with the adaptations, and their filmmakers' arts will somehow ignore or marginalize the film's art or equal primacy and risk not crediting the filmmakers with the creativity they display. But Davies is a scriptwriter and film creator who engages with his chosen authors or books, studies the books with care, and takes risks to bring out what the older text has in common with our world so it can speak to us as a contemporary story. He is also ever mindful to "tread carefully" on the expectations of the broad audience for adaptations that a given film or TV series will centrally convey, even if it reinterprets the original text.[27] Sarah Kozloff argues the prejudice against using letters, voice-over, and narrators (especially female ones) stems partly from masculinist prejudices against too much intellectuality, subjectivity, talkativeness, and nonaction sequences.[28] If so, Davies's bold willingness to defy the conventional hostility is of a piece with his openness toward males who do not conform to normative ideals, his openness toward unconventional sexuality, and the wide humane liberality of his political and social vision.

NOTES

1. See my essay, "Trollope's Comfort Romances for Men: Heterosexual Male Heroism in His Work," Victorian Web, 11 June 2010, accessed 28 September 2013, http://www. victorianweb.org/.

2. Ellen Moody, "Partly Told in Letters: Trollope's Story-telling Art," *Trollopiana* (February 2000): 4–31; Sue Birtwistle and Susie Conklin, *The Making of Pride and Prejudice* (London: Penguin, 1995), 7–11.

3. Tony Tanner, *"The Way We Live Now*: Its Modern Significance," *Critical Quarterly* 9 (1967): 256–71; Lisa Surridge, "The Private Eye and the Public Gaze": *He Knew He Was Right*," in *Bleak Houses: Marital Violence in Victorian Fiction* (Athens: Ohio University Press, 2005), 165–86.

4. Robert C. Allen, "A Reader-Oriented Poetics of Soap Opera," in *Imitations of Life: A Reader on Film and Television Melodrama*, ed. Marcia Landy (Detroit: Wayne State University Press, 1991), 507–12.

5. See Sarah Cardwell, *Andrew Davies* (Manchester, UK: Manchester University Press, 2005), 54–55, 123–25, 130–36, 140; Sarah Cardwell, *Adaptation Revisited: Television and the Classic Novel* (Manchester, UK: Manchester University Press, 2002), 160–83; Nic Ransome, "A Very Polished Practice: An Interview with Andrew Davies," in *European English Messenger* 10, no. 1 (2001): 38–39; John Caughie, *Television Drama: Realism, Modernism, and British Culture* (Oxford: Oxford University Press, 2000), 94–102.

6. Cf. Anthony Trollope, *He Knew He Was Right*, ed. John Sutherland (Oxford: Oxford University Press, 1985), 418–26, 566; and Davies's *He Knew He Was Right*, episode 2. (*He Knew He Was Right* is cited as *HKHWR* for the rest of this chapter.)

7. Cf. Anthony Trollope, *The Way We Live Now*, ed. Robert Tracy (Indianapolis: Bobbs-Merrill, 1974), 135–50, 235, 269–73; and Davies's *The Way We Live Now*, episode 2. (*The Way We Live Now* is cited as *TWWLN* for the rest of this chapter.) Robert C. Allen, *Speaking of Soap Operas* (Chapel Hill: University of North Carolina Press, 1985), 142–73.

8. See Thomas McFarland's *Tragic Meanings in Shakespeare* (New York: Random House, 1968), 60–191. *HKHWR* refers to the play; an episode occurs in Venice. Davies appropriated the play too in his *Othello* (CBC, London Weekend TV/WGBH, 2001), with Eamon Walker (as a black police officer), Christopher Eccleston (jealous underling), and Keely Hawes (an enigmatic sexy white wife).

9. Trollope meant to create sympathy for Louis: See Anthony Trollope, *An Autobiography*, ed. Michael Sadleir and Frederick Page, introduction by P. D. Edwards (Oxford: Oxford University Press, 1980), 321–22; Ellen Moody, *Trollope on the 'Net* (London: Hambledon Press, 1999), 47–80.

10. Cf. Trollope, *HKHWR*, 18, 27, 41, 72, 76, 96, 733; Davies, *HKHWR*, episode 1.

11. Davies, *HKHWR*, episode 1.

12. Davies, *HKHWR*, episode 1, is a dramatic transposition of Trollope, *HKHWR*, 86–92.

13. Cf. Trollope, *HKHWR*, 512–13, 679–70, 772–73; and Davies, *HKHWR*, episode 4.

14. Cf. Trollope, *HKHWR*, 576–77, 629–39; and Davies, *HKHWR*, episode 3.

15. Marcus Stone's illustration, "Mr Bozzle at home," offers a visualization and emphasis on Mrs. Bozzle and their domestic environment not found in the text; Davies has picked up on this. See Ellen Moody, "On the Original Illustrations of Trollope's Fiction, *He Knew He Was Right*," 20 February 2004, accessed 28 September 2013, http://www.jimandellen.org/.

16. See Davies, *HKHWR*, episode 2. Cf. Trollope, *HKHWR*, 492–93, 495, 565–66.

17. Cf. Trollope's *TWWLN*, 684–85; and Davies's *TWWLN*, episode 4 (a letter dramatized). And cf. Trollope's *TWWLN*, 634–44; and Davies, *TWWLN*, episode 4, the "Breghert correspondence," as acted-out scenes (Jim Carter as the noble Jewish businessman and Anne-Marie Duff as Georgiana Longestaffe, a squire's daughter, who is callow, is bigoted, and although despising the man is left bereft when he departs).

18. Trollope, *TWWLN*, xxxiii–xxxv. Melmotte dies on p. 678. Davies discusses how he reverses emphases and rearranges plot designs in the feature to his *Little Dorrit* (BBC/WGBH, 2008): "I am taking all the bits in the novel which are all there but rearranging the order and completely restructuring the book."

19. Trollope, *TWWLN*, 803–10; Davies, *TWWLN*, episode 3 (Paul to Mr. Fiske [Michael Riley]: "He's a damned scoundrel and so are you . . . this whole enterprise a gigantic fraud . . . well I won't go along with it"); episode 2 (Hetta: "Are you suggesting he's [Sir Roger] agreed to buy me in installments? I shall marry for love if I marry at all; I would rather work the telegraph at a city office, or be a nurse at a women's hospital or be a writer like you, mama, than marry simply for security"); episode 3 (Hetta: "I don't want a society life").

20. See Davies, *TWWLN*, episode 4. The source for this scene may be a closely analogous one in Tolstoy's *War and Peace* (for which Davies is now working on a six-hour script), where a hero uncovers flagrant theft and is told his exposure of the man threatens any promotion and himself. In the original plan, Felix was to have died after having been beat up by Ruby's fiancé, John Crumb (Nicholas McGaughey); in the extant novel, it is hinted Felix was shipped to Europe to become a remittance man, dramatized by Davies as a final flippant dumb show in episode 4.

21. Robin Gilmour, *The Ideal of the Gentleman in the Victorian Novel* (London: Allen & Unwin, 1981); Simon Raven, *The Decline of the Gentleman* (New York: Simon & Schuster, 1962).

22. Cf. Trollope, *TWWLN*, 670–78; and Davies, *TWWLN*, episode 4.

23. Davies, *TWWLN*, episode 4.

24. Figure 6.2, Suchet's last stand in public, is also reminiscent of Lionel Fawkes's illustration, labeled "Mr. Melmotte speculates." See Ellen Moody, "On the Original Illustrations."

25. Davies also imitates and elaborates from the original illustrations to *HKHWR* by Marcus Stone; see Moody, *Trollope on the 'Net*, 146, 246; and figures 6.1 and 6.2.

26. Davies, *TWWLN*, episode 3. There is no equivalent insulting of Roger Carbury and no equivalent speeches by Melmotte at banquet or election as Trollope's Melmotte is not sufficiently well educated to hold forth.

27. This paraphrase of how Davies characterized his approach to film adaptation in general is from one of the features to the DVD of Jane Austen's *Sense and Sensibility* (2008).

28. Sarah Kozloff, *Overhearing Film Dialogue* (Los Angeles: University of California Press, 2000), 11; Cardwell, *Andrew Davies*, 34–59.

Chapter Seven

"What Are We Going to Do with Uncle Arthur?"

Music in the British Serialized Period Drama

Karen Beth Strovas and Scott M. Strovas

Music in the 1970s' teledrama *Upstairs, Downstairs* plays an understated but meaningful role. Unless actually performed on-screen, music is mostly sparse within each episode, and the few scenes that use music usually quote directly from the title themes of the opening and closing credits. Yet, beginning with the program's pilot episode, the title music works beyond its surface-level function of providing incidental music. During the opening credits, a series of images portrays a culture in which authority and identity rest with the aristocratic class. The first of three illustrations depicts an upper-class woman in conversation with a subservient figure. Sitting with her arms resting to one side, she exhibits seemingly casual authority over her opposite, who stands before her, back to the viewer, and hands clutched submissively behind her back. As this illustration foreshadows one of the episode's forthcoming scenes, what transpires between the two figures is hardly casual. Lady Marjorie, a politician's wife whose personal fortune operates the house at 165 Eaton Place, *renames* her new employee "Sarah," for "Clemence is not a servant's name." The rhetoric of the credits' illustration thus becomes clear as the episode unfolds: the unseen face of the standing figure has no personal identity. Her identity as a servant is bestowed on her by Lady Marjorie, as is her tenuous position within the house. Complemented by the episode's title, "On Trial," the illustration provides a succinct but powerful portrayal of Edwardian aristocratic power. Lady Marjorie is at once employer, owner, judge, and potential executioner of Sarah, a superiority supported by the music of the opening credits.

95

The title theme of *Upstairs, Downstairs* is comprised of two contrasting sections. The first of these is of a stately character reminiscent of Elgar's familiar "Pomp and Circumstance" March no. 1 in D Major, a work performed for an elite mix of early Edwardian-era aristocrats at London's Promenade Concerts shortly after its composition in 1901. Imitative of Elgar's famous trio theme, the first section of the teledrama's title music is thus representative of the "pomp" and pretense of Britain's society class. It is this Elgar-esque music that accompanies the illustration that opens episode 1:1.

The second section of the title music presents a strong musical and social contrast to the "upstairs" qualities of the first. It is livelier, more songlike and playful, rhythmically bouncier, and thus far less inflated. The long-winded strings and brass melody is replaced by a quipping flute. The stream of inner orchestral voices playing steady on-the-beat accompaniment gives way to a sort of irreverent commentary on the new melody. This is cabaret music of a whimsical character seemingly intended to reflect more lowbrow tastes—the strongest indication of this being Sarah's raucous vaudeville performance in episode 1:13, "For Love of Love," in which she sings bawdy lyrics to this melody while dancing in a comically sensual manner. Meanwhile, the opening illustrations have progressed to depicting a "downstairs" conversation. Before any live action has taken place, the producers have established the upstairs-downstairs polarization that is the series' central dramatic preoccupation, a binary conflict not only *seen* in the illustrations that open the first episode but also *heard* in the contrasting artistic temperaments of the opening credits music.

The capacity of music to reflect, interpret, and intensify the narratives of moving pictures has long been exploited by filmmakers. But today, scholars of the music of media can no longer focus on film as the only worthwhile media while relegating discussion of television to the children's table. While most of the scholarship available on television music pertains to music TV (such as MTV and VH1) and music in TV advertising, the study of the music of television shows is gaining steady ground and credibility as a worthwhile topic set apart from film music, or at least standing prominently beside it. John T. Caldwell made the case in 2005 that television was already outperforming film in terms of production quality. He argues, "Film now functions mostly as a subset of television and electronic media, popular assumptions to the contrary, rather than vice-versa."[1] More recently, Erica Jean Bochanty-Aguero's research on the use of popular music on TV tells us that "from a television industry perspective, not only have TV music budgets increased in the last 5–7 years (whereas film music budgets have decreased), but also producers are increasingly considering music as a character on a show, conceptualizing a program's 'sound' early on in the production process."[2] Bochanty-Aguero's ideas are relevant for nonpopular music employed by television shows—particularly period dramas—as well. In a recent doomsday-

like editorial for *The Musical Quarterly*, Leon Botstein mourned the demise of classical music in large, unfillable concert halls, wishing for some type of popular media to excite the public about concert music the way Steven Spielberg was able to revive the public's interest in President Lincoln: "Imagine an HBO or BBC series of the *Sopranos* or *Downton Abbey* sort where musical culture is at the center!" he exclaims, not realizing that—while music is not at the center of the narrative of *Downton Abbey* and period dramas of the same family—music is certainly at the center of the social conflicts of the dramas.[3]

In this chapter, we discuss the function of music within three serialized period dramas: *Upstairs, Downstairs* (1971–1975), *The Forsyte Saga* (2002–2003), and *Downton Abbey* (2010–). Each series presents music of vastly different stylistic character, differences that appeal to the varying settings and rhetorical content of the programs. Despite these differences, music remains a powerful device, and not just for establishing the period settings of the dramas. Of the three, only *The Forsyte Saga* consistently features music that would have been heard and performed within its London setting; *Upstairs, Downstairs* uses music of an early 1900s British character, albeit newly composed, and *Downton Abbey* features a contemporary orchestral soundtrack. We demonstrate the ways in which all three programs nonetheless exploit music as a tool to define and intensify the conflicts of class and gender central to their narratives. If music is indeed "open to infinite association,"[4] then it is worth investigating its role as a rhetorical element of television period dramas in emphasizing the conflicts of the turn-of-the-century class and gender politics depicted and explored in the programs.

UPSTAIRS AND DOWNSTAIRS

Written by British composer Alexander Faris, the title music of *Upstairs, Downstairs* has a history of its own, if overshadowed by the dramatic events that unfold at 165 Eaton Place. Seeking music that would characterize the Edwardian setting of the teledrama, producer John Hawkesworth asked Faris to resubmit his initial attempt, requesting that it "be a little bit more like Elgar."[5] The full title theme includes a refashioning of the stately march into a three-step waltz and a fuller development of the cabaret melody. But Faris's music is never heard in its entirety; rather, snippets of the waltz, march, and cabaret music variously accompany the opening and closing credits in the first several episodes. By the end of the first series, a pattern solidifies in which the march and dance-hall music complement respectively the opening and closing credits.

The ultimate segregation of the two themes to the beginning and closing credits might be read as a reinforcement of their solely musical function as

incidental music, a development that coincides with what Edith P. Thornton has identified as the program's steady gravitation toward more traditional "high art" depictions of the upstairs-downstairs binary. Thornton identifies Faris's "British music hall song" as pivotal to Jean Marsh and Eileen Atkins's conceptual genesis of depicting, and thus empathizing with, the life experiences of the "downstairs" ensemble, and of working-class women in particular.[6] While Thornton stops short of associating the "upstairs" ensemble with the more stately music, she implies that Sarah's vaudeville performance of "What Are We Going to Do with Uncle Arthur?"—a crass tune about a grabby elderly fellow written by script editor Alfred Shaughnessy to Faris's cabaret melody—indeed promotes a "downstairs" narrative early in the series in which the sometimes bawdy, "low art" elements of mass culture challenge traditional power structures within the politics of class, gender, and sexuality. Yet, as with the linear separation of Faris's march and cabaret music—an everyone-back-to-your-corners relegation of the "downstairs" music to the last and least interesting portion of the program—the teledrama gradually moves away from its early subversive elements toward what Thornton argues are the more traditional aesthetic hierarchies, "solidified by James's ascent to protagonist status," of a masculine-dominated literary tradition and single, tragic aristocratic figure.[7]

Early in the first series, when the program's effort to blur social boundaries between the upper and lower classes is more resolute, the title music does indeed seep beyond its function as incidental music literally and figuratively, often lingering briefly into the on-screen action. If one figure is intended to embody the discontented spirit of the servant class, it is Sarah, the Bellamy household's new under-house parlormaid. In the opening scene of episode 1, Sarah calls at the front door of 165 Eaton Place, only to be pointed by Hudson, the butler, to the side, downstairs entrance. All the while, the cabaret section of the title music develops beneath the dialogue-less action. Sarah's impunities in episode 3, "Board Wages," include dressing in Lady Marjorie's clothes and assuming her persona. She also begins a romantic involvement with James Bellamy that leads ultimately to her pregnancy in series 2. Her feelings for James being incompatible with her position in the house, Sarah chooses to leave on her own terms (episode 1:3). Adamant to depart through the same front door that Hudson had formerly barred her from entering, she leaves as an equal, accompanied by Faris's pomp-and-circumstance march.

Despite this first and most dignified of Sarah's many exits from the Bellamy house (later departures include her impregnation by James and her extortion of Richard and Lady Marjorie), it is her less reserved nature and Faris's vaudeville music that audiences most likely identify with Sarah. But while the cabaret music closely follows her actions in episodes 1:1 and 1:3, and she twice sings the lewd "Uncle Arthur" lyrics, one must stop short of casting this music as solely Sarah's theme. Illiterate and orphaned, Sarah is easily

read as a sort of everywoman, a representative of the forgotten masses of which only a few find themselves fortunate enough to find work, shelter, and board as servants in the households of the aristocracy. Unimpressed by Sarah's ostentatious arrival in the Bellamy home at the start of series 1, Rose, Hudson, and Mrs. Bridges force her to admit to being, in Mrs. Bridges's words, "a common, ignorant, worthless girl," an "ordinary person," echoes Hudson, "like the rest of us." Sarah is thus representative of the entire downstairs ensemble. If we do not immediately associate the dance-hall music with the servant characters, then their association with the theme becomes clearer in "The Wages of Sin" (episode 2:12). Unaware of Sarah and Thomas's extortion of the Bellamys, the downstairs ensemble celebrates their departure and future marriage. A rousing chorus of "Uncle Arthur" begins, which even Hudson, the stalwart "downstairs patriarch," joins in singing.[8]

OLD AND NEW WORLDS

Compared to the high-tech productions of contemporary television, *Upstairs, Downstairs* exhibits a scarcity of music beyond its on-screen performances and title music. Yet, its music has the capacity to characterize, and thus reinforce, the upstairs-downstairs binary upon which the production is predicated. The title music to *Downton Abbey* is comparable to its predecessor in that it likewise features music of a dualistic quality, albeit scaffolded rather than linear. Inner strings repeat a fast two-note pattern, creating a rhythmically driving foundation for a call-and-response that takes place between the upper strings and the combined forces of piano and lower strings. Supported by the bass instruments, the piano enters first, expressing a relatively static melody that progresses across only four different pitches. The upper strings then answer the piano with a lush, expansive melody that first rises, then falls. Despite the consistent pulsations of the inner strings, a manipulation in time occurs. At first, the beat is felt on every two notes of the pulsating strings. But upon the entrance of the piano, the melodic line progresses every three notes of the inner pulsations. The result is a perceived expansion and compression—a speeding and slowing—of time between each beat.

As with *Upstairs, Downstairs*, such musical dichotomy can certainly characterize the collision of aristocratic and servant classes portrayed in *Downton Abbey*. In episode 1:1, the chugging inner strings accompany the bustle of downstairs activity that begins an average day at a large Edwardian-era country estate. Upon Lord Grantham's first entrance, in which he calmly makes his way down Downton's elegant main staircase, the pulsating drive pauses, leaving only serene upper strings, which represents the solemn dignity of his social stature. Moreover, the scaffolded architecture of the theme reflects the physically and culturally hierarchized, yet intertwined, lives of

Downton's inhabitants. Yet, composer John Lunn suggests that he intended his music for *Downton Abbey* to express complexities far beyond the series' binary of upper class and lower class. He recalls that he conceptualized the program's title theme as a three-part musical representation of the pilot episode's opening visual images: "One was the power of the train, so there's a kind of speed and momentum [to the music]. And then there's [John Bates] looking wistfully out of the window, so there's a kind of selective plaintive tune which is played on solo piano. And then it becomes . . . gradually . . . grander and grander, and eventually you arrive on this chord . . . when you see the house."[9]

Lunn speaks of a direct interpretation of on-screen images, emphasizing, as do the show's producers, the role of the house as a character in the narrative. Lunn's explanation, while revealing of his creative process, nonetheless leaves one unsatisfied as to the interpretive implications of the layered, pulsating musical colors that continue to "mak[e] us drool" well into the subsequent series and seem to provide a much richer interpretive resource for considering the program's period constructs.[10]

The contrasting elements of the *Downton Abbey* title theme, we contend, encapsulate more than merely the fleeting opening visuals of its pilot episode. Series 1 centers on an aristocratic world in conflict with electrical and industrial technologies and the consequential change in social order it fears they will bring about. The first screen shot of episode 1:1 is not of the (in)famous "hound's bum" that faithful viewers have come to recognize but of a telegraph machine, the technology that in the latter 1800s would have opened Downton's country setting to a broader world and begun the process of chipping away at its aura of supreme authority.[11] A montage of technological developments follows: a telegraph machine, the steam-powered train, and electric wires. Reactions to the invasion of technology pervade series 1, from the Dowager Countess's hyperbolized response to electrical lighting to Carson's childlike waltz with the telephone. While depictions of old-world figures such as Carson and the Dowager Countess toiling with the hassles of a modern age speckle flecks of humor into the otherwise dramatic palette of *Downton Abbey*, the very premise of series 1 is rooted in the disastrous consequences of failed or abused technology.

Series 1 is bookended by the sinking of the *Titanic*, heralded as an indestructible modern marvel, and the beginning of the First World War, during which the technology of killing would be responsible for more deaths than any war to date. The resulting loss of Downton's immediate heirs aboard the *Titanic*, and the potential loss of its new heir Matthew in the war, inform audiences that the dramatized world of the early 1900s British gentry is at best on shaky ground; at worst, facing the end of a centuries-old way of life. We are thus reminded both of Lunn's chugging musical undercurrent, which reflects the interminable momentum of the train, and of the music's vacillat-

ing sense of time. The title score's pairing of a churning, forward-pushing minimalist accompaniment with a plodding, deliberate melody characterizes the conflict between technological progress and the reluctant complacency of tradition. Within this subtext, Lunn's contemporary score is an effective tool for intensifying the clash between old and new worlds that is the first season's raison d'être.

SOURCE MUSIC AND UNDERSCORE

Heretofore in this chapter, our reading of music in the British period teledrama has centered on title themes—themes that, in their binary constructs, reflect the narrative conflicts depicted in two early twentieth-century British settings. The remainder of this chapter focuses on the relationship between music and on-screen action. Generally, this music is characterized as *source music*, music that is performed on-screen or otherwise sounded from an on-screen source such as a radio, and *underscore*, often newly composed music that complements the on-screen action or emotional content of a scene but that the characters would not hear. [12] Source music intensifies the clash of high art and low art in *Upstairs, Downstairs*. For example, celebrating Sarah and Thomas's supposed windfall and thus immersed in their chorus of "Uncle Arthur," the servants only gradually notice the rare entrance of Sir Richard and Lady Bellamy into the downstairs quarters. Sarah feels compelled to continue her song in a classical, faux-learned style, slowly and with vibrato before allowing the pretense to fade away and returning to her usual cabaret-style tempo, rhythm, and cockney accent. Both *Downton Abbey* and *Upstairs, Downstairs* use source music to great effect in the context of the First World War; the reserved personas of Lady Mary and Hudson are challenged when they are both asked to sing, Mary for the wounded soldiers during Downton's use as a convalescent home (episode 2:3), and Hudson upon the announcement of war (episode 3:13). The more contemporary *Forsyte Saga* and *Downton Abbey* prominently feature musical underscore. And while these productions regularly engage underscore to heighten the emotional intensity of individual scenes, it is rather the programs' transitions between source music and underscore that we examine in the remainder of this chapter. Points of transition between source music and underscore are particularly ripe with meaning. Exploring these moments in *Downton Abbey* and *The Forsyte Saga* reveals much about the conflicts of propriety and gender politics within the programs' settings.

One way in which the historical past asserts itself in period drama is in the way it revives a sense of the past through manners and behaviors that contrast those prevalent in the viewer's current time and place. It is not the actual past one views on-screen but instead the symbols and details that

trigger a sense of realism related to a time and place. Despite occasional inaccuracies or inevitable contradictory representations of the fast-changing period (for example, "buttoned-up," prudish manners mixed with an industrial age in flux),[13] the *Downton Abbey* set, costumes, and other iconography provide historical "obviousness" relating to the 1910s and 1920s.[14] Still, the characters' demeanor and notably modest, stereotypically reserved, and "highly gendered separate sexual cultures" and social spheres play an arguably more influential role in shaping narrative than do elements of set and dress.[15] Characters in all three period dramas in our discussion rely on an overt presentation of upstairs social understatement and modesty, with any so-called wrinkle in these characterizations functioning as a "disruptive force."[16]

Naturally, the directors and producers imbed some of the most interesting and dramatic moments of period dramas within the wrinkles. For example, in episode 2:8 of *Downton Abbey*, Matthew and Mary momentarily abandon the pretenses of British upper-crust society in which maintaining one's social and financial stature trump acting on individual emotional desires. Amid the house's bustle of dealing with the sick, and with Matthew's fiancée, Lavinia, supposedly laid up in a guest room, Matthew and Mary find themselves alone dancing to a gramophone record of a tune from a recent musical theater production, "a show that flopped," as Matthew puts it. Both still engaged to their respective intendeds, Matthew and Mary acknowledge their love for one another openly and outside the rules of Britain's courting rituals. It is at this moment of catharsis between Matthew and Mary, and thus within the metanarrative of *Downton Abbey*, that the producers employ the resources of both underscore and source music to keen effect. In a move reminiscent of Alfred Hitchcock's *Man Who Knew Too Much* (1956), in which Hitchcock weaves an entire movie around the cymbal crash in an orchestral performance, the producers of *Downton Abbey* layer Matthew and Mary's reconciliation sequence over the timing of the record, beginning with a close shot of the gramophone player's needle set onto the wax disc. The two dance while blithely remarking on the events of the recent past. But with her comment, "We were a show that flopped," Mary guides the discussion to the taboo topic of their romantic past. At this moment, the on-screen gramophone music fades out and is replaced by intense, yearning underscore. The camera zooms in to the couple, and visually, aurally, and emotionally the audience is transported away from the sights, sounds, and troubles of the Crawley family and immediately into the psychological and emotional world of Mary and Matthew (see figure 7.1). With their engagements now only an afterthought, and with the cultural pretenses against Matthew's middle-class upbringing assuaged by time and by war, the couple at last kisses. The camera circles Mary and Matthew, continuing the dance though the pair is lost in motionless embrace, and the underscore climaxes. "Hello," calls Lavinia, who has for a

brief moment left her sickbed. And with her interruption, the producers instantly dissolve the audiovisual emotional energy that heretofore has been only rising. The camera pans out, Matthew and Mary separate, reclaiming their dispassionate fronts in an instant, and the lush musical underscore vanishes, leaving only the final scratchings of the gramophone record.

It is routine for underscore to be employed to intensify the emotional content of the on-screen action. Thus, what makes the use of underscore in this scene critical and unique to *Downton Abbey* as a period drama is its ability to reinforce the uncharacteristic nature of the on-screen kiss within a culture in which propriety is valued above personal emotions. What the producers of *Downton Abbey* do well is transition from on-screen source music to underscore, which we argue constitutes an intentional and temporary displacement of the social posturing and pretense that the series portrays. The gramophone recording represents the outward world of social airs that its inhabitants occupy on a daily basis in constant suppression of their inner desires. At precisely the moment that Mary lets down her guard, the recording is overcome by underscore. This decision by the producers is more than enough to imply an intentional movement away from the period source music, which reinforces the program's historical setting, to music that is more suggestive of the emotional and psychological content of the narrative. The underscore thus removes the audience from the reality of early 1920s Britain just as Matthew and Mary are for a moment removed from the real-

Figure 7.1. "We were a show that flopped." The source music transitions to underscore as the camera zooms in on Matthew and Mary (*Downton Abbey*, episode 2:8).

ities of their individual circumstances. With the subtle transition to under-score, the audience joins the pair on their emotional journey and shares their all-too-brief moment of emotional satisfaction. Compared to the lush strings of the underscore, the dry, scratchy record to which the scene returns upon Lavinia's entrance leaves the audience as suspended and equally unsettled as does Matthew and Mary's relationship. Their dance, swirling into underscore out of source music, is emotionally compelling; however, it is only one moment. In contrast, *The Forsyte Saga* employs this method of almost im-perceptibly weaving in and out of source music and underscore throughout the series.

Britain's ITV adaptation of John Galsworthy's *Forsyte Saga* differs from the other two teledramas because of its much more thorough and overt use of music from its time and place. *Upstairs, Downstairs'* 165 Eaton Place is not a particularly musical household, and while *Downton Abbey* does offer scenes of amateur piano performance both upstairs and downstairs, its coun-try setting is not innately tied to the types of urban cultural resources consis-tently portrayed in *The Forsyte Saga*.[17] Set in late-Victorian London and holiday destinations such as Bournemouth and Paris, *The Forsyte Saga* is able to capitalize on depictions of public and private musical performance both to reinforce the program's period setting and to progress the narrative forward. The mix of Beethoven violin sonatas and Chopin piano works per-formed in episode 1:1 is faithful not only to the program's nineteenth-century setting but also to its parent novel, in which key moments of the narrative occur within musical settings: for instance, Irene Heron and Philip Bossi-ney's defiant dance, and Irene's friendship with Old Jolyon in which she performs privately for him and teaches piano to Holly, his granddaughter. Geoffrey Burgon's newly composed underscore to the adaptation, with its limited instrumentation for strings and occasional wind soloist, nicely com-plements the chamber musical settings depicted on-screen. However, while Burgon's underscore is pervasive throughout the series, it is nonetheless the production's use of Chopin, Beethoven, Gluck, and other "classical" com-posers' works as both source music and underscore that transition the audi-ence between the musical sights and sounds of late-Victorian society and the internal and external conflicts of its characters.

Scenes of music in *The Forsyte Saga* are also scenes of narrative and character development, particularly with regard to romantic relationships. The production uses concert halls, social dances, and private piano perfor-mances to invoke the male gaze upon females and to thrust different person-alities and motivations into tight spheres, all the while exploiting the on-screen performed music, or source music, as aural accompaniment to the emotional complexity of the scenes. A concert of Beethoven chamber music in Bournemouth provides the context for Soames Forsyte first to lay eyes on Irene and gaze at her from across the concert hall (episode 1:1).[18] From their

initial sounds, the on-stage violin and piano function beyond strictly source music, as they first sound as underscore during the final moments of the previous scene, set in Old Jolyon's London manor nine years prior. The change in scene introduces Soames as a central figure, and the driving on-stage music complements the beginning of what will become his relentless pursuit of Irene. With Soames's decision to introduce himself to Irene during intermission, the music decidedly cadences. The introduction of Beethoven's "Kreutzer" violin sonata interrupts their conversation, at which point Soames retakes his box seat across the concert hall from Irene. The oscillating camera shots that follow center not on the performers but on the back-and-forth glances between Irene and Soames. Their courtship enters its first stage of curiosity in an unspoken, toying manner that mimics the dialogue-less, back-and-forth musical conversation between the violinist and pianist. The source music thus takes on the function of underscore in characterizing the exchange between Soames and Irene, a function the producers solidify by altering Beethoven's original score as the allegro music begins. The camera pans in for a final time on Soames, his churning desire for Irene reflected in the repeated melody of Beethoven's music. But Beethoven's original music does not repeat. It is rather a production decision to repeat the vibrant violin phrase again and again, unlike the original score, to construct an intensity that matches Soames's pursuit of Irene.

The simple fact of there being musicians and music lovers among the characters, most notably Irene, enhances and elaborates the possibility of such transitions between source music and underscore in *The Forsyte Saga*. Her abilities as a pianist and interest in the aesthetics of art are feminine traits within the gendered expectations of the nineteenth-century Britain society classes. But her deep affinity toward music leads her ultimately to reject the very cultural conventions that not only prevented her from losing her social position but also improved her rank. Upon recently losing her father, and with her inheritance dwindling, Irene hesitantly allows Soames to court her at the insistence of her stepmother. Having learned to play piano well enough to master the nocturnes of Chopin, Irene personifies the stereotype of the female pianist of the "cultivated middle class,"[19] for whom, having to work neither outside of the home nor within it, music served as a worthwhile pursuit without which "the hours cannot pass otherwise than heavily," writes one nineteenth-century essayist.[20] When Irene performs privately for Soames, a businessman dispassionate about art except as a trophy, the un-spoken material pretense of the performance is clear: Irene is to be portrayed as accomplished and thus suitable as a potential wife for Soames despite her lower rank. For his part, Soames plays his role in the ritual, listening intently and hitting all the right notes in his response: "I congratulate you, Miss Heron. . . . That really was accomplished and delightful" (episode 1:1). Despite her fear that Soames is purchasing her as he would a well-crafted

artwork, Irene reluctantly accepts his marriage proposal. It becomes clear that her musical abilities relate more closely to her ideals of love and art than to her newly acquired social status and expectations as a wife. She actively prevents becoming pregnant by Soames, has an affair with the Bohemian architect Bossiney, and sabotages the relationship into dysfunction.

The Forsyte Saga intensifies the conflict between Soames and Irene and other conflicts of gender politics at points of transition from one mode of music to another. Irene's accomplished talent on the piano allows her to stand out as a respectable, if not respected, partner for Soames; additionally, Irene's musical abilities allow the production crew to use her playing as a vehicle through which to transition from source music to underscore. At one point in episode 1:1, Soames approaches his London house on foot, and the underscore accompanying the action on screen is Chopin's Nocturne in E-flat Major, op. 9, no. 2. As he enters his house, the underscore becomes source music, for we see Irene playing the piece that we have been hearing. Soames fingers her hair and neck, visibly distracting but only momentarily pausing Irene's playing. The nocturne continues throughout the scene, transitioning back to underscore as Soames takes Irene to their bedroom. During the sex scene, we hear the piece rising in emotion toward its musical climax; only, Soames's sexual climax does not coincide with the tingling trill of Chopin's nocturne. Instead, his finish arrives before Chopin's and, symbolically, before Irene's, as she is never satisfied sexually by her husband. She exits the bed even before the last notes sound. In addition to purposely awkward timing, visually, Soames's bouncy, arguably rough treatment of Irene in bed is also out of character with Chopin's delicate blending of chords and enchanting melody. Putting all the elements together, viewers are led to interpret the Forsytes' sexual act as uncoordinated at best, and disturbing at worst. The transition from source music to underscore produces a *negative* musical accent in the bedroom scene, rather than complementing the on-screen action. The producers create a similar negative accent during episode 1:3, wherein Soames rapes Irene. Rather than enhancing the moral complexity of the situation with a more sinister-sounding tune, a delicate music played by upper strings and woodwinds obfuscates his movements. The music stops the moment Irene wakes up and tries to defend herself. The audience is thus forced to watch a brutal sexual encounter without any music to intervene between the rape and the viewers' understanding of it.

Neither can music complement the violent action that is Mr. Green's rape of Anna Bates in season 4 of *Downton Abbey*. Similar to that of *The Forsyte Saga*, *Downton*'s music (and notable musical absences) transcends its role as supplementary to a scene's action and emotional content. In episode 2, an intimate house recital becomes the pretext by which the producers isolate Anna in an otherwise busy, crowded downstairs.[21] Traveling opera singer Dame Nellie Melba is invited to Downton to perform for the Crawley family,

and the servants are allowed to partake in the upstairs entertainment. Anna declines to stay for the entire performance due to a headache. While Dame Nellie sings "O Mio Babbino Caro," an aria from Giacomo Puccini's opera *Gianni Schicci*, Anna finds herself cornered and then attacked by Lord Gillingham's valet. Opera, in this scene, brings about prime narratological conditions for the rape—a loud and distracting source of entertainment for the entire household that leaves Anna alone and vulnerable to the ill intentions of Mr. Green. Upstairs, the Crawley family and servants, who had heretofore been antagonistic toward operatic singing, sit captivated and in serene quietude during the performance. Downstairs, however, Anna's desperate, unaccompanied cries resemble and displace the shrieking that the family had formerly been so wary of with regard to Melba's performance. Anna's rape is not the only scene that occurs during this performance. A card game among male houseguests takes place in a drawing room not too far from the recital. The singing, while muted, seeps into the room; in contrast, not a single note of opera can be heard downstairs. By highlighting the contrast of what can be heard in rooms away from the performance, the producers of the show make a pointed statement about music and its relationship to women and violence. Essentially, by isolating Anna from the housemates *and* music, the show argues that there is *no music* that could adequately parallel the tragedy occurring downstairs.

CONCLUSION

The above analysis of *Upstairs, Downstairs*, *Downton Abbey*, and *The Forsyte Saga* investigates various ways in which British period teledramas rely on music to enhance and complicate conflicts between genders, classes, and worldviews. Aside from its function as accompaniment to opening and closing credits, title music can accomplish many narrative tasks, such as providing or deepening characterization, differentiating between the upstairs and downstairs ways of life, and defining and intensifying other potential binary conflicts that are central to the themes of the shows, such as the gender roles for men and women, or old world ideology versus a modern, industrial age. Additionally, we have demonstrated the potential of teledramas to make effective use of source music and underscore, either to capitalize on their emotional effects or to traverse between the two as a means to allow character and setting to break the molds of aural realism while maintaining fidelity to setting and emotional space.

While this chapter does not attempt to catalog the entirety of the music or musical tools employed in the three series, it outlines some of the ways in which music may be introduced into discussions of television or any other medium of narrative. As discussed above, *Downton Abbey* and *Upstairs,*

Downstairs use music as an aural divider to parallel and enhance the spatial divide of socioeconomic status and class, among other prevalent binary themes; however, further analyses of the music in period dramas undoubtedly will elucidate the ways in which music divides or blurs other types of cultural markers, such as those with ethnic, sexual, or religious connotations. As season 4 of *Downton Abbey* progresses into the Jazz Age, to provide one example of a situation that deserves further inquiry, Rose MacClare's romantic interest in a black jazz singer hints at further potential conflicts of race and sexuality.

Additionally, our current analysis details the significance of the musical transitions between underscore and source music in *Downton Abbey* and *The Forsyte Saga*; especially, we note *Forsyte*'s broad use of source music and live performances and the way in which (and regularity with which) the producers nearly seamlessly blend the source music into underscore. Still, scholars of film and television would benefit from further analyses of the interaction between these and other shows' characters and the music they can and cannot hear. In relation to nineteenth-century settings in particular, more can be said on the topic of gendered instrumental space and the ways in which production teams capitalize on Victorian ideologies of separate spheres while creating a bond between a female character and her ability to make and internalize music. The various frameworks set forth in this chapter's analysis of *Downton Abbey, Upstairs, Downstairs*, and *The Forsyte Saga* should be useful to those studying music, cinema and film, or any narrative medium. Music in the British period drama is a significant element of production to consider when analyzing the sites at which the understood binaries and themes of the programs clash and embrace.

NOTES

1. John T. Caldwell, "Welcome to the Viral Future of Cinema (Television)," *Cinema Journal* 45, no. 1 (fall 2005): 92.
2. Erica Jean Bochanty-Aguero, "Music That Moves: Television Music, Industrial Travel, and Consumer Agency in Contemporary Media Culture" (PhD diss., University of California at Los Angeles, 2009), 72.
3. Leon Botstein, "Patronage, Performance, and Scholarship," *Musical Quarterly* 95, no. 4 (winter 2012): 458.
4. Robert Stam, *Film Theory: An Introduction* (Malden, MA: Blackwell, 2000), 220.
5. Alexander Faris, "Bonus Features: The Making of *Upstairs, Downstairs*, Part 2," *Upstairs, Downstairs*, series 2, disc 4, DVD (Silver Spring, MD: Acorn Media, 2011).
6. Edith P. Thornton, "On the Landing: High Art, Low Art, and *Upstairs, Downstairs*," *Camera Obscura* 11, no. 31 (January/May 1993): 32.
7. Ibid., 31.
8. Ibid., 33.
9. John Lunn, quoted in Brian McCreath, "The Music of *Downton Abbey*," *CNE Journal*, WGBH, 2013, accessed 18 September 2013, http://www.wgbh.org/.
10. Diane Mapes, "Why the 'Downton Abbey' Theme Song Makes Us Drool," *Today*, 17 February 2013, accessed 18 September 2013, http://www.today.com/.

11. Dan Stevens, quoted in Sarah Crompton, "Dan Stevens: Why I Left Downton Abbey," *Telegraph*, 26 December 2012, accessed 30 September 2013, http://www.telegraph.co.uk/.

12. Source music and underscore are also referred to as diagetic and nondiagetic. See Stam, *Film Theory*, 220; and Claudia Gorbman, *Unheard Melodies: Narrative Film Music* (Bloomington: Indiana University Press, 1987), 3.

13. Garrett Stewart, "Film's Victorian Retrofit," *Victorian Studies* 38, no. 2 (winter 1995): 154.

14. Belén Vidal, *Figuring the Past: Period Film and the Mannerist Aesthetic* (Amsterdam: Amsterdam University Press, 2012), 27.

15. Hera Cook, *The Long Sexual Revolution: English Women, Sex, and Contraception, 1800–1975* (Oxford: Oxford University Press, 2004), 85.

16. Belén Vidal, *Heritage Film: Nation, Genre and Representation* (New York: Wallflower, 2012), 104.

17. However, season 4 of *Downton*, set at the beginning of the Jazz Age, uses music to a degree unmatched in its previous seasons, both in bringing professional musicians to Downton and by the family spending more time in London society. In fact, music has become a pivotal narrative tool through which the show's producers explore such themes as race relations (Lady Rose MacClare's romantic involvement with black jazz singer Jack Ross) and violence against women (Anna's rape by a fellow servant).

18. Later, an operatic production of Gluck's *Orpheo ed Euridice* serves as the setting for Irene becoming reacquainted with the Forsyte family, this time with Old Jolyon in pursuit (episode 1:4).

19. Howard Irving, "'Music as a Pursuit for Men': Accompanied Keyboard Music as Domestic Recreation in England," *College Music Symposium* 30, no. 2 (fall 1990): 132.

20. "Vetus" (Richard Mackenzie Bacon), "Music as a Pursuit for Men," *Quarterly Musical Magazine and Review* 2 (1820): 425, quoted in Irving, "Music as a Pursuit," 134.

21. This episode was the third of series 4 when shown in the UK. It aired as episode 2 on *Masterpiece Theatre* in the United States (the first two episodes aired as one extended episode).

Part II

The Costume Drama, History, and Heritage

Chapter Eight

British Historical Drama and the Middle Ages

Andrew B. R. Elliott

When considering the impact of British historical or period dramas on the wider televisual landscape, the Middle Ages is perhaps not the period that springs most readily to mind. Recent global hits such as *Downton Abbey* (2010–), *Call the Midwife* (2012–), or *Lark Rise to Candleford* (2008–2011) continue to support James Redmond's claim that "while there have been some outstanding successes with the Tudor and the late Stuart periods, the period most frequently portrayed or recalled is the recent past—the last part of the nineteenth and the first part of the twentieth centuries."[1] Although several critics recognize that other periods have also been plundered for source material, even in these cases the Middle Ages are often notable by their absence; to cite only one example, Lez Cooke's list of historical dramas and the periods they depict leaps from ancient Rome in *I, Claudius* (1976) directly to the eighteenth century of *Poldark* (1975–1977).[2]

The logical question that this oversight raises, however, leads to a rather revealing response, most notably in Colin McArthur's suggestion that

> it seems reasonable to suppose that a society going through a period of transi-
> tion and finding it immensely painful and disorientating will therefore tend to
> recreate, in some at least of its art, images of more (apparently) settled times,
> especially times in which the self-image of the society as a whole was buoyant
> and optimistic. For post-war Britain, faced as it is with adjustment to being a
> post-colonial power, a mediocre economic performer, a multi-racial society
> and a society in which the consensus of acceptable social and political behav-
> ior is fragmenting (all, of course, factors which are intimately inter-related),
> what better ideological choice, in its art, than to return to the period of the
> zenith of bourgeois and imperial power or to immediately succeeding periods
> in which the facade of that power appeared convincing.[3]

In this case, then, perhaps the question might be not why the Middle Ages and early modern periods are *not* included but rather why we would want to in the first place, if they do not offer the same kind of "usable past" that could be harnessed in the service of a nostalgic return to a golden age of British power. The answer is, as I hope to show, that dramas set in the medieval and early modern period can also bring something to the debate, frequently harnessing precisely those same values and ideas that characterize the more familiar kinds of period dramas.

In order to reduce a highly complex debate to something more manageable, rather than trying to analyze each series in any depth, this chapter will give a brief overview of some general trends. When looking at the broader picture, from the 1950s to the modern day, medieval dramas have tended to cluster around three key topics—namely, Robin Hood, King Arthur, and the Crusades—which will each be discussed in terms of their ability to address three key issues of importance to the period dramas. The first issue concerns historical drama's ability to speak to ideas about national identity and nostalgia, which in the above quotation McArthur argues is primordial. The second is the status of British drama as the flag bearer of quality television, providing an "international brand image of British television as a provider of a certain kind of content: middle-class fare skewed in various ways towards the maintenance and reproduction of a literary and cultural heritage."[4] The third is the importance, outlined elsewhere in this book, of the past as a means of critiquing, commenting on, or addressing contemporary concerns, which is motivated not by a desire for pure escapism, but instead, as Tony Garnett suggests, "we go into the past to draw lessons from it. History is contemporary."[5]

Nevertheless, although certain examples of medieval British dramas can be seen to operate *functionally* in the same way as those depicting later periods, it is also important to note that significant differences exist. To begin with, as noted elsewhere, the Middle Ages by no means occupies an innocent position in the British cultural memory and very often becomes a contested period of British history, used variously to promote nationalistic agendas, or else might be used as a period of barbaric primitivism to be compared unfavorably with the modern day. More problematically, over the course of the last two centuries the period has also become one that is readily fused with ahistorical fantasy worlds such as Tolkien's Middle Earth, or the cycle of 1980s sword and sorcery films like *Excalibur* (1981), *Willow* (1988), or *Dragonslayer* (1981), which also affect television depictions of the period seen in, for example, BBC's *Merlin* (2008–2012) or HBO's *Game of Thrones* (2011–).[6] As such, some of the series discussed here, such as Sapphire Films' *Adventures of Robin Hood* (1955–1959) and *The Adventures of Sir Lancelot* (1956–1957) or HTV/Goldcrest's *Robin of Sherwood* (1984–1986), fall more easily into the fantasy version of the Middle Ages

than any serious attempt to resurrect the period. Even so, I hope to demonstrate that, even if the series is not intended to be taken wholly seriously, in some cases the political subtexts of many of them may well have something to say.

ROBIN HOOD

The most recurrent medieval theme, and the first to appear on television, is the legend of Robin Hood, who appeared on British television screens as early as 1955 with Sapphire Films' long-running *Adventures of Robin Hood*, with Richard Greene in the title role alongside a host of other notable British actors including Paul Eddington, Patrick Troughton, Nigel Davenport, Donald Pleasence, and Leslie Phillips. Based as much on the 1938 Errol Flynn film of the same name as anything identifiably medieval, the series offered a fast-paced, action-packed adventure in which Robin battled against the establishment (here interpreted as a tyrannical Norman occupation) to redistribute wealth and champion the downtrodden Saxon population. Though ostensibly positioned as a children's program, it drew audiences from a range of ages and by 1957 had already been moved into a "prime-time" slot of 6:00 to 7:00 p.m.,[7] and its success allowed it to run through to 1960.

Perhaps the most significant legacy of the series, however, was not to be uncovered until much later, which was that Sapphire Films was later revealed to be the cover for a number of blacklisted Hollywood screenwriters, such as Ring Lardner Jr. and Ian McLellan Hunter, which made the series into "a Trojan Horse that carried Hollywood's communists into our homes."[8] The significance and influence of these writers has been well documented elsewhere; however, for our purposes it is worth noting that the series thus not only was a lighthearted caper but also fulfilled, in its way, the kind of contemporary social critique outlined above, most obviously in its emphasis on "social justice, humor and wit, [and] on the constant threat of informing and betrayal."[9]

In more commercial terms, the success of *The Adventures of Robin Hood* demonstrated a sizable market for swashbuckling adventure series that would become the hallmark of Sapphire Films and, later, the Danziger brothers' forays into television, as we shall see below. Curiously, the series was also hailed as a British phenomenon; though in reality a US-UK coproduction, the US influence was often overlooked in a general "insistence on its British origins, qualities, language and settings," and indeed the success of the series has often been measured not only by its domestic success but also by its ease of export to a ready-made North American audience.[10] As such, the series can be held directly responsible for the sudden appearance of a number of other similar costume adventures such as *The Adventures of Sir Lancelot*

(1956–1957), *The Adventures of William Tell* (1958–1959), *Ivanhoe* (1958), and *Sword of Freedom* (1958–1961), all of which sought to ape the same format in a range of medieval or early modern settings.

However, despite attempts to replicate the success of *Robin Hood* in its format, the actual subject of Robin Hood was not to return to British screens for two more decades, excepting Hammer Film's *Wolfshead: The Legend of Robin Hood* (1969), which was never broadcast, though the pilot was subsequently released in cinemas as a short film under the same title. In 1975, the BBC tried its own hand at a Sherwood Forest drama with *The Legend of Robin Hood*, with the lead role filled by Martin Potter. As the first BBC attempt to retell the classic British tale, *The Legend of Robin Hood* offers an interesting version of Sherwood that, according to Lorraine Stock, was "unusual for being gritty and realistic—no spangled green tights for this Robin."[11] Despite its uniqueness, however, the series is far closer to Richard Lester's film *Robin and Marian* than its TV predecessors, reflecting a wider dissatisfaction with war prevalent in the 1970s, which produced some of the "gloomiest versions of the greenwood legend ever filmed."[12] The pretextual use of Sherwood thus suggests that in many ways the medieval setting was more incidental than instrumental and served a more serious purpose of social critique.

It was once again ITV that was to breathe new life into the Robin Hood legend in HTV/Goldcrest's *Robin of Sherwood*. Unlike the BBC's interpretation, the series ran from 1984 to 1986 and, according to Stephen Knight, offered "the most innovative and influential version of the myth in recent times," whose radical reinterpretation of the legend inspired a large and devoted audience.[13] Adopting a thinly veiled political approach to the topic, Richard Carpenter's Sherwood used the distant medieval past to make some serious arguments about the present, reframing Robin not as an individual struggling against personal adversaries but as a champion of social revolution against a corrupt system. So pervasive is the distrust of authorities that even the return of King Richard, traditionally the signal of the restoration of justice, is shrugged off by the outlaws as merely another political ploy. As Laura Blunk argues, "Much more than any other retelling of the legend, the series stresses resistance to the existing social and political order of medieval England. . . . Authority is respected in Carpenter's Sherwood only when it earns acceptance by being justly wielded for the good of the community—whether that community be the tightly knit band of outlaws or the people of England as a whole."[14]

After 1986, and despite his success in two hit series, Robin and his men disappeared for the next two decades from British screens, recrossing the Atlantic for a slew of American productions, most notably three big-screen outings: Kevin Reynolds's *Robin Hood: Prince of Thieves* and John Irvin's *Robin Hood* (both 1991), followed by Mel Brooks's parodic *Robin Hood:*

Men in Tights (1993), alongside the Warner Bros/Baltic Ventures copro-
duced TV series *New Adventures of Robin Hood* (1997–1999). Ranging from
the sublime to the ridiculous, many of these ventures extirpated Robin from
history and placed him in fantastic settings amid a legendary greenwood,
presumably to capitalize on the popularity of pseudo-historical fantasy series
like *Xena: Warrior Princess* (1995–2001) or *Hercules: The Legendary Jour-
neys* (1995–1999).

Thus, by the time the BBC was finally to score a hit with a Robin Hood
series, this time with its 2006–2009 coproduction with Tiger Aspect, many of
the familiar tropes had become fixed elements of a legend very familiar to
audiences on both sides of the Atlantic, allowing historical realism to take
something of a back seat. With Jonas Armstrong in the title role, *Robin Hood*
tracked Locksley's return from the Crusades, which here was exploited as an
opportunity to reconstruct Robin as an enlightened postcolonial leader suffer-
ing from posttraumatic stress (coinciding with real-life Western invasions of
the Middle East that drew unfavorable comparisons with the Crusades), re-
cruiting an interracial band of outlaws united in their battle against injustice.
The backdrop of a deeply unpopular war occasionally proved to offer irresis-
tible parallels for the series writers. In one example, the unrepentant sheriff
proposes fresh security measures for Nottingham in the continued "War on
Terror"; in another, he makes no attempt to disguise that his chief weapon
against the outlaws is that he controls the flow of information to the wider
populace, transforming what is traditionally a game of cat and mouse be-
tween the sheriff and the outlaws into a reckless pursuit of dangerous terror-
ists that tramples over the law. The explicit comparison with the Bush-Blair
coalition paints the Norman institution in rather broad strokes as a more
corrupt system even than that of the 1980s *Robin of Sherwood*. Where *Robin
Hood* does offer an interesting twist, however, is in its elimination of the kind
of infighting witnessed in *Robin of Sherwood* and *The Adventures of Robin
Hood*, to reframe the band of Merry Men as an indestructible unit in which
"Robin Hood" comes to signify much more than the man: the undying (and
indestructible) notion of "the people" (prompting numerous scenes in which,
like musketeers in Lincoln green, they join hands and claim in unison, "I am
Robin Hood").

THE CRUSADES

The second most common focus of medieval British historical dramas is that
of the Crusades and their enduring legacy in British cultural memory. Since
the closure of the airwaves during the Second World War meant that the
emergence in Britain of a fully fledged television service coincided with the
dismantling of the British Empire, perhaps it is no surprise that alongside

Figure 8.1. Robin as an enlightened postcolonial leader (BBC/Tiger Aspect's *Robin Hood*, **episode 2:1)**

more explicit reflections on the empire at its zenith, the Crusades offered a ready-made metaphor for European hegemony. Particularly favored in television seems to be the Third Crusade of the late twelfth century, which saw the involvement of several recognizable medieval figures; these include Richard I (the Lionhearted), his brother Prince John (later King John of the Magna Carta fame), Saladin, and Eleanor of Aquitaine, as well as familiar fictional characters such as Ivanhoe (a kind of ideal ego of Robin Hood) and, however anachronistically (at least in popular culture), Robin Hood himself.

The first depiction of the Third Crusade on British television comes as early as 1958, with Sydney Box's *Ivanhoe* starring Roger Moore as "a typically handsome, athletic and courageous hero fighting for freedom and justice, his actions tempered by tenderness and the desire for comradeship."[15] This version, rather more MGM than Walter Scott, clearly adopts the same ideological approach as Sapphire's *Adventures of Robin Hood* in perceiving late twelfth-century England as a land of tyranny and imperial dominance, in which a regime of Norman aristocrats subjects the native people to oppression and injustice. Although admittedly the series, "crammed with the familiar conventions of a genre that emphasised action and spectacle,"[16] is more in keeping with a matinee costume adventure than a serious historical drama, its reconfiguration of the Third Crusade is nevertheless interesting. In place of his traditional role as defender and symbol of Englishness, Richard I is recast as a rightful king fighting for freedom in foreign lands, but one whose abandonment of his own kingdom leaves him open to criticism. Emerging against

a backdrop of the emergence of the European Economic Community (EEC) and the signing of the Treaty of Rome (after which France overtly petitioned against UK entry into the EEC), the series' rejection of French authority in its implicit championing of the Saxon cause against the so-called Norman yoke (which included the French-born King Richard himself) offers a tempting reading as an unwitting manifesto against European integration as well as a meditation on the loss of English/British national power.

The Third Crusade was reprised only three years later in the Danziger brothers' *Richard the Lionheart* (1961) that, given the Danzigers' traditional style of "gritty social realism and shabby location filming," had the potential to offer an interesting critique of one of the best-known medieval kings.[17] However, while undoubtedly ambitious in its scope, Wheeler Dixon suggests that the series struggled from the outset to deliver the "period costumes, sword fights, and detailed post-production work" that the series demanded, leading the Danzigers ultimately to abandon the series, apparently midway through its run.[18] Tise Vahimagi's synopsis on the British Film Institute's ScreenOnline database neatly summarizes the problems of the series in his suggestion that despite possessing "all of the components necessary for a spectacle," the scripts and pace of the series were ultimately uncontrolled and lacking in narrative tension.[19]

Accordingly, it was not until the 1980s that the Third Crusade began to offer a solid and multifaceted backdrop to the historical drama, finding a means to address issues of national identity and multiculturalism in both *Robin of Sherwood* (as discussed above) and a 1982 TV movie of *Ivanhoe*. The latter, with Anthony Andrews and James Mason starring as Ivanhoe and Isaac of York respectively, was perhaps rather more notable as an expensive and one-off event than as a lasting contribution to *Ivanhoe*'s legacy. Boasting a range of notable actors, including Sam Neill as Brian de Bois-Guilbert, Olivia Hussey as Rebecca, Julian Glover, John Rhys-Davies, and Michael Horden, as well as an accomplished crew behind the scenes, the shorter running time (at 142 minutes) left little room for character development or any attempt to explore the contemporary significance of the subject matter; more crucially, the all-star cast was to place its budget far out of the reach of most TV series at the time.

The high production values of the series, together with its focus on the Crusades and their effect on England, did however lead to a more memorable version of *Ivanhoe* in the 1997 A&E/BBC coproduced miniseries with Steven Waddington in the title role; he also played the eponymous king in Derek Jarman's *Edward II* (1991). In this version we see the Third Crusade once again operating as a pretextual means of exploring race and identity, emphasizing otherness while at the same time universalizing human experience, most especially in the hero's struggle against Brian de Bois-Guilbert (superbly played by Ciarán Hinds). Both are warriors back from the Holy Land,

and both fall for the Jewish maiden Rebecca (Susan Lynch), making their struggle for the hand of the girl a miniature version of the Crusade itself, only this time played out back in Merrie England. However, one key difference emerges in its translation from the text: in many adaptations of Scott's novel, Ivanhoe's choice between the Saxon Rowena and the Jewish Rebecca offers a means of reinforcing English national identity by tying it back to a proto-Saxon identity. Thus, the tension between Saxon and Norman often translates into as much a celebration of the Self as a rejection of the Other, and a means for Ivanhoe to make peace with his Saxon father (read, embrace his rightful national identity). Consequently, as Michael Ragussis puts it, the *Ivanhoe* story allows us to "explore national identities in Britain through the figure of outlandish outsiders."[20] In the 1997 series, however, the clash between Bois-Guilbert and Ivanhoe is fought over an empowered Rebecca who eventually chooses *neither* Bois-Guilbert *nor* her rescuer Ivanhoe but consciously embraces her own status as outsider. The rejection of both Saxon and Norman identities allows the series to use the Third Crusade not only as a multicultural stick to beat the present by unexpectedly rejecting its implicit support of an expansionist ideology but also as a means of offering empowered female characters who are able to do more than pout longingly at the Crusaders.

A newfound spirit of freedom and questioning of authorities was also in evidence in ITV's *Cadfael*, which ran from 1994 to 1996, this time set against the aftermath of the First Crusade and what was effectively a civil war between King Stephen and Empress Matilda (the same period that *The Pillars of the Earth*, a US-Canadian coproduction, would depict a decade later). Over three seasons, the Crusader-turned-monk functions as a modern-day detective, solving crimes amid a turbulent and often bloody war of succession; his status as a cloistered monk who has experienced the Crusades firsthand works as a clever narrative device that permits him to act as a dispassionate social commentator on a particularly murky period of Britain's past. In many of his cases (as with Robin Hood in later iterations), the backdrop of the Crusades allows Cadfael to speak as an enlightened, modern man who has seen the failings of ideology and, coupled with his own background as a Welsh monk operating in an English border town, the breakdown of simplified nationalistic agendas. In many ways, then, Brother Cadfael is perhaps better understood as a man of both the 1990s and the 1130s, offering a nexus through which the present views the past.

KING ARTHUR

The third recurrent theme of British historical dramas on television concerns the legends of King Arthur. As a core image of English national identity, it is perhaps unsurprising that Arthur should appear on British television; what *is*

surprising is how little he does so, appearing as he does in only three British television dramas, and even then how rarely he is depicted as the major character of the series. Despite the occasional use of Arthur in the Second World War, and later his centrality as "an historical icon for post-war British society" in the 1950s,[21] it was Robin Hood and not King Arthur who took primacy in medieval settings. Indeed, *The Adventures of Sir Lancelot* (1956–1957) does not even place the king as the central character but instead follows Lancelot through a vaguely medieval setting only partly connected with Camelot. As another Sapphire Films' production following hot on the heels of *The Adventures of Robin Hood*, the format and structure of the series, as I have argued elsewhere,[22] follows that of *Robin Hood* and clearly sought to capitalize on the earlier series' success by placing William Russell into the title role as a defender of a Camelot threatened by dark external forces and concealed internal traitors—once again reflecting the paranoia and distrust among the blacklisted Hollywood writers working for Sapphire.

The first British series to directly feature Arthur himself was thus HTV's *Arthur of the Britons*, again an ITV production, broadcast over two seasons from 1972 to 1973, with twenty-four episodes in total. As with other 1970s productions mentioned above, the series radically reassesses Arthur's legacy, stripping away the layers of legend to reveal a Dark Age warlord battling on two fronts to forge a national identity, struggling both to resist a barrage of Saxon invasions and to unite the disparate leaders of Jutes, Celts, Angles, and Picts against their common enemy. The result, while not wholly a critical success (the series survives better on DVD as a film version made from a patchwork of different episodes), poses an interesting reconfiguration of medieval Britain, offering a sense of ur-nationalism only as a loose, convenient union between different racial groups, rather than the sense of national destiny that many medieval Arthurian narratives try to offer; as a result, the "legendary image of Arthur as a heroic warrior king ruled by destiny is constantly downplayed."[23]

Later attempts to bring the Arthurian legend to British television (most obviously Shine TV's *Merlin*) once again tend to shift their focus away from Camelot and, more importantly, away from the territory of the historical drama and into the fully fledged fantasy series. Consequently *Merlin*, like *Camelot* (2011) and Steve Barron's miniseries *Merlin* (1998), freely intertwines the real with the fantastic in its focus on dragons, sorcery, and fairy-tale plotlines, and functions less as an examination of the past and more as a parallel medieval world drawing on other popular-cultural depictions, offering a deracinated, transnational version of the Arthurian mythos.

CONCLUSION

Thus, the use of the Middle Ages on British television presents a complex picture of the period amid a multifaceted, and at times self-contradictory, political and ideological landscape, both then and now. Though grouped around three key themes, it is clear that depictions of the period are by no means static but have evolved considerably over time, reflecting not only changing tastes of audiences but also significant shifts in industrial practices and trends. What began as an often-formulaic style in the costume adventures of Sapphire films designed for export would develop over time into more cynical critiques of the British past in the 1970s and 1980s with an eye to a domestic audience, allowing a more introspective turn in their critiques of national founding myths that would make little sense to foreign audiences. During this same period, however, the emergence of competition both domestically (with the launch of BBC Two and Channel 4) and internationally, along with the greater ease of international syndication, spurred on investment in these historical dramas, transforming medieval dramas into expensive productions with higher production values, and therefore budgets. Indeed, the recent boom in medieval and early modern themes seen in *The Borgias* (2011–), *The Tudors* (2007–2010), *Pillars of the Earth* (2010), and *The White Queen* (2013) demonstrates the continued domination of high production values that make "TV movies often seem closer to their feature-film cousins than to their made-for-TV ancestors."[24] As a result, the recent past has seen an increasing reliance on a coproduction model to fund the series and frequent involvement of international partners, meaning that any immediate focus on the national context is played down in the name of global export. Such a complex production ecology means that—despite their higher production values—recent series like *Merlin* or *Camelot* are far less capable of critiquing the present than their predecessors like *Arthur of the Britons* or *Robin of Sherwood*.

Implicit in this picture, however, is the historiographical acknowledgment that the past is not simply a collection of facts but rather a process of selection and reassembly. The differences between television's treatment of the Middle Ages demonstrate that even if the Middle Ages is not the period most readily associated with the period drama, it nevertheless fulfills a useful role in exploring, challenging, adapting, and appropriating the story of Britain in its infancy, and thus offering a similar kind of "usable past" as the later periods under discussion elsewhere. The fact that these series change so radically over time is also indicative of contemporary moods, beliefs, and desires: with the 1950s offering a Middle Ages of heroism and chivalry, we see a degree of nostalgia for a simpler time but also an image of unchecked male hegemony linked to political and physical power. This male power, however, began to be challenged in the 1970s by a more ambivalent depic-

tion of both Arthur and Robin Hood as national heroes, and which were once again challenged by a subsequent generation of medieval-themed dramas that prioritize multiculturalism and criticize British imperial power. Coming and going in waves and cycles, the Middle Ages thus come to serve, paradoxically, both as a distant mirror reflecting (and distorting) a remote period of British history past and as a parallel world from which powerful critiques of contemporary Britain may be launched. The end result suggests that despite their surface differences, British TV dramas may well use the Middle Ages in the same way as the nineteenth and twentieth centuries, as a means to "create an understanding of the issues of the present by putting them in the context of the past."[25]

NOTES

1. James Redmond, *Drama and Society* (Cambridge: Cambridge University Press, 1979), 220.
2. Lez Cooke, *British Television Drama: A History* (London: British Film Institute, 2003), 111–12.
3. Ibid., 113; Colin McArthur, *Television and History* (London: British Film Institute, 1978), 40.
4. Tom O'Regan, "The International Circulation of British Television," in *British Television: A Reader* (Oxford: Oxford University Press, 2000), 304.
5. Redmond, *Drama and Society*, 220. Garnett, speaking in the *Radio Times*, is quoted in Cooke, *British Television Drama*, 99.
6. For more on this, see Umberto Eco's famous essay "Dreaming of the Middle Ages," in *Travels in Hyperreality*, trans. William Weaver (London: Picador, 1987), 68–72. See also my own discussion of the uses of the period in *Remaking the Middle Ages: The Methods of Cinema and History in Portraying the Medieval World* (Jefferson, NC: McFarland, 2010), chap. 7.
7. Cooke, *British Television Drama*, 30.
8. Tom Dewe Mathews, "The Outlaws," *Guardian*, 7 October 2006, accessed 3 September 2013, http://www.theguardian.com/. For a more detailed account of the exact involvement of these writers, see Steve Neale's excellent study, "Swashbucklers and Sitcoms, Cowboys and Crime, Nurses, Just Men and Defenders: Blacklisted Writers and TV in the 1950s and 1960s," *Film Studies*, no. 7 (winter 2005): 83–103; see also Neale, "Pseudonyms, Sapphire and Salt: Contributions to Television Costume Adventure Series in the 1950s," *Historical Journal of Film, Radio and Television* 23, no. 3 (2003): 245–57.
9. Steve Neale, "Swashbuckling, Sapphire and Salt: Un-American Contributions to TV Costume Adventure Series in the 1950s," in *"Un-American" Hollywood: Politics and Film in the Blacklist Era*, ed. Peter Stanfield et al. (New Brunswick, NJ: Rutgers University Press, 2007), 200.
10. For more on the commercial performance of *The Adventures of Robin Hood*, see Steve Neale, "Transatlantic Ventures and Robin Hood," in *ITV Cultures: Independent Television over Fifty Years*, ed. C. Johnson and R. Turnock (Maidenhead, UK: Open University Press, 2005), 74–80. On an interesting side note to this issue, in his article on the series, James Chapman argues that it was the perception of its Britishness that helped to sell the series back to the United States in the first place. Chapman, "The Adventures of Robin Hood and the Origins of the Television Swashbuckler," *Media History* 17, no. 3 (2011): 277.
11. Lorraine Stock, "Now Starring in the Third Crusade: Depictions of Richard I and Saladin in Films and Television," in *Hollywood in the Holy Land: Essays on Film Depictions of the Crusades and Christian-Muslim Clashes*, ed. Nickolas Haydock and Edward L. Risden (Jefferson, NC: McFarland, 2009), 114.

12. Ibid.

13. Stephen Knight, *Robin Hood* (Oxford, UK: Wiley, 1994), 239.

14. Laura Blunk, "Red Robin: The Radical Politics of Richard Carpenter's Robin of Sherwood," in *Robin Hood in Popular Culture: Violence, Transgression, and Justice*, ed. Thomas G. Hahn (Woodbridge, UK: Boydell & Brewer, 2000), 30, 33.

15. Andrew Spicer, *Sydney Box* (Manchester, UK: Manchester University Press, 2006), 162.

16. Ibid., 161–62.

17. Wheeler W. Dixon, *The Transparency of Spectacle: Meditations on the Moving Image* (Albany: State University of New York Press, 1998), 100.

18. Ibid., 100–101.

19. Tise Vahimagi, "Richard the Lionheart (1961–65)," BFI ScreenOnline, 3 September 2012, accessed 8 September 2013, http://www.screenonline.org.uk/.

20. Michael Ragussis, quoted in Ann Rigney, *The Afterlives of Walter Scott: Memory on the Move* (Oxford: Oxford University Press, 2012), 87.

21. Donald L. Hoffman, "Arthur, Popular Culture and World War II," in *King Arthur in Popular Culture*, ed. Elizabeth S. Sklar and Donald L. Hoffman (Jefferson, NC: McFarland, 2002), 45–58; N. J. Higham, *King Arthur: Myth-Making and History* (London: Routledge, 2002), 36.

22. Andrew B. R. Elliott, "The Charm of the (Re)making: Problems of Arthurian Television Serialization," *Arthuriana* 21, no. 4 (summer 2011): 53–67.

23. John Aberth, *A Knight at the Movies* (London: Routledge, 2003), 11.

24. Mark Jancovich and James Lyons, eds., *Quality Popular Television: Cult TV, the Industry and Fans* (London: British Film Institute, 2003), 66.

25. Cooke, *British Television Drama*, 110.

Chapter Nine

Desacralizing the Icon

Elizabeth I on Television

Sabrina Alcorn Baron

IMAGINING THE VIRGIN QUEEN

More contemporary images exist of Elizabeth I (r. 1558–1603) than of any other monarch who lived prior to the age of photography. These contemporary images were manipulated for political propaganda purposes, lending plasticity to both Elizabeth I's visual image and her identity. If the portrait, or image, is the essence of the person it represents, that essence or personality becomes equally malleable. Such a flexible image was tailor-made for film and television when they developed in the late nineteenth and early twentieth centuries. Indeed, Elizabeth I is the English monarch most portrayed in those media.[1] She was a character in one of the earliest motion pictures made in the Anglophone world (1895) and has remained a feature-film character down to the present day.[2] Likewise, in 1938 she was a character in one of the earliest television broadcasts, becoming one of the most durable if adaptable presences in that medium as well.[3]

The primary reason for the creation of the number and nature of Elizabeth I's images in her lifetime was the necessity to mitigate the fact that she was a woman who had inherited a position specifically intended by God for males. Neither did she fulfill the obligatory early modern female roles (especially in Protestantism) of wife and mother, remaining unmarried and childless her entire life. In fact, she lived in a culture that conceptualized women only as sex objects; as a woman who did not engage in sexual acts, the Virgin Queen was notorious. Moreover, Elizabeth I was a woman who had to fulfill a very visible public role as she aged and became less sexually objectifiable. Many of her portraits were painted as miniatures, to be worn as jewelry by male

courtiers in the fashion of a lady's favor given to a lover.[4] These miniatures have led many to cast the aging queen in the role of the sexually desirable female, sought after by numerous suitors. This situation is often misunderstood, with politically ambitious young men, such as Robert Devereux, second Earl of Essex, described as seeking sexual, marital relationships with the much older Elizabeth I.[5] In fact, what Essex and many like him wanted was financial favor and political preferment, and since the monarch in control of that largesse was a woman, and since women in sixteenth-century English society were perceived solely as sex objects, male courtiers resorted to the language and rituals of sexualized romantic courtship rather than politicized favor in seeking to achieve their goals.

Unmarried, childless, and queen in her own right, Elizabeth I was to most of her contemporaries and subjects a curiosity, a mystery, and an anomaly, if not an abomination. Thus, the queen's male ministers engineered her image in order to transcend gender and to make an atypical female monarch approachable for ambitious elite males. They were so successful in this that the art historian William Gaunt wrote that Elizabeth I's portraits came to "exclude" not just her realistic female image but also "[her] humanity."[6] Sir Roy Strong, the foremost expert on Elizabeth's portraits, has argued that images of the queen became icons; universally recognizable symbols; revered objects in their own right, often in place of the queen herself; and what David Grant Moss has called "a trademark, a logo for England itself."[7]

Portraits of the queen were contrived first to overcome a female encumbering a public, political, by-definition male office and, ultimately, to objectify an aging female ruler by creating a perpetually sexually desirable avatar that was accessible to men.[8] Turning an aging female monarch into an eternally youthful sexualized icon served to reverse the natural life progression of a woman who never married, never reproduced, and experienced menopause. The queen's state of perpetual youth could also be identified with perpetual virginity since stereotypically virgins were young, unmarried women. It was even more vital to showcase virginity in the case of royal women who were under intense pressure to reproduce. Moss notes a Second World War–era speech given by the future Elizabeth II, twinning her as was often the case with Elizabeth I: "When an unmarried female member of the royal family must make a speech, the words hark back to the last Tudor queen."[9] Elizabeth I came to be painted with numerous symbols highlighting her sexual purity, as well as a youthful, interchangeable face frozen in time, for example, in the so-called Sieve and Ermine Portraits. She continued to also be painted as Astraea (the just Virgin), Venus (the eternally beautiful goddess of love), and Diana, or Cynthia (the immortal goddess of the moon).[10]

Strong has shown that in the 1590s, many stock images of Elizabeth I were reproduced as separate prints on paper, making them more affordable,

and indeed more public—they could be strewn about the streets, or tacked up on the wall in a home, an ale house, or a print seller's shop. Strong theorizes that many of these prints were based on a miniature painted by Isaac Oliver, considered flawed because it portrayed the queen accurately as an aging woman.[11] In 1596, an order was issued that all unflattering portraits of the queen—in other words those that made her look her actual age—should be destroyed.[12] Although a few portraits exist that depicted Elizabeth realistically in her older years (one by Marcus Gheerats just authenticated in 2013),[13] the very end of her life produced the most symbolic and idealized portraits of all. Most prominent among these is the Rainbow Portrait depicting Elizabeth with her ginger hair loose and flowing under a bride-like headdress; with her skin smooth and unblemished, smiling enigmatically; and with her clothed in a shimmering copper-colored gown decorated with realistic human eyes and ears and a beaded serpent of wisdom holding a heart in its mouth, in her hand a rainbow symbolizing peace with the motto "*Non sine sole Iris*—No rainbow without the sun."[14] The queen by this time was sixty-seven with thinning, receding hair, bad teeth, wrinkles, and pockmarks. But in this portrait, she appears as a beautiful, nubile, sexualized young woman, her hair loose around her shoulders in the fashion of virgin brides, indicating sexual availability and desirability.[15] Elizabeth I thus had a kind of inverted Dorian Gray relationship with her portraits: while she aged and became undesirable, her portraits increasingly appeared young and attractive.

Iconized images were how the patriarchal society in which Queen Elizabeth I lived coped with a female who was the chief public figure in the realm. If the female could not be physically altered (or passed over in the succession) to alleviate social dissonance, then the image, the essence of the female, could be transformed. She was depicted as heroic female figures from classical mythology and even the Judeo-Christian Bible (especially the Virgin Mary) and clothed in allegorical symbols, alleviating anxieties provoked by the most visible woman in the kingdom never marrying, never reproducing, experiencing menopause, and becoming sexually undesirable.[16] Unlike other women in the same situation, the queen could not be pushed to the margins of society or banished to a dower house in the country; she was a woman "alone and apart" in the public eye.[17] Scholars, Strong chief among them, have argued that this manipulation of image was a successful political strategy, which allowed an anomalous woman to sit on the throne for forty-six years unmarried, undesirable, unassailable, and unforgettable.[18]

ELIZABETH I IN THE TELEVISION AGE

Four centuries later, the plastic image of Elizabeth I was adapted to one of the greatest mechanisms known for manipulating images and personalities:

television. She was an obvious character for television, familiar to later ages
not only via images but also through drama, opera, poetry, and literature.
Two of her first major television appearances were products of great British
literary figures: George Bernard Shaw and Sir Walter Scott. Shaw's one-act
play, *The Dark Lady of the Sonnets* (1939), was also produced for British
television on three subsequent occasions: 1946 (notably on the first day the
BBC resumed programming after the Second World War), 1947, and 1955.[19]
The next TV show to feature her was *Kenilworth* (1957), based on the novel
by Sir Walter Scott, produced by the BBC in six live thirty-minute episodes
aired weekly, and remade in 1967.[20] Shaw's play was a comedy focusing on
illicit sexual relationships in Elizabeth's court, featuring William Shake-
speare, author of the sonnets.[21] Scott's novel was a stereotypical Victorian
historical romance, published in 1821 in three volumes, focusing on sexual
relationships in the queen's court in the form of various love triangles and
clandestine marriages involving Robert Dudley, Earl of Leicester; his first
wife, Amy Robsart; his steward; one of Amy's former suitors; and Queen
Elizabeth. Contemporaries believed Leicester had murdered Amy in order to
marry the queen. Scott attempted to exonerate them but left some doubt over
Elizabeth's role and knowledge.[22]

From the outset, television cast Elizabeth I in the context of romance, rife
with sexual desire and illicit plotting, as well as comedy. As Moss writes,
"She is most often used as a cipher upon which current views of women are
projected . . . having the same problems but missing the proper solution: the
fulfillment of marriage and the surrender of power to a husband."[23] The titles
of the shows are revealing in themselves, referencing one of the greatest
romantic mysteries and erotic relationships (the sonnets) along with one of
the most notorious love triangles and murder conspiracies (*Kenilworth*) in
English literature. In both of these stories, the fact that Elizabeth I was queen
was totally ancillary. It was her gender and her potential as a sex object that
was highlighted by Shaw, Scott, and the BBC.[24] These television trends
would continue and transform the image of the queen from a successful early
modern political icon into a clichéd, sexualized, powerless female.

In 1968, television portrayals of Elizabeth I turned toward more histori-
cally accurate depictions. NBC's *Hallmark Hall of Fame* that year presented
Elizabeth the Queen, adapted from Maxwell Anderson's 1930 play, starring
Judith Anderson as Elizabeth and Charlton Heston (starring in *Planet of the
Apes* the same year) as Essex. It depicts a romantic, sexualized relationship
between the queen, from age fifty-four, and Essex, from age twenty-two.
"May-December romances" existed in the sixteenth century, many with the
female as the senior partner, mostly for economic reasons. But the relation-
ship between Elizabeth and Essex has been cosmically misunderstood over
time because it has been inappropriately romanticized in literature (perhaps
most notably by Lytton Strachey),[25] poetry, opera, and another medium audi-

ences look to for the ultimate happy ending, film. Male-female relationships that transcended sexuality were essentially an unknown concept in the Elizabethan era and are arguably still a rare situation today. In the Elizabethan period, older, postmenopausal women were especially viewed as sexually predatory because often their husbands were dead, leaving them without male supervision and sexual partners; they were infertile, infirm, and sexually unattractive, and thus willing to, it was widely believed, enter into pacts with the devil in exchange for sex. Elizabeth and Essex have often been incorrectly presented as the early modern version of "the aging spinster who is foolish enough to fall in love with a much younger man."[26]

In *Elizabeth the Queen*, she and Essex engage in sexual banter and romantic encounters. Essex kisses her and calls her a "bitch of brass," an attack on both her sexual honor and moral character. In another vividly ahistorical moment, Elizabeth visits him before his execution to ask why he could not love her enough (clearly in the romantic sense) to try not to take her kingdom from her. He says he cannot answer because he does not know but allows, "A woman governs better than a man perhaps, being a natural coward," delivering yet another insult based on her gender.[27] This scene is more than vaguely reminiscent of Bette Davis playing Queen Elizabeth in the 1939 film, *The Private Lives of Elizabeth and Essex*, begging Essex, played by Errol Flynn, to take her kingdom in exchange for sexual attention and romantic love.[28] Essex, like all Elizabethan men, knew no other way to approach a woman, even—perhaps especially—a queen but as a sexualized object.

Generally considered to be the best of all television dramatizations about Elizabeth I is 1971's *Elizabeth R*, produced by the BBC in six episodes spanning nine hours, with Glenda Jackson in the starring role. As Bethany Latham points out, it is this length of time to explore and develop the story and characters that makes this the best treatment of Elizabeth.[29] It is also very historically accurate. Jackson's Elizabeth is a calculating and successful head of state, attending Privy Council meetings, writing and signing orders, choosing officials and overruling her male councilors, and beating everyone at political cat and mouse (as well as cards), despite all of the sexist opinions and actions around her. But in the final analysis, this series too highlights that above all else, Elizabeth was a female who was expected to become a wife and mother. The debate about her marriage emerges in the first episode, and three further complete episodes concentrate on Elizabeth's need to marry as well as her alleged romantic relationships with Leicester (here sorely lacking passion), the French Duc d'Alencon (later Anjou), and Essex (played by Robin Ellis, who would go on to *Poldark* fame four years later). As William Robison has correctly pointed out, the series significantly downplays the real political problems she faced during her reign.[30]

The iconization of the queen's image is clearly visible in the series with, in Strong's words, the "individual" being "transposed into a symbol."[31] In

episode 6, "Sweet England's Pride," the queen is essentially a caricature with contrived wrinkles, the white kabuki mask of lead-based face paint, the receding hairline, the stylized wig, darkened teeth (which Jackson insisted on), and fake eyebrows visibly drawn on above her natural ones; looking glasses were banned from her presence, and her clothing and jewelry became more fantastical by the scene. Her relationship with Essex is appropriately portrayed as maternal rather than sexual (if mother-son relationships are asexual), with the queen's full cognizance: "I will no longer play guilty parent to his hurt child." Following Essex's implosion after abandoning his Irish post, Elizabeth meets his petulant, adolescent displays with politic silence, as is historically accurate, rather than pleading for his sexual attention as in film and television. Indeed, Essex in *Elizabeth R* is the embodiment of Robison's shrewd observation that Essex has never been acted or portrayed well in any production while Elizabeth I has been portrayed by a long line of great actresses, beginning with Sarah Bernhardt.[32]

For the balance of the 1970s and 1980s, Elizabeth I appeared in British-produced TV shows that were comedies and satires, if not farces, including Graham Chapman in drag (wearing a copy of her dress from the Ditchley portrait) in a more-nonsensical-than-usual segment of *Monty Python's Flying Circus* called "Erizabeth L."[33] A *Carry on Laughing* episode from 1975, "Orgy and Bess," was a sexual farce, which needs no explanation beyond the title.[34] Her stint as a comedic character culminated in 1986's *Blackadder II* where Elizabeth was played by Miranda Richardson as exceedingly frivolous and eccentric. Richardson introduced that characterization in her audition after forty other actresses had read for the part and been rejected. The creators were so taken with her performance that they rewrote scripts around her portrayal.[35] Moss points out that in the series Richardson's character is never referred to by name; she is universally recognizable by her red hair, dress, and jewelry, again copied from the Ditchley Portrait.[36] Elizabeth I was presented as a stereotypical sexualized female, attractive but empty-headed; as unrealistically bloodthirsty, beyond the comprehension of the men around her; and as "the redheaded stereotype."[37]

ELIZABETH I IN THE TWENTY-FIRST CENTURY

In the early twenty-first century, television turned to highly fictionalized and sexualized dramatizations of the queen such as *Elizabeth Rex* (2002), a Canadian production based on a Canadian play in which "drama overtakes the logic of history."[38] It has yet another revealing title. Elizabeth is referred to as Rex, the Latin word for king, rather than Regina, the Latin word for queen. This usage echoes the medieval and early modern political paradigm of the king, or queen's, two bodies, the notion that the monarch had not only a

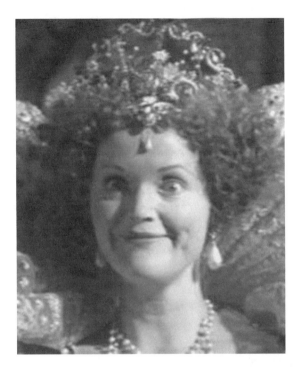

Figure 9.1. Miranda Richardson as Elizabeth I, in *Blackadder II*

physical body, which in Elizabeth's case was female and weak and sexual, but also a theoretical or political public body, which in the case of all monarchs, regardless of biological sex, was male or at least neuter, and therefore strong.[39] Set after a performance of Shakespeare's *Much Ado About Nothing* the night before Essex's execution, this production shows Elizabeth I experiencing gender confusion but ruled by her romantic feelings for Essex. The queen talks with a male actor from the play-within-the-play, who portrays women and has male lovers, asking him to teach her how to be a woman, and in exchange, she will teach him how to be a man.[40] While this particular encounter and overt gender bending is highly unlikely, historical evidence shows that Elizabeth did wrestle with some of these issues and did employ the two-bodies political theory. She frequently referred to herself as "prince," as for example in 1601's Golden Speech delivered to a joint session of Parliament, and occupied the king's rather than the queen's apartments in Whitehall Palace.

Three years later, two award-winning series aired, hoping to capitalize on recent film portrayals of Elizabeth I: *Elizabeth I: The Virgin Queen* (PBS/ Masterpiece Theatre, 2005; BBC, 2006) and *Elizabeth I* (Channel 4, 2004;

HBO, 2005). The first series featured a young unknown cast (who also age little in the series) situating this production within the youth or "emo" movement—rooted in punk, grunge, and gothic—which borrows from Victorian and Elizabethan culture.[41] Fashion and creating a certain look are central tropes of emo and clearly on display here.[42] Elizabeth, played by Anne-Marie Duff, exhibits from the outset the very pale skin prized by emo, which becomes even more pronounced when she dons the white makeup of her later years.[43] Emo's interest in androgyny is a useful theme for exploring Elizabeth I, with her personal female body and her public male body.

The series concentrates on the queen's relationship with Leicester, alternately sexually tense and jealously sniping. They frequently meet alone and engage in erotic foreplay, although Elizabeth insists nothing sexually inappropriate ever happened between them. Duff's Elizabeth is very emotional in very female ways, not just with Leicester, but also in frequent anxiety and panic attacks, hissy fits, and collapsing in bouts of sobbing. When Duff's Elizabeth is shown dealing with political issues and meeting with her council, she conveys nothing of the historical savvy politician that Glenda Jackson showcased in her performance. Moreover, this series has Elizabeth designing her iconization by instructing an artist as to how she is to be portrayed in portraits: "Let there be no shadows on my face and neck because they accentuate age. Immortal is the look we're after sir. And virginal. Divinity if you can manage it. And my hair must be loose."

Maternal rhetoric and imagery are used in some interesting ways in this production, with Elizabeth shown longing for a child, to fulfill the early modern role assigned to women, if primarily to secure the succession and protect England. Leicester reminds her of a childhood vow to never marry and asks, "Would you forgo motherhood, Bess, for the sake of a childish vow?" She responds to him with a discursion on the two sides of her coinage representing the queen's two bodies. Elizabeth is shown undergoing a gynecological examination in order to prove she is virginal and fertile and therefore acceptable as a bride for Anjou. Told the positive results, she falls back on her bed, with an adolescent smile and sigh of relief. Elizabeth talks to Essex of unconditional mother's love and reminds him that when he first met her as a child, she frightened him. Essex (portrayed here as a petulant, unstable adolescent with emo-style lank greasy hair hanging in his face, wearing leather pants) kisses her palm and proceeds to erotically suck her fingers; she flinches in horror. Notably in this series, Essex is manipulated more by his biological mother—Lettice Knollys Devereaux Dudley (Leicester's second wife), a curious Elizabeth doppelgänger—than he is by his political mother, the queen.[44]

Elizabeth I, starring Helen Mirren and Jeremy Irons, was wildly popular in the UK, picked up by HBO in the United States and also broadcast in Canada, Australia, and New Zealand, garnering multiple awards from ten

organizations including the Emmy, Peabody, Golden Globe, Screen Actors' Guild, and BAFTA awards.[45] *Elizabeth I: The Virgin Queen* was actually broadcast first in the United States to avoid competition with this series starring household-name actors. The series is built around the queen's two alleged great love affairs, with Leicester (Irons) and his stepson Essex (Hugh Dancy). It begins when Elizabeth I was forty-two years old (Mirren was in her sixties), opening with the gynecological exam that proved she was still a virgin and fertile, although at that age, the queen was on the cusp of the average life expectancy for females at the time. Ironically, her chances of living longer were improved because she was not having children when childbirth was the leading cause of death for women.

For such a distinguished actress, Mirren disappoints in this series. She famously played Deputy Chief Inspector Jane Tennison (a woman in a man's profession who has problems with romantic love and motherhood), in *Prime Suspect* (ITV, 1991–2006), for the same director, Tom Hooper, fighting against the glass ceiling firmly in place for women at Scotland Yard. She subsequently portrayed Elizabeth II on film (*The Queen*, 2006) as a high-minded monarch severely lacking the common touch. But her Elizabeth I comes across as snide, shallow, and shaky, displaying postmodern bitchiness, frequently screaming and swearing like a fishwife, and physically assaulting the men in her court who displease her in any way. She constantly dissolves into hysteria even while presiding in the Privy Council. Her relationship with Leicester is presented as emotional and sexual, with Leicester protective and Elizabeth very much in need of protection. This series veers away from the historical record in many ways, beginning with the premise of two grand romances for the queen, not to mention Elizabeth secretly meeting with Mary, queen of Scots (arranged by Leicester) and later her son, James VI (arranged by Robert Cecil). Mirren's Elizabeth even gets the degree of blood relationship between herself and the queen of Scots wrong. The series also has her personally facing down Essex and his rebels. Indeed the queen is often so brainless here that some of the best lines from her historical reign are fed to her by men, for example, when she tells Leicester prior to the Tillbury speech that she has no idea what to say to the troops because she is an "unwarlike woman," and he responds she will know what to say because she has "the heart and stomach of a king."

Elizabeth I's relationship with Essex is also played as a sexualized romance, with the queen "genuinely smitten" with the much younger man, and the "policies of the English government . . . a function of which boys the queen likes."[46] In a markedly ahistorical deathbed scene, Leicester links their hands and tells Essex to take care of Elizabeth because she needs looking after.[47] But the element of romance does not ring true with Elizabeth's lascivious posturing among the ladies of her court, taunting Essex's future wife, Frances Walsingham Sidney, the widow of Sir Philip Sidney, and constantly

pointing out to Essex that he is nothing but a boy who owes everything to her. She comes across, as one blogger has written, as "an adolescent girl trapped in her grandmother's body."[48] When Elizabeth and Essex are alone, drinking wine, reclining on cushions in front of an open fire, and he attempts to seduce her because he says she is looking at him as if she wants to eat him, she breaks away. She displays stereotypical female fickleness, torn between her duty as queen and her sexual desires as a woman, with the latter frequently threatening to dominate. Even when the queen ultimately tells him they must be friends as she and Leicester were in the end, Essex insists he wants a love relationship with her.[49] Despite the ratings and awards for this series, *New York Times* critic Alessandra Stanley was correct when she wrote, "This interpretation, like so many others, wallows in the painful self-pity of a powerful, aging woman who craves true love."[50] The iconization of Elizabeth I is treated intriguingly in this series, perhaps because Mirren was the same age as the historical queen at that point in her reign. Mirren as the aging Elizabeth, even when unmade up, is not at all horrible looking; she bears the age well. The fantastically dressed, white-faced, bewigged queen appears in this production only at important public or state events.

Elizabeth's television appearances elsewhere in the 2000s reside in the long-running science fiction series *Doctor Who* (BBC, 1963–1989, 2005–), where she first had a cameo in 1965. She reappeared enigmatically at the end of "The Shakespeare Code" (2007) set in 1599, announcing the doctor was her sworn enemy and ordering her guards to kill him based on her knowledge of his earlier behavior toward her, which in true *Doctor Who* time-bending fashion would not be revealed until future episodes. In 2009's "The End of Time: Part One," the Doctor reveals, "Got married . . . to good queen Bess, let me tell you her nickname is no longer (coughs) never mind."[51] *Doctor Who* fandom was not at all sure how to deal with the implication that the asexual Doctor had deflowered the second most notorious virgin in the history of Western women. The Doctor's sexual relationship with Elizabeth I was confirmed in "The Beast Below" (2010). Liz 10, revealed to be the very fictional Queen Elizabeth X (wearing a mask that makes her look old because her natural aging process had been stopped to keep her young), names Elizabeth I as one of her ancestors acquainted with the Doctor and discloses that he eradicated her virginity.[52] The Doctor divulged in 2011's "The Wedding of River Song" that "Liz the first is waiting in a glade to elope with me," indicating he had left her at the altar, or he planned to bigamously marry River Song in that episode. The Doctor's relationship with Elizabeth I was as convoluted as the series itself but always portrayed as sexual.

One of the major plotlines of "The Day of the Doctor" (2013), celebrating the fiftieth anniversary of the *Doctor Who* franchise (the largest simulcast in history, airing in 94 countries and 1,500 theaters worldwide), had the Doctor trying to distinguish the real Elizabeth I from a Zygon.[53] The queen had left

orders for him, received in 2013, to come back to 1562 to help foil the Zygon plot to take over earth. Ultimately, the Zygon threat is eliminated and the Doctor and Elizabeth I go off to get married. Again a sexual relationship between the two is exposed when one of the Doctor's many incarnations muses to another, "Oh, good work, Doctor. Nice one. The Virgin Queen? So much for history." The multiplicities in this special are as inherent as in the series as a whole. For example, the show references the many symbolic portraits of Elizabeth I by having her create an Underground Gallery to house dangerous art, including a fictional portrait of her indicative of the Zygon threat to earth; arguably, some of her actual historical portraits might qualify to hang in this gallery.[54] Although science fiction is a genre in which women are generally accorded the same, or even greater capabilities than men, and even in a series with a puritanical hero who neither swears nor engages in sex, once again Elizabeth I is a sex object, and a humiliated one at that (one reviewer noting strong parallels with Elizabeth I of *Blackadder II*),[55] rather than a powerful political figure.

CONCLUSION

The argument in this chapter is that the image and thus the essence of Queen Elizabeth I was manipulated in her lifetime to ensure that she transcended her femaleness to succeed as a public political figure in an overtly patriarchal office and culture. But quite ironically in a postmodern Western world in-formed by feminism, television has reshaped, or desacralized, Elizabeth I into a sexualized female stereotype who failed at love and motherhood, and thus did little else of consequence. She is portrayed as unsuccessful in the achievements most desirable to women, reverting to the age-old stereotype of the female as inherently flawed, inferior, and oversexed.

As with the manipulation of the queen's portraits in the early modern era, so her portrayals in television series have allowed "images" to "replace reality and the distinction between reality and irreality [*sic*] blurs."[56] It was recognized as early as 1948 "that the primary impact of exposure to mass communication is likely to be not change but maintenance of the status quo." Moreover, the famous television theorist George Gerbner has argued further that television is a medium that "reproduces the status quo in a highly conser-vative manner" and serves the interest of the ruling class[57]—in other words, the wealthy males who continue to dominate and control our society despite women being supposedly closer to equality with men than ever before in Western history. Neither television nor contemporary society appears to have any idea how to deal with Elizabeth I as a visible, aging, postmenopausal, nonsexualized woman. In her own time she was turned into an icon, a sacred

image, to overcome the natural processes of aging, while our time has turned her into a caricature that is frequently ridiculed and humiliated sexually.

NOTES

1. "Ten Facts About Queen Elizabeth I," Ten Facts About . . . , 2014, accessed 1 April 2014, http://www.tenfactsabout.co.uk/; "Elizabeth I of England," *New World Encyclopedia*, last updated 25 July 2013, accessed 1 April 2014, https://www.newworldencyclopedia.org/.

2. Sue Parrill and William B. Robison, "About the Films," TudorsOnFilm, 2012, accessed 1 April 2014, http://www.tudorsonfilm.com/.

3. "The Virgin Queen," TV Tropes, accessed 1 April 2014, http://tvtropes.org/.

4. Roy Strong, *The Cult of Elizabeth* (London: Thames and Hudson, 1977), 70–75.

5. Strong, for example, believes that Elizabeth and Essex had a romantic relationship. Ibid., 67–81. Latham takes a firm stand on the fence on the nature of their relationship. Bethany Latham, *Elizabeth I in Film and Television: A Study of the Major Portrayals* (Jefferson, NC: McFarland, 2011), Kindle loc. 1722.

6. William Gaunt, *Court Painting in England from Tudor to Victorian Times* (London: Constable, 1980), 37.

7. Roy Strong, *Gloriana: The Portraits of Queen Elizabeth I* (London: Thames and Hudson, 1987), 16; David Grant Moss, "A Queen for Whose Time?: Elizabeth I as an Icon for the Twentieth Century," *Journal of Popular Culture* 39, no. 5 (2006): 798.

8. "Representing the Queen," National Maritime Museum, Greenwich, accessed 1 April 2014, http://www.rmg.co.uk/.

9. Moss, "A Queen for Whose Time?," 807.

10. Strong, *Gloriana*, 87; Strong, *Cult of Elizabeth*, 44–48; "Representing the Queen."

11. Elizabeth I actually sat for Oliver, and even though the portrait(s) were considered flawed, Strong believes Oliver's pattern image to be the most accurate portrayal of the queen from this time in her life. Strong, *Gloriana*, 142–45.

12. Ibid., 147.

13. Jonathan Jones, "Elizabeth I's Portrait Brings Us Face to Face with the Ravages of Age," *The Guardian*, 12 February 2013, accessed 1 April 2014, http://www.theguardian.com/.

14. Strong, *Cult of Elizabeth*, 50, 52; Strong, *Gloriana*, 156–60; The Rainbow Portrait, ca. 1600, Hatfield House, Hertfordshire, UK.

15. Loose hair was ironically the identifier of both unmarried virgins and prostitutes, or women who were sexually available.

16. S. P. Cenasano and Marion Wynne-Davies, eds., *Gloriana's Face: Women, Public and Private, in the English Renaissance* (Detroit: Wayne State University Press, 1992), 2–4.

17. Latham, *Elizabeth I*, Kindle loc. 277.

18. Strong, *Gloriana*, 35–36.

19. Sue Parrill and William B. Robison, *The Tudors on Film and Television* (Jefferson, NC: McFarland, 2013), 38–39.

20. Video of this production does not survive, but it featured Jeremy Brett (later the star of *Sherlock Holmes*) as Amy's suitor and Gemma Jones (later starring in *The Duchess of Duke Street*) as Queen Elizabeth. Ibid., 124.

21. Ibid., 38–39.

22. "Kenilworth," Walter Scott, Edinburgh University Library, last updated 20 July 2012, accessed 1 April 2014, http://www.walterscott.lib.ed.ac.uk/.

23. Moss, "A Queen for Whose Time?," 798–99.

24. Between these two shows, Elizabeth I was featured in *The Bachelor Queen* (1948), a live broadcast of a play produced for NBC's *Television Playhouse*. The title is a dead giveaway, focusing on her unmarried state. According to the plot, Elizabeth realized that if she was to succeed as queen, she could not succeed through normal female behavior. Parrill and Robison, *Tudors on Film*, 23.

25. Lytton Strachey, *Elizabeth and Essex: A Tragic History* (New York: Harcourt, Brace, 1928).

26. Postmodern society in the main does not have this diabolical view, but menopausal women are still "othered" in our society, not at all well understood, because for the first time in history, significant numbers of postmenopausal women, women no longer considered acceptable sex objects by males, have long life spans. Moss, "A Queen for Whose Time?," 798.

27. Parrill and Robison, *Tudors on Film*, 83–84.

28. Moss, "A Queen for Whose Time?," 798.

29. Latham, *Elizabeth I*, Kindle loc. 3717.

30. *Elizabeth R*, Netflix, accessed 1 April 2014, http://www.netflix.com; Parrill and Robison, *Tudors on Film*, 65.

31. Strong, *Gloriana*, 9.

32. Parrill and Robison, *Tudors on Film*, 11.

33. "Erizabeth L," *Monty Python's Flying Circus*, YouTube, accessed 1 April 2014, http://www.youtube.com/; Moss, "A Queen for Whose Time?," 804. The Ditchley Portrait was painted for Sir Henry Lee of Ditchley, one of Elizabeth's champions. The portrait was given to the National Portrait Gallery, London, by one of his descendants in 1932.

34. Parrill and Robison, *Tudors on Film*, 158–59; "Orgy and Bess," Carry On Wiki, accessed 1 April 2014, http://carryon.wikia.com/.

35. Parrill and Robison, *Tudors on Film*, 23.

36. Moss, "A Queen for Whose Time?," 796.

37. Latham, *Elizabeth I*, Kindle loc. 253.

38. Parrill and Robison, *Tudors on Film*, 78–79; Iris Winston, "Review: Elizabeth Rex," *Variety*, 10 July 2000, accessed 1 April 2014, http://variety.com/.

39. Ernst H. Kantorowicz, *The King's Two Bodies* (Princeton, NJ: Princeton University Press, 1997); Marie Axton, *The Queen's Two Bodies: Drama and the Elizabethan Succession*, Royal Historical Society Studies in History (London: Royal Historical Society, 1977); Regina Schulte, *The Body of the Queen: Gender and Rule in the Courtly World, 1500–2000* (New York: Berghahn Books, 2006).

40. Parrill and Robison, *Tudors on Film*, 78–79.

41. Robison also noticed they were slow to age on screen. Ibid., 57.

42. Ibid., 9; Luke Smith, "British Youth Timeline," Prezi, 5 April 2012, accessed 1 April 2014, http://prezi.com/.

43. "Emo Scene Fashion including Emo Hair, Clothing, Makeup and Accessories," SoEMO.co.uk, accessed 1 April 2014, http://www.soemo.co.uk/. Prior to this series, Duff's most notable role was in the UK version of *Shameless* (2004–), where she played the young heroine Fiona Gallagher who was also victimized because of her gender.

44. *Elizabeth I: The Virgin Queen*, Netflix, accessed 1 April 2014, http://www.netflix.com/.

45. Parrill and Robison, *Tudors on Film*, 50.

46. Adam Cadre, "Elizabeth I," 31 December 2012, accessed 20 January 2014, http://www.adamcadre.ac/.

47. *Elizabeth I*, part I, YouTube, accessed 29 March 2014, http://www.youtube.com/.

48. Cadre, "Elizabeth I."

49. *Elizabeth I*, part II, YouTube, accessed 30 March 2014, http://www.youtube.com/.

50. Alessandra Stanley, "Elizabeth I: The Flirty Monarch with the Iron Fist," *New York Times*, 21 April 2006.

51. "Elizabeth I," Tardis Data Core, Wikia, accessed 1 April 2014, http://tardis.wikia.com/.

52. "The Virgin Queen," TV Tropes; "The Beast Below," *Wikipedia*, last updated 3 September 2014, accessed 1 April 2014, http://en.wikipedia.org/; "The Fourth Dimension," Doctor Who, BBC One, accessed 1 April 2014, http://www.bbc.co.uk/; Dave Golder, "Doctor Who 'The Beast Below' In-Depth Review," SFX, 21 April 2010, accessed 1 April 2014, http://www.sfx.co.uk/; "Quotes from Doctor Who: 'The Beast Below,'" Planet Claire, accessed 1 April 2014, http://www.planetclaire.org/.

53. "The Day of the Doctor (TV Story)," Tardis Data Core, Wikia, accessed 1 April 2014, http://tardis.wikia.com/.

54. "Elizabeth I," Tardis Data Core.

55. Jim Shelley, "Doctor Who's 50th Anniversary Episode Breaks the Timelord's Number One Rule and Re-writes History—and Reminds Us Why Matt Smith and David Tennant Were So Irritating," *Daily Mail* , 23 November 2013, accessed 1 April 2014, http://www.dailymail.co.uk/.

56. Douglas Kellner, "Toward a Critical Theory of Television," 6–7, 13, accessed 1 April 2014, http://pages.gseis.ucla.edu/.

57. George Gerbner, Larry Gross, Michael Morgan, and Nancy Signorelli, "Living with Television: The Dynamics of the Cultivation Process," in *Perspectives on Media Effects*, ed. Jennings Bryant and Dolf Zillmann (Hillsdale, NJ: Erlbaum, 1986), 21.

Chapter Ten

"It's not the navy—we don't stand back to stand upwards"

The Onedin Line *and the Changing Waters of British Maritime Identity*

Mark Fryers

Producer Peter Graham Scott describes the situation at the BBC in the early 1970s as "leaderless."[1] Rather than taking risks with contemporary shows, he writes, "drama began to look backward to the Victorian era and the certainty of the Second World War." However, one show did appeal to Scott, and he subsequently became producer on *The Onedin Line* (1971–1980), which he described as "embracing the strong popular lure of the ocean with a chance to expose the cruel hardships and ruthless ambition that dominated Victorian life."[2] The show did exactly that and went on to become one of the BBC's most popular programs, not just in Britain but also successfully exported as far afield as North America, Australia, Zambia, Singapore, and Jordan. The balance of sea romance and urban deprivation enabled the show to blend elements, retaining the splendor and familial intrigue of the costume drama with sea adventure, spectacle, and the exotic evocation of Britain's maritime heritage. This chapter will discuss the show's particular use of spaces, the delimination and transgression of generic boundaries, and its use of dramatic juxtaposition to suggest that, through the use of television's specific visual and presentational mechanics, *The Onedin Line* offered an often dramatic reinterpretation of British maritime identity on British (and international) screens. The program facilitated the metamorphosis of maritime symbols of national identity, from naval and military dominance to notions of an empire built by the harshness and vagaries of mercantile endeavor.

BRITAIN AND THE SEA

As an island nation, Britain has long been associated with the sea. As Susan Rose writes, "It has been suggested that there is hardly a single poem written in Anglo-Saxon which is not full of images of the sea."[3] The Spanish Armada was something of a turning point for English (and later British) national identity, as it marked the beginning of a cultural fascination with both maritime success as being vital to the wealth and security of the British nation and the idea of "difference" and "exceptionalism" predicated on both cultural and geographical factors. The defeat of Catholic Spain and France enabled Britain to continue uninhibited with Protestantism, with its unique religion (Church of England) to match its unique liberty, monarchy, and judiciary. Britain was a nation, literally set apart from mainland Europe geographically, and this difference was also expressed as a cultural "uniqueness" in such fields as the English language, humor, and even its morality (characterized by a sense of "fair play").[4] Britain's empire was protected by its navy and the unique character of the men who sailed in it, all facilitated by the concept of island and isolation. This sense of difference arguably reached its apex during the Second World War, when the rhetoric of Churchill's speeches galvanized this myth as powerful propaganda.

Scholars have been slower than might have been expected to trace the lineage of maritime and island nation to formations of national identity and character, but in recent years the cause has been taken up in various fields including film. Jonathan Rayner has focused on the way that film and the Royal Navy have been used to express ideas of national identity,[5] while Victoria Carolan has expanded this to consider the wider role of the maritime and British film.[6] Likewise, Penny Summerfield acknowledges the different representation of the Merchant Navy in 1940s and 1950s British Second World War films.[7] From the silent era until the early 1960s, the navy has been a constant presence on British film, from early "prenarrative" films featuring fleet reviews and ship launches to the Ministry of Information–approved naval films of the Second World War, during which the film industry provided a vital cultural propaganda arm to the Royal Navy. The navy, particularly from Victorian times onward, often served as a shorthand for the stratified levels of power and servitude in British society and was emblematic of the British virtues of courage, stoicism, discipline, and dignity.[8] A "continuity of tradition" therefore marked the British relationship with the sea and its practices.

This suffered a precipitous decline after 1960, with the number of sea and navy films reduced drastically. The majority of depictions were henceforth historic rather than contemporary, looking back on past glories while Britain was dwindling rapidly on the world's stage, supporting a "phantom empire" of inflated importance. The historic myth of Britannia "ruling the waves"

was routinely mobilized in times of national security (the "cod" wars with Iceland [1950s and 1970s] and the Falklands conflict [1982] as examples), while the myth that Britain is a small island with a big influence continues to this day.[9] Such evocations of maritime identity are typical even within the tourist industry, which Ken Lunn and Ann Day describe as "a tendency to drift into a wider symbolism"; they suggest, for example, that the Royal Naval Museum in Portsmouth's recent bicentenary of the Battle of Trafalgar "will, no doubt, raise yet again the image of Nelson as an ahistorical figure, one who transcends time and who comes to symbolise a peculiarly British 'character,' perpetual and unchanging."[10] Again, a continuity of tradition would seem to typify the strength of symbolic myth.

THE ONEDIN LINE

Television, often seen as film's poorer relation, was the perfect vessel through which to energize old myths and, throughout the 1950s and 1960s, churned out swashbucklers such as *The Buccaneers* (1958–1960), *Sir Francis Drake* (1961–1962), and *Hornblower* (1964), all aimed primarily at a juvenile audience for whom the exploits of these maritime adventurers presumably held more relevance than for their adult counterparts. Yet while contemporary depiction of the navy in film became almost nonexistent, it was more visible on television. The BBC drama *Warship*, which ran from 1973 to 1977, had the full cooperation of the admiralty, which loaned them numerous ships and planes for filming. *The Onedin Line* sought to fill a large gap in the British public for the romance of the age of sail. Yet the show achieved much more than this by suggesting that modern mercantile Britain was forged as much by the men (and women) of the Merchant Navy than by the men of the Royal Navy.

The program navigated less-explored "maritime spaces" and therefore articulated and gave prominence to a maritime Britain outside of the "Trafalgar" mentality. Over the nine years of its run, the central character, James Onedin (Peter Gilmore), built up a shipping empire from nothing, lost and won it back on more than one occasion, and traveled the world meeting danger and subterfuge in both his maritime and his business life. He lost two wives, one to diphtheria and another in childbirth, as well as having a stillborn child. He fought continually with business nemeses, including his sister Elizabeth (Jessica Benton), who ended up owning a rival shipping line through marriage to sea captain Daniel Frazer (Philip Bond). His lust for profit meant that he became embroiled in many of the important global events of the latter nineteenth century, including revolution in Brazil and Venezuela, the American Civil War, and the communard occupation of Paris; he was even responsible for carrying Garibaldi back into Italy after his exile.

Onedin was not interested in politics unless it affected his business interests, and this became the dramatic impetus for his various conflicts. Originally airing on a Friday evening, the show fast became a Sunday-evening fixture on BBC One, with ITV eventually resorting to broadcasting *The Love Boat* in the same time slot.[11]

THE SEA: SHIPS, SAILING, AND MASCULINITY

It is undeniable that *The Onedin Line* foregrounds the form of maritime heritage that may be typified as "nostalgic." The full power of this is derived from its visual and aural presentation and its juxtaposition against the series's other elements. From the opening titles, which featured the visual and aural contiguity of Khachaturian's romantic *Spartacus* theme against shots of the series's featured ships majestically sweeping through the seas, the presentational paradigm of both the sea and sailing ships as fetishized objects of beauty is established. Here, the visual medium evokes Britain's heritage of landscape, and particularly maritime painting. Specifically, the romantic notion of the sea as "sublime" so famously evoked by J. M. W. Turner is replicated with the added power of music. Turner was less interested in naval supremacy than he was with the inspiring power of nature, or as Sarah Monks describes, "The sea was emphatically assigned the status of testing ground for a self able to convert the world into indicative sensual experience."[12]

The beginning of each episode is almost exclusively established at sea—aboard ship, at docks, or at shorelines—and each episode features interstitial establishing chapters where the ship, the sea, and the refrain of *Spartacus* coalesce to perform the ritual function of nautical panacea. To take the episode "No Smoke without Fire" (6:1) as an example of this style, the episode opens aboard ship as sailors busy themselves to the sounds of seagulls and a lone accordion player, while an old sailor shows a novice how to tie a sheepshank. The episode then goes below decks into James Onedin's cabin as he discusses the business of gold bullion and South African mining. Once "business" is concluded, the action is back on deck again as the ship sets sail with the sound of a "heaving" sea chantey audible over a montage of shots of sailors at work in rigging, hauling ropes, and setting sails. The chantey is gradually faded in to the nondiegetic *Spartacus* refrain as wide shots of the ship at full sail conclude the sequence. The action then moves into the more functional and mundane offices of the Frazer Shipping Line and dockyard as the aspiring young businessman William Frazer (Marc Harrison) announces, "I want forty of the men laid off straight away." The contrast between the two sequences is pronounced, with the romance of the sea and the life of a seaman truncated by the prosaic business of redundancies: the Machiavellian

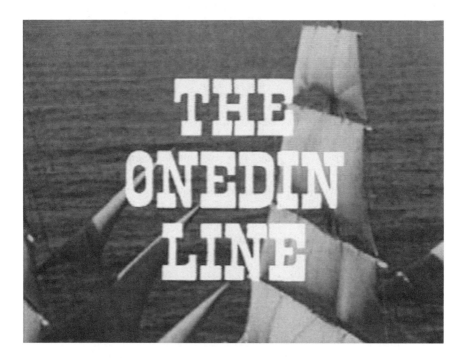

Figure 10.1. The opening titles, set to Khatchaturian's *Spartacus* theme, evoke the romance of sailing and the age of tall ships.

scheming of the land. These interstitial sequences are not just purely decorative but also fulfill an ideological function to elide these contrasts.

The episode continues in this vein as further sequences of the Machiavellian scheming of Victorian business are contrasted with nautical romance. A sequence that deals with Elizabeth Frazer's strained business dealings is followed by a full ten-second sequence of a ship sailing and the *Spartacus* theme. It was clearly the view of the creators to establish this contrast and heighten it through the proper implementation of nautical verisimilitude. Here, male authorship is crucial. A BBC press release from the 1970s sums up the aims of the creator and "ex-sailor" Cyril Abraham: "In the Onedin Line, for which he has also written several scripts, he has drawn on his long study of maritime history to tell a story that combines the glamour of the square-rigged sailing ships of the 1860's with action, adventure and a realistic view of the harshness of Victorian Life."[13]

This strategy is echoed by original producer and occasional director Peter Graham Scott, who served on the first three seasons. He indicated that each fifty-minute episode "should give us about ten minutes action at sea."[14] Scott went to great lengths and expense to create the exterior shots, filming ships

from helicopters, in all weather conditions and locations to create a "library" of shots to fulfill this function, believing that without this endeavor *The Onedin Line* would have "sunk unnoticed after one run."[15] Like many of the writers and directors on the series, Scott had previous experience filming at sea, having worked on *Sir Francis Drake*, so he shared a collective vision of what the maritime could and should look like on television. It is unsurprising perhaps that the version of the maritime in *The Onedin Line* should have a masculine association.

This association is likewise dramatically emphasized in the themes, narrative, and characterization. Onedin is a man made tough by the sea. It has engendered a rigid individuality that sets him at odds with everyone he comes into contact with; he is an English cowboy whose ranch is the sea and whose empire is not land and property but ships and cargo. Yet perhaps more than James, the most enduring and endearing character is Captain Baines (played by Howard Lang, an ex-naval gunner), Onedin's faithful servant. Baines, more than any other character, represents the old sea salt, made tough by the sea but uncomfortable with the affairs of land. Unlike Onedin, he has heart and humanity and represents what may be best described as a true English oak adrift at sea. This, of course, has its roots in Britain's literary heritage with sea texts like *Robinson Crusoe* (1719) and *Treasure Island* (1883), prescribed as "the energising myths of Empire": boys-own stories to produce "men."[16] Episode 6:1 perfectly adumbrates the sensibility. In a discussion regarding the possible opening of a Panama Canal, Daniel Fogarty (Tom Adams) declares "and that will be the end of the sailing ship." This is greeted with lamentation from Baines, for whom sailing round the horn is not only the mark of a true sailor and test of a man but also a masculine rite of passage: "When that happens, no more real men. Just milk sops. Canal sailors."

The same episode coincidently features what was known as the Neptune Ceremony, a nautical tradition for sailing past the equator in which two sailors dress up as Neptune and his wife and humiliate unfortunate victims. One of the unfortunates in this sequence is a young lad who is dunked in water and forcibly shaved, while Baines and Onedin look on smirking, recalling their own experiences of this degrading spectacle as a masculine initiation. The sea, ships, and sailing therefore create a nexus of masculinity, bearing comparison to Christine Geraghty's description of real and symbolic space in 1950s maritime war films as a "masculine world operating in a clearly defined and separate 'space.'"[17]

The sea, ships, and sailing, and their proximity to definitions of British masculine identity invite further comparisons with the American Western film, typified by a national mythology allied to strong and silent men made tough by the landscape.[18] Here, the sea represents the masculine frontier: a place of both romance and danger, whose successful navigation is a mascu-

line "rite of passage." Both production and reception materials support this. Speaking of the show, Peter Graham Scott stated, "I like the sea, every Briton likes the sea—it's one of those really root things with the people of these islands,"[19] and Shaun Usher from the *Daily Mail* described "oceans for prairies and wind jammers replacing horses."[20] Similarly, reviewing the show in the *Daily Telegraph*, Sylvia Clayton described it as "one of the few adventures to use the sea as a kind of frontier background," adding, "There are few sights more beautiful than the clipper in full sail."[21] Elsewhere, reviewers routinely praised the authenticity of the series and its nautical heritage, suggesting a continuity of national tradition.

However, while *The Onedin Line* clearly both used and foregrounded romantic notions of British maritime identity and engaged with imperial masculine and other literary conceptions of the sea as being both in the blood and character of the archetypal British man, it still differed significantly from earlier projections of British maritime identity, offering a more diffuse and complicated notion of British national identity than previously found in imperial adventures. Perhaps the most striking feature of this is the manner in which the Royal Navy, so strongly associated with national pride and identity, is almost entirely absent in both thought and deed over the ninety-one episodes. There are three main characters who represent the navy during the series, and none can claim much respect or credit. Onedin's father-in-law, Webster (James Hayter), is an old naval captain and makes intermittent appearances until series 3. He is a curmudgeon, ill tempered, and set in his ways. Episode 3:3 has Webster go head-to-head with Captain Baines on a voyage regarding the correct protocol for sailing, the suggestion being that Merchant Navy masters and Royal Naval captains are from two different worlds. In series 7, Sarah Onedin (Mary Webster, the widow of James's brother Robert) is romanced by an ex-naval frigate commander who "fought at Sebastopol," but he turns out to be purely after her money and is sent packing by James. Perhaps the most odious advocate of naval imperialism appears in episode 2:9 in the form of diplomat Sir Charles Gray (John Harvey), who tries to intervene with James and Albert Frazer doing business helping to provide ships for a Turkish fleet, calling it "treason." He seeks to keep down every nation but Britain, proclaiming, "Gold on our plates, dung on theirs." It is James Onedin himself who perhaps illustrates the difference in attitude when he chides a young ship's boy for incorrectly giving him a naval salute, which involves him standing back on his heels: "It's not the navy—we don't stand back to stand upwards." The message is clear: the navy has its place, but the upward trajectory of Britain was consistently predicated on the merchant ships that carried goods back and forth all over the world, and the men who sailed them were the ones who built Britain. As Summerfield suggests of filmic depictions of the Merchant Navy, "Its presence on screen was disruptive: the complex class, gender, and racial iden-

tities with which it was associated undermined the secure portrayal of national unity."[22]

Although the sea is treated as a space of enterprise and fortitude, of sublimity and romance, it is also a space of danger and death, and destruction and disaster. The heritage industry (including film and television) is often criticized for sanitizing history and making it romantic and easily digested,[23] but *The Onedin Line* does not shrink from showing the full horror of life for the common seaman and the relatives they left on land. At least two episodes concern themselves with the practice of "coffin ships" in which unscrupulous owners deliberately overload unseaworthy ships and send them out into hazardous waters where they founder and sink, taking their crew with them, in order to claim insurance. Sailors and immigrants suffer death and injury, have limbs mangled and amputated, and catch dysentery, yellow fever, cholera, and sleeping sickness, among numerous other diseases; and with highly flammable and explosive cargoes, danger and depredation is never far away. Episodes also deal with the attempts to form unions to improve sailors' pay and conditions, strikebreakers, and the establishment of missions and orphanages to help the lot of the sailor and his family. Another common theme is the practice of "crimping" or "shanghaiing" unsuspecting sailors or landsmen by getting them drunk or beating them and forcing them aboard ship as crew. Similarly, several episodes also deal with slavery and the slave trade. The series did not shy away from depicting the atrocity of establishing capitalist spaces.

Yet despite this, the sea is still home to the merchant crews and their space of identification. In episode 3:1, when Samuel Plimsoll himself declares that he is determined to help "that most miserable creature—the British seaman," James responds by saying, "I think you'll find that seaman would prefer no other life." The national maritime identity here, therefore, is expressed not as the actions or deeds of fighting men of the navy, bound to institution and nation or the arcane symbols of nationhood expressed by the defeat of the Armada or Trafalgar, but by the commonality of experience shared by men and their communal day-to-day lives. The "lure of the sea" is not just a symbolic myth or a passive adjunct of the "tourist gaze" but a learned and tactile experience. The symbols of national identity migrate and morph in *The Onedin Line* from simple class-bound projections of institutional and national servitude to symbols less simple but no less potent, which foreground the tensions between sea and land. The landscape for which Higson and others describe as articulating a British national identity are not the bucolic landscapes of green fields and rolling pastures but the endless, undulating ocean and the liminal spaces of docks and shorelines in between.[24]

GENDER AND GENRE

The question manifests, therefore: what is it about *The Onedin Line* that created the space for this difference in conceptions of British identity and the maritime? One obvious difference lies in its televisual format. The advantage of the long-running series is the ability to develop themes and characters with nuance, which fluctuate over time, and even confound expectation. Cyril Abraham is quoted in *The Radio Times* as stating, "First it [*Onedin*] broke all the rules, for a series is essentially anecdotal in form and content, each episode telling a complete story. Onedin had the construction of a novel, in which the characters were involved in continuing development."[25]

This "novel" approach (along with the series lasting nine years) allowed for intricate stories and ensemble casting and for the audience to grow alongside the characters—a luxury not afforded to the myriad maritime-themed films that had proliferated in Britain until the 1960s. As pointed out, these tended to foreground the exploits of the navy at their core, but others that tackled other nautical themes—for example, shipbuilding (*Red Ensign*, 1934), smuggling (*The Ship that Died of Shame*, 1951), or whaling (*Hell Below Zero*, 1954)—were generally restricted to this narrow focus due to the film's standard running time of approximately an hour and a half.

Arguably the show's prestige status of "costume drama" allowed it to straddle boundaries. Again, the way the show juxtaposed different elements, like the adventure of sailing and the land-based mercantile activities, powerfully emphasized the tensions at the heart of nineteenth-century Britain. The show's use and arrangement of space exemplified this, with Liverpool docks representing the liminal boundary between the freedom and adventure of the seas on the one hand and the restrictions of society, business, and familial relations on land on the other. At the same time as the visual beauty and nautical panacea of sailing ships and the sea gave dramatic visual splendor to the maritime sequences, the land sequences functioned with an equal verisimilitude, and the female costumes in particular provided their own decorative splendor. This clearly allowed producers to appeal to multiple audiences. Put in simple binary terms, these were an intended male audience craving action and adventure and a female audience more interested in drawing rooms, costumes, and domestic drama.

The female characters in *The Onedin Line* also tended to elide different boundaries. While the sea sequences were dominated by males, women tended to dominate the other spaces, and James's first wife, Anne, and his sister Elizabeth were highly visible and highly vocal presences both on ships and in dockyards and business spaces, troubling the gendered boundaries of these masculine spaces. The odds were skewed in favor of male authorship with only one episode penned by a female writer and one directed by a female (Elaine Morgan wrote episode 2:3, "A Woman Alone," and Moira

Armstrong directed 1:3, "Other Points of the Compass"), but the emphasis on active rather than passive females dominated the series, despite the period setting. By eliding boundaries between the costume drama and the sea adventure, *The Onedin Line* conflated two versions of history: the "sanctioned version of the past" with what Alison Light describes as "that other history, a history from inside."[26] Light elaborates that this version of history privileges the place of private life in the national context, entwining the public and personal in the national story.[27]

Indeed, this seemed to irk sections of the right-wing press, particularly Peter McKay in the *Evening Standard* who wrote of the final series, "Since this salt-caked series first put to sea in October 1971 we have had equal rights legislation, and this now seems to be reflected in the story lines, despite the fact that they are all set in the last century."[28]

McKay added that Jessica Benton, who plays Elizabeth Fogarty/Onedin, "has become the small screen's answer to Vanessa Redgrave" and that "men dutifully cringe before the women, who run things both on sea and on land."[29] McKay also complained that the series was becoming "a whining wife on the ocean wave" with "trendy Women's Lib lines."[30] He especially lamented that Benton, who "at the start of the series would have been the dream hammock partner of many a mariner," has "turned into a glaring egomaniacal monster who makes Captain Baines look like a nancy boy."[31] An earlier interview with Ann Stallybrass (who played James's assertive wife in the first two seasons) appeared to vindicate McKay's concerns. An article, which appeared in the *Sun*, attempted to explain the early appeal of the series, concluding that "a ringside seat at the battle of the sexes" was a main consideration. It then quoted Stallybrass as saying, "I was discussing it with Jessica Benton, who plays Onedin's sister . . . we're both very anti-Women's Lib. But in those days, women really needed protection. If a woman walked out on her husband society turned its back on her."[32]

So if *The Onedin Line* did fall short of successfully "feminizing" British history, it did set out with clarity the terms of the imbalance. Such concerns further demonstrate the complicated form of national identity articulated in the series: that which challenged previous articulations of national identity surrounding the maritime sphere as hegemonic and almost unanimously masculine.

CONCLUSION

The Onedin Line remained popular until the final series and continued to be popular abroad, selling to over eighty-five countries.[33] It was most likely due to the weariness of lead Peter Gilmore with being typecast, along with the continually high cost of filming at sea, that eventually led to the series'

cancellation (the show was originally canceled after the third series when Gilmore initially declined further involvement). [34] Audiences flocked to exhibitions of the series' costumes at Greenwich, and the fate of the main ships, the *Charlotte Rhodes* and the *Christian Radditch*, [35] involved in the filming was regularly reported long after the show's cancellation, [36] suggesting the appeal of the age of sail to people in Britain. *The Onedin Line* therefore marks an important watershed for the projection of maritime and national identity on British television. [37] It tapped into British visual and maritime heritage and how the concept of an island nation and maritime landscapes created a form of collective identity in Britain. The sea is an important site for identity formation, but as *The Onedin Line* suggests, it is not uniform and fully prescribed. It is a site of danger and hard work as well as romance and adventure. Collective identity is framed not through conformity to secure military and institutional symbols of dominance but through hard labor and experience. The sea is projected very much as a masculine frontier but is complicated by the occasional transgression of gender boundaries and the vicissitudes of business and commerce, building a more complex notion of collective and national identity.

The show also set the tone for many future costume dramas on British television that engaged with maritime heritage. *To the Ends of the Earth* (2005) took the concept of the navy and the maritime as places of security and romance and inverted it still further, while Channel 4's *Longitude* (1999) suggested that Britain's dominance of the seas was as much the result of an obscure, uneducated watchmaker, toiling away in isolation to successfully solve the problem of nautical navigation, as it was of flagship naval victories. The BBC's adaptations of Jane Austen's *Persuasion* (1995 and 2005) both highlighted the tensions between naval officers at sea (respected heroes) and in polite society (circumspect), while on ITV, *Hornblower* (1998–2003) was cast in the mold of swashbuckling adventure more in tune with the successful *Sharpe* series (1993–2008). Similarly, *Downton Abbey*'s (2010–) opening episode dealt with the aftermath of the sinking of the *Titanic*, one of Britain's worst maritime disasters. The failure of ITV's *Making Waves* (a contemporary naval drama first broadcast in 2004 but canceled after three episodes) suggested that there was little interest in the contemporary navy after the 1970s: the navy's place was clearly in the past in the public imagination. It is difficult to pinpoint exactly why this may have been, but Victoria Carolan suggests a number of factors such as the disarmament movements in Britain since the 1960s, the continuing dissolution of the British Empire, and the shift of emphasis in teaching Britain's naval past in school history syllabuses, all contributing to the distancing and historicizing of the navy in the social sphere. [38] Crucially, Carolan points to the abolition of national service in 1960 as a catalyst for the estrangement of the larger British public with firsthand experience in the military, reducing the impact and relevance of

naval stories. Here, another comparison can be made with the Hollywood Western, whose ubiquity in film until the 1960s first transferred to television (*Gunsmoke, Rawhide, Bonanza*, etc.) and then whose central myths were subject to increasing revisionism as social changes instigated a questioning of traditional American history. As a founding myth of how modern Britain was built on warfare and aggressive commerce, depictions of the navy now fulfill a similar function, occasionally surfacing to interrogate history, or provide a romantic version of it. *The Onedin Line* clearly strove to perform both ritual functions.

NOTES

1. Peter Graham Scott, *British Television: An Insider's History* (Jefferson, NC: McFarland, 2000), 208.

2. Ibid.

3. Susan Rose, *The Medieval Sea* (London: Continuum, 2007), 3.

4. See, for example, Jeffrey Richards, *Films and British National Identity: From Dickens to Dad's Army* (Manchester, UK: Manchester University Press, 1997).

5. Jonathan Rayner, *The Naval War Film: Genre, History and National Cinema* (Manchester, UK: Manchester University Press, 2007).

6. Victoria Carolan, "British Maritime History, National Identity and Film, 1900–1960" (PhD diss., Queen Mary University, 2012).

7. Penny Summerfield, "Divisions at Sea: Class, Gender, Race and Nation in Maritime Films of the Second World War, 1939–60," *Twentieth Century British History* 22, no. 3 (2011): 330–53.

8. Victoria Carolan, "British Maritime History," 172.

9. See, for example, "'Small Island' Britain: Cameron Rejects Slight," *Sky News*, 6 September 2013, accessed 8 September 2013, http://uk.news.yahoo.com/.

10. Ann Day and Ken Lunn, "British Maritime Heritage: Carried Along by the Currents?," *International Journal of Heritage Studies* 9, no. 4 (June 2010): 295.

11. "Television Listings," *Times* (London), 15 July 1976, 6.

12. Sarah Monks, "'Suffer a Sea-Change': Turner, Painting, Drowning," *Tate Papers* (spring 2010): 3.

13. BBC press release, quoted in Sean Day Lewis, "Sea Saga More Like Sheltered Pool," *Daily Telegraph*, 16 October 1971 (British Film Institute archives).

14. Scott, *British Television*, 215.

15. Ibid., 222.

16. Martin Green, *Dreams of Adventure, Deeds of Empire* (New York: Basic Books, 1979), preface, 3.

17. Christine Geraghty, *The Fifties War Film: Gender, Genre and the "New Look"* (London: Routledge, 2000), 176.

18. See, for example, Richard Slotkin, *Gunfighter Nation: The Myth of the Frontier in the Twentieth Century* (Norman: University of Oklahoma Press, 1998).

19. *The Radio Times: Onedin Line Special* (London: BBC, 1973), 83.

20. Shaun Usher, "Television Review," *Daily Mail*, 18 September 1972 (British Film Institute archives).

21. Sylvia Clayton, "Television Review," *Daily Telegraph*, 13 November 1971 (British Film Institute archives). The *Tribune* also concurred, suggesting, "The sea runs in our English veins, no doubt" (Audrey Williamson, "Television Review," *Tribune*, 28 May 1976 [British Film Institute archives]).

22. Summerfield, "Divisions at Sea," 332.

23. See, for example, Raphael Samuel, *Theatres of Memory: Past and Present in Contemporary Culture* (London: Verso, 1994).

24. Andrew Higson, *Waving the Flag: Constructing a National Cinema in Britain* (Oxford, UK: Clarendon Press, 1995).

25. *The Radio Times*, 83.

26. Alison Light, *Forever England: Femininity, Literature and Conservatism between the Wars* (London: Routledge, 1991), 5.

27. Ibid.

28. Peter McKay, "Very Wavy Navy," *Evening Standard*, 25 July 1979, 18 (British Film Institute archives).

29. Ibid.

30. Peter McKay, "Meanwhile, Back on Our Own Ranch . . . " *Evening Standard*, 2 August 1979 (British Film Institute archives).

31. Ibid.

32. Gail Curtis, "All Aboard for the Onedins," *Sun*, 16 September 1972 (British Film Institute archives).

33. Scott, *British Television*, 231.

34. Shaun Usher, "Onedin Wants to Quit," *Daily Mail*, 5 January 1974 (British Film Institute archives).

35. *BBC Annual Report and Handbook 1983* (London: BBC, 1983), 78.

36. "Onedin Ship Sank Because Vital Repairs Not Done, Ex-Owner Claims," *Times* (London), 5 November 1985, 4.

37. Carolan, "British Maritime History," 294–97.

38. Ibid.

Chapter Eleven

Good-Bye to All That

Piece of Cake, Danger UXB, *and the* Second World War

A. Bowdoin Van Riper

Monarchs were deposed in the aftermath of the First World War, empires carved into nations, and the map of Europe literally redrawn. The effects of those changes shadowed the two decades following the armistice: wars and rumors of wars, the rise of dictators and the tottering of democracies, economic catastrophe and the threat of unrest (if not outright revolution) among the working classes. The British—part of Europe, however much they might have wished otherwise—felt the effects of the tumult, but it was buffered by Britain's geographic and cultural insularity. Beneath the glossy, modern surface of the 1920s and 1930s, echoes of the long nineteenth century lingered on in Britain. Only the return of total war, signaled by the renewal of German air attacks in the summer of 1940, snuffed it out for good.

Perhaps because of this quirk of history, British television costume dramas have embraced the interwar years. The plot arcs of *Upstairs, Downstairs* (1971–1975), *The Duchess of Duke Street* (1976–1977), and *Downton Abbey* (2010–) carry their Edwardian-era characters through the Great War and seamlessly into the 1920s. The series *Edward and Mrs. Simpson* (1978) stretches from the mid-1920s to 1936, while *Brideshead Revisited* (1981) and *To Serve Them All My Days* (1980) span the twenties and thirties. All of them, to varying degrees, present the era as a kind of Indian summer, a last moment in the sun for the Edwardian-inflected lifestyles of the upper classes before the winter of the Second World War.[1] Their settings—London townhouses, country estates, and rural boarding schools—isolate them from the slow-rising tide of modernity that would, in wartime, become a flood.

Danger UXB (ITV, 1979) and *Piece of Cake* (ITV, 1988) are about the flood. They share the form of the interwar costume dramas—limited-run series with richly detailed historical backdrops, large ensemble casts, and intertwined, character-driven plot arcs—but not their outlook. Set during the early years of the Second World War, they cut against the grain of the genre and consistently subvert its conventions. Their characters are overwhelmingly male, they center on the public rather than the domestic sphere, and they place work squarely in the dramatic foreground. Their focus on work, however, heralds a more audacious subversion of the genre. The two series are, at their core, tales of men defined by their knowledge and skills rather than by their wealth and social position. Inattentive, incompetent, and inflexible characters routinely fall and frequently die; the survivors, in turn, learn to be more focused, more skillful, and more adaptable. Equally important, they learn to develop an all-consuming focus on The Work and to embrace the values of the industrial age: speed, practicality, and ruthless efficiency.

The serialized Second World War drama was, by the late 1970s, a familiar and established subgenre in British television. A half dozen such series, along with the popular wartime comedy *Dad's Army*, aired in the decade before *Danger UXB* premiered; more, notably including the long-running *Allo Allo* (1982–1992), premiered in the decade that followed.[2] Both *Danger UXB* and *Piece of Cake* broke new ground, however, in their focus on combat operations and the historical precision of their settings. Rather than simply use the war as backdrop, they took place on the de facto front lines at particular, clearly identified moments within the war. They were, in this respect as well as in others, spiritual successors to *Wings*, a 1977–1978 BBC production about the Royal Flying Corps in the First World War.[3] *Piece of Cake* follows "Hornet Squadron" of the Royal Air Force (RAF), from the outbreak of war in September 1939 to the climax of the Battle of Britain—the German Luftwaffe's campaign to neutralize the RAF in preparation for a possible German invasion of Britain—in September 1940.[4] The first nine episodes of *Danger UXB* (out of a total of thirteen) take place between September 1940 and December 1941, during the aerial "Blitz" on British cities that Germany hoped would push Britain toward a negotiated peace. The series are thus centered on the period when Britain stood alone against Nazi Germany, "holding the ring" until the Axis powers' aggression brought the Soviet Union (June 1941) and United States (December 1941) into the war.

The Battle of Britain and the Blitz carry a heavy load of ideological freight in the popular memory of the war. They have come to represent (in Churchill's phrase) the "finest hour" not just of the servicemen who saved Britain but also of the British nation as a whole.[5] The two series tap into that mythology while simultaneously challenging key aspects of it. Where the popular image of the Battle of Britain and the Blitz frames those saviors as

the embodiment of prewar values, however, *Piece of Cake* and *Danger UXB* present them as symbols of a new cultural order. They depict the final disintegration of the world celebrated by more traditional costume dramas, but—far from lamenting its passing—they valorize the knowledge-driven, technocratic society that took its place.

MEN AT WORK

Costume dramas traditionally concern themselves with affairs of the leisured classes and those who serve them, but *Piece of Cake* and *Danger UXB* are dramas of the workplace. Both sets of characters are rarely off the job, and even when they are, work is never far away. The pilots rest on lawn chairs in the sun, but they are dressed in their boots and flying jackets, their aircraft only a minute's sprint away. The sappers take their tea breaks in mud-spattered coveralls,[6] gathered around a portable stove set up on a truck bed or an overturned crate. The handful of scenes in each series that take characters away from work are, even so, shadowed by it. *Danger UXB* uses the trope repeatedly, in settings both comic and tragic. Lieutenant Brian Ash, the central character, finds that his trysts with his married lover, Susan Mount, are complicated less by the actions of her husband than by urgent summons from headquarters. Corporal Jack Salt, one of his men, goes AWOL in the episode "Digging Out" in order to persuade his family to leave their frequently bombed hometown of Manchester for the safety of the countryside. Minutes after his arrival a German bomb hits the neighborhood, demolishing his house, killing his wife, and rendering his home indistinguishable from the rubble-strewn bomb sites in which he works.

The centrality of work shapes both series' presentation of their characters. Within the ensemble casts, individuals are framed as heroes or villains, admirable or despicable, according to their ability to get the job done. Innocence, charm, wit, integrity, and social grace—the virtues that define the heroes of prewar costume dramas—count for little. Focus, intensity, adaptability, and ruthless efficiency—the virtues of industrial capitalism and the factory floor—are everything. Characters who would have been banished to the fringes of traditional costume dramas thus move to the center of wartime ones.

Pilots Chris Hart and "Fanny" Barton, the closest thing to conventional heroes in *Piece of Cake*, set themselves apart from their fellow pilots by treating war as a serious business: something to be studied, worked at, and practiced with clinical efficiency. Hart, a wealthy American who flew for the Loyalist air force in the Spanish Civil War, is the only pilot in the squadron with combat experience. Barton—haunted by his role in mistakenly shooting down a British aircraft—becomes his protégé. In episode 3, for example, the

other pilots are exuberant over their first success against the enemy, but Hart remains unimpressed and coolly analytical. "It's a Mickey Mouse kill," he tells Barton as they examine the wreckage of the German bomber, "like rolling a drunk in the street." The squadron enjoyed a six-to-one numerical advantage with no interference from enemy fighters, he notes, and *still* scored only a handful of hits on their target. Hart—who has quietly adjusted his guns so that their streams of bullets converge only 250 yards ahead of his aircraft, rather than the RAF-mandated 400—tells Barton that he closes with the enemy and holds his fire until he cannot miss. "You should do it to, too," he says. "Next time it could be one-on-one instead of six-on-one." An episode later, Hart instructs a mechanic again in defiance of RAF practice—to install a steel plate behind the seat of his aircraft: rudimentary armor to protect him from shrapnel and bullet fragments in the event of an attack from the rear. The potential value of such protection is made manifest a few scenes later, when the squadron returns from a mission with one pilot's right hand mangled by bullets and the commanding officer (CO), Squadron Leader Rex, bleeding from a score of shrapnel wounds in his back.

The vindication of Hart's ideas about tactics takes more time and additional losses. Rex insists on using the RAF's standard prewar formation: predetermined attack patterns, and three-plane V formations in which the second pilot watches the leader's flanks and the third, "tail-end Charlie," covers the other three.[7] As combat intensifies and losses mount, the squadron's most experienced pilots—Hart, Barton, "Flash" Gordon, and "Moggy" Cattermole—grow increasingly dissatisfied with Rex's inflexibility. "We spent a great deal of time regrouping," Cattermole says in a postmission debriefing in episode 4, implying that the time and energy needed to fly tight formations would be better spent fighting the enemy. We go into battle in "a tidy, tight formation, flying wingtip to wingtip," Hart says after a rookie pilot is shot down in episode 3, quoting Rex's own words in a bitter, mocking tone. "It's supposed to terrify the Nazis." Barton, more measured and clinical, observes that the new man died because "tail-end Charlie looks out [for] the formation. We can't look out for him."

Change comes, eventually, by attrition rather than enlightenment. Rex's poor grasp of tactics catches up with him, and in episode 4 he is killed in a suicidal attack on a far superior enemy force. Barton steps into the role of squadron leader, with Hart as his de facto second-in-command, and it is Hart's tactics that he drills into the less-experienced pilots. Episode 5 opens with him reminding his pilots of what are, clearly, now standing orders: "Get in close, hammer the buggers hard, and then get out . . . don't take chances." The series frames the change in leadership as the triumph of the adaptable over the hidebound, and its architects as outsiders—Barton is an Australian rancher, Hart a wealthy American—who already possess the unsentimental, win-at-all-costs attitude the modern battlefield requires. Zabarnowski and

Haducek, refugees from occupied Europe who join the squadron when it returns to Britain, possess similar ruthlessness, fueled by a single-minded desire to avenge their homelands. A staff officer refers to them as "real killers," using the term approvingly and arguing that such men are precisely what Britain needs to survive.

The enlisted soldiers in *Danger UXB* are outsiders in a different sense: manual laborers in a society defined by its disdain for such labor and the working classes who perform it. To them falls the job of physically uncovering the bomb—shifting hundreds of pounds of earth, rock, and debris in the process—and creating a stable workspace around it. Once the fuse has been neutralized, they extract the bomb from the ground and load it into a waiting truck for removal. Their war is fought with spades, pickaxes, and wheelbarrows, an extension of their peacetime jobs as laborers, milkmen, and truck drivers. The bombsites depicted in the series are, overwhelmingly, in "ordinary" urban settings: working-class residential streets, factories, parish churches, and shops.[8] Their familiarity with, and comfort in, such settings is palpable, as is their *dis*comfort when they are dispatched to the stately country home shared by Susan Mount and her scientist-father, Dr. David Gillespie.

Country house and paid domestic staff notwithstanding, however, Gillespie is no member of the ruling elite. References to his prewar work in the mining industry suggest that he earned, rather than inherited, his money, and his wartime work as an explosives expert advising the Ministry of Defence on bomb disposal suggests a background in engineering or applied science, and a doctorate from the University of Glasgow or the Royal College of Mines rather than Oxford or Cambridge. Ash, though "an officer and a gentleman" by courtesy because of the lieutenant's pips on his shoulder boards, is likewise a man of no particular social distinction.[9] He drives an MG roadster, but insecurity over his family background, redbrick-university education, practical degree course (civil engineering), and makeshift officer's training render him awkward and self-conscious around the more polished, socially connected members of the prewar officer class.[10]

VALORIZING KNOWLEDGE

Ash and Gillespie, the men of 347 Section, and the pilots of Hornet Squadron are defined by their work, and their work is defined by machines. Their lives depend on their knowledge of the material world and their mastery of the tools used to manipulate it, and those qualities define the stories. The two series are tales of heroic actions but also of accumulating expertise. They take place in worlds where knowledge is strength and the fate of the nation rests in the hands of people who make it their business to know things.

The equation of knowledge and strength is particularly prominent and straightforward in *Danger UXB*, which takes place in a world where that which does not kill the heroes makes them smarter. Brian Ash enters the story fresh from training: a tabula rasa who knows little of military protocol and nothing of bomb disposal. He is, however, a compulsive seeker after knowledge, willing to talk to anyone who will supply information he lacks. The first episode, "Dead Man's Shoes," opens with a string of such moments: Ash in his car, asking a pair of schoolboys for directions; Ash at what he believes is his new unit's headquarters, asking for confirmation from the corporal of the guard; and Ash in a briefing room, receiving a crash course in German bombs from more experienced officers. On his first field assignment, he begins, once again, in complete ignorance. His unflappable Scottish second-in-command, Sergeant James, schools him on which tools to use and remains at his side, quietly offering advice, as he makes his first approach to the bomb. Ash orders the obviously reluctant James to safety only when he is ready to extract the bomb's fuse, an act that military protocol, and his own sense of honor, require him to perform alone.

In waving Sergeant James off, Ash implicitly declares that he is knowledgeable *enough* to attempt defusing his first bomb. His success (and thus survival) confirms that belief. The first stage of his education ends when he emerges alive from the pit, but the larger process of his education continues. Each subsequent episode introduces new information that Ash must master if he is to survive: larger bombs, booby-trapped fuses, and new tools for neutralizing them. He and his fellow officers are shown constantly learning: formally from manuals and technical briefings as well as informally from conversations with each other. The enlisted men enter the story already knowledgeable, but they, too, steadily expand their expertise, applying their knowledge of basic physics (ramps, pulleys, levers, and pendulums) to new challenges. Episode 7, "Digging Out," has Ash confronting a new type of bomb while—elsewhere in the same bombed-out factory—Jack Salt and three fellow sappers use an improvised derrick to shift a second bomb and free a young woman trapped in the wreckage beneath.

Piece of Cake draws a similar link between strength and knowledge. Hart's combat experience in Spain makes him, early in the series, the most formidable pilot in the squadron. What the others are in the process of learning—and *must* learn, if they are to survive—he already knows. Later in the series, Barton, Cattermole, and Gordon—by then veterans themselves—follow his lead in criticizing Rex's prewar tactics, arguing for the primacy of hard-won experience over abstract doctrine. On the ground, intelligence officer "Skull" Skelton uses gun-camera footage, and the probing questions he asks during after-action debriefings to separate the actual numbers of enemy aircraft destroyed and damaged from the (invariably higher) numbers reported by the pilots. Good faith and earnest belief are not enough, he argues

in response to the irritation—or outright hostility—this engenders. War is serious business, and it is essential to *know*.

Both series' most powerful equation of knowledge with national strength takes place, ironically, at the margins of the story. The pilots in *Piece of Cake* are far more effective in defense of Britain than they were in defense of France because they know where, when, and in what strength the enemy is attacking. They thus go into battle forewarned and forearmed, with no need to waste time, fuel, attention, or other scarce resources seeking out their targets. Ash and the other bomb-disposal officers in *Danger UXB* receive a steady flow of information about German bombs, their fuses, and how best to disable them.

The source of these streams of information—left (almost) entirely off-screen—is a vast network of individuals intimately engaged with a complex system of machines. The pilots of Hornet Squadron are guided to their targets by the RAF's centralized fighter-control network, which draws its information on incoming enemy aircraft from a chain of coastal radar stations.[11] Susan Gillespie assists her scientist-father in developing better tools for disarming German bombs, but they are part of a network of thousands of scientists and technicians working in laboratories all over Britain to further the war effort. Susan's husband is kept away from her (enabling her affair with Ash) by his own work in cryptanalysis, making him another part of the military-industrial-university complex that will shape the postwar era. Neither series spends much time explaining these realities—assuming, perhaps, that viewers will easily recognize the beginnings of the world in which they live.

GOOD-BYE TO ALL THAT

The collision between the emerging postwar world and the dying prewar one is, in both series, a source of tension and conflict second only to the war itself. The gulf of incomprehension that separates junior officers from senior ones aligns, precisely and consistently, with the fault line dividing the two worlds. Similarly, in *Piece of Cake*, the cultural chasm divides the English pilots from those born in the provinces, or abroad. The defense of Britain in 1940–1941 was led, both series suggest, by men who—on the whole—had little connection with, and often less regard for, the prewar order of things.

Danger UXB's embodiments of the prewar world—the three senior officers of the 97th—are acutely aware of and (more often than not) befuddled by its passing. Lieutenant Leckie, the adjutant, whose beefy frame and luxuriant mustache evoke the 1910s, is an amiable but ineffectual time-server constantly recalling how things were done "in the last war." Major Luckhurst, the CO who welcomes Ash to the unit, is more conscientious as well as

more imaginative. All too aware of how ill prepared he is to lead a bomb disposal unit, he muddles through knowing that his time has passed. Captain Francis, initially the executive officer, actively tries to hold back the passing of the old order. When he becomes CO, he incites a near mutiny among the younger officers by demanding that they adopt the time-consuming spit-and-polish and elaborate social rituals of peacetime rather than the scruffy, informal efficiency of wartime.

The senior officers in *Piece of Cake* are, if anything, even more out of touch with the realities of modern warfare and even more determined to preserve the gentility of the prewar world. Rex, the CO, orders fine food and wine from Harrods for the officers' mess and pays for it out of his own (evidently vast) personal fortune. When the squadron is posted to France, he requisitions a country estate to serve as their barracks and has his personal automobile shipped (and pet dog flown) across the channel to join them. Skelton, the intelligence officer, aptly describes his leadership style as "almost feudal": he dispenses largesse in the form of food, wine, and plush accommodations but demands absolute personal loyalty from the pilots in return. The pilots—with the notable exceptions of Hart and, to a lesser extent, Barton—follow his example, acting like sons of landed gentry or upperclassmen at an elite boarding school. They toboggan down staircases on tea trays, play rugby with a chamber pot in the library, and enjoy lavish meals in what Rex's superior officer, Air Commodore Bletchley, calls "the only decent officer's mess" in the area.

Rex's behavior is part of a broader attempt, abetted by squadron adjutant and First World War veteran "Uncle" Kellaway, to carry prewar cultural norms into wartime. The CO openly plies Bletchley with food and wine, and directs the collection of "trophies" (bits of wreckage) from the downed bomber as if the base were a hunt club. Kellaway cautions Hart against lecturing others on lessons learned in Spain on the grounds that too much "shop talk" is bad for morale, and Rex dismisses the conflict there as "not a real war." Later, the adjutant reproves Skelton for his enthusiastic embrace of gun cameras. His determination to know "what really happened" in battle is, Kellaway insists, an affront to the pilots, who—as officers and gentlemen—should be taken at their word when they report the number of enemy aircraft they destroyed and damaged. Bletchley, too, seems determined to deny the reality of war. Summing up the geopolitical situation as the Nazis overrun France, he uses an elaborate football metaphor, expressing satisfaction that Britain now has "home-ground advantage" for the "final" with Germany. All three—like the senior officers in *Danger UXB*—belong to a world that, they sense, is crumbling around them, never to be rebuilt.

The younger men, too, recognize that the Edwardian-tinged prewar order is crumbling, and something else—its shape not yet apparent—is rising in its place. The enlisted men's comments on arriving at Gillespie's country house

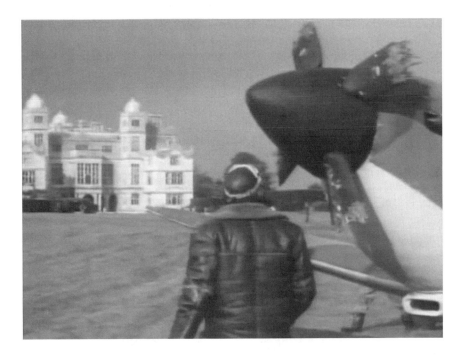

Figure 11.1. The pilots of Hornet Squadron wage modern, high-tech warfare in their Spitfire fighters but live amid the "nearly feudal" atmosphere created by their aristocratic commander in a requisitioned French chateau. (*Piece of Cake*, episode 4).

in the episode "Cast Iron Killer" hint at the forces that brought the Labour Party to power in the last months of the war. One observes that "it's one war for this lot and another one for us, in't it?" and another that their own lot didn't seem bad until they experienced privilege. Lieutenant Skelton, in the same speech where he describes Rex's leadership as "feudal," muses that Barton's is "almost democratic." Moggy Cattermole, meanwhile, becomes one of the squadron's most effective pilots by casting aside the once-stringent "rules" of war and embracing his inner sociopath. He shoots down unarmed German rescue planes over the channel, machine guns downed enemy pilots in their rafts, and berates a newer pilot for his squeamishness about doing the same. Bletchley quietly commends him for his initiative but orders him never to mention it. "The public," he says, "would never understand."

Cattermole's ruthless cost-benefit analysis extends, as well, to his own countrymen. Early in episode 6, he bails out of his Spitfire after it suffers a catastrophic engine failure, and (without a pilot's hand on the controls) it

crashes into a row of houses and kills four civilians, including an infant. Criticized by Skelton for not staying with the aircraft longer, he retorts, "I don't have an ounce of gallantry, and I don't intend to get myself killed to save three and a half [civilians] . . . it's their war as well, you know. They're always saying this is a 'people's war.' Well, now they know what it's like."[12] Skelton, appalled, acidly reminds him that "they used to say women and children first," but the pilot is unmoved. "Did they," he says. "But they can't fly Spitfires, can they?" Moggy is portrayed, throughout the series, as a callous, self-centered bully. He is also, however, the character who most consistently speaks the absolutely unvarnished truth, leaving viewers to wonder if he might have a point.

The series' ambiguity toward Moggy's ruthlessness is prefigured by an earlier scene, from the end of episode 4. As France crumbles and Hornet Squadron prepares to evacuate, Squadron Leader Rex's dog stands outside the chateau, still awaiting the return of his dead master. Barton—a rancher's son turned pragmatic war leader and the series' most consistently sympathetic character—considers the animal for a moment and then draws his service revolver and shoots it. There is no room for dogs on the transport aircraft and no room for Edwardian sentimentality in modern war.

CONCLUSION: BRAVE NEW WORLD

Britain emerged from the war determined to defend its dominant position in global affairs and with good reason to expect success. It still possessed a global empire, was less damaged by the war than any major power save the United States, and had developed many of the technologies that would define geopolitical power in the postwar world: the early warning radar network, the jet engine, and the digital computer among them. Britain pursued that dream through the 1950s and into the early 1960s, committing itself to developing homegrown versions of the high-status technologies of the era. Postwar "boffin films" like *The Sound Barrier* (1947) and *The Dambusters* (1954), along with novels like Nevil Shute's *No Highway* (1948) and Arthur C. Clarke's *Prelude to Space* (1951), celebrated the dream in fictional form, imagining a world in which Britons, having helped the war with their technological ingenuity, went on to define the postwar world and ensure Britain's continued preeminence in it.[13]

Reality proved, in the end, to be more complicated. Shorn of its empire, and reduced to junior-partner status in Cold War diplomacy, Britain lost most of its geopolitical influence and with it most of its justification for resource-intensive enterprises such as supersonic aviation, space travel, and a homegrown nuclear deterrent force. Economically and technologically, too, Britain emerged into the shadow of the United States. Its global influence, and

reputation for cutting-edge innovation, increasingly rested—as the 1950s gave way to the 1960s—on culture: sports, fashion, and the arts. That shift rendered the cultural gulf between prewar and postwar Britain even more pronounced. The "boffins" of the 1940s and 1950s (real and fictional) had come from outside the traditional elites but made common cause with them. The leading cultural figures of the 1960s—the ones who made Britain's influence felt beyond the British Isles—were likewise "outsiders" but ones who defined themselves and their work in opposition to the cultural institutions of the recent (that is, prewar) past. [14]

Piece of Cake and *Danger UXB*, which depict the first stirrings of those changes, were products of the Thatcher era, when the changes came to full fruition. [15] Thatcher was a grocer's daughter and university-trained scientist whose political base lay outside the traditional public-school and Oxbridge elite, and both series reflect her political style: hard edged, ruthlessly practical, and intolerant of tradition for its own sake. Their heroes, though themselves apolitical, are presented as heroic because they embody distinctly Thatcherite virtues. Fanny Barton, Flash Gordon, Brian Ash, and Jack Salt come from the social margins of the Anglophone world: from the sheep station, the building site, the mines, and the redbrick university. They are practical men, masters of machines and products of a world shaped by them, whose lives are shaped by work rather than leisure and who value efficacy over tradition. They are—as the "Iron Lady" saw herself—heroic *because* they are uncompromising in pursuit of their goals, willing to defy convention and trample the sensitive feelings of others when the survival of the nation is at stake. They are the architects (though perhaps unwittingly so) of the world that postwar Britain will become: the world of Orwell and Pinter, Jagger and Daltrey, Margaret Thatcher, and Manchester United. If the characters in traditional prewar costume dramas embody Britain's self-assured past, then their wartime equivalents—Hornet Squadron and 347 Section—stand for its uncertain future.

NOTES

1. For the flavor of the period, see Robert Graves and Alan Hodge, *The Long Week-End* (1940; repr., New York: Norton, 2011).

2. These series typically focused on small "home-front" communities (*Dad's Army*, *Enemy at the Door*, *Private Schulz*, and *Allo Allo*) or members of the Allied forces behind enemy lines as prisoners (*Colditz*), evaders (*Manhunt*, *Secret Army*), or covert agents (*Wish Me Luck*). *Pathfinders*, a 1972–1973 series about a Royal Air Force unit assigned to mark targets for night bombing raids, was unusual for the period and the genre in that it dealt with combat operations.

3. Much of *Wings* takes place during the era of the "Fokker Scourge" (roughly July 1915 to January 1916) when Allied—particularly British—aircraft were markedly less sophisticated, and thus more vulnerable, than the German fighters they faced in combat. Its focus on issues of class and technical expertise (the hero, son of a provincial blacksmith and amateur aviator, is

commissioned an officer because his technical experience trumps his low social standing) prefigures that in the series discussed in this chapter.

4. The scholarly and popular literature on the Battle of Britain is vast, but Richard Overy, *The Battle of Britain* (New York: Norton, 2011), and Paul Addison and Jeremy A. Crang, eds., *The Burning Blue* (London: Faber and Faber, 2011), provide a useful introduction.

5. On the popular memory of 1940–1941, see Angus Calder, *The Myth of the Blitz* (London: Jonathan Cape, 1991); Malcolm Smith, *Britain and 1940* (London: Routledge, 2000); S. P. MacKenzie, *The Battle of Britain on Screen* (Edinburgh, UK: Edinburgh University Press, 2007); and Garry Campion, *The Good Fight* (London: Palgrave Macmillan, 2010).

6. In the Royal Engineers, "sapper" is the rank equivalent to "private" in other branches. The name derives from "sapping"—undermining enemy fortifications by tunneling—which was once a principal mission of combat engineers.

7. Overy, *Battle of Britain*, 73.

8. The celebration of "ordinary" (that is, working-class) Britons began during the war itself. See Anthony Aldgate and Jeffrey Richards, *Britain Can Take It* (Oxford, UK: Blackwell, 1986), 218–45.

9. Ironically, Ash is played by Anthony Andrews, who two years later would play the aristocratic Sebastian Flyte in *Brideshead Revisited*.

10. On the persistence of class snobbery in the British armed forces during this era, see Clive Ponting, *1940: Myth and Reality* (London: Sphere, 1990).

11. Overy, *Battle of Britain*, 43–47.

12. "People's War" was a propaganda term intended to allay Soviet and American suspicions that Britain was, primarily, fighting to preserve its empire. On the sociopolitical realities of the "People's War" in 1940–1941, see Calder, *Myth of the Blitz*; and Richard North, *The Many, Not the Few* (New York: Bloomsbury, 2013).

13. On the origin of "boffin" (roughly, "eccentric technical wizard") and the postwar "boffin films," see Christopher Frayling, *Mad, Bad, and Dangerous* (London: Reaktion Books, 2005), 171–95.

14. Mark Donnelly, *Sixties Britain: Culture, Politics and Society* (London: Routledge, 2005).

15. Margaret Thatcher served as leader of the Conservative Party in opposition from 1975 to 1979 and as prime minister from 1979 to 1990. *Danger UXB* appeared in the year of her first general election victory (1979), the novel *Piece of Cake* in the year of her second (1983), and the television adaptation of *Piece of Cake* in 1988, two years before her general election defeat.

Chapter Twelve

Upstairs, Downstairs (2010–2012) and Narratives of Domestic and Foreign Appeasement

Giselle Bastin

The 2010–2012 BBC production of *Upstairs, Downstairs*[1] marks a fascinating departure from its original 1970s series[2] for the ways it engages in contemporary debates about historiography about Britain in the interwar period. The new series, despite filling its episodes with stock appearances by important historical figures and famous events from the period, avoids some of the more simplistic representations of 1930s Britain by situating one of its main protagonists, Sir Hallam Holland, as a compromised character within the various discourses that feed into the overarching theme of domestic and foreign appeasement. By making the master of the house an equivocator in his domestic affairs in ways that mirror the Chamberlain government's confused dealings with the German leadership throughout the late 1930s, the new *Upstairs, Downstairs* gives a partial nod to many postwar debates about appeasement while resisting the tendency of many other popular representations of the period that paint England's relationship with prewar Germany in a simplistic light.

CROSSCURRENTS BETWEEN THE 1970S AND
2000S *UPSTAIRS, DOWNSTAIRS*

Conceived by two well-known English actresses, Jean Marsh and Eileen Atkins (both of whom appear in the 2010 remake), both the 1971–1975 and 2010–2012 series trace the interconnecting lives of the above- and below-stairs characters across a selection of historical moments in the early twenti-

eth century. In the original series, the head of the house is Sir Richard
Bellamy, a Tory peer, who is married to Lady Marjorie, an earl's daughter.
Sir Richard and Lady Bellamy have two children, James and Elizabeth, and a
below-stairs "family" of servants consisting of Hudson the butler, Mrs.
Bridges the cook, parlormaid Rose Buck (who returns in the 2010 series),
Alfred the footman, Ruby the kitchen maid, and Sarah the feisty under-house
parlormaid who, despite dreaming of better things, nonetheless becomes en-
tangled with the chauffeur, Thomas. In the new series, Eaton Place is re-
opened for business under the ownership of one of Britain's "sons of em-
pire," Sir Hallam Holland and his wife, Lady Agnes, a daughter of an impov-
erished earl from an ancient family. Hallam and Agnes preside over an up-
stairs world that consists of Lady Agnes's sister, Lady Persie Towyn; Lady
Maud Holland (Hallam's mother); and Dr. Blanche Mottershead, who is
Lady Maud's half-sister. Downstairs is run by Mr. Warwick Pritchard, the
butler; Mrs. Thackeray the cook; Mr. Amanjit Singh, Lady Maud's personal
servant; Johnny the footman; Eunice the parlormaid; Mrs. Buck the house-
keeper; and Beryl, the feisty nursery-cum-lady's maid who by series' end
marries the chauffeur, Spargo.

 According to Carl Freedman, the original series depicts an England that
"never quite existed" but that corresponded "to what an England in the early
seventies dearly wished itself to have been."[3] Further, aired on America's
high-brow *Masterpiece Theatre*, the original series acted as "a sort of finish-
ing school conducted by the former chief imperial power for the current
one."[4] America like Britain was undergoing a period of economic hardship,
and this produced a ready-made audience for *Upstairs, Downstairs*, one in
need of escape from contemporary realities such as Watergate and Vietnam.
Moreover, the program's depiction of the decay of the Edwardian system of
social order, best summed up by the suicide near the end of the original series
of the Bellamy's wayward son after he gambles away the Bellamy "empire"
on the stock market, gratified the American audience's feelings of "*invidia*"
that the former colony felt for its "Mother country."[5] James Bellamy, as
Freedman summarizes, is accused by his father, Sir Richard, of having "en-
joyed virtually every advantage for which a young man might wish—inde-
pendent wealth, intelligence, social prominence, good looks . . . and yet . . .
has made a record of unbroken failure at every serious endeavor to which he
has set his hand."[6] This sense of a class in decline and beset by a deficit of
moral and social leadership is taken up with renewed vigor in the contempo-
rary series.

 Like the original series, where British history is "refracted through the
Bellamy household,"[7] the new series has been accused of assuaging the
audience's uncertainties about the present and producing "a text not unduly
disturbing to middle-class sensibilities."[8] According to Jenny Diski, the con-
temporary BBC production of *Upstairs, Downstairs*, like its rival on ITV,

Downton Abbey, distracts from the present while also eliding aspects of the past. The "past," she suggests, is reduced to a set of easily identifiable signifiers, ones that a modern audience can recognize easily and engage with on a superficial level; both *Downton Abbey* and *Upstairs, Downstairs* are characterized by taking "a familiar time, drawing a horizontal line along an axis, and marking it out with peak events everyone has heard of, weighting them with their most commonplace interpretations. This is then used as a moving backdrop in front of which the cast stand still and mime their progress while reiterating received opinions."[9]

What Freedman identifies as the "elegiac tone" of the original is replaced in the new series by an awareness that the social and ideological structures embedded within the narrative structure of the 1970s 165 Eaton Place are no longer viable. This is because the thirty-year intermission between the old and new series has been marked by some important changes in the growth of the popular heritage market generally, particularly in the ways that contemporary audiences expect their "history" to be presented. The contemporary series sets out to inform audiences about a "past" that audiences would now recognize as being refracted through a contemporary vision of how the "past" has been shaped by earlier narratives about the period under review. In the intervening years since the 1970s, audiences have been fed a steady diet of narratives about Britain's history through both fictional and nonfictional accounts, as well as from a history industry that has trained audiences to interpret the past through multiple historiographic lenses.

PLACES, PLEASE: 165 EATON PLACE RECOMMENCES

The new series of *Upstairs, Downstairs* opens in the year 1936, with the arrival of Sir Hallam and Lady Agnes to a dingy and dustcloth-covered 165 Eaton Place. The promise of new beginnings after the departure of the Bellamys marks the tone of the early scenes of series 1. Hallam's mother, Lady Maud, has come to the house, bearing the remnants of empire in the shape of her pet monkey, Solomon, and her manservant, Mr. Amanjit Singh. Where Lady Maud sets about cataloging her bric-a-brac from her time in India, and reciting her memoirs about her time as the wife of a colonial ruler, her daughter-in-law Lady Agnes sets about redecorating Eaton Place and overseeing the employment of the band of servants who will run the house. Early scenes such as one where a cast-iron bath crashes over the balcony into the foyer below, one in which Lady Agnes has a very near miss, serve as prescient reminders that all the papering over of the walls of Eaton Place cannot cover the fractures that are starting to appear in the delicate fabric of 1930s British society. Good servants are hard to come by—a realization that dawns slowly on Lady Agnes and is exemplified in the first episode by the parlor-

maid Ivy's painted nails that she keeps hidden beneath her gloves. The flash of red on Ivy's fingertips sends an early warning signal that the 1930s servant class is on the brink of rebellion, a rebellion that will be hastened by the onset of war.

Lady Agnes's domestic "setting in order" of Eaton Place is counter-pointed by a subplot involving the 1936 abdication of King Edward VIII, who, in his desire to renounce the throne to pursue his own interests and be with the woman he loves, sets the tone for all the incidents of the abrogation of duty that are about to beset this small corner of the fallen empire. Hallam and Agnes's existence at the heart of London society is established early with their trying to do their bit by rallying behind their friends the Duke of Kent and Anthony Eden, who want a media cover-up of details of the king's affair with the divorcee, Mrs. Simpson. Their efforts coincide with Mrs. Simpson's introduction of the figure of Herr Ribbentrop, the German ambassador to London, into their home that, like the plummeting bath scene in episode 1, presages the tragedy that will beset the household in the coming years. Anthony Eden's command that Hallam "get his house in order" and eradicate the poison at its core establishes early that Eaton Place serves to represent the site of domestic upheaval that is about to have its full expression in Britain's compromised position on the international stage.

After setting the scene with the abdication of Edward VIII, the new series uses as its organizational framework the time line and coordinates of Britain's descent into war with Germany throughout 1936 and 1939. The mapping of the fate of the Holland household according to key turning points in Britain's road to war signals the new series' intention to merge personal and public histories of Britain's prewar period. Where the original 1970s series used historical events of the day such as the suffragette movement and the First World War as backdrops to the lives of the characters, the new series embeds events in interwar social history within, not only the content of the story line, but also the structuring of the narrative itself. "History" here moves away from being a backdrop to the story and becomes instead a structuring principle of the main plot. This is most clearly expressed in the structuring of Hallam's and Persie's affair according to Britain's flirtation with, and seduction by, the Nazi regime in what becomes a convergence of public and personal history.

"CAUGHT NAPPING": HALLAM, PERSIE, AND MUNICH

After the abdication of 1936, *Upstairs, Downstairs* moves on to cover the 1938 Anschluss, which saw Germany's annexation of Austria, an annexation that coincides with Lady Persie's arrival at Eaton Place and her eventual move to Munich where she can be nearer her German lover, Friedrich. While

in Munich in 1938 to oversee the signing of the Munich agreement with Prime Minister Chamberlain, Hallam has his first intimate encounter with his sister-in-law, an event that prefigures his concerted effort to get Persie out of Germany following the horrors of "Crystal Night." The second episode of the second series, titled "The Love that Pays the Price," offers a portent of what awaits Persie, Hallam, Eaton Place, and Britain by series' end. Persie's and Hallam's affair begins in earnest during the same period that Germany enters the Sudeten territories of Czechoslovakia, also in 1938, and by series' end Lady Agnes and the below-stairs staff will have discovered Lady Persie's "treachery"—both "domestic" in terms of her affair with her brother-in-law and "foreign" in terms of her dealings (both sexual and political) with representatives of the German government. Persie, whose name closely resembles "perfidy," becomes the ultimate symbol of domestic and foreign betrayal in the story line as a whole. When confronted by Agnes, who demands to know when Hallam's and her treachery began, Persie shoots back, "Munich, if you must know!" After Britain declares war with Germany, Persie, under threat of state arrest under the Emergency Powers Clause 18B, topples over the bannister and meets her demise in the well-tiled foyer of Eaton Place. From her appearance in series 1 as the disaffected and rootless daughter of an ancient and declining aristocratic family, Persie becomes the symbol of the collusion of her class and her government on the road to war with Germany. Her early flirtation with the figure of German foreign minister Herr Ribbentrop is juxtaposed with her relationship below stairs with the chauffeur, Spargo, who for a time shares her fascination with Oswald Mosley's fascistic Blackshirts. As historian David Cannadine has noted about the proliferation of figures like Lady Persie in this period,

> During the interwar years, many disappointed and déclassé aristocrats held opinions that were remarkably similar to Mosley's: they regretted and resented the decline of their class; they hated capitalists, especially Jews; they despised democracy and parliamentary government; they were attracted by the authoritarian regimes on the continent; and they wanted peace with Hitler. Viewed against this broader historical background, Mosley may usefully be seen as the supreme example in his generation of patrician resentment, aristocratic paranoia, and upper-class marginality. [10]

Yet, although she forms the repository of much of the guilt and treachery that informs the main story line of the new series, Persie is not alone in being implicated in the narratives of domestic and foreign appeasement throughout the two series. She is unwittingly, though enthusiastically, aided in her downfall by Hallam, who despite his frequent expostulations about the evils of appeasement in his public life, is soon identified to be as much an equivocator in his domestic affairs as are Chamberlain and his Whitehall cronies in European diplomacy. It is Hallam who covers for his sister-in-law when

Persie aborts Friedrich's baby. Persie's squalid backroom abortion (albeit one brought to realization in the comfortable surrounds of the Whitehall hotel of choice, the Dorchester) and Hallam's aiding of the tragic and risky procedure reflect the squalid backroom attempts by those in power in Whitehall to make a deal with Germany, thereby aborting their duty to England and its people. Hallam's sense of duty to his country is tested at one stage by the Duke of Kent, who asks him to act as courier for a letter that his brother, King George VI, has written personally to Hitler: Kent says, "You believe in England, don't you?" And Hallam answers, "Always." Yet he stands as a bulwark against appeasement in foreign policy, a policy, as the duke's request suggests, that reaches the highest forms of government. That Hallam is blind to how his own behaviors compromise the future of his home forms the tragedy at the heart of this story.

"SHUFFLING OFF THE HEAVY CLOAK OF HINDSIGHT"

Hallam's opposition to appeasement, alongside the subplot that sees him "caught napping" with Persie—in much the same way that Hitler is quoted in the program as suggesting that Chamberlain's Britain has been "caught napping"—suggests a willingness on behalf of *Upstairs, Downstairs'* producers and writers to engage with some of the complexities of the debate about prewar appeasement.[11] Hallam expresses early and repeatedly his disagreement with what he sees as the folly of Britain's negotiations with Germany. Despite being warned off his antiappeasement views by his boss, the foreign secretary Lord Halifax in episode 1 of the second series, he stands firm and tells his friend the Duke of Kent, "We are facing an all-out ideological

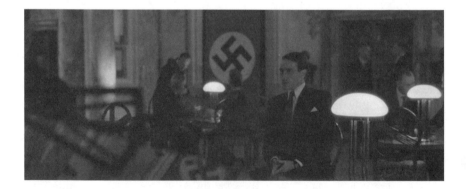

Figure 12.1. Hallam Holland in Munich, "A Faraway Country About Which We Know Nothing" (*Upstairs, Downstairs*, episode 2:1)

war. . . . I cannot sanction 'peace at any price' . . . [we will] have to pay in blood."

It is Hallam who offers an early voice of warning to Persie during her time as a Blackshirt, telling her, "Persie, you have embraced an ideology that you do not understand," and it is Hallam who exhorts Agnes to give up dreams of moving to America just as England is "being pushed to the edge of the abyss!" In a characteristic gesture prominent in many contemporary explorations about Britain's lead-up to the Second World War, Hallam proves to be a warning voice about what the rise of the Nazi regime will mean for Germany's Jewish population and other marginalized groups. For example, it is he who brings his Down syndrome sister, Pamela, to live at Eaton Place, and despite some resistance on his part, he also allows his homosexual aunt to continue living in the house (although he continues to refer to her in the parlance of the time as an "invert"); most importantly, he takes responsibility for the well-being of the young Jewish girl, Lotte, after her mother, Rachel Perimutter, dies from an asthma attack brought on by her shock at witnessing fascist violence in London. All of these characters prefigure those who will be the most vulnerable victims of the oncoming Nazi terror. That they are the people who are already scorned, hidden, and marginalized by their British countrymen and countrywomen contributes to the program's central motif that the problems that Britain faces in the coming war are ones that are already in evidence at home. To Persie's nonchalant refusal to return from Germany and her teasing of Hallam that he is the only person she knows "who seems to think the world is going up in flames; everyone else has been all smiles since Munich," Hallam replies presciently, "I think the Jewish population might disagree with that."

Hallam's stance on the threat facing Germany's Jewish population, one that sees him sense—unlike most of his countrymen—the dangers that are to come, at first reflects a propensity in popular representations of the period to elide or suppress moments in public history that do not suit public discourses about Britain's prewar history. For example, films such as Stephen Poliakoff's *Glorious 39* (2009)[12] and Richard Loncraine's *Gathering Storm* (2002),[13] based on Winston Churchill's war journals, present either two-dimensional, corrupt aristocratic arch-appeasers (Poliakoff) or otherwise clear-visioned, aristocratic arch-antiappeasers (Loncraine). Neither *The Gathering Storm*'s nor *Glorious 39*'s protagonists display the slightest degree of equivocation about their stance about Germany, be it supportive or condemnatory; interwar political history, as these films tell it, is, to quote literary theorist Michael André Bernstein, "inevitable simply because it happened."[14] Yet, it is in Hallam's opposition to what we would now recognize as "an already established future,"[15] along with his complicity in treachery at home, that distinguishes this program from films such as *Glorious 39* and *The Gathering Storm* that seek to elide the degree to which debates about

appeasement, both before the war and since, have been tinged by shades of gray. Knowing as we do the horrific outcomes of the Second World War and the Nazi atrocities, historiographical accounts of the period are more often than not filtered through a lens that implicates the appeasers of Nazi Germany in the atrocities themselves. Yet, as noted historian William R. Rock says of this period, appeasement was imbricated in Britain's domestic as well as foreign policies:

> Appeasement was as much a stepchild of British domestic politics . . . as a reaction to the Nazi regime. No students of interwar history can fail to be impressed by the troublesome internal divisions of English society, the degree to which unsolved economic and social problems absorbed the nation's attention and energy, and the uncertain vacillations in political life and attitudes that resulted therefrom.[16]

Hallam is a comparatively rare creature, therefore, in the pantheon of programs about this period. In series 2, episode 5, he can walk away from his affair with Persie with the words, "I'm walking away from a lethal situation," but the viewer knows, even if he does not, that it is already too late for Eaton Place. The figure of Lord Halifax is able to say to Hallam, when he finally realizes the Nazis' true intentions, that "it is all very easy to see where it will end," but the fact that Hallam has been able to see all along where the Nazi threat "will end" while being blind to what his domestic maneuverings will mean for his household and his marriage suggests an awareness at narrative level of the vagaries of historical foreshadowing and backshadowing.

Just as in other fictional representations of this period, the new *Upstairs, Downstairs* depicts a convenient repository of fascistic sympathies in the guise of the character of Persie. Her role as a Mitford-esque young aristocrat ("To other people I'll always be the brainless younger sister who fell in love with the Nazis") is to reflect her and her class's sense of disaffection with its declining status in British society, while allowing also for the creation of distance between her and other fair-minded English countrymen and countrywomen who did not share her views. The idea that her "foreign" treachery is mirrored in her activities at home where her allure has embroiled Spargo as well as Hallam suggests nonetheless that her toxic ideological views have permeated both upstairs and downstairs; Persie, in other words, does not represent an evil "other" but offers a snapshot of British ideological sympathies of the time. Having acted as a traitor to her family and her country, it is perhaps inevitable that she must die, metaphorically plunging to her death from the heights above. Tellingly, it is left to Eunice, the lowly parlormaid, to clean up after Persie in what becomes a literal as well as figurative mopping up by the servant class after the squalid escapades of the people upstairs.

THE PEOPLE'S CENTURY

For the downstairs staff, life is shaped by its waking up after a long sleep after the frenetic party that is post-Edwardian England. After the Servants' Ball near the end of series 2, one described as the servants' "last hurrah," nearly everyone wakes up with a hangover on what turns out to be the eve of war. The servants Johnny the footman and Spargo the chauffeur have, for the edification and entertainment of their masters, been representing Eaton Place in the boxing ring, figuratively enacting the fighting they will be doing for real in the near future on the fields of war. Mr. Amanjit, despite being referred to by a Whitehall mandarin as a mere "colonial," continues as the most trusted and reliable defender of Eaton Place's future. The internal fractures evident in the below-stairs culture (Pritchard's pacifism, for example) are nonetheless counterbalanced by the servants' quiet embracing of the future: Mrs. Thackeray forges on with her desire to serve interesting new food from the "new world" at the Joseph Kennedy dinner party in series 2, regardless of her plans being scuppered by Pritchard and Agnes who insist on traditional fare; Beryl and Spargo, too, embrace the promise of a new life in America, despite their plans being thwarted by Persie's accidental wounding of Beryl on the eve of war. With Lady Agnes's permission, Beryl and Spargo hold their wedding reception in the formal drawing room, which necessitates Hallam having to answer his own front door to the Duke of Kent who, upon being assured by Hallam that the circumstances are exceptional and that "the normal scheme of things will resume this evening," replies, "There is now no normal scheme of things. For as long as this war lasts, we are all each other's servants." Throughout *Upstairs, Downstairs*, the servants have observed the upstairs events from the sidelines and crouched listening in doorways; it is they who have understood the meaning of the perfidious lipstick on Hallam's shirt collar; and it is they who will make their voices heard in the future 1945 election when, as a people newly empowered by their saving of Britain's shores during the country's "finest hour," will oust Conservative prime minister Churchill from office and usher in a Labour government.

Although facing Hitler's bombs, Eaton Place is already a house in ruin, one where the sandbags gathered at the house's entrance are as indicative of the threats from within as from without. By the series' end the fractures in foreign and domestic policy, as they are represented in the twin settings of Whitehall and Belgravia, mean that the days of Britain's old social order and world dominance are over. Life closes at the end of the 2012 series with Mr. Pritchard ushering Lady Agnes and Dr. Mottershead downstairs, via the outside servants' entrance, to the designated air raid shelter; this closing scene offers a striking visual contrast with the opening scenes of series 1 when Lady Agnes enters her house by the front stairs at the same time as new nursery maid, Beryl, makes her descent down the servants' stairs. In contrast

to the clearly delineated worlds represented in the program's early scenes, there is a quiet acceptance in the end that the old world order has altered irrevocably. Where in the original 1970s program Lady Marjorie Bellamy met her demise when she went down with the *Titanic*, the new series depicts an empire also found to be sinking; and despite Spargo's and Beryl's aborted attempts to board the boat for a new life in America, there is a degree of acceptance that they will have to stay put and help bail out their country. Hallam ends his glory days as an up-and-coming Whitehall civil servant by being demoted, in relative financial and political terms, to the role of equerry to the Duke of Kent. Like the empire itself, Hallam's access to real power will become largely ceremonial as a result of this; it will also be short lived, given the actual Duke of Kent's death in 1942. Lady Persie, the brittle, impoverished aristocrat, has ended her days colluding with the Germans and seducing her brother-in-law—a twin act of treachery that suggests Persie's foreign dalliances merely mask a dissatisfied, rootless, fidgety, corrupt life at home. Persie's last act of accidentally shooting Beryl is telling in that her act of folly very nearly takes the life of one of the members of the lower orders. It is Lady Agnes who gasps in the final episode, "I can't breathe!" bringing to a climax the narrative thread of suffocation and toxicity that has permeated the two series. A maid's dying of stress-induced asthma, a monkey gassed in a well-intentioned experiment, and a gasping, shocked lady of the house are all premised on the notion that the Holland household, funded as it is by the Hollands' asbestos mining fortune, is a site of toxic decay.

Unlike the tone of elegy that accompanies the original 1970s program, however, the recent *Upstairs, Downstairs* strikes a tone that is at once both melancholic and quietly accepting of the ruptures in the status quo. After anticipating the cataclysmic event (the Second World War) for two seasons, it comes almost as a relief that the air-raid sirens are finally ringing properly, signaling the end of the old world as it has been. Diski's complaint that costume dramas like *Upstairs, Downstairs* simplistically intone the idea that "Nothing will ever be the same again" is here countenanced with a degree of acceptance and relief that change is coming.[17] *Upstairs, Downstairs* engages, above all, in a dialogue with historiographical representations of the 1930s and also with developments in period drama itself. It is well aware of its place in the pantheon of reconstructions of this era and offers a number of self-reflexive strategies to indicate just how the narratives intertwined of the past are with some of the wider concerns of the period genre. The 2010–2012 *Upstairs, Downstairs'* more nuanced and creative ways of representing the past than both its original version and films like *Glorious 39* suggest that should 165 Eaton Place open its doors again in future, more radical interpretations of how the "past" is represented will again be possible. As Dr. Mottershead reminds us at one point when she responds to Eunice's declared

hope after Munich that the threat of disruption for the inhabitants of 165 Eaton Place is over, "This is history, Eunice—it is *never over!*"

NOTES

1. *Upstairs, Downstairs*, DVD (Cardiff, UK: BBC Wales, 2010–2012).
2. *Upstairs, Downstairs*, DVD (London: ITV, 1971–1975).
3. Carl Freedman, "England as Ideology: From 'Upstairs, Downstairs' to *A Room with a View*," *Cultural Critique* 17 (winter 1990–1991): 82.
4. Ibid., 87.
5. Ibid., 92.
6. Ibid., 86.
7. Ibid., 85.
8. Ibid., 93.
9. Jenny Diski, "Making a Costume Drama out of a Crisis," *London Review of Books* 34, no. 12 (21 June 2012): 32.
10. David Cannadine, *History in Our Time* (New Haven, CT: Yale University Press, 1998), 266–67.
11. This title of this section, "Shuffling Off the Heavy Cloak of Hindsight," is from Martin Gilbert, *Britain and Germany between the Wars* (London: Longmans, Green, 1964), ix.
12. *Glorious 39*, dir. Stephen Poliakoff, DVD (London: Momentum Pictures/BBC Films, 2009).
13. *The Gathering Storm*, dir. Richard Loncraine, DVD (London: HBOFilms/BBC Film, 2002).
14. Michael André Bernstein, *Foregone Conclusions: Against Apocalyptic History* (Berkeley: University of California Press, 1994), 27.
15. Ibid., 30.
16. William R. Rock, *British Appeasement in the 1930s* (London: Edward Arnold Publishers, 1977), 98.
17. Diski, "Making a Costume Drama," 32.

Chapter Thirteen

New Developments in Heritage

The Recent Dark Side of Downton "Downer" Abbey

Katherine Byrne

Not since 1981's *Brideshead Revisited* has a period drama come even close to dominating the television ratings, commanding public consciousness, and shaping popular culture in the way that *Downton Abbey* has done over the last few years.[1] Written by Julian Fellowes, ITV's reworking of *Upstairs, Downstairs* (1971–1975) has, at the time of writing, just completed its highly successful fourth-season run in the United Kingdom and shows no signs of stopping there: the *Downton* juggernaut has also reached the United States, where it is currently attracting record-breaking viewing figures.[2] As a result, *Downton* has become a cultural phenomenon and an industry: enhanced tourism benefits from a heritage drama are perhaps inevitable, but *Downton*'s money-spinning abilities are not limited to Highclere Castle, the Yorkshire stately home in which it is filmed and that now receives more than sixty thousand visitors a year.[3] The series has generated several best-selling official book companions, numerous historical explorations of life below stairs in the era, dolls and other merchandise, and even cosmetics. Marks and Spencer's *Downton Abbey* makeup, bath, and body range is the latest example of the show's money-spinning abilities.[4]

Popular support is not matched by critical acclaim, however. *Downton* remains a guilty pleasure for many viewers: it is eminently watchable but at times politically or ideologically indefensible. It has come under attack for its socially conservative message: its portrayal of an aristocratic household in which servants and their employers live a mutually respectful, contented, and even affectionate, existence is, in many views, a problematically idealized representation of social history. I have argued elsewhere that *Downton* displays,[5] in a number of ways, a deliberate and carefully constructed return to

the 1980s heyday of period drama that Andrew Higson famously, if contro-
versially, bracketed as "heritage": films that marketed Britain as a tourist
attraction and that commodified the past.[6] In the views of Higson, Tania
Woolen, and others, this was a genre that articulated "a nostalgic and conser-
vative celebration of the values and lifestyles of the privileged classes,"
through which "an England that no longer existed" was "reinvented as some-
thing fondly remembered and desirable."[7] The most severe view of heritage
film, then, suggested that they gave a superficial, sanitized, and nostalgic
view of a vanished world and undermined the positive social change that had
removed it. The focus of such films was, according to Higson, deeply materi-
alist: the past was assembled through fetishized objects, from lavish cos-
tumes to the luxurious mise-en-scène and the stately home itself. This, of
course, clearly recalls *Downton*, whose opening credits place an immediate
emphasis upon lamps, soft furnishings, and other domestic objects, which are
the historically authentic props that make the series a pleasurable spectacle
for the viewer and also, in the early series, form an important part of plots
concerned with the coming of modernity. Similarly, while the show aims to
follow the lives of servants as much as their employers, it is the Grantham
family's glamor and charm that really command the attention of most view-
ers.

Of course, postheritage criticism from Claire Monk and others in the
1990s foregrounded the many variations and complexities in approach and
politics between period fictions and also reminded us that "heritage ideolo-
gies—and ideological functions—are not specific to films set in the past."[8]
Pamela Church Gibson has also written about the ways the genre became,
over the course of the 1990s, "wider and more experimental and now has the
element of pastiche."[9] With these issues in mind, Higson himself has revisit-
ed and revised his earlier views. He notes, however, that while heritage films
"frequently focus on poignant problems in the English past, on narratives of
dissolution or on the marginal and displaced as much as the apparently privi-
leged . . . they also seem to offer decidedly conservative, nostalgic, and
celebratory visions of the English past—and it is difficult to argue convinc-
ingly that the majority do not still."[10] This is, as I have previously argued,
true of *Downton Abbey*.[11] Its "vision of the past" can be described as "post-
post heritage": it does look like and feel like a self-conscious pastiche of the
Merchant Ivory film or the Jane Austen adaptation but as an homage rather
than in any way a subversive critique. It is also deeply nostalgic for a certain
past. After all, it is essentially a portrayal of an attractive, ordered society in
microcosm, where everyone knows their place, and servants and their em-
ployers live together in symbiotic harmony. And conservative it undeniably
is; a paternalistic world like this negates the need for a welfare state, justifies
class privilege by making those in charge worthy of their wealth, and plays
with the viewers by acknowledging their reservations about luxury and idle-

ness, and then gradually assimilating them into the visually seductive past portrayed on screen.

A NEW DIRECTION FOR *DOWNTON*?

Yet in its recent conception, *Downton* seems to have altered and evolved, perhaps in response to those who have criticized its glossy view of history. Originally the drama rose to popularity alongside the newly elected Conservative-dominated coalition government and offered a mix of soap opera detail and escapist fantasy to an audience in the grip of worldwide recession. Perhaps in a response to the disillusionment that accompanies continued economic hardship, that fantasy has become more problematic and less rosy in the third and fourth seasons, however. The death of key characters Sybil and Matthew in series 3—the latter, most controversially taking place in the Christmas special, aired on British television on Christmas Day 2012—and the rape of Anna in series 4 have given a grittier feel to the previously saccharine *Downton* world. The drama's previous representation of history, of course, had much of its darkness edited out. The servants are, largely, happy and healthy in a way their real-life counterparts from the early twentieth century would not have been; the First World War and Spanish flu claim the lives of only two (expendable and minor) characters; and Bates's wrongful conviction and imprisonment for the murder of his wife is finally overturned, and he is happily restored to his wife and employment. Thus legal, medical, and political systems largely seem to be successful, to be working, even if they usually require a member of the Crawley family—most often Lord Grantham himself—to intervene (his appeal to the home secretary is the reason Bates's death sentence is revoked, for example). It is this that is most problematically conservative about *Downton*: its portrayal of a status quo that is successful under the loving, paternalistic eye of the patriarch.[12] It is also, of course, one of the most seductive aspects of the television series: its feel-good sense of an ordered and secure world where your loyalty to your employer is rewarded by his care and concern for you, and in which he uses his power for your benefit.

By the middle of series 3, however, those systems are breaking down. The fracturing really begins with the death of Lady Sybil in childbirth, an unexpected tragedy that was greeted by an outpouring of grief from shocked fans. This plot was especially interesting because it can be considered the first direct way in which *Downton* engaged with the dark realities of the past. Even by the 1920s, the maternal mortality rate was still high at five fatalities per one thousand births, and "it was the only major cause of death to show an increase in the inter-war period."[13] As a result, despite the medical advances of the nineteenth century that lowered mortality rates generally, thousands of

women still died in childbirth every year, and Sybil is representative of these, as the Dowager reminds us: "Our darling Sybil has died, in childbirth. Like too many women before her."[14] Moreover, her death displays a breakdown in the security offered by the Crawley household: youth, love, and privilege— which pays for the most expensive medical treatment of the time—does not save Sybil from her fate. As Jane Lewis notes, death in childbirth was democratic, in that elevated class status did not seem to positively affect the maternal death rate in the interwar years, unlike the infant mortality rate that responded well to the advantages offered by wealth.[15] Indeed, "Women of the highest and healthiest classes . . . despite their better health and physical development, had a higher maternal death rate than those in the lowest social class."[16] Marjorie Tew argues that the increasing attendance of physicians, and thus increased likelihood of intervention, for wealthy women may have been responsible for these statistics.[17] It is not my purpose here to debate the reasons behind Sybil's death, but it is worth noting that childbirth was, and indeed still remains, a site of struggle between a female-dominated midwife profession and traditionally patriarchal obstetrics,[18] and thus is an appropriate signifier of the gender politics that begin to surround *Downton* from this point on. Sybil's death thus also represents a breakdown in the faith in patriarchal order, wisdom, and control, an ideology that, as represented by Lord Grantham, has reigned absolute in the first two series. Her father and his specially selected London consultant, Sir Philip, together make the decisions regarding Sybil, their authority sidelining the concerns of the village doctor, Dr. Clarkson, that she may have eclampsia. When the family argue over the best way to proceed, Robert stubbornly maintains that "I think we must support Sir Philip in this. . . . Tom [Sybil's husband] has not hired Sir Philip. He is not master here. And I will not have Sybil put at risk on a whim."[19] Significantly, Robert's wife, Cora, shares Dr. Clarkson's fears—"I would have taken her [to the hospital] an hour ago!"—and, of course, they are later proved correct. As a result, Cora's grief-stricken bitterness and fury are directed at Robert, who despite being warned, "knew better, and now she's dead!"[20]

Robert has for the first time in the drama failed to make the right choice and protect his family (in series 2, for example, we see him nobly giving up a love affair for moral and altruistic reasons). He and Cora are eventually reconciled, but from this point on Robert arguably ceases to be the moral compass and authoritative heart of *Downton*. Soon, for example, he is revealed to have risked the family fortune on some bad investments. Matthew intervenes, saving the estate from destruction and ruin, and putting it on the road to modernity, but Matthew's potential as new patriarch is soon curtailed by his own death as soon as he has produced an heir. Thus, by series 4, Robert is able to be absent from *Downton* for months on end without being greatly missed (by family or indeed by viewers). Even when home, he is

largely ineffectual: it is Mary and the former chauffeur, Branson, who plan for the future of the estate. More disturbingly still, the rape of his servant Anna and the lonely illegitimate pregnancy of his daughter Edith both occur under his roof and without his knowledge or aid.

"A WHOLLY UN-*DOWNTON* DARKNESS"

Up to this point the movement away from patriarchal control in *Downton* seems to be a positive thing: the viewer is invited to recognize the increased power and centrality of the female characters and to see their increasing independence as a reflection of new freedoms associated with first-wave feminism. Edith's sexual awakening (even if she is punished for this by becoming pregnant) and the range of decisions she makes regarding her child can also be seen in this light. However, at this point in series 4 the loss of the old stability and order at the Abbey becomes deeply problematic for many viewers. The rape of Anna, in particular, has had a dramatic and, according to many critics, negative effect on what the *Washington Post* described as the "tenor of the show":

> In its final minutes, the show descended into a wholly un-*Downton* darkness from which I'm not sure it can fully recover and that likely will lose it some of the more than 10 million fans who tuned in to watch last week. . . . Nothing prepares you for his violent attack and rape of Anna, *Downton*'s most likable and kindest character. It is an act so out of step and sensibility with what *Downton Abbey* has become that it feels almost like the worst sort of gimmick, an attempt to shock an audience that was just out for a nice walk in the park. Simply put, the rape of Anna and the grim aftermath that will surely linger the rest of the season and into future seasons seems too disturbing a turn for a show that is at its core a celebration of fluff, frivolity and fabulous fashion. Yes, there have been numerous deaths on *Downton* and moments of great sorrow and sadness. But to this point, the show had steered clear of any close encounter with evil. The show had been a guilty pleasure. Now the pleasure is, if not gone altogether, certainly muted. [21]

In one sense these comments indicate exactly why Fellowes might feel the need to inject some more serious and demanding story lines into the "fluff, frivolity and fabulous fashion" that *Downton* "has become" (or, indeed, always was). We might recall here Higson's comments about the empty superficiality of "heritage," and here it is apparent that such superficiality and the deliberate sanitizing of history it epitomizes have assisted rather than hindered the show's success. This reviewer does seem to ignore *Downton*'s soap opera roots, however, and the inevitable confrontation with violence and evil that necessitates. A British review from the *Telegraph* understands

these fictional conventions but points out that Fellowes is transgressing narrative codes of morality here:

> "The entire concept of 'story' can pretty much be boiled down to bad things happening to people we can (usually) root for, which they overcome in the end through the power of persistence," says the novelist Jenny Colgan. . . . But the problem is that Anna is morally blameless and in *Downton* the system is comfortingly portrayed as pleasant and paternalistic—whether it's Carson dispensing homespun advice to Lady Mary, Lady Violet advising former chauffeur Branson on social etiquette, or Lord Grantham worrying about the welfare of his servants. "There is no redemption to be gained from this, only misery as Anna is thrown casually to the wolves of narrative rather than, as in the best stories, being led there inexorably by the world she inhabits and the choices she makes," says Colgan. Realism is all very well, but when story lines verge on the nasty and gratuitous, a writer should take care. Fellowes breaks his pact with viewers at his peril.[22]

Fellowes's slightly Faustian sounding "pact" with viewers is clearly based on the understanding that the show must deliver a certain type of entertainment and moral lesson. Its fictionality, and the rules of "story," are here accepted and indeed prioritized over "realism."

These reviews, and the ownership of the plot they imply, indicate the extent to which *Downton* has become national heritage: ownership of it is public, and the expectation that it will provide a certain type of televisual experience for its audience is crucial. Indeed, it is clearly more important to viewers than the accurate representation of the past—in which sexual violence was a sadly commonplace reality for female servants whose jobs frequently made them vulnerable to sexual abuse. As Ronald Hyam and Lucy Delap have observed, they were a "class of subordinate and sexually accessible women"[23] who had "no privacy, and may be observed at [their] most intimate moments" by their employers.[24] Of course, a more historically credible portrayal of the rape would have shown the perpetrator to be a member of the aristocratic family, given that members of this class frequently viewed their domestic employees as there for the taking.[25] One of the series' source texts, *Upstairs, Downstairs*, had a similar plot in which a housemaid was raped by the son of her employers.[26] *Downton* is, however, extremely wary of portraying the upper classes as in any way irresponsible or deviant (the adulterous romance between Robert and housemaid Jane in series 2, for example, is gently affectionate, transparently mutual, and never consummated). The program thus avoids tackling any difficult questions surrounding predatory class relations by making Anna's attacker both a servant and an outsider: the valet to one of Lord Grantham's guests, Tony Gillingham, who in fact "doesn't really like [his valet]" and is thus disassociated from his crimes.[27] Mr. Green—played by *EastEnders*'(1985–) bad boy Nigel Har-

man—is an all-too-plausible charmer who reminds the viewer that life outside the estate is a much more unknown and frightening prospect.[28] The sanctuary of those walls, however, is undermined by this incident in a way that contrasts dramatically with the plots in *Downton* thus far.

Significantly, the rape takes place during a house party in which Dame Nellie Melba (played by Dame Kiri Te Kanawa in a piece of stunt casting) performs for the Crawleys, their staff, and their guests. While she sings "O Mio Babbino Caro" upstairs to a delighted audience and the family chat about the merits of Puccini over Bartok, Anna's ordeal takes place unheard in the servant's quarters. There has always been a contrast in light and color— as well as more straightforwardly in set—between upstairs and downstairs in *Downton*: the scenes set in the kitchens are shot through a dark, grey filter that contrasts with the brightness and warmth above stairs. No contrast is as dramatic as this episode, however: the kitchen scenes of violence are interposed with the happy attentive faces of the rest of the cast upstairs, and Melba's high notes drown out Anna's screams. The kitchen loses its usual homeliness and becomes a bare, empty gothic space: the final long shot of the hall, in particular, makes the deserted passageway resemble the set of an institution in a horror film like *The Shining* (1980).

This temporary lapse into gothic melodrama is a real departure for *Downton* but does feel like a significant turning point for the series and offers some kind of answer to its critics. This is mainly because of its self-consciousness and self-reflexivity: the contrast it deliberately creates between all we expect from a "typical" period drama—glossy, highbrow entertainment—and the disturbing historical reality of sexual violence. This scene of Melba singing initially epitomizes everything "heritage": the culture, beauty, and art that represent that which is most cherishable about the past. Even the Puccini song she is singing happens to be the opening music of *A Room with a View* (1985), the quintessential Merchant Ivory heritage drama. Here, however, it is interrupted and undercut with violence that is disturbing to watch. There is a clear awareness that the Crawley family and their servants have been occupying a charmed bubble in which suffering and violence seldom intrude and that the viewer wishes to share that position. Immersed in their cultured entertainment, they are distracted from and oblivious to the horrors of a life below stairs that comes to represent a suppressed historical reality. The audience is symbolically aligned with them, except that while they are *unable* to see, we would prefer *not* to see—as the horrified public response (on social media) to Anna's ordeal displayed.

That response accused Fellowes of exploiting rape for ratings, creating a dramatic plotline to liven up a series whose initial episodes were rather banal.[29] Certainly it is difficult to argue that violence against women is anything but gratuitous when served up for entertainment purposes, no matter how well acted and moving the scenes might be (Joanne Froggatt has

been applauded for her performance here) and even if it may encourage dialogue about the shame and secrecy that still surround rape today. It is nonetheless significant in the way it represents a further crisis in the ideology of the series, in that the abbey, and the state in microcosm it represents, fails Anna: it does not protect her from violence or even support her afterward. Given that the Crawleys themselves are oblivious to what has happened, paternalism is not, as it has previously been, a panacea for all ills. Instead, Anna is a victim of a predatory masculinity that sees her as something to be used. And, indeed, the way in which the aftermath of and punishment for Anna's rape are represented in the drama also focus on masculinity in a way that might be problematic to a feminist viewer. None of the characters show any intention of reporting Green to the police, or indeed, to Lord Grantham, in a significant indicator of the decline of his patriarchal power. We might recall here *Upstairs, Downstairs*' treatment of its rape plot in which, in contrast, the victimized housemaid turns to Richard Bellamy, the head of the household, for help and support.[30] Instead, Anna is terrified that her husband, Bates, will seek his own vengeance, as indeed it seems he does—given that Green dies in a mysterious "accident" later in the series. This revenge plot and the moral dilemmas that surround it become the program's most lasting legacy from the rape. Here it is helpful to recall Lisa M. Cuklanz's discussion of rape on American television, in which she, discussing John Fisk's comments, suggests that "prime time's treatment of rape has more to say about masculinity and male characters than about rape as a social issue or as a problem for activists."[31] Certainly *Downton*'s rape plot does not center around Anna's recuperation and coping mechanisms so much as it focuses on her anxiety about Bates finding out, his frustration and worry, his detective skills as he uncovers the truth, and the mystery surrounding Green's subsequent death. As Fisk and Cuklanz observe, it is commonplace for on-screen rapists to be violently attacked, or even killed, by their pursuer as punishment for their crimes, and such behavior is legitimized by the plot:

> The extreme evil and brutality of rape also serve as a clear contrast to the detective's behaviour and legitimise his use of force. . . . Although such violence is not always condoned by other characters, it is presented as understandable and is common enough to be considered a basic element of hegemonic masculinity as constructed in these programmes.[32]

This casts interesting light on the plot that follows the rape, which centers on Mrs. Hughes and Lady Mary discovering that Bates may be a murderer, and yet eventually agreeing to conceal, and by implication condone, this fact. Essentially, they—like Anna, who from the very first moments after being attacked, is aware that her husband's reaction will be a violent one—reinforce and accept "the mainstream construction of masculinity as macho."[33]

Series 4 might chart a decline in the patriarchal power and authority of Lord Grantham, but traditional views of masculinity—at their darkest, however—are still being reinforced through the character of Bates. With this in mind, we might agree that one of the most objectionable things about Anna's ordeal is not only that it is violence served up as entertainment but also that it is ultimately more about masculinity, and male identity, than it is about the victim.

FURTHER VIOLENCE IN SERIES 4

This is not the only plotline that might disturb (especially feminist) viewers in the recent series, however. My final points regard the relationship between Tom Branson, the former chauffeur turned son-in-law, and Edna, the new lady's maid, which makes for almost equally uncomfortable viewing. Edna is a classic cartoon villain, a scheming social climber who aims to seduce and exploit Tom in order to insert herself into the family. The same evening that Anna is raped, Edna acts what the viewer is meant to regard as a kind of symbolic rape of Tom, whom she plies with whiskey, comforts in his still-

Figure 13.1. Anna (Joanne Froggatt), thrown casually to the wolves of narrative in series 4 (*Downton Abbey*)

grief-stricken distress, and then has sex with. The next morning her carefully laid plans are fully revealed when she comes to Tom's room and demands he promise to marry her if she is pregnant. The blackmailed Tom is guilty and worried for days before he turns to the housekeeper, Mrs. Hughes, for help, and in surely the second-nastiest scene ever shown in *Downton* they confront Edna with her crime:

> Edna: I want my baby to have a father, and I won't change my mind about that. No matter what you offer.
>
> Mrs. Hughes: I wasn't planning to make an offer.
>
> Edna: Why not?
>
> Mrs. Hughes: Because there is no child.
>
> Tom: You can't know that. Nobody can.
>
> Mrs. Hughes: But I do know that actually. Edna's not pregnant. Do you think she would have let herself get pregnant before she was sure of you? And she knew how to prevent it. Why else would you buy this book of instructions? Marie Stopes, *Married Love* . . . Once you'd agreed she would have got pregnant, don't you worry . . .
>
> Edna: What proof have you got?
>
> Mrs. Hughes: Oh, none . . . at the moment. But if you persist in your lie, I'll summon the doctor and have him examine you.
>
> Edna: You can't force me.
>
> Mrs. Hughes: Oh yes I can. First I'll lock you in this room. Then when he's arrived I'll tear the clothes from your body and hold you down, if that's what it takes! . . . If you want a reference, or another job in your natural lifetime, you'll hold your tongue![34]

The moral message of this exchange seems unambiguous: Edna has already had a second chance to settle down at the abbey, and any character through-out the series—there are, of course, very few—who does not repay the Craw-leys' generosity with loyalty is defined as "bad" and suitably punished. Edna is no exception to this rule, particularly as it is the kindly and sensible Mrs. Hughes, one of the wisest servants in *Downton*, who condemns her. This simple, effective morality is usually one of the main reasons for the show's popularity, as Glenda Cooper indicates above, but here it is problematic for

the viewer. As Mrs. Hughes is also the only person Anna turns to for help after her ordeal, the two plots—and by inference the two crimes—are symbolically linked. Mrs. Hughes is powerless against Green and is forced to let him leave the abbey without censure, but the housemaid can and will be punished. The suggestion that attempted blackmail can be equated with rape is itself disturbing, given that sex with Tom was consensual, if manipulated and orchestrated by Edna. Moreover, the violence of Mrs. Hughes's response is extreme and antifeminist: Edna is effectively threatened with medical rape, over and above losing her job. This is a frightening and disproportionate punishment for seduction and opportunism, all the more so because Tom, of course, receives no condemnation—even though it is not the first time he has made this mistake.

CONCLUSION: SOCIAL CHANGE AND SOCIAL DISORDER

Downton, then, has become a much darker and grittier place in the recent series. Sexuality was always problematic in the drama: sexual intercourse was punishable by death right from the very first episodes, when Lady Mary's seducer, Kemul Pamuk, died in her bed. Back then, however, it had the element of farce, for the scenes where Mary, Anna, and Cora carry his body furtively through the house could not be taken entirely seriously. Now there is nothing comic about the show's association between sexuality and rape—whether literal or actual—and with death, which occurs for Sybil during childbirth and for Matthew (and possibly also for Edith's missing lover, Michael) after.

Moreover, morality itself is complicated and less black and white than it had been. In recent episodes in *Downton* bad things happen to the most decent of people, as in the case of Anna, and formerly good characters like Bates and even Mrs. Hughes show their dark side. It is tempting to speculate that there is a social ideology behind this change in tone: that Fellowes is making a point about the way in which society begins to crumble when the old order is challenged or subverted. Certainly many of these events are linked, in one way or another, to the increasingly ineffectual Robert's decline in authority and control, and they are frequently the product of characters taking matters into their own hands, whereas in series 1 and 2 they would have turned to their employer for his help. Yet such developments seem inevitable as the series moves through the twentieth century and closer to the modern world. Many viewers might embrace the feminist progressions represented by Mary and Edith and the increasing autonomy of the servants, as well as the less sanitized and arguably more realistic view of the past offered now by the drama. However, if we regard *Downton* as a political allegory, social disorder—illegitimate pregnancy, rape, and even possibly murder—is

the price that is paid for these new personal freedoms. And, in turn, the cost of a movement away from the conventional, nostalgic heritage drama is that the world offered instead is less comforting and more disturbing: a world that, it seems, many viewers do not wish to inhabit for it resembles too closely their own.

NOTES

1. "Downer" Abbey was taken from Chuck Barney, "Review: 'Downton Abbey' Season 4 Off to a Mournful Start," *San Jose Mercury News*, 31 December 2013, accessed 27 January 2014, http://www.mercurynews.com/. *Brideshead* is commonly in the top ten of "greatest television shows of all time" lists (it was second in the *Guardian*'s 2010 top fifty, for example). For a list of the numerous awards it has won, see *"Brideshead Revisited*: Awards," IMDb, accessed 9 September 2014, http://www.imdb.com/.
2. See Charlotte Runcie, "Why Americans Love Downton Abbey More than Ever," *Telegraph*, 7 January 2014, accessed 20 January 2014, http://www.telegraph.co.uk/.
3. See Morgan Brennan, "Inside Highclere Castle, the Set and Real-Life Muse for Downton Abbey," 5 February 2014, accessed 11 February 2014, http://www.forbes.com/.
4. Some of these are discussed by the *Guardian* at Ami Sedghi, "The Best (or Worst) Downton Abbey Merchandise: From Makeup to Wine," *Guardian*, 8 October 2013, accessed 2 February 2014, http://www.theguardian.com/.
5. Katherine Byrne, "Adapting Heritage: Class and Conservatism in Downton Abbey," *Rethinking History* (8 August 2013): 2.
6. Andrew Higson, *English Heritage, English Cinema: Costume Drama since 1980* (Oxford: Oxford University Press, 2003), 11.
7. Ibid., 12.
8. Claire Monk, "The Heritage-Film Debate Revisited," in *British Historical Cinema*, ed. Claire Monk and Amy Sargeant (London: Routledge, 2002), 192.
9. Pamela Church Gibson, "Fewer Weddings and More Funerals: Changes in the Heritage Film," in *British Cinema in the 1990s*, ed. Robert Murphy (London: British Film Institute, 2000), 124.
10. Higson, *English Heritage*, 29.
11. Byrne, "Adapting Heritage," 5.
12. Ibid., 9.
13. Jane Lewis, *The Politics of Motherhood* (London: Croom Helm, 1980), 36.
14. *Downton Abbey*, DVD (London: ITV, 2010–), series 3, episode 2.
15. Lewis, *Politics of Motherhood*, 38.
16. Marjorie Tew, *Safer Childbirth? A Critical History of Maternity Care* (London: Chapman and Hall, 1990), 99.
17. Ibid.
18. See, for example, ibid., 21.
19. *Downton Abbey*, series 3, episode 5.
20. *Downton Abbey*, series 3, episode 6.
21. Joe Haim, "'Downton Abbey' Recap: An Unthinkable Act Changes the Tenor of the Show," *Washington Post*, 12 January 2014, accessed 14 January 2014, http://www.washingtonpost.com/.
22. Glenda Cooper, "Rape at the Abbey: Has *Downton* Gone Too Far for Sunday Nights?" *Telegraph*, 7 October 2013, accessed 20 January 2014, http://www.telegraph.co.uk/.
23. Ronald Hyam, *Empire and Sexuality: The British Experience* (Manchester, UK: Manchester University Press), 59.
24. Lucy Delap, *Knowing Their Place: Domestic Service in Twentieth-Century Britain* (Oxford: Oxford University Press, 2011), 174.

25. For examples of the numerous servant/master rape trials in the nineteenth century, see Martin J. Weiner, *Men of Blood: Violence, Manliness, and Criminal Justice in Victorian England* (Cambridge: Cambridge University Press, 2004).

26. *Upstairs, Downstairs*, dir. Derek Bennett (London: ITV, 1971–1975), series 1, episode 6.

27. *Downton Abbey*, series 4, episode 4.

28. Harman played charming rogue Dennis Watts—a "young Dirty Den"—in the popular British soap.

29. Nicola Methven, "*Downton Abbey* Fans Furious Over Anna Bates Rape Plotline: 'It's Like Having a Murder on Teletubbies,'" *Daily Mirror*, 7 October 2013, accessed 3 January 2014, http://www.mirror.co.uk/.

30. *Upstairs, Downstairs*, series 1, episode 6.

31. Lisa M. Cuklanz, *Rape on Prime Time* (Philadelphia: University of Pennsylvania Press, 2000), 19.

32. Ibid., 20.

33. Ibid.

34. *Downton Abbey*, series 4, episode 4.

Chapter Fourteen

Experimentation and Postheritage in Contemporary TV Drama

Parade's End

Stella Hockenhull

At the beginning of episode 3 of Tom Stoppard's adaptation of Ford Madox Ford's 1920s' tetralogy *Parade's End* (2012), the central character, Christopher Tietjens (Benedict Cumberbatch), lies in hospital wounded, suffering flashbacks to his First World War experiences in the trenches. The sequence commences with an extreme close-up of his bloodied face, before a dissolve introduces a kaleidoscopic and bleached image of his beautiful wife, Sylvia (Rebecca Hall). This shot is immediately followed by that of Tietjens's lover, Valentine Wannop (Adelaide Clemens), before returning to the more realistic and gruesome events at the hospital. The story chronicles the life of Tietjens, a wealthy landowner and man of principles, and his promiscuous socialite wife, Sylvia. Tietjens has joined up to fight, but the events that occur in the war form only one layer of the complex plot and backdrop to the love triangle with suffragette Valentine. The flashback and the optical effect of the kaleidoscope is a repeated motif in the serial, and director Susanna White introduces a variety of experimental, surreal, and perplexing images throughout this fast-moving drama.

Parade's End, a BBC/HBO collaborative project, is, as noted, an adaptation of Madox Ford's four-part classic novel. Visually, the serial is comprised of a mix of images of stately homes set in the beautiful English countryside, immoderate London dwellings, expensive and lavish interiors, and sumptuous costumes—all of which pay close attention to historical accuracy. In sum, the adaptation might be interpreted as a mannered production containing all the essential ingredients of a heritage package, while incorpo-

rating what Robin Nelson terms a "high end" TV drama.[1] Indeed, *Parade's End* does not entirely conform to traditional heritage formulae; instead, the serial is dominated throughout by inventive and melodramatic imagery, and women are represented as independent and sexually promiscuous. This chapter will analyze the five-part adaptation in terms of its visual style, suggesting that *Parade's End* has its origins in heritage drama, yet corresponds with what Nelson terms high-end TV and Claire Monk labels postheritage production. This correlates with a number of changes present in contemporary TV dramas generally, arguably as an attempt toward mass audience appeal.[2]

NATIONAL FLAGSHIPS? HIGH-END DRAMAS AND POSTHERITAGE CINEMA

Writing in 2007, Nelson suggests that high-end drama signifies big-budget and elevated production values, with prime-time positioning on a major channel. High end does not necessarily mean heritage, and Nelson suggests that serials such as *The Sopranos* (1999–2007), *Six Feet Under* (2001–2005), *Sex and the City* (1998–2004), *Deadwood* (2004–2006), and *Carnivále* (2003–2005) also qualify for such classification.[3] However, most heritage/costume dramas do constitute high end, featuring highbrow or middlebrow literary adaptation, the best of British actors—those associated with theater and quality and who lend class to drama—high production values, and the export of Englishness abroad.[4] Traditionally, heritage uses country houses, has lavish budgets, and invokes nostalgia for "better times" when Britain was deemed at its zenith. However, much contemporary high end, Nelson argues, is now multilayered, multigenre, and generally hybrid in an attempt to appeal to a mainstream target market. Such TV productions might also adopt a cinematic visuality, using techniques associated with film, which require a more concentrated viewing response and an aesthetic designed for the large screen.

Claire Monk notes postheritage trends, specifically in relation to cinema, with some adaptations deploying a distinctive if restless visual treatment that mobilizes a distancing effect. She suggests that period dramas have altered considerably since the 1980s when they reached their pinnacle, and a whole host of examples now offer a departure from the conservatism of their predecessors. Additionally, she argues that such adaptations might now be reassessed in line with the increased integration of British film production into the global entertainment industry.[5] The changes, for Monk, take place through dialogue, camera work, and, significantly, in terms of sexuality, dating from 1993 with Sally Potter's *Orlando*. She suggests that postheritage films are united "by an overt concern with sexuality and gender, particularly non-dominant gender and sexual identities,"[6] albeit noting that forerunners

such as *A Room with a View* (1985) have sexuality as central to their appeal. For Monk, nonetheless, whereas heritage aims at authenticity and fidelity to the novel, postheritage remains faithful to its original source while offering playful asides.

Quality dramas of the 1980s and 1990s made way for more progressive techniques, and the new commercial ethos in broadcasting led to a postmodern, consumer-driven culture.[7] Ultimately, this period witnessed a market-led approach resulting in the resurgence of costume dramas and literary adaptations such as *Middlemarch* (BBC Two, 1994), *Martin Chuzzlewit* (BBC Two, 1994), *Pride and Prejudice* (BBC One, 1995) and *The Tenant of Wildfell Hall* (BBC One, 1996). These adaptations, according to Nelson, not only appeal to a quality market but also champion popularity, with *Middlemarch* in particular establishing discontinuities in dramatic form and narrative tradition, while operating as a "national flagship piece with an eye to overseas sales."[8]

MARKETING, YOUTH APPEAL, AND THE COSTUME DRAMA POSTMILLENNIUM

Correspondingly, and in relation to more recent costume dramas, Nancy West and Karen Laird note a number of changes in high-end US/UK coproduction adaptations postmillennium. They are primarily discussing the US series, *Masterpiece*, and its predecessor, *Masterpiece Theatre*,[9] and indicate that changes have manifested that redefine adaptation. Noting six modifications in all, they argue that heritage dramas pride themselves on appealing to an elitist niche market; however, since 2008, *Masterpiece* has aimed for a greater involvement with a mass audience through marketing and youth appeal rather than aesthetic appraisal. Secondly, and in a similar vein to Monk, they note greater and more obvious sexual content in these recent adaptations rather than the subdued treatment usually associated with costume drama. In terms of visual style, West and Laird observe increasingly inventive camera work and editing, and greater innovation in technique in adaptations such as *Bleak House* (BBC One, 2005). As they suggest, "These cinematic examples reveal [that] the visual style featured on *Masterpiece* no longer plays second fiddle to dialogue, nor does it function mainly to infuse adaptations with pictorial nostalgia."[10] Equally, they note variations in screenwriting that, they argue, now offer greater originality; also the production of identical adaptations has increased with numerous versions of Austen displaying "the pleasure . . . of having a familiar story repeated for us vis-à-vis a new adaptation."[11] Finally, for West and Laird, the contemporary adaptation has veered more toward melodrama, bringing to the surface, through visual techniques, the subjugation of emotions and feelings.

Accordingly, costume dramas and adaptations have witnessed an upheaval since the 1990s, and twenty years on they have ushered in visual and aural innovations, arguably to cater to a more populist and less elitist audience. As noted, although West and Laird's rationale is geared toward an analysis of *Masterpiece* since *Masterpiece Theatre* in 2008, it might also be deemed appropriate for the analysis of *Parade's End.*

CLANDESTINE MOMENTS, EXPERIMENTATION, AND VISUAL FLAMBOYANCE IN *PARADE'S END*

In some respects, Stoppard's adaptation does conform to the tenets associated with heritage. *Parade's End* cost £12 million to make, reputedly the most expensive program ever broadcast on BBC Two,[12] and includes established and theatrically trained actors associated with quality dramas, such as Benedict Cumberbatch, Miranda Richardson, Janet McTeer, and Rupert Everett. It is adapted from classic literature, observes close attention to detail in costume and objets d'art, and incorporates a few lengthy scenes of stately homes and the landscape. An example of the latter is seen in episode 1 when, through a short sequence of establishing shots, the spectator is first introduced to Groby Hall, Tietjens's grand country house in Yorkshire. He and Vincent Macmaster (Stephen Graham), Tietjens's friend and colleague, are engaged in conversation in their London workplace, when an edit discloses a picturesque rolling landscape. The image, taken from a high angle, includes a steam train in the distance, transporting Tietjens and his son, Michael, to Groby. A lone sheep stands to the left of the frame, the sky dark and menacing, and the image remains on-screen for some time for spectator contemplation. Sylvia has absconded with her lover, and Tietjens is taking his young child to live with his sister, Effie (Candida Benson), and this bucolic image lingers for a few seconds before Groby Hall, a large palatial country seat, is presented off-center, overtitled with the words "Groby, Yorkshire." This image remains briefly in the frame, but Groby is again shown from a distant shot as Tietjens's sister drives a pony and trap along its sweeping driveway. The above partially conforms to the heritage codes of displaying buildings of national interest for spectator contemplation, the landscape as a pastoral idyll, and close attention to historic detail.

Indeed, Groby Hall appears again later in episode 1 as a mark of national tradition and changing times. Mr. Tietjens senior (Alan Howard) selects a tobacco pipe that is strangely hidden in the depths of the great cedar tree that stands outside the main door. No one is permitted to smoke in the house, and Tietjens senior and his workmen hide these items in the ancient tree, a ritual that is well documented in the serial (albeit not in the original novel where a different emphasis is given to the tree). Indeed, the cedar also becomes an

important symbol of power in the relationship between Tietjens and Sylvia.[13] From this incident, the camera cuts to the landscape, where a lone horse in the distance pulls a plow. Tietjens senior observes the pastoral imagery, commenting, "The motor plow didn't answer," to which Tietjens replies, "It will, though. It's all coming."[14] However, the main focus here is on characterization rather than settings, and the landscape serves two purposes: in heritage idiom it is placed for spectator contemplation to suggest inheritance, wealth, and permanence, yet through the dialogue it acknowledges a changing society, the onset of war, and mechanization. Much later, following the death of his father, Tietjens observes the same scene, but now he sees the motorized version of the farming activity rather than traditional rural life. This sequence is described by critic Gerard Gilbert as a "Downton-moment, and there probably wasn't much they could do about that: a vista of the British countryside that Tietjens loves so much, bearing the imprints of large-scale modern agriculture."[15]

If the Madox Ford serialization indulges its audience with the visual pleasures of heritage, it also distances itself from the conservatism associated with costume drama through adherence to West and Laird's notion of innovative visual strategies. Similarly, Stoppard's abstruse screenplay is challenging and cerebral with parts of the story told in flashback. Indeed, the opening sequences offer the spectator a visual and narrative roller coaster that condenses four years into just over seven minutes of screen time. As noted, episode 1 commences with an elaborate kaleidoscope effect, and this operates as a framing device for the opening sequences of each subsequent installment, developing into a repeated motif throughout the hour-long programs.

Following the credits in episode 1, an overhead shot focuses on a sumptuous room presented through a mirrored effect. In extreme close-up, the camera subsequently frames a glass chandelier, through which a table adorned with white flowers and other accoutrements, such as gift-wrapped boxes and a pair of white stockings, is visible. Again, seen from an overhead shot, a maid packs suitcases that litter the floor and, from this, the camera swoops gently to the ground to reveal the train of an elegant gown. The sound of a telephone ringing coincides with the upward tilting of the camera to frame a beautiful and elegant woman, Sylvia Satterthwaite. Framed through a gilt-adorned doorway, she answers the telephone speaking in French. No explanation or establishing shots set the scene, and rather than presenting the opulence and splendor associated with heritage through lengthy takes, arguably, through the self-consciousness and kinesis of the camera, these images disorientate, distance, and confuse. Indeed, the sequence avoids all obsessive focus of the house interior, instead fragmenting such detail and demanding greater spectator investment in the comprehension of the story.

As noted, traditionally, classic adaptations have a slow editing pace in order to display Britain's history and imperial past. However, as West and Laird suggest, "Within the last several years . . . adapters of classic novels have begun to relinquish their dependence on this style, either by employing an ironic use of it or by abandoning it altogether."[16] Indeed, White's fast-paced introduction continues with the visual onslaught, a feature that West and Laird suggest is evident in other adaptations of the period such as White's earlier TV drama, *Bleak House*.[17] From the sumptuous French interior, the camera now cuts to a dark city street, which, the spectator is informed, is Victoria railway station, London. Two suited gentlemen in bowler hats stand on a pavement; the larger of the two is Tietjens, and he gives instructions to a porter to take his luggage to the Dover train to Paris, thus narratively linking him with Sylvia, albeit, at this juncture, the spectator is unaware of the circumstances that have previously connected the characters. Tietjens's comrade, Vincent Macmaster, wishes him well, before a subsequent shot revisits France where, we are informed, Tietjens and Sylvia are to be married. Gerald Drake (Jack Huston), Sylvia's lover, and presumably the person responsible for the earlier telephone call, and the father of her unborn child (although the true identity of Michael's father is never known), forges roughly and aggressively into the room and embraces the young woman; subsequently, seen again from the overhead position above the chandelier, the couple copulate frantically and incongruously amid the wedding paraphernalia.

Later, and strangely reminiscent of documentary footage, the camera cuts to an extreme close-up shot of the wheels of a train, its noise loud and unrelenting, before a medium shot places Tietjens seated in the carriage staring pensively into space. A further kaleidoscope effect suggests a time change that the spectator is informed is a flashback to "two months earlier." In this sequence, Tietjens and Sylvia meet for the first time and, from his point of view, Sylvia appears visually disjointed, indeed divided into segments through the same mirrored effect that permeates the drama. The editing pace to date has been brisk, and this tempo continues to the final flashback before the wedding, where the reason for the reluctant match between Tietjens and Sylvia is explicated: seen from an overhead shot, Sylvia and Tietjens have sex in a train carriage. An immediate subsequent image reveals them together in bed, a child crying in the background, and White also uses an aural assault on the senses when she overlays the sound of the train with that of the crying child, Michael, who is Sylvia and Tietjens's son. Michael, it appears, is now a small boy, and Tietjens comforts him by the window at Groby Hall. A further flashback indicates Tietjens's own childhood memories, as he gazes from the same window toward the cedar tree on the lawn.

In all, the spectator has been introduced to *Parade's End* through a visual offensive lasting, as noted, just over seven minutes, yet the narrative infor-

mation is truncated and compressed into a time span of nearly four years; this indicates the pace and style of the adaptation for the remainder of the serial; and, although *Parade's End* is an adaptation from a classic novel, the opening sequence provides no indication whatsoever that this will be a heritage costume piece. Indeed, the frantic pace of the editing, the mirrored and sometimes skewed presentation of the visuals, and the two explicit sex scenes noted above suggest such hybridity as to defy categorization. The sets, while accurate, precise, and visually rich, are filmed rapidly and inventively to mobilize an experimental and unorthodox effect and the objets d'art become symbolic and emblematic of the underlying problems and politics of the narrative.

White repeats the kaleidoscope and split-mirror effect throughout each episode to create visual interest and also uses esoteric techniques to produce surreal and elaborate imagery. For example, in episode 1 when Tietjens first encounters Valentine, he is playing golf with a group of men. This includes General Campion (Roger Allam), Sandbach (Malcolm Sinclair), MacMaster, and Rt. Hon. Stephen Waterhouse MP (Tim McMullan). Viewed from a distance, Valentine and her suffragette accomplice, Gertie (Naomi Cooper-Davis), are visible on the horizon, darting in and out of the sand dunes. From there, the camera cuts to Tietjens watching through binoculars. Valentine appears from his point of view, but as though a vision, she seems to disappear, leaving him confused and bemused. Her plan is to thwart their game as a protest to gain votes for women, and she and her collaborator storm the course shouting at the group. Later, she and Tietjens are forced to flee at night to escape the police, and she becomes lost to him in the mist. When he finds her, she appears through a white haze. Throughout, just as Tietjens has first encountered Valentine as an apparition, she rematerializes through flashback—White often using the same kaleidoscope motif or a blurred effect to invoke their first romantic encounter.

A further visual flamboyance occurs when Tietjens's son, Michael, throws a coin into the well at Groby. Sylvia has absconded with her lover, and Tietjens has decided to send his son away to be brought up by his sister. Pensively, he waits with the boy outside the house for Effie to collect him. Viewed in close-up, Michael climbs up toward the edge of a disused well to peer into its abyss. He holds a coin in his hand looking into its depth, and from his point of view, it appears murky and bottomless. An edit reveals the boy dropping the money and then a further cut places the camera at the bottom of the well, the coin descending in slow motion toward the camera as the voice of Michael is heard slowly counting to ascertain its depth. Tietjens announces the arrival of Aunt Effie, but the boy continues calculating until, depicted in extreme close-up and slow motion, the coin lands, coinciding with an abrupt edit that heralds his exit from Groby. The sequence, with its mix of innovative cinematography and aural technique, operates as a com-

mentary on the passage of time, the age-old traditions of Groby, and the heartbreaking separation of Tietjens from his beloved son.

Sexual candidness is another aspect that creates a departure from the classic heritage adaptation. According to West and Laird, "As Sarah Cardwell and other critics have argued, viewers have come to expect a subdued treatment of sexuality in costume dramas. Rather than provide scenes of explicit lovemaking, these adaptations have long conveyed sex through costume, dancing, and dialogue, have long transferred desire into materials, motion, and manners."[18]

While this may have been the position adopted by the earlier costume dramas, "*Masterpiece* and its British affiliates have begun to incorporate sexually frank dialogue and graphic images into its series."[19] This is certainly true of *Parade's End*; Grace Dent, writing for the *Independent*, notes that the drama is replete with "clandestine moments of wild and morally louche, Edwardian sex in private railway carriages or cartfulls [*sic*] of big-hatted busy-bodies passing by manor houses 'for tea' but really intent on causing mischief with tittle-tattle."[20] As noted above, in *Parade's End* the spectator is introduced to explicit sexual scenes early on in the adaptation when Gerald Drake (Jack Huston) barges into Sylvia's apartment in Paris, and the two engage in frantic sex, he ripping her clothes off her body and Sylvia baring her breast.

In episode 2, the spectator witnesses frontal nudity when Sylvia takes a bath. She enters the frame wearing a revealing robe that she removes, thus again exposing her breasts. Climbing into the bathtub she stretches out, lazily smoking a cigarette; Tietjens arrives to inform her that Michael is returning to his home with Effie and that she may wish to bid her child farewell. From this, the camera frames his embarrassment as he witnesses his wife's state of undress, before returning to an amused Sylvia observing her husband's humiliation. At this juncture, Sylvia stands, and her nakedness is reflected in the mirror that is placed parallel to the bathtub. "Oh go away if you can't bear to look," states Sylvia, and while he indeed refuses to look, the spectator is enabled a triangular view of Tietjens, Sylvia, and her naked reflection in the mirror.

MELODRAMA AND EXCITEMENT IN STOPPARD'S "NONSLAVISH" ADAPTATION

Whereas literature adaptations always prided themselves for their fidelity to the original text, the postheritage adaptation, according to West and Laird, offers radical rewriting. Possibly in an attempt to appeal to a less elitist and more populist audience, Stoppard's interpretative adaptation contains more explicit sexual scenes and greater emphasis on characterization and plot-

driven narrative. He comments that, while keeping in mind the viewer, he deliberately attempts to create action not present in the book: "Possibly because I did start off as a journalist, my starting point has always been that you've got to keep an audience with you. Whatever you're doing, you always want a script to be a page turner. It's very important never, ever, to feel above that."[21] With a background as a journalist and playwright, this makes for an interesting combination, evident in this work although, significantly, the novel is also multilayered and highly complex, focusing very much on the inner thoughts of the characters rather than action. Clearly, as with all adaptations, this posed a problem of textual fidelity for Stoppard and White. Indeed, the TV dramatization almost omits the last novel in the series of four, *The Last Post*, which Stoppard intersperses into the previous three novels, thus reworking Madox Ford's manuscript in order to condense it. In fact, in *The Last Post* it is revealed that Valentine is pregnant, and this prevents Sylvia from appealing to Tietjens's high moral principles to preserve their marriage. However, in the serial Sylvia attempts to win him back by suggesting that she has cancer, a feature also of *The Last Post* and plausibly also interjected here into the final episode of the adaptation in place of the pregnancy strand.

Similarly, Stoppard introduces hooks to create melodrama and excitement. Whereas the book only hints vaguely at the sexual encounter between Tietjens and Sylvia in the railway carriage, as noted above, the adaptation makes the details of this explicit through Tietjens's flashback to their sexual encounter. Additionally, Stoppard incorporates an actual historical event that occurred in 1914 into his version—again not present in the book: the slashing of the painting, the *Rokeby Venus* (Velázquez, 1647–1651) in the National Gallery by suffragette Mary Richardson in protest of the arrest of Emmeline Pankhurst the previous day. In Stoppard's version of *Parade's End*, he writes Valentine into the gallery to witness the event, and the *Rokeby Venus* pose he uses later when she and Tietjens are to become lovers and she awaits him at her home. They have arranged a clandestine meeting for her to become his mistress, although this is thwarted by her brother's unexpected return home. While she passes the time she imagines herself reclined in a position corresponding to the nude in the painting. Seen from a rear view, she lies across a sofa exposing her nakedness in an erotic pose. In this respect, Stoppard introduces a contradiction: Valentine, a suffragette, adopts a similar pose to the image that Richardson so clearly objected to. In Madox Ford's novel, she adopts no such position, merely awaiting him in agitation. Similarly, Tietjens's father is not a prominent figure in the novel, yet Stoppard again deviates from the original by including him in the first three episodes of the adaptation.

Stoppard makes no apology for his lack of close adherence to the book and, as Jeff Shannon notes, "'Parade's End' is in a class by itself, and Stop-

pard has honoured the essence of Ford's decade-spanning fiction without limiting himself to slavish fidelity. . . . 'Parade's End' is a bit too sprawling to qualify as a masterpiece. It's easy to miss details amidst the density of Stoppard's dialogue . . . and some characters feel sketchy compared to the fully developed leads."[22]

Parade's End's complexity is a point noted by its director, Susanna White, who suggests, "You can happily go off and make yourself a cup of tea in Downton Abbey and pick it up again. You can't make yourself a cup of tea during Parade's End, or you'd be lost."[23] Just as White's earlier direction of *Bleak House* was described as a soap opera meets heritage,[24] so White argues that, in a similar vein, *Parade's End* "is like Downton Abbey meets The Wire in some ways."[25] Indeed, whereas *Downton Abbey* has a straightforward plot structure, Stoppard's *Parade's End* is intricate, with many of the characters never fully fleshed out. However, what optically seems to resemble disjointed flashbacks is actually a close adherence to the written prose, a point noted by Rosemary Goring, who points out in her praiseworthy review that such visuals are "entirely in keeping with Ford's fractured style in which his confusing time-leaps and random interior reflections are intended to represent the breakdown of English society, and the hero's personality, in the face of the Great War and its miserable aftermath."[26]

PERIOD DRAMA VERSUS *MRS. BROWN'S BOYS*: CRITICAL PERCEPTION AND AUDIENCE RECEPTION AT HOME AND ABROAD

Rather than operating as "a custodian, lauded only for the way he preserved the original work under his care,"[27] Stoppard's adaptation is interpretative and action packed, construed visually by White in line with, what West and Laird refer to as "the New Culture of Classic Adaptation."[28] Nonetheless, if the target audience for *Parade's End* was populist, then this aim was not fully realized. For its UK release, the serialization was divided into five parts on five consecutive Friday evenings broadcast at 9:00 p.m. from 24 August 2012 and, despite excellent critical acclaim from reviewers such as Gerard Gilbert who described the production as "dense and ambitious,"[29] and worthy of multiple viewings, audience figures declined. For Grace Dent, its Friday slot rather than the traditional viewing time of Sunday evening was senseless, or as she describes, one of

> gross idiocy on the part of the BBC, which places a wildly cerebral period drama chock-full of British thespian hierarchy raining down dry bons mots on a Friday night. A scarecrow with one boiled egg for an eye could see Parade's End is Sunday night, BBC1, 9pm, damp hair from a bath, comfy clothes, surrounded by Sunday supplements, mugs of tea and a half-hearted supper of

cheese and crackers as one over-ate at lunchtime, type of TV. It's Downton Abbey with a massive, complex brain.[30]

If *Parade's End* was well received by the critics, it did not find the same success with audiences. Despite the popularity of costume dramas in both the UK and the United States,[31] by episode 2 viewing figures had plummeted. Laura Donnelly in the *Daily Telegraph* notes that "Parade's End loved by critics—but viewers switch off."[32] Whereas the first episode garnered 3.1 million viewers, by week two these figures had plunged by nearly one million to 2.2 million. *Parade's End*'s Friday-night slot might be deemed inappropriate,[33] especially toward the latter part of August coinciding with a UK holiday weekend, albeit numbers were high for this particular episode. The competition for the following week (Friday, 31 August 2012), however, was stiff with the opposition including *In with the Flynns* (9:00 p.m., 3 million viewers), *Mrs. Brown's Boys* (9:30 p.m., 4.4 million), ITV1's UEFA Super Cup Live (7:30–10:10 p.m., 2.1 million), and *Celebrity Big Brother: Live Eviction* (2.1 million).[34] Consequently, as one critic suggests, some with an aversion to costume dramas may have missed the first episode because "perhaps you have a partner who threatens to put his head under the grill whenever a period drama starts so you have to watch Mrs. Brown's Boys or Russell Howard's Good News, instead."[35]

Following its UK release, *Parade's End* was subsequently compressed by HBO to three consecutive nights (Tuesday to Thursday) in February 2013. Again, it received equally good reviews from its US critics, later described as "way above average, as evident from the glowing reception it received when it premiered on the Beeb [BBC] last August."[36] However, the serial was not as popular in the United States, possibly because, according to Tim Goodman, "it's less soapy than Downton but also less successfully structured, more insularly British and far less interested in pandering—which in turn might make it substantially less popular with American audiences,"[37] and arguably, "audiences world-wide are known to prefer local product, given the choice."[38]

CONCLUSION

That *Parade's End* is high end is undeniable, yet the concept of heritage, including its various traits and iconography, is useful only in some small measure for its analysis. Apart from accuracy of costume and historical detail, and a few shots of stately homes and upper-class life, the adaptation owes little debt to its more traditional predecessors with their lengthy takes, birthright stately piles, and literary fidelity. On the other hand, Monk's concept of postheritage, in line with West and Laird's more recent theories on the changes from *Masterpiece Theatre* to *Masterpiece*, permits a better

understanding of the drama, mobilizing a number of key elements for discussion and pertinent to Stoppard's adaptation. Conceivably, and more constructive for a scrutiny of *Parade's End*, is Robin Nelson's notion of contemporary TV drama. This framework, while recognizing a cinematic aesthetic and complex cultural form, also acknowledges the industrial context of mixed-mode dramas as a trend in modern-day television. Indeed, *Parade's End* owes a debt to traditional heritage forms yet affords a fast editing rhythm and visual flamboyance in line with other high-end dramas, therefore aligning itself more with American Quality TV.[39] This has favorable and unfavorable consequences in that the program is branded as a sophisticated and distinctive product yet is what Nelson terms "edgy"[40] and experimental—a facet possibly unappealing to an audience requiring the more traditional experience associated with costume drama. Also, despite being a major figure in the literary canon, Ford Madox Ford is not a name familiar to all, a point noted by Alan Yentob in an episode of *The Culture Show* (BBC Two, 2004–) transmitted Saturday, 21 September 2012, and titled "Who on Earth Was Ford Madox Ford?" Here, the author's perceived obscurity is investigated by Yentob, who describes him as "one of the forgotten greats of British fiction."[41] Indeed, in film and television adaptation, Madox Ford has not been celebrated, acknowledged, or branded in the same vein as Dickens or Austen. Likewise, whereas the Jane Austen Society was formed in Britain in 1940 and in the United States in 1979, the UK Madox Ford Society was not inaugurated until 1997, and no equivalent exists in the United States.

Thus, despite its modernist resonances with US product, *Parade's End* failed to attract its audience in the same way as did many of its more conventional predecessors, or indeed its rival, *Downton Abbey*. Whether it was because, in the case of the United States, audiences prefer home-grown products or a more traditional perspective on a classic novel, or in terms of its British broadcast, the timing was poor, it is impossible to speculate. In sum, as Nelson points out, contemporary TV drama in general is "not only difficult to classify but, at times, problematic in terms of viewing response."[42]

NOTES

1. Robin Nelson, *State of Play: Contemporary "High End" TV Drama* (Manchester, UK: Manchester University Press, 2007), 1.
2. Claire Monk, "Sexuality and Heritage," in *Film/Literature/Heritage: A Sight and Sound Reader*, ed. Ginette Vincendeau (London: British Film Institute, 2001), 7.
3. This is summed up in Robin Nelson, "Contemporary Serial Culture: Quality TV Series in a New Media Environment," in *Transnationale Serienkultur: Thoerie, Aesthetk, Naration und Rezeption neuer Fernsehen*, ed. Susanne Eichner, Lothar Mikos, and Rainer Winter (Wiesbaden, Germany: Springer FachMedien, 2013), 27.
4. Andrew Higson, "Re-presenting the National Past: Nostalgia and Pastiche in the Heritage Film," in *Fires Were Started: British Cinema and Thatcherism*, ed. Lester D. Friedman (London: University College of London Press, 1993), 114–15.

5. Monk, "Sexuality and Heritage," 7.

6. Ibid.

7. For further reading, see also Lez Cooke, *British Television Drama: A History* (London: British Film Institute, 2003); and Nelson, *State of Play*.

8. Robin Nelson, *TV Drama in Transition: Forms, Values and Cultural Change* (Basingstoke, UK: Macmillan, 1997), 126.

9. *Masterpiece Theatre* is now known as *Masterpiece* and is a drama anthology television series produced by WGBH Boston. For further reading, see Laurence A. Jarvik, *Masterpiece Theatre and the Politics of Quality* (Lanham, MD: Scarecrow, 1999).

10. Nancy West and Karen Laird, "Prequels, Sequels, and Pop Stars: *Masterpiece* and the New Culture of Classic Adaptation," *Literature/Film Quarterly* 39, no. 4 (2011): 314.

11. Ibid., 318.

12. Anita Singh, "Parade's End: Who Is This Benedict Cumberbatch?" *Telegraph*, 27 July 2012, accessed 9 October 2013, http://www.telegraph.co.uk/.

13. Sylvia, in a display of power, has the tree felled, much to Tietjens's consternation.

14. Tom Stoppard, *Screenplay: Parade's End* (London: Faber and Faber, 2012).

15. Gerard Gilbert, "First Night: Parade's End, BBC2," *Independent*, 25 August 2012, accessed 8 September 2013, http://www.independent.co.uk/.

16. West and Laird, "Prequels, Sequels," 312.

17. See Christine Geraghty, *Bleak House* (Basingstoke, UK: Palgrave Macmillan, 2012). White took over from Justin Chadwick after episode 13 of the serial.

18. West and Laird, "Prequels, Sequels," 310.

19. Ibid.

20. Grace Dent, "Grace Dent on Television: Parade's End BBC2," *Independent*, 8 September 2012, accessed 8 September 2013, http://www.independent.co.uk/.

21. John Preston, "Tom Stoppard interview for Parade's End and Anna Karenina," *Daily Telegraph*, 24 August 2012, accessed 31 August 2013, http://www.telegraph.co.uk/.

22. Jeff Shannon, "Parade's End Movie Review and Film Summary," 20 February 2013, accessed 8 September 2013, http://www.rogerebert.com/.

23. Laura Donnelly, "Parade's End Loved by Critics—but Viewers Switch Off," 2 September 2012, accessed 28 August 2013, http://www.telegraph.co.uk/.

24. See Geraghty, *Bleak House.*

25. In Donnelly, "Parade's End."

26. Rosemary Goring, "The Bleak Brilliance of Parade's End Needs No Comparison to Downton," *Herald Scotland*, 25 August 2012, accessed 1 September 2013, http://www.heraldscotland.com/.

27. West and Laird, "Prequels, Sequels," 315.

28. This is also the title of West and Laird's article.

29. Gilbert, "First Night."

30. Dent, "Grace Dent."

31. Claire Monk conducts an empirical analysis of heritage cinema audiences in the UK. See Claire Monk, *Heritage Film Audiences: Period Films and Contemporary Audiences in the UK* (Edinburgh, UK: Edinburgh University Press, 2011).

32. Donnelly, "Parade's End."

33. Stoppard himself argues that "rightly or wrongly, we thought Parade's End was a Sunday-night sort of show." See Preston, "Tom Stoppard."

34. Jason Deans, "Parade's End Marches On but Loses Out in Battle for Friday Night Ratings," *Guardian*, 31 August 2012, accessed 8 September 2013, http://www.theguardian.com/.

35. Dent, "Grace Dent."

36. Shannon, "Parade's End."

37. Tim Goodman, "Parade's End: TV Review," *Hollywood Reporter*, 22 February 2013, accessed 4 September 2013, http://www.hollywoodreporter.com/.

38. Nelson, *State of Play*, 23.

39. Nelson defines the characteristics of American Quality TV as expensive with a cinematic appearance that includes a "dynamic pace of action-adventure or at least a snappy editing rhythm and a highly mobile camera." Nelson, *State of Play*, 36.

40. Ibid., 3.

41. Alan Yentob, "Who on Earth Was Ford Madox Ford? A Culture Show Special," *BBC 2 The Culture Show*, aired 21 September 2012, accessed 8 October 2013, http://www.bbc.co.uk/.

42. Nelson, *State of Play*, 26.

Part III

The Costume Drama, Sexual Politics, and Fandom

Chapter Fifteen

"Why don't you take her?"

Rape in the Poldark *Narrative*

Julie Anne Taddeo

THE "CULT OF POLDARK"

On 5 October 1975, the first episode of the BBC series *Poldark* (1975–1977) aired. Based on the historical novels by Winston Graham, the series follows British army officer Ross Poldark, recently returned from fighting the war in the colonies, and his struggles to rebuild his ancestral home and mining business in Cornwall. In his absence, his beloved Elizabeth Chynoweth has engaged herself to his weak-willed but wealthier cousin, Francis Poldark. But he soon finds solace in the form of a young street urchin, Demelza Carne, and eventually makes her his teen bride. Captain Poldark seems the perfect romantic hero: tall, dark, brooding, and his handsome face marred by a scar—a souvenir from the war and, as Graham writes, "a symbol of the nonconformity of his nature, the unabiding renegade."[1] By the end of its first season, the television program had garnered fifteen million viewers and was so popular that clergymen in Cornwall had to reschedule Sunday-evening services. As broadcaster Hilary Oliver recalls in the 2008 BBC Four documentary *Cult of Poldark*, "At 7pm on a Sunday evening, the streets were empty. We all went to offices the next day and we all got on with our lives, but that Sunday night television serial lifted us out of all that."[2]

In the decades that followed, the continuing popularity of the *Poldark* books and TV series helped revitalize the Cornish region, once known for its tin and copper mines, but economically hurting in the 1970s; tourists flocked (and still do) to the newly rebranded "Poldark Country," complete with "decorative young wenches," miners in clean overalls, and an eighteenth-century tableau with a "Ross & Demelza kitchen and parlour."[3] Not surprisingly,

heritage scholars lament this "narrative of quaintness" that, in their opinion, obscures the history of mining and the postwar problems of unemployment that had struck this formerly prosperous area.[4] Similar criticisms haunt historical TV programming in general, painting such costume dramas as *Poldark* (and *Downton Abbey* [2010–]) as conservatively nostalgic and escapist. But as media scholar Jerome de Groot counters, such programs have "the potential to include dissident positions" and to be "flexible and innovative . . . problematic or challenging" even as they use familiar heritage tropes; in short, the period costume drama "fosters a more nuanced understanding" of the past, as well as the immediate context in which it is consumed by its fans.[5]

The series crossed the Atlantic, airing from 1977 to 1978 on *Masterpiece Theatre*, which since its inception in 1971 has made an effort to take up the BBC's mantle of "quality programming." And *Poldark*'s popularity has not waned—repeatedly listed as one of the "top ten" favorite *Masterpiece Theatre* programs, *Poldark* was released on VHS in 1993 ("The Cornish Cpt. Rides Again!") and on DVD in 2010, described by an *LA Times* reviewer as "a cure for your *Downton Abbey* blues."[6] Social media sites like Facebook and the Winston Graham and Poldark Literary Society message board connect old and new fans (primarily in Britain and the United States), while YouTube tributes to Ross and Demelza (as played by actors Robin Ellis and Angahard Rees respectively) seal their reputation as one of TV's "sexiest couples." Fans assert their intense personal connection to the TV series and often fail to distinguish between the characters and the actors portraying them: "They are a part of me"[7] being the most typical response, and their devotion to the series has been described as "cultlike," perhaps best demonstrated by the Poldark Appreciation Society's costumed protests that almost derailed HTV's filming of a 1995 sequel because it did not employ Ellis and Rees in the reprised roles of Ross and Demelza: "They *are* Ross and Demelza and it's as simple as that."[8]

Graham once joked that he was "the most successful unknown novelist in England."[9] The *Poldark* novels have never been out of print since their initial publication in 1945, and in the United States, Graham was a regular Book-of-the-Month Club selection, but despite (or perhaps because of) his popular success, he remained pegged as a regional novelist and marginalized by academics and critics. The little attention that *Poldark* (in both its book and TV formats) has received from scholars has tended to focus on the series' depiction of class issues. Nickianne Moody calls Ross Poldark the perfect "post-war settlement" hero, with whom readers after the Second World War—facing the dismantling of the empire and a rapidly changing class structure—could easily identify.[10] Twenty years after the publication of the first four novels—during which time Graham claims "there was a constant procession of letters asking me to continue"[11]—a very different context of

postindustrial decline, miners' strikes, and popular unrest confronted *Poldark* fans. Moody contends that series 1 of the TV adaptation (1975) based on those very same four novels helped viewers recall the glory days of the mining industry that had once made Britain a superpower. Such moments of economic and social crisis inevitably trigger "intense national interest in nostalgia,"[12] and *Poldark*, Moody concludes, in both its forms, engaged with the "anxieties of both the middle and working class."[13]

While I do not deny that class concerns and nostalgic longings were (and still are) triggered by the *Poldark* series, this interpretation ignores the centrality of gender and domestic issues to *Poldark*'s thematic content, its largely transatlantic female fan base, and its continuing popularity into the twenty-first century. In adapting the *Poldark* books to the small screen, both Graham and the BBC's production team quickly realized that the history of Cornish mining and banking and parliamentary politics were of less interest to its mainly female viewers than the Ross-Demelza-Elizabeth love triangle;[14] by its second season, the *Poldark* series clearly reflected what film scholar Claire Monk calls "the pleasures of involvement and identification" that the historical costume drama promises its female viewers.[15] However, *Poldark*, in either of its formats, is no romance in the Mills and Boon tradition; addressing "the rough deal women have" (both in the late eighteenth-century context of his characters and the post–Second World War contexts of his reading and viewing audiences), Graham interrogates "the status of women" issue, paying particular attention to rape and the "psychological repression of women" in and outside of marriage.[16] Nevertheless, though filmed at the height of the feminist movement in Britain (and aired shortly after the BBC's suffragette-themed *Shoulder to Shoulder* [1974]), the TV version of *Poldark* highlights how the commercial realities of the adaptation process competed with the author's original vision; in particular, fans' desires and expectations of a romantic hero complicated (and continue to complicate) their engagement with the *Poldark* narrative.[17]

THE ROSS-DEMELZA-ELIZABETH LOVE TRIANGLE

I want to look first at the coupling of Ross and Demelza, one of TV's "greatest love stories," and how the version in the inaugural novel of the *Poldark* series was changed, against Graham's wishes, for the small-screen adaptation. When they first meet in the dirty streets of Truro, thirteen-year-old Demelza Carne has run away from her abusive father and is living hand to mouth. Ross, lonely after Elizabeth's rejection, takes her home as a lark, cleans her up, and employs her as a house servant. Four years later he marries Demelza, who has taught herself to read and has become a beauty: her earthiness, Ross observes, is a stark contrast to Elizabeth's aristocratic fragil-

ity ("earthenware" versus "porcelain," as he succinctly sums up the differ-
ence between the two women). Graham explains Ross's motivations in mar-
rying Demelza, with whom he has already had sexual relations: "It was not
that he loved her but that such a course was the obvious way out. . . . She had
already proved her worth about the house and farm, none better, and she had
grown into his life in a way he had hardly realized."[18]

Ross's decision to marry Demelza in the televised version, however, is
less matter of fact and deliberately drawn out to reveal his "chivalrous" side.
She is pregnant from their one night together and has left his estate of Nam-
para, headed on foot to town to procure an abortion, when he rescues her and
offers her marriage just as Elizabeth (Jill Townsend) is considering leaving
her first husband, Francis (Clive Francis), and running away with Ross.[19]
Ross nobly gives up the woman he thinks he wants to fulfill his "obligation"
to someone he says he feels "responsible for." Declaring, "You won't be
alone. We'll be married. . . . The child is mine, too—it will have a name, my
name," he then lifts a weeping Demelza into his arms and carries her back to
his home by horseback.[20] Viewers cheered (and still cheer) this seemingly
romantic gesture and recall with pleasure "those beautiful scenes of Ross
carrying her [Demelza] to his horse."[21] As Ellen Moody observes, such
"carrying scenes" that are written into the filmed adaptations of novels reflect
a trope typical of the costume drama—"a test of a man's masculinity whether
he rises to the challenge and takes responsibility."[22] But this moment also
diminishes Demelza, so headstrong in the novel, making her more vulnerable
and in need of Ross's protection. In the next scene, responding to the angry
cries of "trollop" that Elizabeth casts at Demelza, Ross defends the latter's
honor and insists—as a 1970s hero rather than one from the 1790s would—
that he shares "the burden of blame." That it is *Elizabeth*, and not Ross, who
questions the paternity of Demelza's unborn child further seals Elizabeth's
position as the villainess of the love triangle.

At the time of *Poldark*'s adaptation for TV, illegitimacy had lost its legal
and much of its social stigma in England and the United States, and with
contraception and abortion widely available,[23] sympathetic female viewers
would regard Demelza's pregnancy as a decidedly, and thankfully, eight-
eenth-century predicament. Yet, the screenwriters' addition of the pregnancy
as the catalyst to the marriage also makes the TV adaptation much more
conservative in its sexual politics than Graham's novel in which the couple
have simply added sexual relations to their already mutually enjoyable do-
mestic routine. Curiously, when later faced with a similar dilemma, Elizabeth
(pregnant with Ross's illegitimate child) elicits very different responses from
viewers. In the episodes that follow, she becomes more and more the charac-
ter fans love to hate—"a shallow cardboard cut-out of a woman"[24]—and it is
this transformation of Elizabeth's character from book to small screen that

Figure 15.1. Ross carrying Demelza home after proposing marriage (*Poldark*, episode 1:5)

makes what happens to her at the end of the first season less troubling to fans of the TV series than Graham had originally intended.

RAPE OR SEDUCTION?

In the fourth novel, *Warleggan* (1953), Graham presents Elizabeth in a much more sympathetic and relatable light than does her later TV portrayal. Recently widowed (after enduring years of her husband's infidelities) and saddled with Francis's gambling debts, elderly parents to care for, a crumbling estate, and an aristocratic reputation to maintain, "Elizabeth looked into the future and saw it as one in which sickness and age and responsibility were her only companions."[25] She agrees to marry Ross's rival, the nouveau riche banker George Warleggan, as a last resort and hopes that one day she can bring herself to love him. This is a far cry from the TV scene in which she boasts of the money and social clout that marriage to George (Ralph Bates) will give her: "You're all such little people," she exclaims, marking her as a money-grubbing snob rather than a desperate woman facing impending poverty.

In the novel, an enraged Ross, upon learning of the engagement, rides to her house late at night, scales the walls, and enters her bedroom; though she demands he leave, he won't unless she agrees to not marry George, and when

she refuses, he pushes her onto the bed as she cries out, "Ross, you can't intend . . . Stop! Stop, I tell you."[26] Yet, when this scene is filmed for episode 15 of series 1, there are subtle, but very significant, changes that deviate from the novel. Elizabeth's protests are much weaker; there is no slapping of Ross before he pinions her arms and stifles her protests with kisses. Instead, when Ross rushes her to the bed in the TV adaptation, she merely says, "Ross, oh my God, Ross," and the camera cuts away to a knowing Demelza, at home, weeping in her servant's arms and lamenting that Ross has "broken it, he's ruined it" (their marriage). We are also given a brief glimpse of the morning after: Ross and Elizabeth, lying side by side, both looking straight ahead, almost stunned—unlike Vivien Leigh's whistling Scarlet O'Hara the morning after Rhett Butler forcibly carries her up to the bedroom. Nevertheless, they are still together—a whole night has passed—so viewers are left to wonder, was it rape after all?[27] In the novels, Ross often reflects on his behavior that night and justifies his actions by blaming Elizabeth: her "initial resistance," he reasons, really concealed a pent-up desire for him, and her refusals "provoked" him to act this way. He even imagines a conversation in which he explains to his wife his "uneasy conscience" regarding the "misdeed" he committed against Elizabeth when "I took her against her will—though in the end I do not believe it was *so* much against her will."[28]

Fans, both those who viewed the series when it first aired and those who discovered it years later on video or DVD, express disappointment over what they call Ross's "infidelity" and "cheating on Demelza," whom they regard as the "wronged one"; like Ross, fans seem reluctant to label his actions "rape." They have already come to regard him as a hero in his defense of the poor miners throughout series 1, while pegging Elizabeth as a fool to have chosen Francis, and later George, over the more worthy Ross. A heated discussion on the Winston Graham and Poldark Literary Society message board—whose members often conflate the book and TV versions—overwhelmingly concludes that the encounter between Ross and Elizabeth must have been consensual. One member declares, "I can't see Ross being so out of control to do such a vile act," while another insists, "I would not have found a man capable of rape as endearing as I found Ross." It is simply impossible, fans contend, to put Ross in the same category as the overweight, foot fetishist, wife rapist Ossie Whitworth who features prominently in series 2: "Ross, even in anger, had an iron control most of the time and I think would have desisted if Elizabeth had not wanted him."[29]

In both book and TV versions, Ross and Elizabeth never discuss what happened until three years later when they have a chance encounter in a cemetery. In *The Four Swans* (1976), written almost twenty years after the novel in which the rape occurred, we see how Graham has considered this moment in greater depth from Elizabeth's perspective and perhaps how changing attitudes about rape in the 1970s has prompted him to rule out any

earlier ambiguity about that night. Ross, in Elizabeth's opinion, is "this man who had done her such a monstrous, an unforgivable wrong"—not just the rape but all that has followed: her illegitimate son that she has passed off as George's prematurely born heir, and George's jealous suspicion that is making life for her and the boy a misery.[30] Ross admits, "Three years ago, mine, no doubt, was the crowning injury, the insult you can never forgive and forget . . . the guilt was all mine," but he adds, while "it was ill done until now I have not regretted it."[31] She then tells him of George's suspicion, and Ross's ill-conceived solution is for her to fake another premature birth so George will think she is prone to seven-month pregnancies (she will die as a result of this plan in *The Angry Tide* [1977]—her putrefying body a horror to behold). Before they part, he grabs her, despite her resistance, and smothers her face with kisses, suggesting little remorse for his past actions.

Though written during and for the filming of series 2, this scene from Graham's novel was significantly revised for its TV adaptation. When they meet in episode 7, there is almost no discussion of the night three years prior—was it rape or not is no longer of interest to viewers. Instead, Elizabeth simply tells him of George's suspicions about the child and chides Ross for never wondering if Valentine is his son. Her anger is gone, and when Ross tells her his potentially life-threatening plan, she smiles and says, "You *are* good for me." Finally, it is *she* who kisses Ross, very gently, so that the hero is forgiven, and with such a response from Elizabeth viewers are even more inclined to accept that the bedroom encounter involved Elizabeth's consent.[32] While this interpretation is certainly in line with eighteenth-century legal and social attitudes about rape as "seduction by force" or a man's "giving way to passion,"[33] it more importantly reflects the BBC's and viewers' urge to maintain Ross's heroic image; in short, that night is rewritten as what one fan calls "the result of a temporary madness"; adds another, "After all, we know he did it out of love; it was never just a callous rape."[34]

However Ross recalled his actions from that night, his wife regretted how his lack of self-control damaged her "ideal" of him and almost drove her to infidelity. In the novel *Warleggan*, Demelza, seeking revenge, attends a neighbor's weekend house party and drunkenly flirts with another of Ross's nemeses, Captain McNeil (in fact, she prepares in advance to sleep with him, buying the latest undergarments from Paris), but once stripped down to those very drawers, she realizes that she cannot betray her husband. McNeil thinks to himself, "Of course he could still have his way if he chose. It was simple enough: you hit her just once on her obstinate little chin. But he was not that sort of man."[35] Removing himself from her bedroom, McNeil declares, "I like to think of myself as civilized so I give you best, Mrs. Poldark. I hope your husband appreciates such fidelity. . . . When admiration turns to contempt, it is time to go."[36] McNeil (perhaps echoing Graham's own enlightened feminist views) recognizes what Ross so clearly does not: that if a

woman cannot make up her mind, it is still not license to rape her. However, in the televised version, McNeil (Donald Douglas) *does* try to overcome Demelza's resistance, but she expertly knees him in the groin and escapes out the window, keeping her honor intact; such a scene implies that Elizabeth, had she truly wanted to, could have kept Ross out of her bed with one swift kick to the groin.[37] In the final episode of series 1, Demelza tells Ross she was faithful because "I'm better than you" and, in effect, better than Elizabeth, too, whom Demelza accuses of being as guilty as Ross: "You did not stop her and you couldn't stop yourself."

Unlike the BBC version of events that treats Elizabeth and Ross as equally complicit, Graham's novels continue to remind his readers that their one sexual encounter was indeed rape. Almost a decade after series 2 aired, Graham resumed his *Poldark* series, chronicling the lives of the next generation in five novels published between 1984 and 2002. In *The Loving Cup* (1984), an older, but not necessarily wiser, Ross advises his son Jeremy to "take" the woman he loves by force—to storm her bedroom and carry her off: "She belongs to you more than to anyone else," to which his son replies, "Are you joking? . . . This is the nineteenth century—I don't know whether to laugh or to cry."[38] Hearing of this plan, Demelza warns her son that he cannot just "help yourself to a woman," though "aware that Ross in fact had once done that."[39] Though seemingly attributing Jeremy's and Demelza's responses to more enlightened nineteenth-century attitudes, Graham also assumes he echoes the sentiments of his modern readers: such sexism as espoused by Ross—"a little aggression can often help them [women] decide"[40] —is countered by Demelza's assertion that, regarding sex, "it is her [the woman's] decision at the end of it."[41]

Looking back on the TV series in his memoir, Graham recognized how the actors portraying Ross and Demelza carefully crafted their image for their fans, who, in turn, treated them like "idols" and how this sometimes interfered with the integrity of the story: "They had created these two characters on screen from the characters in my novels. For weeks and months in the Seventies they had worked together, projecting themselves into these two eighteenth-century people. . . . They had presented these characters to the world . . . perpetuating the image, and the dream."[42] Of course, practicalities must also be considered here: popular media outlets like the *Sun* and *Cornish Life*, in response to the success of the TV adaptation, gushingly immortalized Ross Poldark (and the actor portraying him on the small screen) as "strong, true, and hot-blooded";[43] if Ross *is* a rapist, viewers might be reluctant to return for a second season. Therefore by the end of series 1, it is made patently clear who the real villains of the story are. The series finale involves a scene—absent from Graham's novels—in which the hungry villagers, angry over land enclosures ordered by Warleggan, burn down the grossly lavish home of newlyweds George and Elizabeth's, and the cowering couple are

rescued by Ross and Demelza. Demelza has at last forgiven Ross for his infidelity, and their courage in the face of the mob stands in stark contrast to the greed and cowardice of the Warleggans. Curiously, Elizabeth (who, in the novels, has indeed grown to love George) asks Ross, with disappointment clearly evident in her voice and face, why he didn't let the villagers kill George. Such a scene not only adds dramatic climax to the series finale but also reaffirms viewers' affection for Ross, who in that moment realizes that he married the right woman.

THE DAMAGED SWAN

When Graham resumed his *Poldark* novels in the early 1970s, he added a new character, Morwenna Chynoweth, yet another impoverished but genteel member of Elizabeth's family. Her arranged marriage to Rev. Osborne Whitworth ("Ossie") in *The Black Moon* (1973) and the ensuing abuse she endures in *The Four Swans* (1976) will become a major plot point of series 2 of the TV adaptation. Written when domestic violence and rape took center stage in feminist discourse and activism, Graham's novels suggest the timelessness of these issues, especially the psychological as well as physical damage caused by rape.

In the TV adaptation, viewers are not privy to the wedding-night rape detailed in the novel, *The Black Moon*: "Once she resisted and once he hit her, but after that she made no protest. So eventually he laid her naked on the bed, where she curled up like a frightened snail. Then he knelt at the side of the bed and said a short prayer before he got up and began to tickle her bare feet before he raped her."[44]

Such scenes were perhaps too explicit for a 1970s costume drama in which clothes remain on and hair and makeup untouched even during the most intimate encounters (as attested by Elizabeth's perfectly coiffed appearance in series 1's bedroom scene with Ross). The BBC's 1967 production of *The Forsyte Saga* had already scandalized audiences with its scene of Soames ripping Irene's bodice, implying the marital rape that would follow. But it is obvious from Morwenna's (Jane Wymark) stunned face and near revulsion after Ossie (Christopher Biggins) rolls off her during their only filmed sexual encounter that she is not a consenting participant.[45] When warned by Morwenna's physician that his nightly sexual demands threaten the health of his unborn child and wife, Ossie (in both novel and TV versions) roars that it is the legal and moral duty of a wife to submit; he echoes, almost verbatim, the oft-cited statement by Justice Sir Matthew Hale that remained in effect until 1991 when the marital rape exemption was at last overturned by English courts: "But the husband cannot be guilty of rape committed by himself upon his lawful wife, for by their mutual matrimonial

consent and contract, the wife hath given up herself in this kind unto her husband which she cannot retract."[46] After two years of nightly rapes, Morwenna internally laments, "I don't exist any longer. Nothing of me—it's all gone—mind—body—soul, even . . . I don't need to be buried, for I am dead already."[47]

While the TV version cannot probe Morwenna's psychological state in the way that Graham's novel does, it does effectively convey the trauma of marital rape. After Ossie's conveniently timed death (just as he is considering having Morwenna committed), she tells Drake Carne (Demelza's blacksmith brother [played by Kevin McNally], who has loved her all along and who now proposes marriage) that she can never be touched by a man again: "What has happened to me has contaminated me."[48] Such language, in the novel and TV series, is clearly shaped by second-wave feminist discourse and the growing awareness in the 1970s of "rape trauma syndrome,"[49] but Graham reminds us that marital rape (and its damaging effects) was just as pervasive (and sometimes even recognized as rape) in the eighteenth century, even if the courts upheld husbands' "rights." As Elizabeth Foyster notes, women in "polite society" like Morwenna *did* find ways to resist, even hinting to others of their situation while still maintaining their social status; in particular, the retreat to the sickbed could afford some protection from further abuse and suggests the complicity of doctors in protecting their female patients from sexually violent husbands.[50] Morwenna's two physicians diagnose her as melancholic and repeatedly insist, much to his dismay, that Ossie cease conjugal relations.

In series 2, Drake and Morwenna rival Ross and Demelza as fans' "favorite couple"—but despite their wedding and kiss that conclude the TV series, fans are left to wonder if the couple "would ever have a happy ending."[51] Indeed, when Graham revisits their marriage in *The Loving Cup* (1984), he reveals that Morwenna, though now outwardly a contented wife and mother, still suffers nightmares from her treatment by her first husband. Even a happy second marriage cannot erase the scars of rape.

This story arc, while speaking directly to female readers and viewers, further complicates our attempts to understand Ross's earlier behavior. In *The Four Swans*, Ross blames Warleggan for thwarting his plans to bring Drake and Morwenna together, in favor of an "over-dressed and loud-mouthed cleric," and he recognizes how marriage to "that man" has left Morwenna "a damaged swan . . . feathers awry and stained."[52] But this brief moment of feminist empathy on Ross's part is immediately countered by his statement to Demelza that the Drake-Morwenna-Ossie triangle is "no different from what I went through thirteen years ago."[53] However, there *is* a key difference, and Graham reminds us of this when Drake promises the newly widowed Morwenna that he will wait for her and never so much as "unbuckle a shoe" until she asks him to ("twill be for you always to say").[54]

Still, this subplot does further endear fans to Ross, who readily declare, "Ross is no Ossie!" There is absolutely no ambiguity concerning the issue of rape in the Whitworth household, in the novels or the TV adaptation; moreover, the depiction of Ossie as gluttonous ("I like my food"), vain, and with a sadistic foot fetish stands him in stark contrast to the dashing Captain Poldark (they are even shown riding together in a coach in series 2, episode 10—Ross's contempt for Ossie almost palpable to viewers). In an online debate as to who is the worst villain in *Poldark*, Ossie beats out even George Warleggan, who, fans agree, is at least redeemed by his love for Elizabeth.[55]

CONCLUSION

Though he sometimes battled the BBC production team for authorial control over *Poldark*'s adaptation to the small screen, Graham recognized that the need for "legitimate dramatization" and the desires of a new, and international, generation of fans, many of whom very likely did not read the books and were becoming more and more personally attached to the actors who portrayed his characters, would inevitably alter "the intention of the book."[56] When Graham resumed the series of novels in the 1970s at the insistence of his fans—and having recognized what an international hit series 1 of the TV series was quickly becoming—he put domestic and women's issues at the forefront of his narrative, earning him praise from one critic for being "an instinctive feminist."[57] Yet, he did not always elicit the reaction from his audiences that he may have expected, and when the TV adaptation rewrote the Ross-Elizabeth rape scene, he used his later novels to redress this interpretation, to limited effect.

Perhaps fans have been complicit with the adaptation process in keeping the myth of the Poldarkian romantic hero alive, but they have also been successful in validating their own version of events. Rachel Moseley and Joanne Hollows remind us that popular costume dramas, while often discredited by academics as antifeminist "trash," in fact offer women viewers an empowering space in which they can discuss matters central to their own lives[58]—even allowing for a contested definition of rape in the case of Ross and Elizabeth.

Viewers' personal attachment to certain characters/actors clearly impacts how they react to a rape subplot, with fans' overwhelming preference for Demelza as the hero's romantic partner making them reluctant to interpret Elizabeth's treatment by Ross as an act of sexual violence. Meanwhile, *Downton Abbey*'s series 4 story arc involving the rape of lady's maid Anna Bates (Joanne Froggat) caused an uproar among fans and journalists alike who suggest the rape was added for shock value only; as one journalist observed, the "problem is the character Fellowes chose. Anna is one of the

best-loved in Downton: a rare beacon of goodness who stood by her husband Bates when everyone else thought him a murderer."[59] Mrs. Hughes's response to news of Anna's rape—"No man should be able to do what he did and get away with it"—while in sync with twenty-first-century attitudes, simply ignores the sad fact that female domestic servants were often subject to sexual harassment and unwanted advances from men both upstairs and downstairs. That Anna is beaten and raped by a visiting valet, rather than by one of Downton's own residents (a far more likely possibility), not only removes any ambiguity about the rape but also fuels fans' expectations for retribution against the perpetrator. *Poldark* viewers, so forgiving of Ross's actions, applaud Ossie's death—the wife-rapist dragged through the streets by his own prized horse—which also paved the way for Drake and Morwenna's much-longed-for reunion.

Whether as costumed protesters, bloggers, amateur Amazon reviewers of DVDs and books, or message board contributors, *Poldark* fans since the 1970s have exercised a degree of control over the production, reception, and afterlife of the series that has also afforded them so much pleasure. They continue to imagine an afterlife for the characters and debate possibilities not covered in the novel or TV series—such as "Could Demelza and Elizabeth ever have become friends?" or "What if Elizabeth had married Ross?"[60] At the time of writing this chapter, a remake of *Poldark* has begun production, prompting a reinvigorated Poldark Appreciation Society to try to dictate to the BBC just who should fill the shoes and petticoats of their beloved characters. As one member of the Facebook group "A Passion for Poldark" asserts, "Just hope the beeb (BBC) remembers what it owes to . . . the adoring fans."[61] Just how the remake will address Graham's depiction of rape and how fans, both old and new, will respond to their hero's transgressions remains to be seen.

NOTES

1. Winston Graham, *Ross Poldark: A Novel of Cornwall, 1783–1787* (1945; repr., Naperville, IL: Sourcebooks, 2009), 319.

2. Hilary Oliver, *Cult of Poldark*, BBC Four, aired 17 February 2008, accessed 10 June 2013, https://www.youtube.com/.

3. Neil Kennedy and Nigel Kingcome, "Disneyfication of Cornwall: Developing a Poldark Heritage Complex," *International Journal of Heritage Studies* 4, no. 1 (1998): 52.

4. Ibid., 52–53. Kennedy and Kingcome also cite heritage scholar Robert Hewison, who notes that the "paradox of the industrial museum movement is that it is ultimately anti-industrial" (53).

5. Jerome de Groot, *Consuming History: Historians and Heritage in Contemporary Popular Culture* (London: Routledge, 2009), 185, 184.

6. Robert Lloyd, "'Poldark': A Cure for Your 'Downton Abbey' Blues," *Los Angeles Times*, 27 February 2012, accessed 13 June 2013, http://latimesblogs.latimes.com/.

7. This conflation of Graham's characters with the actors who portrayed them on-screen is exemplified by fan Dwight's response to the death of Angahard Rees, who portrayed Demelza:

"But when Angharad left us, although there was never any realistic likelihood of her, or indeed Robin, being ever likely to reprise their eponymous roles of Ross and Demelza, to me it felt like it really was Demelza who had left us as well, and while grieving for Angharad, I truly felt that I was also grieving for Demelza, and of course with Ross for the loss of his soulmate." "Dwight," Winston Graham and Poldark Literary Society message board, 10 October 2012, accessed 21 July 2013, http://poldark.activeboard.com/.

8. Oliver, *Cult of Poldark.*

9. Graham's obituary in the *Guardian* notes how he wore this label with pride. Dennis Barker, "Winston Graham," 14 July 2003, accessed 20 July 2013, http://www.theguardian.com/.

10. Nickianne Moody, "Poldark Country and National Culture," in *Cornwall: The Cultural Construction of Place,* ed. Ella Westland (Penzance, UK: University of Exeter, Patten Press, 1997), 132.

11. Winston Graham, "Poldark: How It All Happened," *Woman Magazine,* December 1977, 47, reproduced on the Winston Graham and Poldark Literary Society message board, accessed 19 July 2013, http://poldark.activeboard.com/.

12. David Cannadine, cited in Moody, "Poldark Country," 131–32.

13. Ibid., 132.

14. *Poldark* TV writer Paul Wheeler recalls in *Cult of Poldark,* "You didn't really want to know whether a bank was going to foreclose more than you wanted to know whether Ross and Demelza were going to sleep together." Graham, however, discusses his "angry protests" over changes to his original story, especially regarding Demelza's character, but he "lost" the battle to the BBC's production team of multiple writers and directors. Not until series 2 was he allowed a more "hands-on" approach to the TV adaptation. See Winston Graham, *Memoirs of a Private Man* (2003; repr., London: Pan Books, 2004), 202–6.

15. Claire Monk, "The Heritage Film and Gendered Spectatorship," in *Close Up: The Electronic Journal of British Cinema* 1 (1997), accessed 25 August 2013, http://www.shu.ac.uk/.

16. Ellen Moody quotes Graham's interest in "the rough deal women have" in "Winston Graham's v. Alfred Hitchcock's Marnie," *Ellen and Jim Have a Blog, Two,* 13 January 2011, accessed 22 July 2013, http://ellenandjim.wordpress.com/. Tony Lee Moral discusses Graham's awareness of the "abjection of women within society" in Graham's novel *Marnie* and sees his body of work as a "critique of social inequality"—an interpretation Graham himself was happy to agree with in his *Memoirs* (142). See Tony Lee Moral, *Hitchcock and the Making of Marnie* (Lanham, MD: Scarecrow, 2005), 19.

17. The recent trend in social media sites connecting fans of novels and TV adaptations helps to gauge current audience's reactions as well as mine the nostalgic recollections of older fans, many of whom also write reviews for the books and DVDs on sites like Amazon; articles on *Poldark* and its TV cast featured prominently in *Cornwall Life,* the *Sun,* and *Woman Magazine* in the late 1970s, while memoirs by Graham and Ellis also provide insight into the connection female fans have had with the *Poldark* series. See Robin Ellis's discussion of "Poldark fever" in *Making Poldark: Memoir of a BBC/Masterpiece Theatre Actor* (1978; repr., London: Palo Alto Publishing, 2012).

18. Graham, *Ross Poldark,* 236.

19. Graham pointed out to the show's writers that legalized divorce would not yet be an option for someone in Elizabeth's position until 1857. See Graham, *Memoirs,* 205.

20. *Poldark,* series 1, episode 4.

21. "Nampara Girl," Winston Graham and Poldark Literary Society message board, 27 June 2010, accessed 25 July 2013, http://poldark.activeboard.com/.

22. Ellen Moody, "The Carrying Motif," *Ellen and Jim Have a Blog, Two,* 13 June 2013, accessed 19 July 2013, http://ellenandjim.wordpress.com/.

23. For a history of illegitimacy and contraception laws in twentieth-century Britain, see Leonore Davidoff et al., *The Family Story: Blood, Contract and Intimacy, 1830–1960* (London: Longman, 1999).

24. On the Winston Graham and Poldark Literary Society message board, not a single fan claims "Elizabeth" as her username.

25. Winston Graham, *Warleggan: A Novel of Cornwall, 1792–1793* (1953; repr., London: Pan Books, 2008), 272.

26. Graham, *Warleggan*, 314.

27. On the Winston Graham and Poldark Literary Society message board, "Lori" notes that Elizabeth's "behavior after the whole ordeal in the T.V. series seemed kind of odd for a rape!" (29 July 2011, accessed 25 August 2013, http://poldark.activeboard.com/).

28. Winston Graham, *The Four Swans: A Novel of Cornwall, 1795–1797* (1976; repr., London: Pan Books, 1996), 212.

29. See online debate, "Ross and Elizabeth," May–August 2011, Winston Graham and Poldark Literary Society message board, http://poldark.activeboard.com/. An earlier discussion in 2010 also referred to the rape as "frenzied lovemaking" and concluded that "Ross was no Ossie Whitworth!"

30. Graham, *The Four Swans*, 198.

31. Ibid., 201.

32. "Lori" on the Winston Graham and Poldark Literary Society message board refers to this scene in the TV adaptation: "I think in the graveyard when she kissed him on the mouth and he did not return the affection I felt better!" (27 June 2011, accessed 18 August 2013, http://poldark.activeboard.com/).

33. See Carolyn A. Conley on attitudes about rape in late eighteenth- and nineteenth-century England. "Rape and Justice in Victorian England, *Victorian Studies* 29, no. 4 (summer 1986): 519–36.

34. Winston Graham and Poldark Literary Society message board, 29 July 2011, accessed 20 August 2013, http://poldark.activeboard.com/.

35. Graham, *Warleggan*, 346.

36. Ibid.

37. *Poldark*, series 1, episode 15.

38. Winston Graham, *The Loving Cup: A Novel of Cornwall, 1813–1815* (1984; repr., London: Pan Books, 2008), 533.

39. Ibid., 538.

40. Ibid., 542.

41. Ibid., 539.

42. Graham, *Memoirs*, 225–26.

43. Rachel Moseley, "'It's a Wild Country, Wild . . . Passionate . . . Strange': *Poldark* and the Place-Image of Cornwall," *Visual Culture in Britain* 14, no. 2 (2013): 220n18. News coverage of the series noted hordes of adoring fans chasing Rees and Ellis, and babies and pets named after their TV characters. An *Australian TV Week* article from 4 June 1977, "Poldark: The Sexiest Man on Television?," further noted how female fans conflated Poldark and Ellis: "Women see him as the idealized embodiment of consumed, horse-riding romance. And the fan mail, which includes numerous marriage proposals, proves it."

44. Graham, *The Black Moon: A Novel of Cornwall, 1794–1795* (1973; repr., London: Pan Books, 1996), 532.

45. *Poldark*, series 2, episode 6.

46. Hale, cited in Rebecca M. Ryan, "The Sex Right: A Legal History of the Marital Rape Exemption," *Law and Social Inquiry* 20, no. 4 (autumn 1995): 947.

47. Graham, *The Four Swans*, 200.

48. *Poldark*, series 2, episode 13.

49. In 1974, a two-person team of psychologist Ann Wolbert Burgess and sociologist Lynda Lytle Holmstrom coined the term "Rape Trauma Syndrome" to describe a variant of posttraumatic stress disorder experienced by women who had undergone sexual assault. See Fiona E. Raitt and M. Suzanne Zeedyk, "Rape Trauma Syndrome: Its Corroborative and Educational Roles," *Journal of Law and Society* 24, no. 4 (December 1997): 554.

50. Elizabeth Foyster, "Creating a Veil of Silence? Politeness and Marital Violence in the English Household," *Transactions of the Royal Historical Society* 12, series 6 (2002): 395–415.

51. "Drake and Morwenna," Winston Graham and Poldark Literary Society message board, October 2010, accessed 20 August 2013, http://poldark.activeboard.com/.

52. Graham, *The Four Swans*, 480, 551.

53. Ibid., 58.

54. Winston Graham, *The Angry Tide: A Novel of Cornwall, 1798–1799* (1977; repr., London: Fontana, 1986), 374.

55. "Who Is the Best Villain," Winston Graham and Poldark Literary Society message board, April 2010, accessed 20 August 2013, http://poldark.activeboard.com/.

56. Graham, *Memoirs*, 208–9. Graham was especially concerned that fans had come to regard the actors as "idols" (230).

57. In his *Memoirs*, Graham recalls, "Lee describes me in his book [*Hitchcock and the Making of Marnie*] as an instinctive feminist. Maybe that is right" (142).

58. Joanne Hollows and Rachel Moseley, "Popularity Contests: The Meanings of Popular Feminism," in *Feminism in Popular Culture*, ed. Joanne Hollows and Rachel Moseley (Oxford, UK: Berg, 2006), 4–5.

59. Glenda Cooper, "Rape at the Abbey": Has Downton Gone Too Far for Sunday Nights?" *Telegraph*, 7 October 2013, accessed 5 November 2013, http://www.telegraph.co.uk/.

60. "Could Demelza and Elizabeth Ever Have Become Friends?" Winston Graham and Poldark Literary Society message board, January 2011, accessed 20 August 2013, http://poldark.activeboard.com/.

61. Beverly Ann Merrill, member of Facebook group "A Passion for Poldark and Cornwall," 16 May 2013, accessed 17 May 2013, https://www.facebook.com/.

Chapter Sixteen

The Imaginative Power of *Downton Abbey* Fan Fiction

Andrea Schmidt

Efforts to quickly capitalize on the initial great success of *Downton Abbey* have tempered enthusiasm for the heritage serial revival of the past few years for viewers, fans, and critics alike. As Mark Lawson from *The Guardian* suggests, fans of the show were beginning to show signs of "disappointment" during season 2 of *Downton Abbey* "with suspicions that ITV1's understandable desperation to get its cash cow back on [television] may have led to the 2011 run being written and made in risky haste."[1] Critics and also fans have pointed out that seasons 2 and 3 relied more on shock value to garner ratings rather than the carefully constructed and critically self-reflexive narrative of season 1. A short-lived cameo by Shirley MacLaine as Cora Crawley's mother, Edith Crawley's sudden jilting at the altar by Sir Anthony, and the unexpected deaths of two major characters left many fans feeling nostalgic for the previous narratives, which had relied heavily on the angst-ridden Matthew and Mary romance set against the historical backdrop of the First World War. However, once the romance and the war plotlines resolved themselves, it seems the dramatic arc of the heritage serial has been difficult to sustain. The continued viewership for the show seems to base itself off of nostalgia for its first strong season. Or, as one British friend only half jokingly said in conversation, "We just all watch it for Maggie Smith, now." Yet, the *Downton* heritage text has taken on a life of its own outside of the weekly serial format. From YouTube threads to message boards and creator and screenwriter Julian Fellowes's Facebook page, fans have been voicing their frustration with the series, and many of them have turned to fan fiction as a critical and creative form of expression. As Henry Jenkins argues in his seminal *Textual Poachers*, writing and reading fan fiction provides an outlet for fans

to establish a sense of control over their version of the show.[2] I expand on Jenkins's argument and suggest that *Downton Abbey* fan fiction challenges the idea of a hierarchical creative process and its implicit claims to authenticity in its representation of a heritage past. *Downton*'s appeal lies as a foundational catalyst from which fans can "poach" to create their own meaningful representations of the series.

FAN FICTION AND HERITAGE: HISTORIES AT ODDS?

Heritage film and television criticism has largely ignored fan fiction and vice versa. "Modern" fan fiction has been traditionally viewed as stemming from the science fiction genre, in particular the original *Star Trek* series (1966–1969). Meanwhile, heritage criticism tends to focus on films and television serials with "high production values," such as the texts of Merchant Ivory or Julian Fellowes.[3] Yet the explosion of fan fiction based on heritage texts since the late 1990s, as demonstrated by the numerous *Pride and Prejudice* sequels that surfaced soon after the 1995 Andrew Davies miniseries, indicates the clear commonalities between fan writing and heritage texts. Furthermore, as Suzanne Scott and Jenkins both touch upon in the introduction to the rerelease of Jenkins's *Textual Poachers*, critics have begun expanding the historical understanding of fan fiction by tracing it back to the "participatory" fan culture present in the eighteenth century.[4] The heritage film and television genre lends itself well to the "poaching" Jenkins suggests fan fiction promotes. In a critical piece that supplements her 2011 monograph on heritage film reception, *Heritage Film Audiences*, Claire Monk demonstrates that many heritage productions, such as Merchant Ivory's *Maurice* (1987), have experienced a critical rebirth in diverse online fan communities through the advent of DVD and YouTube. Monk defines fan writings as "stories inspired by a specific text, and hybrid or crossover fictions meshing together characters, narrative events and/or settings drawn from more than one source text or franchise."[5] As Andrew Higson, one of the other foremost critics of the heritage genre suggests, the "heritage" film and television serial itself is one that thrives off of intertextual references whether through literary adaptation or the use of stock actors.[6] Thus, as the appeal of the heritage text already lies in a certain degree of "textual poaching," it is of no surprise that fans would do the same to their beloved heritage serials. In doing so, the fans challenge the problematic depictions of gender roles, the nation, and class in ways that have gone untested in the politically conservative narratives of recent revivals of the heritage serial genre, as exemplified in *Downton Abbey*.

For the purposes of the scope of this chapter, I will focus only on the fanfiction works of one recent heritage text, namely *Downton Abbey*. Of recent

heritage serials, *Downton* has by far the most prolific number of Internet fan texts, which speaks to the immense popularity of the *Downton* series established in such a relatively short amount of time. Its online fan-fiction archives rival in number older heritage texts, such as *Pride and Prejudice* (1995) or *North and South* (2004). Though a reading of the relative fan success of *Downton Abbey* versus other heritage serials lies outside the scope of this chapter, I would suggest that the prolific nature of *Downton* fan fiction correlates to the success of the show itself compared to the other serials that followed. (It does remain to be seen if the *Downton* fictions will continue after the demise of the series, though I strongly suspect they will continue in popularity.) My decision not to focus on other contemporary heritage serials, such as *Mr. Selfridge* (2013–) and the revival of *Upstairs, Downstairs* (2010–2012), lies purely in the scarcity of textual examples. Furthermore, I will use fan-fiction examples from only one of the most popular and accessible fan-fiction websites, FanFiction.Net, which contains fan fiction based on numerous genres and media formats. I will limit the majority of the discussion to the heritage television serial, though the lines are drawn with great difficulty. Monk cites the "infinite" nature of these texts "where fandoms blur with and feed off multiple other fandoms in an 'infinite' continuum or mesh," creating "a rabbit hole of self-referentiality."[7] As an example, a fan may write a *Downton* story inspired by a Tumblr blog that is based on a recent episode of *Sherlock* (2010–), and that would be a relatively tame number of intertextual references for the fan-fiction universe. The multitude of narrative possibilities opens up new possibilities for reader/viewer identification and participation in the *Downton* universe.

In contrast to the narrative opportunities provided by the fan-fiction communities, Fellowes pursues a conservative and generically non-self-reflexive narrative in his series. Indeed, to what extent do heritage texts promote a conservative representation of the past? The heritage film (and implicitly the heritage serial), as defined by Higson, is a film set in the past meant to emphasize a specific representation of the nation—mainly that of the conservative, white, upper-class society. Heritage productions have been criticized for sacrificing a compelling narrative for a stagnant mise-en-scène devoted to an "authentic" representation of the historical nation.[8] Monk has since challenged Higson's narrow definition of heritage productions with her term "post-heritage" film.[9] This concept alludes to a trend of historical films produced in the 1990s that challenge portrayals of gender and sexuality rather than focusing solely on the nation, such as *Maurice* (1987) or *Orlando* (1992). The debates over the representations of gender and nation still remain pertinent to contemporary discussions of the heritage text, as it is often where their points of intersection lie that make them the most interesting.

Yet, as Lawson suggests, Fellowes has missed these points of intersection, suggesting the series' creator "needs to remember that the house has

stairs and that class war is British TV's great subject."[10] In his desire to create a glossed-over representation of the past, he trivializes class conflict and disparities in gender power. Friendships may be cultivated between the Crawley family and the servants, but a class system remains in place. The emphasis on their kindness toward the servants could be read as a justification for the class system. Furthermore, the females' character development lies in their relations to men, and the serial most disturbingly carries undertones of victim blaming and verbal abuse. For example, Tom Branson insinuates that Sybil Crawley remains ignorant, though his assaults are glossed over by her untimely death. Furthermore, though the historical argument could be made that the Crawley family would have little contact with those who do not fit into their white, upper-class world, the entrance of hypersexualized Pamuk into the Downton estate ends in his death and never rises above an exoticized caricature. He then becomes a plot point to be brought up in later seasons.

In the deproblematization and absence of gender, race, and class conflicts, the serial implicitly, and sometimes explicitly, condones them. Indeed, Fellowes received a great deal of backlash in the United Kingdom for using a rape of one of the main characters, Anna, as a plot device in season 4. As Holly Baxter of the *Guardian* points out, though Anna's powerlessness in reporting the rape at the time is most likely historically accurate, the focus of the story line turns to the impact of the assault on her husband and "dignifies" her silence: "Depicting the sexual assault of Anna Bates as the next obstacle for her husband's freedom and happiness does every woman who settles down to *Downton* on a Sunday night a great disservice."[11] If Fellowes refuses to address or complicate these issues in *Downton Abbey*, then fanfiction writers see these gaps as useful points of departure for their own *Downton* stories that are certainly more interesting, self-aware, and sensitive.

AUTHORSHIP AND HERITAGE ACCESS

For *Downton Abbey* fans, there exists a very clear creative force behind the serial, responsible for all creative changes: Fellowes. For example, although actor Dan Stevens's (Matthew) decision to leave and not return to the show was well publicized months in advance, the backlash from fans and critics for Matthew's untimely death fell on the creator/screenwriter. Best known for his Academy Award–winning *Gosford Park* (2001), Fellowes cultivates at least the image of an "old-school" British devotion to meticulousness and quality, furthered by his own upper-class pedigree and place as a Conservative in the House of Lords. A presenter and actor in his own right, his devotion to heritage culture extends beyond the *Downton Abbey* series itself. He recently hosted an ITV documentary series *Great Houses* (2013) where

he toured large estates throughout Great Britain. In addition, he also engages in other heritage texts, including a *Titanic* miniseries (2012) and a recent screen adaptation of *Romeo and Juliet* (2013).[12] Though his creative talents vary, his devotion to a representation of the past lies in a deep-rooted belief in the superiority of privilege. In response to Shakespeare scholars' criticism of his reworking of the bard's language in *Romeo and Juliet*, he stated, "I can do that because I had a very expensive education, I went to Cambridge. Not everyone did that and there are plenty of perfectly intelligent people out there who have not been trained in Shakespeare's language choices."[13] He hence suggests a pedigree of an upper-class education enables him privileged access to a heritage text, embodying the classism for which the genre has been heavily criticized.

As a *Vanity Fair* interviewer argues, "Fellowes's particularity is the very thing that has propelled the *Downton* phenomenon."[14] Through Fellowes's emphasis on his ability to give "value judgment," he implies that a loss of "quality" would occur if creative control over the show were given to anyone else.[15] Indeed, the interview describes Fellowes's interference with the direction of one of the episodes in an effort to maintain historical authenticity. Yet, though the aura of authenticity may have explained fan attraction to the miniseries in its earliest days, its longevity rather lies in the narrative possibilities it provides. Contrary to Fellowes's deep-rooted belief in class structure and heritage, fan writing brings in other value judgments, such as ones that address gender and class conflict, which have the potential, if not to solve, at least to bring attention to problematic depictions of the past perpetuated by Fellowes in *Downton*.

The identification of authors plays an important part in the fan-fiction universe through the emphasis on creative individuality as well as collaborative efforts. *Downton* fan fiction provides a method of breaking down the representation of an implicit hierarchical authorial structure. On the whole, relatively little is revealed online about the personal life of the fan writer, as the emphasis appears to be on the commonality of the *Downton* universe and escapism. Writers originate from a variety of different countries and languages, but the majority are written in English and posted from the United States, Australia, or Great Britain; the prevalence of English-language use in *Downton* fan fiction most likely exists in order to reach a wider audience of readers. Fan writers, instead of using their own names and pictures, will take on pseudonyms and use *Downton* screenshots as avatars. Though the individuality of the respective avatars remains important, there also exists a strong collaborative effort within the fan-fiction communities and an overall desire to better their works through feedback. Although an option enables members of the community to "report abuse," reviews, on a whole, tend to be positive and encouraging. Normally, a lackluster effort incites few responses in the review section of the fan fiction, and the harshest criticism is reserved for

those who leave their readers hanging with an unfinished story. Though the texts differ stylistically and in sophistication of syntax, many of the authors would compete with Fellowes in the attention to period detail in their works. Furthermore, set-aside forums and community boards allow members to present challenge prompts to fellow writers and voice their own frustrations with their work and/or the serial itself. Overall, there lies a determination to test the generic boundaries of *Downton*.

Unsurprisingly, given the emphasis the serial places on "emotional narrative," a term Fellowes uses interchangeably with melodrama, the majority of the stories fall under the romance category.[16] Yet romance, associated with the often critically pejorative term melodrama, takes on an emotional depth and diversity not realized in the serial. First, as Jenkins suggests, one of the major appeals of fan fiction lies in the ability to explore alternative narratives and fringe characters. Compared to the amount of screen time devoted on the show for their specific romance story line, few texts focus on the Matthew/Mary romance (referred to as M/M angst in the fan-fiction world). The interclass marriage between Sybil and Branson, the underwritten affair between Robert and Jane, and the May/December romance between Edith Crawley and Sir Anthony Strallan receive a great deal more online fan interest. "Problematic" romances resolved through less-than-satisfactory twists in the series (Sybil's sudden death, the servant Jane's sudden departure from Downton Abbey, and Anthony's last-minute flight at the altar) are given greater narrative dimension and character depth. Hence, romance that transgresses both traditional class and normative gender boundaries flourishes in the fan-fiction world while merely used as an exploitative plot distraction in *Downton*.

DOWNTON FAN FICTION: EROTICA, INTERTEXTUALITY, AND METAFICTION

Fan writing in the romance genre also explores the sexuality largely absent in *Downton*, even though the program claims to lead the viewer behind the closed doors of the Edwardian household. After two seasons of angst-ridden tension between Matthew and Mary, the postnuptial lack of sexual chemistry between the two characters has been anticlimactic for most fans. They exchange a few chaste kisses during the first few episodes of the third season, several lines of dialogue suggest that problems in the bedroom may exist, and yet, several episodes later a pregnancy appears. In the fifty-thousand-word "smutty epic," "Consequences of the Castle," author Of Sandwiches and Sea-Monsters gratuitously expands on the chaste kisses of Fellowes's characters: "One hand slid around his neck to pull his head down towards her and she kissed him deeply and confidently, letting out a sigh of fulfillment as she did so, as her other hand went round his waist to embrace him fully."[17] As in

many examples of romantic and erotic (sometimes a mixture of the two) fan fiction, the women are the sexual aggressors, giving them agency in the relationships. Taking place over the course of a marathon twelve chapters with constant interruption from nosy family members and servants, "Consequences" is by far one of the most sexually explicit examples of *Downton* fan fiction. Yet, in contrast to other examples of fan fiction, such as *Fifty Shades of Grey* (2011), which has created controversy due to its portrayal of females as passive and submissive, the female characters exhibit a great deal of power in their sexual experiences.

Furthermore, several communities are devoted to the popular erotic genre slash fiction, which most often features male characters in sexual relationships. One *Downton* community challenges the male-centric tendencies of slash fiction with "femslash," most often featuring an interclass relationship between Cora Crawley and her maid, Sarah O'Brien. In "Hearts Aflame," for example, Cora and Sarah have a moment of passion literally behind a closed door: "Cora kissed her fiercely and pushed her back against the wooden door. They had just a couple of minutes snatched in between the dinner and when she was expected to join the others."[18] A love affair between arguably the least sympathetic character on the show (O'Brien) and the most underdeveloped character (Cora) gives narrative depth to their characterizations denied to them in the series itself. Another popular story line in the femslash forum involves an affair between Lady Mary and Lavinia sans Matthew, a subversion of the traditional marriage plot fulfilled within the television drama: "She brought my face to hers, my eyes closed. And then our lips were together, so softly together."[19] The fan founder for the *"Downton Abbey* Femslash Community" writes in the introductory paragraph that "lesbian non-canon couples need a place to be recognized."[20] As the founder does not clarify "non-canon *Downton* couples," this statement implies that this lack of recognition in nonmale slash fictions plagues the fan-fiction community at large. Furthermore, she addresses Fellowes's conservative narrative but also the "potential" that lies in the serial, "the one thing Julian Fellowes has given [her]."[21] Hence, not only do *Downton* fans test the boundaries of the show, but also they give voice to underrepresented communities in the fan-writing world itself.[22]

When set in the present day, fan fiction subverts the notion that the appeal of the heritage serial lies in the depiction of a "pastness" and alternately highlights the "pastness" latent in the present.[23] Popular with fellow fan writers for its erotica but also a well-researched critique of heritage culture, Silvestria's modern-day "University Challenge" places Mary and Matthew as two politically polarized rival Oxbridge students. Set many years after the heritage serial itself, Downton Abbey has been sold to the National Trust, and Lady Mary mourns her sense of displacement as a member of the aristocracy: "All she could look forward to was the opportunity to live in one wing

of the Abbey, watching tourists trample all over her family's ancestral home and hold vintage car rallies in the grounds." Stripped of the estate, but continuing to hold on to her aristocratic ideals, Mary finds herself isolated from her colleagues and treated as an outdated relic of the past at her university: "It was the Annual Conservative Association versus the Labour club's debate and dinner. She would have never bothered going normally as she was only a member of the CA to meet rich and upper class men to marry." Instead of her rich, upper-class man, Mary finds herself, of course, attracted to Matthew, a Labour Party member who has the exact opposite political views. What seems a setup for a clichéd romance of opposites instead includes academic stress and the drama of Sybil's unexpected pregnancy. A possible story line only hinted at on the *Downton* series itself addresses the unfulfilling sex between the two leads. When asked to describe her sexual experience with Matthew, Mary uses less than gracious terms: "'Memorable,' she said finally as she sat up and reached for the bedclothes. Matthew thought it was a curious term but did not question it."[24] Not only does fan fiction connect the anxieties of the class system of early twentieth-century *Downton* with similar concerns facing Great Britain a century later, but also the fiction manages to weave in the personal anxieties of modern university students.

This line between past and present is also achieved through intertextual references to modern-day literature. LadyEdithC's "Confessions of a Single-MiddleSister" takes Edith away from the early twentieth-century country setting and "follows the journey of an urban single woman trying to survive life and family." Beginning on New Year's Day and written in a diary-entry style, the fan fiction emulates Helen Fielding's 1996 best-selling novel *Bridget Jones's Diary* (itself based on *Pride and Prejudice*). Edith describes the dreaded New Year's Day dinner, "sitting between Mary and Matthew, absorbing all the pent up sexual frustration and trying to eat my pudding avoiding the passive-aggressive cutlery-abuse as lustful glances are stolen on both my sides." Here, Edith, a fringe character in Fellowes's serial, undermines the primary romantic plot in a sarcastic and funny voice denied to her in the series. In particular, Edith's desperation as the one Crawley sister who cannot seem to marry has become almost unwittingly laughable on *Downton*. Instead, in "Confessions," she is able to ironize her unsuccessful encounters with the opposite sex: "Bammo, another successful interaction with a man!"[25] Hence, the author's emulation of Edith as a Bridget Jones–esque character dismantles the separation between past and present but also gives Edith narrative voice denied to her in the television serial as the "middle sister."

Interestingly, some examples of fan fiction also engage in self-reflexive experimentation to directly challenge Julian Fellowes through his on-screen characters. As Jenkins points out, fans often protest when they feel a character development has gone awry as the series progresses.[26] In "Leave Us

Alone, Julian Fellowes," written by Darthsydious, the figures from the show choose to criticize their own serial story lines. Here characters of *Downton* disrupt the television program to question Fellowes's writing midscene. The piece establishes its authenticity by opening with a monologue by an unnamed, but very famous, film star. After kissing Jane, Robert complains about the sudden change in plot, at odds with his once staunch moral code established earlier in the series. His wife, Cora, cuts him off: "Save it dear, it's called bad script writing, the best of us have suffered from it."[27] More-than-miraculous recoveries, troubling gender politics, and the use of tokenism are all criticisms levied at Fellowes. Lady Violet, the one figure in *Downton* who, according to the piece, has remained true to her original characterization, saves the day by handing Fellowes over to the wrath of disgruntled fans. The characters go on to finally criticize the serial format itself: "Must we go through every single moment of our lives from middle-age to old-age to death? Good heavens, there are much more important things to watch on the television. Like *Doctor Who*."[28] In a final dismantling of Fellowes's devotion to authenticity and detail at the sacrifice of narrative, even the *Downton* characters prefer the science-fiction fantasy of *Doctor Who* over the nostalgic, yet limiting, comforts of their own program. This fan fiction creates a self-reflexive fantasy environment where fan and characters dynamically communicate, sans Fellowes.[29]

In a further metafictional twist, *Downton Abbey* characters also indulge in reading fan fiction as well. A story contributed as part of a *Downton Abbey* fan-fiction metafiction challenge, Clara Webb's "Afterglow" features Lady Sybil reading fan fiction based on the program's characters. Her husband, Tom, catches her reading fan fiction in bed one night. "Sybil—his gorgeous wife, the daughter of an earl, a political rabble-rouser educated at some of England's finest schools—had another side only he knew about. 'You've been reading smutty fan fiction again, haven't you?'"[30] A mix of identification occurs within the scene: the fan-fiction writer identifies with Lady Sybil, who identifies with the characters she reads about in the fan fiction. The emphasis in this passage is that Sybil is accomplished and admirable through both her political and her personal connections and still enjoys reading fan fiction. If fan-fiction characters are designed to live out the fantasy of the writers, then their avatars also engage in and enjoy the same fantasy practice. As Jenkins points out, the fans do have "lives,"[31] and the characters they project themselves on also engage in the imaginative constructions.

Though containing instances of humor and irony as illustrated in the examples above, in contrast to recent spoofs of the series, *Downton Abbey* fan fiction does not set out to trivialize the serial and implicitly its viewers. (Admittedly, the novelty factor of these parodies also wears off rather quickly after the first few minutes.) The focus of the works remains on pastiche rather than parody. The majority of writers and readers in the fan-fiction

forums acknowledge the *Downton Abbey* television serial as its own text (and, perhaps, also out of fear of copyright laws). Oftentimes, these plotlines become more complex and interesting than the ones featured on the drama itself. Their works participate in the universe initially created by Fellowes, though also highlight the fact that the producer/writer's creation is certainly not self-contained. Indeed, it is debatable to what extent the term "fan" remains useful in connection to these writers. As evidenced by their message-board commentaries and the content of the stories themselves, many are dissatisfied with the series itself and its limited possibilities; rather, they find interest in the narrative possibilities provided by its characters. Their profiles and online activity have a broad array of interests in many different genres, not merely limited to the *Downton* universe. Furthermore, fan-fiction writers exhibit an incredibly sophisticated sense of the intertextual nature of the heritage serial itself and its genealogy in nineteenth-century literature. They also, through their works, comment on the changing nature of the relation between screen and text in adaptation itself. To make a separation between a "critic" and "fan" of the series seems pejorative and also perpetuates the same artistic hierarchical limitations Fellowes promotes.

CONCLUSION

Using the *Downton Abbey* "source" text as a springboard, fan-fiction writers use the series' frameworks as catalysts for their own imaginative narratives. Fan fiction allows viewers of the show to challenge the conventional narratives and authorial hold Fellowes has chosen for *Downton Abbey*. They do so through the creation of supportive communities, which seek to improve their writing through feedback and creative prompts. In addition, they use the program as a catalyst to pursue their own personal and often subversive story lines. Finally, the use of metanarrative provides useful commentary for the potential impact of fan groups on established productions. Perhaps, like *Fifty Shades of Grey*, a fan fiction will come to the attention of mainstream popular culture (though the *Downton* erotica is far more empowering to women). As Fellowes has already expressed pleasure with some of the online viral parodies like "Downton Arby's," he may also be aware of some of the more popular *Downton* fan fiction.[32] The lagging narrative of his serial would surely benefit from another value judgment and bring a degree of generic self-reflexivity to representations of gender and class. Further study of fan writing could also lead to conversations on predecessors of the television serial itself. For example, Marc Napolitano's chapter in this collection ponders how Dickens, an author with a very specific representation of Great Britain, incorporated fan desires and/or writings into his serialized novels. Fan fiction ensures that at least in some universes, if not in Julian Fellowes's

Downton Abbey, fans will act and experience through infinite screens dynamic conversations on representations of a heritage past.[33]

NOTES

1. Mark Lawson, "TV Review: *Downton Abbey*," *Guardian*, 25 December 2011, accessed 1 August 2013, http://www.theguardian.com/.
2. Henry Jenkins, *Textual Poachers* (New York: Routledge, 2012), 118.
3. Andrew Higson, *English Heritage, English Cinema: Costume Drama since 1980* (Oxford: Oxford University Press, 2003), 38–42.
4. Suzanne Scott and Henry Jenkins, "Introduction," in Jenkins, *Textual Poachers*, xxii.
5. Claire Monk, "Heritage Film Audiences 2.0: Period Film Audiences and Online Fan Culture," *Participations: Journal of Audience and Reception Studies* 8, no. 2 (November 2011): 450–52.
6. Higson, *English Heritage*, 38–42.
7. Monk, "Heritage Film Audiences 2.0," 452.
8. Higson, *English Heritage*, 38–42.
9. Claire Monk, "Sexuality and Heritage," *Sight and Sound* 5, no. 10 (1995): 33, as cited by Higson, *English Heritage*.
10. Lawson, "TV Review."
11. Holly Baxter, "The Rape of Anna Bates: What If Stieg Larsson Had Written *Downton Abbey*?" *Guardian*, 12 November 2013, accessed 20 November 2013, http://www.theguardian.com/.
12. "Julian Fellowes," IMDb, 26 November 2013, accessed 30 November 2013, http://www.imdb.com/.
13. Sabrina Sweeney, "Romeo and Juliet: Julian Fellowes Reinvents a Classic Tale," *BBC News*, 10 October 2013, accessed 15 November 2013, http://www.bbc.co.uk/.
14. David Kamp, "The Most Happy Fellowes," *Vanity Fair*, December 2012, 170.
15. Ibid.
16. Ibid.
17. Ibid.
18. Of Sandwiches and Sea-Monsters, "Consequences of the Castle," FanFiction.Net, 23 January 2012, accessed 15 August 2013, http://www.fanfiction.net/.
19. MirrorOfSin, "Hearts Aflame," FanFiction.Net, 16 November 2011, accessed 1 August 2013, http://www.fanfiction.net/.
20. Kissthespider26, "Forbidden Kisses," FanFiction.Net, 20 November 2011, accessed 1 August 2013, http://www.fanfiction.net/.
21. Kissthespider26, "Forum: *Downton Abbey* Femslash," FanFiction.Net, 22 November 2011, accessed 1 August 2013, http://www.fanfiction.net/.
22. Kissthespider26, "Forbidden Kisses."
23. Jenkins, *Textual Poachers*, 189.
24. Higson, *English Heritage*, 38–42.
25. Silvestria, "University Challenge," FanFiction.Net, 15 August 2011, http://www.fanfiction.net/ (1 August 2013).
26. LadyEdithC, "Confessions of a SingleMiddleSister," FanFiction.Net, 11 October 2012, accessed 1 August 2013, http://www.fanfiction.net/.
27. Darthsydious, "Leave Us Alone, Julian Fellowes!," FanFiction.Net, 18 November 2011, accessed 1 August 2013, http://www.fanfiction.net/.
28. Ibid.
29. Jenkins, *Textual Poachers*, 118.
30. Clara Webb, "Afterglow," FanFiction.Net, 8 June 2013, accessed 20 October 2013, http://www.fanfiction.net/.
31. Jenkins, *Textual Poachers*, 10.
32. Kamp, "The Most Happy Fellowes," 170.

33. Marc Napolitano, "It Is but a Glimpse of the World of Fashion": British Costume Drama, Dickens, and Serialization," *Upstairs and Downstairs: British Costume Drama Television from* The Forsyte Saga *to* Downton Abbey, eds. James Leggott and Julie Anne Taddeo (Lanham, MD: Rowman & Littlefield, 2014).

Chapter Seventeen

This Wonderful Commercial Machine

Gender, Class, and the Pleasures and Spectacle of Shopping in The Paradise *and* Mr. Selfridge

Andrea Wright

Splendor, opulence, and meticulous attention to period detail have been defining features of the British costume drama. Indeed, such focus on the visual delights of the past has encouraged some commentators to dismiss the productions as frivolous entertainment that negate opportunity to make any serious social or political comment. Andrew Higson, engaging with the "heritage debate," which explored the tension between the spectacle and the substance of the predominantly cinematic period adaptations of the 1980s and early 1990s, criticized the "conservationist desire for authenticity" at the expense of preserving the irony or satire of the original texts.[1] This approach to the period drama persists and has characterized responses to the recent BBC and ITV productions, *The Paradise* (2012–2014) and *Mr. Selfridge* (2013–). Michael Hogan, in his two-star review of the series finale of *The Paradise*, described the program as "mid-market tweeness," which "blew its budget on fancy packaging and forgot about the product."[2] Similarly, Lara Prendergast, in a marginally better two-and-a-half-star review of the final episode of the first season of *Mr. Selfridge*, noted, "If the next series wants to keep viewers hooked, it must offer something more subtle than sumptuous window displays."[3] However, both reviewers overlook that these two programs, and the books on which they are based, are about spectacle and seduction. Unlike heritage cinema, these productions deliberately revel in the pleasures of consumerism and invite the viewer to experience the wonders of the grand department store. But, just as it is questionable that the earlier period adaptations sacrificed any serious intent for style, it is remiss to claim that these

more recent productions are simply vacuous ocular treats. Fundamentally, spectacle and shopping are intrinsically bound up with gender representations, class structures, and social change, and the retail environment provides a fascinating alternative to the more common country house settings.

This chapter will explore these relationships, as well as addressing the specific viewing pleasures on offer via the resplendent halls of the department store. In particular, the role and representation of women, and their association with consumerism and commodification, will be examined. The two series will also be discussed in relation to their closest predecessor, 1920s-set *House of Eliott* (1991–1994). While the earlier program focused on the developing couture business of two independent women, the more recent productions center on the rise of two ambitious men determined to revolutionize the British shopping experience. Consequently, *The House of Eliott* seems domestic and genteel, while *The Paradise* and *Mr. Selfridge* are public and exhibitionist. Ultimately, the two recent series are seductive and sensational and, although familiar in some respects, invigorate the costume production by making shopping and its attendant pleasures the main attraction.

STORE WARS

Chris Hastings's June 2012 article about upcoming dramas on British television in the *Daily Mail* was titled "After Upstairs v Downton It's Store Wars. . . ." It was reported that the BBC and ITV were about to reignite their costume-drama rivalry with similar-themed series, but after poor audience figures and subsequent cancellation of the revived *Upstairs, Downstairs* (2010–2012), the corporation was keen to air its program first.[4] Accordingly, the BBC's *The Paradise* premiered on 25 September 2012, and ITV's *Mr. Selfridge* commenced nearly five months later on 6 January 2013. *The Paradise*, based on Émile Zola's 1883 novel *Au Bonheur des Dames* (*The Ladies' Paradise* or *Ladies' Delight*), exchanges mid-nineteenth-century Paris for an unnamed town in the north of England (most likely Newcastle), while *Mr. Selfridge* adapts Lindy Woodhead's 2007 biography of the charismatic Harry Gordon Selfridge, founder of the eponymous West End department store that opened in 1909.[5] Both focus on middle-class entrepreneurs, John Moray (Zola's Mouret, played by Emun Elliott), and Selfridge (Jeremy Piven), who are building their businesses by simultaneously attempting to coax investors and seduce shoppers. To help facilitate the costume drama's staple upstairs-and-downstairs format, they also centralize a motivated and aspirational young working-class woman, Denise Lovett (Joanna Vanderham) in *The Paradise* and Agnes Towler (Aisling Loftus) in *Mr. Selfridge*. Each explores the lives, loves, scandals, successes, and failures of these characters and their relationship to the department stores. Significantly, both Moray and Selfridge

risk their reputations and businesses because of personal and professional indiscretions. Moray becomes romantically entangled with Denise, thus jeopardizing the financial backing of upper-class investor Lord Glendenning (Patrick Malahide), to whose overbearing socialite daughter, Katherine (Elaine Cassidy), he is rather reluctantly engaged. Selfridge's weaknesses for gambling and beautiful women consistently threaten to overshadow his business innovations and risk his marriage.

Such plot preoccupations situate both, like many television costume dramas, in a curious position in regard to generic classification. Producer of *The Paradise*, Simon Lewis, when asked about what "edge" the show had over other costume dramas, replied, " When I read it I thought, it's sort of *Sex and the City* in the 19th century. I think a lot of the values are fairly contemporary. We've dressed it up in a very fancy setting and actually a lot of the dynamics that the characters face are really modern."[6]

Lewis's comments, although suggesting a rather more racy interpretation than the program itself delivers, highlight the continued appeal of the period text because of its familiar format and preoccupations. Creator, writer, and executive producer of *Mr. Selfridge* Andrew Davies explained perhaps even more surprising similarities with other television genres: "I began to see parallels to my favourite TV show *The Sopranos*. A charismatic hero with self-destructive tendencies, at the centre of a drama that explores the world of business and the emotional joys and traumas of family life."[7]

More accurately, though, they appear to be somewhat of a hybrid of the aforementioned period/heritage cycle and soap opera. Chris Louttit, writing about the BBC's *Bleak House* (2005) and *Cranford* (2007–2009), highlights how similar combinations of generic styles have characterized other period adaptations since the mid-2000s. Louttit discusses how elements such as length, editing, aesthetics, and stripped-back narratives have contributed to a perception that these programs were transforming the costume drama, but that often innovation was tempered by conservative ideologies and an emphasis on their "quality" status.[8] He concludes that they contain "a conservative strain which reveals not only our 'obsession with the past' but also, especially in recent years, a growing anxiety about the future."[9]

A preoccupation with the past as a way of mediating the present aligns the television costume drama much more closely with its cinematic predecessors. However, the relationship between past and present is complex, and as Higson points out, the nostalgia of the heritage cycle is ambivalent and can be read in numerous ways. He argues that

> nostalgia is always in effect a critique of the present, which is lacking something desirable situated out of reach in the past. Nostalgia always implies that there is something wrong with the present, but it does not necessarily speak from the point of view of right-wing conservatism. It can of course be used to

flee from our troubled present into the imaginary stability and grandeur of the past. But it can also be used to comment on the inadequacies of the present from a more radical perspective. [10]

This kind of vagueness means that it is sometimes difficult to attach a particular reading to a heritage text. Such texts were perhaps a distraction meant to counter, at least in part, the reality of living in Britain in the political and economic climate of the 1980s, but at the same time, they can also be recognized as means to remark upon contemporaneous culture and politics. This uncertainty lingers within post-1980s heritage cinema and television, and the productions are still readily tied to contemporary political commentary. One of the most poignant connections appeared on the cover of a 2010 edition of *Private Eye* magazine; under the heading "Downturn Abbey," the heads of key members of David Cameron's cabinet (including Cameron himself in the position of Lord Grantham) were Photoshopped onto the promotional shot of the *Downton Abbey* (2010–) cast posed in front of Highclere Castle. [11] Essentially, the television costume drama has not lost its cinematic predecessors' ability to comment upon, or at least be used to comment upon, contemporary social and political life, and like Higson's description of the ambivalent meaning of nostalgia, recent costume dramas can be understood as a way to escape the present and to explore the implications of current changes. As Louttit notes, when commenting on the scheduling of *Cranford* in relation to the documentary *The Blair Years* (2007), "Adaptations like *Cranford* are a part of their own historical moment as much as a reflection on the past." [12]

The contemporary resonance of some of the themes around shopping, such as commodification, raised by *The Paradise* was recognized by the series producer Lewis:

> [Zola] was talking about the big shops killing off the artisans, the craftsmen, and you think, well that's no different to us bemoaning the arrival of another chain store on the High Street. He was talking about capitalism and how it was killing off the art of making things individually and personally and replacing it with something much more cynical—that's a completely contemporary notion. [13]

But Lewis's comments perhaps only go so far in explaining how both *The Paradise* and *Mr. Selfridge* are a response to current changes in retail and shopping experiences. The point of dramatic transformation brought about by the department store from the mid-nineteenth century into the early twentieth century saw small shops, merchants, and craftsmen under threat from the magnificent premises and enhanced experience offered by their much bigger rivals. Michael B. Miller, writing about Paris's Bon Marché, describes how the stores were "dazzling and sensuous, a fantasy world, a spectacle of

extraordinary proportions" and that visiting them "became an event and an adventure."[14] In the early twenty-first century, the British high street is in a precarious state because of the increasing popularity of alternative shopping attractions and the digital economy. In 2011, retail expert Mary Portas published an independent report detailing the decline of the high street and twenty-eight recommendations designed to reinvigorate it. She wrote that "the phenomenal growth of online retailing, the rise of mobile retailing, the speed and sophistication of the major national and international retailers, the epic and immersive experiences offered by today's new breed of shopping mall, combined with a crippling recession, have all conspired to change today's retail landscape."[15]

The sense that the old, or at least traditional, is being usurped by something new and somehow less authentic is foregrounded frequently in *The Paradise*, particularly in the relationship between the small drapers and haberdasheries that occupy one side of the street and the grand store that dominates the other. Tailor Edmund Lovett (Peter Wight), Denise's uncle, describes The Paradise as a phantom, a daydream, thus underscoring the almost ephemeral quality of the store and its goods when compared to the work of traditional tradesmen. The distinction is further emphasized when Edmund is commissioned by Katherine, to spite Moray when it seems he is not willing to marry her, to create a gown. The process of designing and crafting a garment of quality by hand is presented as requiring passion, commitment, and pride. Edmund spends many hours working on the dress in his small shop, and his workmanship speaks for itself. Conversely, the young saleswomen in The Paradise simply produce enticing garments from boxes and tempt their customers with florid descriptions of the fabrics.

Interestingly, though, both programs seem to offer something more significant: a nostalgia for a certain kind of shopping itself. By focusing on the pleasures of the retail environment, the goods, the display cabinets, window designs, and the personal input of the floor staff, they recall an experience that is less important in modern retail, which is overwhelmingly characterized by cavernous hypermarkets and malls (all offering a similar selection of shiny units and brands) that lack the individuality and character of their forebears. Moreover, online shopping in the UK has increased at a staggering rate, with the Centre for Retail Research indicating that by 2012 it already accounted for 12.7 percent of all purchases.[16] Both *The Paradise* and *Mr. Selfridge* create a visual hyperbole of shopping, and the multitextured and almost tactile quality of the sets and dressings produces a potent retail fantasy that is potentially absent for viewers. It is in this respect also that these productions share aesthetic concerns with heritage cinema. Higson describes the key iconography of the heritage film as "completed by the rich *mise-en-scène* of the antique collector, with its tasteful period décor, furniture and

ornaments."[17] In these programs, the opportunity to revel in the creation of a period wonderland is aided by the department-store setting.

In the opening section of *Au Bonheur des Dames*, Zola describes the bustling streets of Paris and its consumer temptations as seen through the eyes of Denise. He describes her fascination with the Ladies' Paradise, which seems to be a dynamic machine vibrating with warmth and energy that contrasts with the drab and old-fashioned surroundings of her uncle's shop.[18] The opening shots of the television adaption feature a young woman being drawn to the elegant white-painted beacon on an otherwise gray city street. Before entering her uncle's shop, she crosses the road to stare in wonder at the decorative and brightly lit window displays. When Denise first enters The Paradise to seek employment, the camera follows her progress and reveals the delights of the interior. Delicate glass and china objects arranged on elegant shelves catch the light in the entrance halls, and the stylish ground-floor department glows in pale candlelight. The nondiegetic music, played on predominantly wind instruments, heightens the sense of wonder and is accompanied by the soft tinkle of glass as customers handle goods, and movement disturbs the dangling crystals of the candelabra. While the BBC chose not to emphasize Zola's gender designation of the store and removed "Ladies" from the title, the style and contents of The Paradise are clearly intended to entice the female shopper. Production designer Melanie Allen has described how, architecturally, it is an amalgamation of stores and buildings from the 1800s, "but its 'look' is based on the work of [James] Tissot. In the 1870s, when our story is set, he was here painting society ladies. It's his influence that gives *The Paradise* its French feel—romantic and feminine."[19] The pale color palette, fine décor, and elegantly dressed ladies in particular reveal Tissot's influence. Despite the feminine interiors, though, it is a man who provides the new pleasures for women, and in this very public space he orchestrates how women will spend their money and leisure time.

In the first episode of *Mr. Selfridge*, before the opening of the store, Selfridge tells his staff that "we are going to show the world how to make shopping thrilling," and indeed as Piven plays him, he is portrayed as a consummate showman. Each of the events that the store hosts, including visits from explorer Ernest Shackleton and aviator Louis Blériot, is focused on performance and garnering appreciation from shoppers and the popular press. The interior of the store itself is more ordered and formal than The Paradise. The white marble walls with grand classical columns and wide staircases give a sense of space and grandeur, and the goods are neatly displayed on and inside large glass and wood cabinets. The sweeping camera shot that ushers the viewers from the upper balcony to the sales counters as the (predominantly female) staff excitedly prepare for the opening accentuates the spectacle. Throughout the series, there is much emphasis placed on the window displays. Although this is partly to enable the relationship be-

tween Agnes and the suave French window dresser, Henri (Grégory Fitoussi), its function is to showcase the consumer goods in a manner that seduces the customer and ultimately augments the exhibitionist nature of the department store.

By contrast, *The House of Eliott* , although sharing a similar concern for period detail, has a far more domestic feel. Initially, Beatrice (Stella Gonet) and Evangeline Eliott (Louise Lombard) work from their family home, and when their couture business is established, they move to a building that houses their apartment and workrooms, meaning there is little distinction made between home and employment. The industrious heart of the business is the sewing room, a small and feminine space filled with fabrics and patterns. A team of women, who regularly gossip and quarrel, make garments based on designs created by the Eliott sisters. It is not until the final episode of the first season that there is any public show of their work, and when their collection is premiered, it is a genteel affair. Each of the gowns is introduced by Beatrice as a small number of models walk out onto a stage and wait for the response of a polite upper-class audience and writers from upmarket fashion publications. They struggle with the showmanship and confidence that seems natural and acceptable for men in the public sphere, a historically important representation.

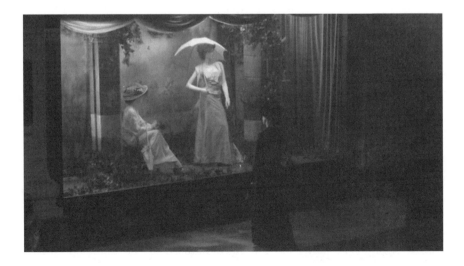

Figure 17.1. Agnes (Aisling Loftus) admires the first Selfridges window display (*Mr. Selfridge*, episode 1:1)

SHOPPERS, SHOP GIRLS, AND MODERN WOMEN

In *Shopping for Pleasure*, Erika Diane Rappaport explores retail, gender, and class in London from the latter part of the nineteenth into the mid-twentieth century. She argues that a bourgeois femininity was "born" within this public realm and that "public space and gender identities were, in essence, produced together."[20] She states that contemporary social observers professed the city a "pleasure zone" and women, the "natural" shoppers, "pleasure seekers."[21] But she also highlights the tension between the public and the private that emerged as the idealized middle-class wife and mother who belonged to the domestic sphere gradually made her way into the public arena. For Maggie Andrews and Mary M. Talbot, the department store offered a space where such tensions could be negotiated as they "were in the public sphere, but in their very construction, architecture and aura they presented themselves as part of the private sphere."[22] Andrews and Talbot and Rappaport imply that there was a complex relationship between women, shopping, and the new freedoms that consumerism and access to city spaces provided. Rappaport argues that "class and gender conflicts were fought out through the construction of the female consumer as either a victim or an emancipated woman" but that these constructions should not be understood as simply emancipatory or oppressive.[23] Furthermore, Brian Nelson notes that for middle-class women, in particular, the store was a "dream world" where women could enjoy a "sense of freedom from husbands and the restraints of family life" but that ultimately the pleasures of shopping were "half-illusory."[24] This complexity surrounding the association of women, shopping, and the public sphere is consistently foregrounded in *The House of Eliott*, *The Paradise*, and *Mr. Selfridge*.

There is frequent concern expressed about respectability and reputation in all three programs that impacts women of all classes. In *The House of Eliott*, Beatrice and Evangeline's business ambitions are hindered by suspicions that their enterprise is not appropriate for women of their social background. When the women lose their father, their aunt encourages Beatrice to apply for a position as a lady's companion because it is befitting a spinster, and they find it difficult to secure and sustain financial backing, despite their obvious talents. In *Mr. Selfridge* bold marketing strategies are employed to entice women into the store, but reservations about the suitability of advertising what are perceived to be intimate items such as toiletries, perfumes, and makeup are expressed by senior staff. Ultimately it is decided that scents, particularly the sentimental lily-of-the-valley signature perfume, should be displayed at the front of the store but that lipsticks and rouge should be discreetly concealed under the counters. One of Denise's innovations for The Paradise is to invite women to the store after hours to exclusively view luxurious underwear and nightwear ranges. The secrecy of the event is simul-

taneously intended to allow the respectable middle-class clientele to shop without damaging their reputations and to increase the profits of the male entrepreneur, which appears to be an acceptable negotiation. The notion that middle-class women could take refuge in shopping, if only temporarily, is also prominent. After the death of their controlling father, Beatrice and Evangeline immediately indulge in the previously denied consumer pleasures, and a montage shows them carefree as they try on hats and shoes. In the second episode of *The Paradise*, Katherine's friend, Mrs. Brookmire (Olivia Hallinan), describes the store as a "piece of heaven" and masks her personal unhappiness in her marriage by gleefully ordering multiple items on credit.

While the department store helped to facilitate the emergence of middle-class women into the public sphere, it did not offer working-class women the same, however limited, freedoms. Nelson, in his introduction to Zola's novel, observes that "for working-class women the store was hardly different from the street: whether in the street or in the store, Denise and the other working-class salesgirls are constantly a prey, because of their subordinate and economic status, to the masculine gaze; and they themselves are also buyable objects."[25]

Appearance and presentation are consistently foregrounded as essential to the success of a woman working in the retail environment. Miss Audrey (Sarah Lancashire), the spinster head of ladieswear in The Paradise, regularly inspects the girls' attire and hairstyle, and Mr. Selfridge lines up almost identical female lift attendants wearing matching outfits for his appraisal before they enter the shop floor. Over the counters the girls demurely smile at female customers as they make their selections and often flirtatiously engage male shoppers; they are ultimately as on display as the goods they sell. However, the commodification of femininity is perhaps best exemplified by the character Ellen Love (Zoë Tapper) in *Mr. Selfridge*. Although she is not a shopgirl, she is initially used to help promote the store, and she is described as the "spirit of Selfridges." Selfridge is immediately attracted to the young actress when he sees her in a somewhat risqué music-hall performance as she suggestively sings about how she would like to be "his new girl." From that point she is consistently presented as a spectacle to be appreciated. When she first enters the store, she sweeps through the shop floor dressed in red as the male and female staff look on in admiration, and Selfridge himself cannot resist her charms. Framing and costume make sexuality overt and unquestionably construct woman-as-object; she is a consumable pleasure.

In keeping with Louttit's suggestion that television dramas produced since the mid-2000s are somewhat ideologically conservative, the recent productions (and indeed their earlier predecessor) fail to offer consistently progressive roles for women and reiterate rigid class structures. Female roles are often compromised and even trivialized, thus indicating an ambivalent attitude toward female empowerment. For example, the presence of the suf-

fragettes and Selfridges' endorsement of their cause may appear positive, but the representation of individual female characters is more problematic. In *The Paradise*, Denise regularly shows initiative and imagination. She is distinct from her peers, who seem either flighty or spiteful, and she has ambition and an ability to understand the changing retail market. In episode 1:7, when Denise has left The Paradise because of her feelings toward Moray, she proposes that her uncle and the shopkeepers who have lost trade because of their much bigger rival collaborate and offer incentives to shoppers. Such positive representation of an aspiring young woman is tempered, however, by the need to gain approval from men and by the way in which established structures restrict her progression. The cooperative of shopkeepers ultimately fails because of internal disagreements and an unwillingness to be guided by a woman.

This representation of Denise seems to be in keeping with Nelson's reading of Zola's character. He argues that feminist critics such as Naomi Schor have been inclined to understand Denise as "an allegory of feminisation and female revenge, transcendence of the commodity, and the achievement of autonomy," but that what is more significant is the way that Mouret is humanized and domesticated by bourgeois ideology.[26] Fundamentally he contends that "although Denise breaks the mould of masculine domination, her influence and independence are only achieved in terms of her critical presence within the existing system."[27] The BBC adaptation does not portray Moray as a ruthless exploiter of women who needs to be reformed in the way that Mouret is in Zola's text, but there is the same sense that Denise, a modern, capitalist woman, recognizable to contemporary audiences, brings about change by knowing and understanding the evolving business world that she inhabits, not by challenging patriarchy. This is further emphasized by the contrast between Katherine and Denise, and by the brief appearance of Clemence Romanis (Branka Katic) early in season 2. Katherine is an upper-class woman who attempts to manipulate others through her social status and wealth, but she ultimately fails and loses Moray.

More significantly, the representation of Clemence, a French business-woman invited to The Paradise by Moray, demonstrates a reluctance on the part of the producers to allow a successful woman to operate unproblematically outside of patriarchal influence. As soon as she arrives, Clemence attracts considerable male attention, which she uses to her advantage in attempting to secure a deal for the (rather appropriate) fireworks that she is promoting. Importantly, the visit coincides with Miss Audrey's announcement that she will be leaving her employment to marry Edmund. Her fear of dying a spinster has precipitated her decision, but she is not without doubts about having to give up her livelihood. Clemence's questioning of the position of women in a man's world stirs up strong feelings in the women around her, especially when she gives a rousing speech about her own success and

makes a toast to women's passion. Denise admits to Clemence that she wants to be just like Moray and run The Paradise, and the older woman says that she knew they wanted the same thing and kisses Denise on the lips. Denise recoils, but she discloses to another assistant, Clara (Sonya Cassidy), that she does not want to tell Moray that his friend tried to seduce her because she respects the other woman's philosophies and still wants her to win the contract. Miss Audrey also repeats Clemence's words about a woman's calling to Edmund and tells him that she is reconsidering her decision. However, the way in which Clemence manipulates the men, in particular the married shop manager Dudley (Matthew McNulty), is portrayed as villainous, and she reveals to Denise that she has had to flee Paris because of some mysterious "difficulties." It seems that she believes that toying with men is the only way that a woman can do business, thus confusing what seemed to be feminist ideas. Moreover, her sexuality is handled in a manner that casts her as a dangerous Other with the potential to corrupt those around her. Ultimately, and in keeping with the conservatism of the program, Clemence is only a temporary interruption, and she is exposed to be driven by bitterness because a former lover chose a man over a life with her. The hapless Dudley is rescued from committing adultery, and Edmund and Miss Audrey are reconciled. Normalcy is restored as Clemence retreats, literally, into the darkness after the successful fireworks display at the store.

Agnes is also ambitious, but her prospects are even more limited. She is given some opportunities, but she is always beholden to men. In the first episode she impresses Selfridge by breaking the rules of the store that she worked in by allowing him to see and handle the goods without intention to buy. At the end of the day she is told not to return and is forced to seek out the mysterious American. He gives her a position in his new store and continues to offer paternalistic support, especially in dealing with her own father, a violent drunk. She does not have a physical attraction to her employer, and instead falls for Henri, but the relationship is controlled by him and is presented as her sexual education rather than emancipation. He eventually leaves to go to work in America with his much more experienced French lover, and Agnes reevaluates her potential union with a young waiter who is firmly indicated as belonging to the same class.

There are far more derogatory female characters to be found in both series that perhaps highlight popular culture's persistence in using established representations of femininity. Denise's working life is made uncomfortable by her relationship with Clara, an outgoing, aggressive, and competitive assistant. Physically they are distinguished in a manner that relies on conventional stereotypes of virgin and whore. Denise, as the ingenue, is petite, blonde, and suitably bashful when she receives male attention. Meanwhile, Clara is brunette, tall, with a consistently hostile posture and manner, and is sexually experienced. While Moray refers to Denise as his "little champion" and

"inspiration," and respects her business acumen, it becomes clear that he has had a brief sexual relationship with Clara and is now keen to distance himself from her. Dudley warns Clara that she is to cease in pursuing her employer and "restrain" herself. Indeed her desperate attempts to win Moray's attentions make her appear undignified and reckless. Clara is revealed to harbor secrets, in addition to her encounter with Moray, that threaten her position, and she—and other characters, such as the desperate Miss Bunting (Pippa Haywood) who steals from Selfridge—highlight the precarious nature of a working-class woman's reputation. Interestingly, in both programs, the central upper-class women, Katherine and Lady Mae (Katherine Kelly), who initially helps Selfridge find additional financial backing, are portrayed as calculating, greedy, and controlling. Their unsympathetic representation perhaps aids in underscoring the promotion of bourgeois ideals and the success of Moray and Selfridge as central to progress.

It is through these representations that *The Paradise* and *Mr. Selfridge* reveal their inherently conservative attitude toward women. It is also this aspect that separates them most decisively from *The House of Eliott*. While, as noted earlier, there are restrictions for the Eliott sisters in their business dealings, which seem to be tied as much to their social position as their gender, they are afforded considerably more autonomy in their private lives. Birgitte Søland, writing about young women in the 1920s, notes that the decade saw considerable social changes and shifts in gender politics, and although it "may not have ultimately overturned fundamental power relations between men and women, it transformed many patterns of daily life."[28] Søland acknowledges that differing accounts of women circulate perceptions of the 1920s and that

> the "Modern Woman"—the scantily clad, sexually liberated, economically independent, self-reliant female—was a rhetorical construction, the quintessential symbol of a world in disarray. But, "modern women"—women who cut their hair, wore short skirts, worked for wages, and enjoyed themselves outside the home—were not just figments of anxious imaginations.[29]

The House of Eliott represents changes linked to the "modern woman" rather than a sensationalized and revolutionary shift, and Beatrice and Evangeline embody a sense of steady progress. In her relationship with Jack Maddox (Aden Gillett), Beatrice maintains her independence and often appears to be more rational and more confident in both business and social situations. Once they are married, she is initially reluctant to start a family because of the implications it will have for her professional life. Eventually this causes them to separate, and Beatrice embarks, for a time, on another relationship. Although she does come to realize that Jack is her true love and settles into family life, she has arrived at this conclusion after a journey of

self-discovery. Evangeline has numerous relationships throughout the three seasons, and there are strong implications that many are sexual. After turning twenty-one, she makes the decision, as a newly autonomous woman, to take a position at a couture house in Paris. The stay is short lived, but she makes clear, with a revealing smile to a rather stunned Beatrice, that the affair with designer Gilles Caragnac (Patrice Valota) was fun and that she was unsure who seduced whom. Unlike Agnes's sexual education, this encounter seems to mark Evangeline's maturity and liberation. Arguably, in this respect, the Eliott sisters have more in common with Moray and Selfridge, and often their colorful private lives threaten to eclipse their public and professional careers. Equally they are less consumers or consumables than their counterparts in *The Paradise* and *Mr. Selfridge*.

CONCLUSION

The seduction of shopping and the retail fantasies provided by *The Paradise* and *Mr. Selfridge* make the programs stand out from other contemporary period productions. As a response to the present social and economic climate, they offer a particular type of escapism linked to shopping. However, in their representation of women and class they remain determinedly conservative and largely reliant on established stereotypes. The programs are, therefore, paradoxically, forward and backward looking, and continue to engage debates concerning style, substance, and gender politics. Zola frequently describes The Ladies' Paradise as a machine, a dream-machine or a commercial machine, controlled by a man and designed to draw women in when pleasures of retail were an emergent force. These slick, attractive productions, wonderful commercial machines themselves, likewise seduce and indulge their audiences and provide new delights alongside familiar representations.

NOTES

1. Andrew Higson, "Re-presenting the National Past: Nostalgia and Pastiche in the Heritage Film," in *Fires Were Started: British Cinema and Thatcherism*, 2nd ed., ed. Lester D. Friedman (London: Wallflower Press, 2006), 101.
2. Michael Hogan, "*The Paradise*: The Last Episode," *Telegraph*, 17 November 2012, accessed 4 April 2013, http://www.telegraph.co.uk/.
3. Lara Prendergast, "*Mr Selfridge*, Episode 10, ITV," *Telegraph*, 10 March 2013, accessed 4 April 2013, http://www.telegraph.co.uk/.
4. Chris Hastings, "After Upstairs v Downton It's Store Wars . . . and This Time, the BBC Is Determined to Get Its Drama On First," *Daily Mail*, 29 June 2012, accessed 2 September 2013, http://www.dailymail.co.uk/.
5. Émile Zola, *The Ladies' Paradise* (Oxford: Oxford University Press, 2008); and Lindy Woodhead, *Shopping, Seduction and Mr Selfridge* (London: Profile Books, 2007).

6. "The Paradise: Bill Gallagher's Glittering New BBC One Drama Series," BBC Media Centre, 12 September 2012, accessed 29 August 2013, http://www.bbc.co.uk/.

7. "Mr Selfridge: Production Notes," ITV Studios, accessed 29 August 2013, http://ianwylie.files.wordpress.com/2012/12/mr-selfridge-wylie-itv-production-notes.pdf.

8. Chris Louttit, "Cranford, Popular Culture, and the Politics of Adapting the Victorian Novel for Television," *Adaptation* 1, no. 2 (2009): 34–48.

9. Ibid., 45.

10. Andrew Higson, "The Heritage Film and British Cinema," in *Dissolving Views: Key Writings on British Cinema*, ed. Andrew Higson (London: Cassell, 1996), 238.

11. "Downturn Abbey," *Private Eye*, 12 November 2010.

12. Louttit, "Cranford," 45.

13. "The Paradise: Bill Gallagher's Glittering."

14. Michael B. Miller, *The Bon Marche* (Princeton, NJ: Princeton University Press, 1981), 167.

15. Mary Portas, "The Portas Review: An Independent Review into the Future of Our High Streets," December 2011, accessed 29 August 2013, http://www.maryportas.com/wp-content/uploads/The_Portas_Review.pdf.

16. "Online Retailing in Britain and Europe in 2012," accessed 29 August 2013, http://www.retailresearch.org/.

17. Andrew Higson, *Waving the Flag: Constructing a National Cinema in Britain* (Oxford, UK: Clarendon Press, 1995), 27.

18. Zola, *The Ladies' Paradise*, 16.

19. Lucinda Everett, "Behind the Scenes on 'The Paradise,'" *Telegraph*, 2 October 2012, accessed 28 August 2013, http://www.telegraph.co.uk/.

20. Erika Diane Rappaport, *Shopping for Pleasure: Women in the Making of London's West End* (Princeton, NJ: Princeton University Press, 2001), 5.

21. Ibid.

22. Maggie Andrews and Mary M. Talbot, "Introduction: Women in Consumer Culture," in *All the World and Her Husband: Women in Twentieth-Century Consumer Culture*, ed. Maggie Andrews and Mary M. Talbot (London: Cassell, 2000), 3.

23. Rappaport, *Shopping for Pleasure*, 13.

24. Brian Nelson, "Introduction," in Zola, *The Ladies' Paradise*, xviii.

25. Ibid.

26. Ibid., xxi.

27. Ibid.

28. Birgitte Søland, *Becoming Modern: Young Women and the Reconstruction of Womanhood in the 1920s* (Princeton, NJ: Princeton University Press, 2000), 8.

29. Ibid.

Chapter Eighteen

Taking a Pregnant Pause

Interrogating the Feminist Potential of Call the Midwife

Louise FitzGerald

In her essay "Rethinking Culture: Doing Justice to Feminism," Diane Elam writes that "the shared importance of feminism and cultural studies as an academic practice is that in their better moments they manage to situate both culture and gender as instances that always demand to be rethought."[1] What follows then is a discussion, a rethinking about the tensions and contradictions of the "feminist"-inflected analyses that emerged in the media about the BBC One's highly successful Sunday-evening drama series *Call the Midwife* (2012–). This chapter mirrors my own conflicting feelings about the program. While I embraced *Call the Midwife* for its presentation of women being nice to one another (a rare paradigm in a postfeminist culture that encourages female misogyny) and appreciated its apparent critical reflection on the current budgetary constraints placed on public services by Britain's coalition government, I also became increasingly uneasy about the appropriation of *Call the Midwife* as "worthy" feminist television by prominent women in the media.

Call the Midwife tells the story of Jenny Lee (Jessica Raine)—later Jenny Worth—a young and newly qualified midwife who arrives in the post–Second World War working-class community of Poplar, in order to complete her training alongside two other novice midwives and the Anglican order of nuns at Nonnatus House. Lee is described as a middle-class woman who once lived in Paris, who loves classical music, and who was more used to working in the surroundings of clean and orderly hospitals than in the slum conditions of 1950s East End of London. *Call the Midwife* follows Jenny as

she comes to term with her new environment and her role as community midwife. I want to suggest here that neither Heidi Thomas, the program's writer, nor Jennifer Worth, the author of the best-selling trilogy, *Call the Midwife: A True Story of the East End in the 1950s* (2002), *Shadows of the Workhouse* (2005), and *Farewell to the East* (2009), initially or explicitly framed *Call the Midwife* as influenced by feminist politics. However, after the success of the first series, Thomas does begin to correlate feminist politics with her approach in adapting the book for the second series of the program. In an interview with the *Big Issue*, she notes that the program was shaped by her "respect" toward "other people [who] had done the hard work, the women who had stuck their necks out; the bra burning generation. I have always been a conscious feminist; I went to an all-girl school where all of the teachers were women. Interestingly feminism was never mentioned—but it was lived."[2] The absence of such explicit political positioning prior to the broadcast of the first series raises the question as to why the program was taken up by a number of cultural observers as feminist television.

It is with these issues in mind that I seek to interrogate some of the conflicting ideas circulating around the BBC's adaptation of *Call the Midwife* to ascertain the declarative significance and discursive symbolism of the program as feminist television. My interest in the show has to do with the way it became, momentarily at least, what Caroline Bainbridge might describe as a "token of exchange" in larger debates about feminism.[3] Where are feminist politics located in *Call the Midwife*? How is a feminist discourse directed? Does the fact that *Call the Midwife* is set in a prefeminist era impact on a feminist reading?

CALL THE MIDWIFE DOES FEMINISM

Like most screen culture that deals with female issues and female expression, the critical reception of *Call the Midwife* often ran along the fault line of gender, with a number of male writers agreeing that the BBC One's program was nothing more than sentimental, nostalgic claptrap all too familiar for the Sunday-evening slot. For example, David Herman from the *New Statesman* argued that *Call the Midwife* is "Rose tinged nostalgia," a show full of "soapy romance" that removed traces of the "dark side of British history."[4] The author's evidence of *Call the Midwife*'s mediation of a certain form of British history, "the dark side," is concentrated on the lack of accuracy between the books and the series and *Call the Midwife*'s emphasis on romance plots and "cakes and Horlicks." The *Guardian*'s Sam Wollaston took his criticism in a different direction when he suggested that *Call the Midwife* was explicitly and problematically sexist in its portrayal of masculinity as either

violent or inept or sometimes both and criticized the show for its wholesale marginalization of men from the central narrative.[5]

But the show garnered much more enthusiastic and politically motivated responses from female cultural observers. Caitlin Moran, self-confessed feminist rock star and author of the best-selling 2011 book *How to Be a Woman*, referred to *Call the Midwife* as "Call the Radical Feminist" in her *Sunday Times* TV review, where she wrote, "There's an argument to be made—by me, now—that lovely Christmas special-y, cover-of the Radio-Times sensation Call the Midwife is actually the most radical piece of Marxist-feminist dialectic to ever be broadcast on prime-time television." Moran locates feminism in what she refers to as "the socialist agenda of the programme."[6] *Radio Times* reviewer Alison Graham claimed that "Call the Midwife is the torchbearer of feminism on television,"[7] while the feminist website the *F-Word* suggested that the program "engages with feminist ideas through women's different battles."[8] The *Guardian*'s Suzanne Moore described the program as "delivering drama, history and Female Empowerment,"[9] and *UK Feminista* along with *Bitch* magazine located *Call the Midwife*'s feminist potential in its engagement with the politics of reproduction and female agency. And *Salon* ran an article titled "Call the Midwife Defies Viewers' Ageism," which suggested that "the BBC series finds beauty in elderly women's bodies and offers a corrective to TV's patriarchal sub-culture."[10]

US reviewers were not quite so ready to position *Call the Midwife* as a feminist text; this, Gerald Gilbert suggests, is because midwives do not have such a visible presence in the US as they do in the UK where "82% of babies are delivered by midwives . . . compared with 8% in the US."[11] Nonetheless, *Call the Midwife* was seen as the harbinger for the rejection of Obama's aims for socialized health care and a rightly realized fear about the loss of reproductive rights for women. Many of the US reviewers pointed to similarities of *Call the Midwife* to Danny Boyle's politically charged 2012 Olympics opening ceremony that prioritized the UK's National Health Service (NHS) just as the coalition's policies were beginning to bite, but it was also the political nature of the show, its bleak thematics and "socialist" ideologies of free national health care, that, it was suggested, had resulted in smaller audience numbers in America than *Downton Abbey*, which was being positioned in the United States as *Call the Midwife*'s natural bedfellow.[12]

The attention that *Call the Midwife* received both in the UK and United States suggests a deep investment in the thematics of the show and demonstrates the desire of cultural observers to align *Call the Midwife* with politics. But a cursory glance at these reviews reflects some of the problems that arise when declaring a cultural product to be aligned with a particular political worldview because what feminism and "feminist television" might mean to one person does not mean that it will resonate in the same way for another. Nonetheless, feminist scholarship has argued that television has often and

quite distinctively been located as a definitively female-centered cultural space and is recognized as a site of struggle over meaning where oppositional values are negotiated on a daily basis.[13] It has been exactly the struggle over meaning that has proved to be extremely fruitful for feminist scholarship, so in assigning *Call the Midwife* the mantle of feminist TV, feminist cultural observers have undermined one of the central ideas of feminist critique by "professionalizing" meaning.[14] However, if telling women's stories is in itself feminist praxis because it accords agency to the female voice, then *Call the Midwife* appears to meet the requirements of "feminist television." Written by a woman, narrated by another woman (British actress Vanessa Redgrave, whose own political activism is often associated with the women's movement), and adapted for screen by Thomas (screenwriter of TV films and serials: *I Capture the Castle* [2003]; *Madame Bovary* [2000, BBC Two]; *Cranford* [2007, BBC One]; and *Ballet Shoes* [2007, BBC One]—all of which prioritize the female voice), then *Call the Midwife* begins to look like the holy trinity of female authorship. Indeed, Thomas told *Hollywood Reporter* that series 3 of *Call the Midwife* will be directed solely by women, a move that might mirror the alleged political agenda of the show or might serve as a response to the cultural investment in *Call the Midwife* as "the torchbearer to feminism."

Much to the earlier chagrin of *Guardian*'s Sam Wollaston, all of the stories prioritized in *Call the Midwife* are about women; four young women and a group of nuns who occupy an almost exclusively female world and the pregnant women whom they care for are also supported by mothers, sisters, female neighbors, and friends. Jessica Raine suggests that the show is doing something distinctive in its screen presentation of women: "It's very interesting," she says, "seeing a show where none of the women are defined by their relationships with a man. That is unbelievably rare on television. The amount of scripts I read where there are two women in the show and it's a mother and a wife, it makes me really angry."[15] Helen George, who plays midwife Trixie Franklin, reiterates Raine's sentiments about the show's more interesting treatment of women when she notes, "The focus is the women and the work, the vocation, having a through-line with your life. It's so nice to do a female-friendly show that isn't about fighting over a man or whatever."[16] Pam Ferris (Sister Evangelina) makes the feminist potential of the show much more explicit when she claimed that as a self-proclaimed feminist she thought the show "tells us where we come from and that as women we should be really grateful for the things that have changed over the last fifty years."[17] If Ferris is suggesting that women's bodies are always political, then the correlation of a fictional program set in the 1950s about midwifery and the emergence of the NHS clearly has feminist potential; however, the implied sentiment in her response to the show, that women should be grateful for what has been achieved on their behalf, smacks of a repudiation of the continued struggle

over women's reproduction agency. Nevertheless it is the rare prioritization of a female ensemble on screen that appeared to be one of the most treasured elements of the show.

Not since the BBC's adaptation of *Cranford* has the television screen been occupied by what academic Nina Auerbach might describe as a "Utopian community of women."[18] Auerbach argues that *Cranford* moved away from the romance plot of Gaskell's novel that would traditionally be the fare of Sunday-night costume dramas by focusing on the stories of a group of middle-aged, unmarried, unglamorous women. It is the "utopian community of women," or the "gynocentric focus of *Cranford*," argues Katherine Byrne, that "championed a feminine ethic of compassion and care and its exploration of the relationship between private and public and the bonds within and between classes."[19] The alignment with and interweaving of the domestic and familial, personal with public, and political and community that made *Cranford* appear to be politically motivated is mirrored in the private and domesticated, familial, and personal community of women in *Call the Midwife*. The program's foregrounding of the personal with the public (whether in Nonnatus House or the domestic setting of the homes and communities that house the pregnant mothers and their families) provides the criticism of patriarchy precisely because *Call the Midwife* suggests that domesticity *is* valuable history.

Women's domestic and community life is as worthy of study as anything in the public (men's) realm precisely because, as Nancy Armstrong notes, the domestic cannot be removed from the political; it is here where the nation's

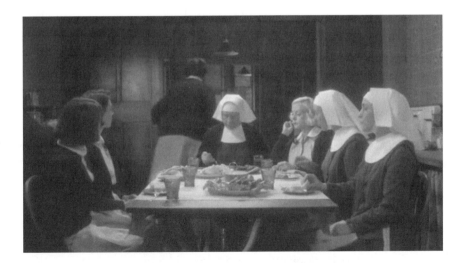

Figure 18.1. *Call the Midwife*'s ensemble of women (episode 2:2)

Louise FitzGerald

future is being formed through childbearing and through management of household expenses, health, and community issues.[20] To hear the voices of these domestic working-class women from the interior of a text "at a point at which the authorial subject is constructed independently rather than as a site at which male lack is disavowed"[21] is feminist politics.

Call the Midwife's feminist potential can be located not only in the holy trinity of female authorship and the focus on female subjects often ignored in the cultural imagining of the nation's history but also in Worth's personal decision to tell her story of midwifery. After reading an academic article in the 1998 *Medicine Review* titled "Impressions of a Midwife in Literature" in which the author of the article asked why midwives were virtually nonexistent from the literary landscape, Worth made the decision to make the midwife a visible literary figure and raised the profile of another female voice that has been traditionally excluded and silenced by patriarchy. Historically, feminism and midwifery have been intermingled by the fact that they both serve to advocate for reproductive rights on the behalf of and for women; midwifery is often perceived then as feminist praxis. But I would also suggest that the midwife has been appropriated as a feminist figure because she has been so consistently cloaked in misogyny. Indeed, as Lucy Fischer writes, the midwife is a feminist figure because she has been seen as a subversive woman. Often associated with witchcraft, the midwife became "the repository of patriarchal fears of female strength and as a scapegoat for the new obstetrical profession."[22]

Fischer's analysis of the relationship between horror films and parturition offers an account of the historical positioning of the midwife as abject prior to the "ascendancy of the male physician."[23] Quoting from the 1484 *Malleus Maleficarium* (Witches' Hammer), Fischer demonstrates how this compendium on witchcraft aligns the midwife's association with birth and death as an indication of her collusion with evil spirits. Whether the alignment of witchcraft with midwifery is a myth, as suggested in David Hurley's revisionist interrogation of the witch/midwife figure,[24] the fact remains that the persistent association of the midwife with the witch figure has more to do with the desire to professionalize childbirth by replacing these women with medically trained male doctors. Thus both accounts from Fischer and Hurley highlight the ways in which the midwife has been disavowed by patriarchy. Worth's books and Thomas's adaptation rescue this female figure from the margins by centralizing the midwife as an authorial subject whose agency is not disavowed by male lack.

Call the Midwife's focus on the story of the midwife and the work she does with and for women is mirrored in another extremely popular and BAFTA-winning British reality program, *One Born Every Minute* (Channel 4, 2010–) where viewers watch women's labor (in both senses of the word) on a maternity ward. *One Born Every Minute* cuts between the experiences of

the midwives—who in direct-camera address discuss the joys and pains of their job—and the women who are in the process of giving birth. *One Born Every Minute* is also interspersed with moments of a "Utopian community of women" when the midwives sit together in their staff room to discuss personal and professional issues with care and compassion. *Call the Midwife* and *One Born Every Minute* take their place among the raft of programs that have emerged over the last ten years on British television that focus on the process of childbirth, producing what Imogen Tyler and Lisa Baraitser call "the cultural cacophony of maternal publicity."[25] Tyler and Baraitser suggest that the contemporary cultural trend to foreground the visceral nature of partum can be seen as a feminist act precisely because it breaks the "aesthetic taboo" of childbirth. Traditionally, the cultural presentation of partum was kept hidden from view within the domestic sphere, and more often than not, stories of childbirth were absent the actual birth; they were not "represented, but staged around a series of lacunae, gaps or missing images, particularly of the maternal vagina 'holding' the head of the emerging feotus and the maternal face in pain and pleasure, such that the birthing subject is both there and not there simultaneously."[26] Tyler and Baraitser offer an extensive account of the relationship between birth, women, and feminism, showing how patriarchy has "consistently eviscerated and/or appropriated women's reproductive capacities" within Western culture to argue that one of the tasks of feminism has been to "write birth back into the story of subjectivity and politics."[27] The very fact is that the predominance of the "new visual culture of birth" (with all of its concomitant paradoxes and problems) is challenging the traditional paradigm of abjection normally associated with the birthing female body and "returning birth to women."[28] The visceral nature of birth, the bodily fluids, and the "abject" image of the "maternal vagina holding the head of the emerging foetus" might not be as explicit in *Call the Midwife* as it is in programs such as *One Born Every Minute*, but this has more to do with its Sunday-evening's prewatershed broadcast slot; however, *Call the Midwife* does return birth to women through its "graphic and realistic" envisioning of partum. But I also want to suggest that in focusing on working-class women in the process of partum, *Call the Midwife* breaks the "natal aesthetic taboo" further.

Birth and reproductive rights continue to be a central feminist issue, and the womb remains the most political place on earth, especially the womb of poor women. Images of working-class women laboring are rare because working-class pregnancy and birth have been historically framed as horrifying; the working-class woman is perceived as an overly fecund, parasitic female figure whose body reproduces an undesirable working/underclass. In the telling and showing of the birth stories of working-class women, not only does *Call the Midwife* put the story of birth back with women, but also its

political potential is in the fact that it prioritizes the natal stories of a group of women that feminism has been so often accused of leaving behind.

If birth and pregnancy are understood as feminist issues, then abortion is the flashpoint of feminism. *Call the Midwife* does not shy away from abortion; in series 2 an episode focused on the story of Nora Harding (Sharon Small) living in squalor and abject poverty with her unemployed husband and their eight children. Nora is dismayed to discover that she has fallen pregnant and is desperately worried about adding to an already struggling family. *Call the Midwife* depicts the Hardings as a loving and supportive family and frames Nora's single minded determination to terminate her unplanned pregnancy with candor and little sentimentality. Without the support of the health system, Nora has little choice other than to terminate the pregnancy herself. Nurse Lee recognizes the impact another pregnancy will have on Nora's health, but abortion is illegal at this point, and by law Nurse Lee is required not to support Nora's decision. The nuns, constricted as they are by their religious beliefs, are not judgmental toward Nora; rather, their support for her is based on a deep understanding of the socioeconomic position for economically disenfranchised women of childbearing age and the risk of backstreet abortion before the widespread accessibility of the pill. As a way of highlighting exactly the risk associated with backstreet abortion, Diane Munday, Colin Francome, and Wendy Savage's analysis of maternal deaths in the UK state that one hundred thousand illegal abortions were documented in the 1950s and that 25 percent of all maternal deaths were a result of illegal abortion.[29] These stark figures illustrate the social and political resonance of Nora's story, and as the episode continues the audience witness her trying and failing at different methods of termination—scalding hot baths, taking Epsom salts, and punching herself in the stomach—before she seeks the help of Mrs. Pritchard, the local herbalist, to perform the abortion. Nora contracts septicemia and ends up in the hospital fighting for her life. While the episode concludes with a happy ending—Nora survives, and the family are rehoused outside of Poplar—Thomas frames the narrative with a discussion of birth control, which was still a scientific work in progress.

Nora's personal experience serves as a case study in the personal becoming the political, and according to Thomas this was intentional because Worth felt very strongly about the right for women to have control over their own bodies. Indeed, Thomas suggests that this particular episode has ramifications for today when intervention into abortion rules signifies a turning back of the clock for women's reproductive agency. However, I want to stay with the abortion story line as a way of highlighting some of the tensions involved in framing *Call the Midwife* as feminist television. Before Nora has the abortion, she clearly states that both she and her husband had had their "fun." The implication here is that the unintended pregnancy, the termination, and the subsequent risk to Nora's life are as a result of sexual desire. At

the same time that Nora is dealing with the consequences of having "fun," Trixie is seen preparing for a night out with an American film star whom she had agreed to meet if he helped to raise funds for Nonnatus House. As the abortion is being performed on Nora, the camera cuts to Trixie painting her nails with blood red varnish that drips onto a white tablecloth. The scene cuts again to the abortion scenario where Nora is writhing and screaming in pain while Mrs. Pritchard continues the termination. Not long after this distressing scene has ended, Trixie is assaulted by her date. Both Nora and Trixie are punished, and although *Call the Midwife* ensures that neither woman is judged by her community, the experience of abortion and of sexual assault are implicitly framed as a direct result of their sexual desire. *Call the Midwife* might "live" feminism through its thematic focus on issues that affect women, but it does not speak about feminism. To do so would mean that the program would have to make visible and challenge embedded patriarchal discourses that frame female desire as punishable as well as offer some suggestions for alternatives that do not limit female experience.

RETHINKING *CALL THE MIDWIFE'S* FEMINIST POTENTIAL

Clearly *Call the Midwife* resonates with themes and subjects that have been associated with feminism: domestic violence, abortion, rape, birth, and prostitution. But its main narratological and thematic concern is in the relationship between poverty and social welfare, not feminism. Indeed, the idea that showing intelligent, educated, white women who temporarily forsake romantic relationships while they care for other women and are nice to one another is somehow politically engaged enough to serve as an example of "feminist television" is worrying, but it is also indicative of the paucity of television programs that centralize the stories of a "community of women." Much of the success of *Call the Midwife* has been attributed to the phenomenal success of *Downton Abbey*, another British period drama that draws attention to the British class system, but as I suggested earlier its success can also be attributed to Channel 4's reality television show *One Born Every Minute* and the high prioritization of birth stories that dominate the screen. Birth has taken center stage within popular culture, and it comes at a time when a more traditional, conservative drive to reinforce the "fact" of women's biological difference has positioned labor and childbirth as the very pinnacle of womanhood, the moment of epiphany when women experience total fulfillment and total self-expression. That *Call the Midwife* is so widely seen as feminist television suggests a ghettoizing of what it means to be feminist because midwifery, childbirth, and motherhood are already demarcated as female spaces. As such, *Call the Midwife* does not offer any new points of identification for women; rather, it reaffirms postfeminist notions of women as only

258 Louise FitzGerald

ever the bearers of any form of cultural power if and when associated with birth.

The cultural agency of working-class women in *Call the Midwife* is also mediated by the way in which they are framed both as spectacle and as repositories of a nostalgic gaze. Working-class women are "othered," and their stories are secondary to the women of Nonnatus House, a place that is based in Poplar but kept at a distance from the working-class world of Poplar. The opening scene of the first episode explicitly marks the working-class culture as a different and dangerous world. Working-class men are depicted as threatening as they whistle, heckle, and glower at Jenny as she makes her way through the streets of Poplar. Working-class women fight one another, ripping each other's clothes until a policeman and a nun intercede and restore order. *Call the Midwife* cannot tell its story about a middle-class young woman learning to work with people whose "otherness" is marked by class without setting up this world as alien, but the fact that Lee's education is predicated on coming to terms with a working-class community demonstrates how *Call the Midwife* relies on the juxtaposition of class identity and reinforces class-based hierarchies. For all the rhetoric about the Marxist and socialist nature of *Call the Midwife*, the program is reliant on hierarchical systems; the church runs Nonnatus House, the nuns have authority over their younger female charges, and the young nurses serve to educate the poorer and disenfranchised working-class women. More worrying is the near invisibility of nonwhite people in the show; the only story that prioritizes a nonwhite woman deals with racist treatment by a small group of white, working-class women that is overcome by the birth of a child. *Call the Midwife*'s treatment of this story puts the blame and shame squarely on the shoulders of working-class women. In stark contrast, Sister Evangelina's "unintentional" racist remarks about the number of "black faces" coming out of school in her response to Chummy's (Miranda Hart) "calling" to do missionary work in Africa does not attract the same sort of disquiet among the nuns as does the behavior of the working-class women. As such, *Call the Midwife* not only makes a distinction between "intentional" and "unintentional" racism, but also explicitly aligns "intentional" racism with uneducated working-class women. The same episode does make some reference to the racist overtones of a golliwog doll that the senile nun is knitting, but her attitude and behavior are associated with her pathology, and the issue of miscegenation is dealt with when Winnie (Tessa Churchard), a white married woman, gives birth to a black baby after having an affair. When the baby is born, Nurse Lee hands him over to Winnie's husband, Ted (John Ashton), who makes no reference at all to the fact that the child is black—a silence that continues throughout the episode. In her own telling of the story, Worth supposes that Winnie spoke to her female friends to make sure her child's racial background was never spoken of. Indeed, in both the television episode and in the book, race

is not discussed; rather, it serves to reconfigure Ted's masculinity from a seventy-year-old man "to a man who looked ten years younger."[30] The real story here then is about Ted as a man and as a father; the subject of race and racism in *Call the Midwife* serves only as a narrative device to further demonize working-class women and to reconfigure "tired" masculinity.

The absence of nonwhite people within Poplar sits in stark contrast to the realities of life in the 1950s East End of London that saw new populations from commonwealth countries such as the Caribbean and the Indian subcontinent settle in the area. Britain was suffering from severe labor shortages after the Second World War, so much so that in 1945 the government funded a recruitment drive in commonwealth countries, appealing for at least thirty thousand already qualified nurses and midwives to work in the newly founded NHS.[31] Perhaps the absence of these women's stories, women who were nurses, midwives, and members of this community, from BBC's *Call the Midwife* is as much to do with the nostalgic overtones of the show as any explicit exclusionary practices. *Call the Midwife*, despite its visceral nature, *is* nostalgic, and it is well documented that nostalgia allows for a certain rewriting of history that can result in a sort of social amnesia.[32] For a show that is predicated on remembering, on representing women who have not been traditionally remembered within the nation's cultural storytelling practices, this sort of social amnesia marks *Call the Midwife* as an extraordinarily and problematically white utopian account.

Which stories dominate, what narratives are excluded or marginalized from the screen, is always a question of power and authority, but perhaps one of the questions that should be asked is how and why a story about a midwife in prefeminist 1950s East End of London became so popular now. The reification of the 1950s within contemporary culture and especially on television has been noted by scholars who have suggested that the "retreatist"[33] elements of postfeminism are most evident in programs that are set in a time prior to Betty Friedan's *Feminine Mystique* (1963). *Call the Midwife* might seem radical in its cultural presentation of women, but its feminism is safe and contained within the past. When feminism is located in the past, its present political interventions and future political aims do not have to be addressed.

By way of conclusion I want to argue that the discursive symbolism of *Call the Midwife* as feminist television should be tempered because it achieves its feminism by creating a hierarchy that is based on class; it does not offer new identification paradigms for women, nor does it systematically challenge systems of oppression and inequity, and its utopian community of women ignores and excludes nonwhite women. It is exactly these issues that have been indicative of a larger problem in feminism: white middle-class privilege and the inability to identify with women of color and with working-class women.

NOTES

1. Diane Elam, "Rethinking Culture: Doing Justice to Feminism," 1992, accessed 12 January 2014, http://www.pum.umontreal.ca/.
2. Adrian Lobb, "Call the Midwife: Men Have Been Watching This More than Top Gear," *Big Issue*, 22 December 2013, accessed 10 January 2014, http://www.bigissue.com/.
3. Caroline Bainbridge, "Knowing Me, Knowing You: *Mamma Mia* as Feminine Object," in *Mamma Mia: Exploring a Cultural Phenomenon*, ed. Louise FitzGerald and Melanie Williams (London: Tauris, 2013), 76.
4. David Herman, "Horlicks for Chummy: Britain's Romance with Cosy TV Nostalgia," *New Statesman*, 7 February 2013, accessed 9 January 2014, http:///www.newstatesman.com/.
5. Sam Wollaston, "TV Review: Call the Midwife," *Guardian*, 20 January 2013, accessed 7 January 2014, http://www.theguardian.com/.
6. Caitlin Moran, "Call the Radical Feminist," *Sunday Times*, 26 January 2013, accessed 17 September 2013, http://www.thetimes.co.uk/.
7. Alison Graham, "Call the Midwife," *Radio Times*, accessed 17 September 2013, http://www.radiotimes.com/.
8. Emily Kenway, "Call the Midwife: Another Kind of Nostalgia," F-Word, June 2012, accessed 14 December 2013, http://www.thefword.org.uk/.
9. Suzanne Moore, "On the Set of Call the Midwife with Suzanne Moore," *Guardian*, 21 December 2012, accessed 10 January 2014, http://www.the.guardian.com/.
10. Stephanie Bower, "Call the Midwife Defies Viewers' Ageism," *Salon*, 9 July 2013, accessed 10 January 2014, http://www.salon.com/.
11. Gerald Gilbert, "Call the Midwife Returns: All Hail the, Er, Breaking Bad of Midwifery," *Independent*, 29 December 2013, accessed 29 December 2013, http://www.independent.co.uk/.
12. Neil Genzlinger, "A Career in Obstetrics, with On-the-Job Training," *New York Times*, 28 September 2012, accessed 19 January 2014, http://www.nytimes.com/; Maureen Ryan, "How Call the Midwife Is Like Downton Abbey," *Huffington Post*, 27 September 2012, accessed 19 January 2014, http://www.huffingtonpost.com/; Mary McNamara, "Review: BBC's Call the Midwife Is Sweet, Stirring Medicine," *Los Angeles Times*, 28 September 2012, accessed 19 January 2014, http://articles.latimes.com/; Dina Copelman, "Real Life History of Call the Midwife," *WETA: Public Television and Classical Music for Greater Washington*, accessed 19 January 2014, http://www.weta.org/.
13. Charlotte Brunsdon, Julie D'Acci, and Lynn Spigel, *Feminist Television Criticism* (Oxford: Oxford University Press, 1997); Janet McCabe and Kim Akass, "Feminist Television Criticism: Notes and Queries," *Critical Studies in Television* 1, no. 1 (spring 2006), accessed 12 December 2013, http://uhra.herts.ac.uk/bitstream/handle/2299/8303/904664.pdf; Christine Geldhill, "Pleasurable Negotiations," in *Spectators: Looking at Film and Television*, ed. E. Deirdre Pribram (New York: Verso, 1998), 64–89; Joanne Hollows, *Feminism, Femininity and Popular Culture* (Manchester, UK: Manchester University Press, 2000); Bonnie Dow, *Prime Time Feminism: Television, Media Culture and the Women's Movement Since 1970* (Philadelphia: University of Pennsylvania Press, 1996).
14. Ien Ang, *Watching Dallas: Soap Opera and the Melodramatic Imagination* (London: Methuen, 1985), 132.
15. Stuart Kemp, "Call the Midwife: Season Three to Be Directed Exclusively by Women," *Hollywood Reporter*, 17 June 2013, accessed 12 December 2013, http://www.hollywoodreporter.com/.
16. Ibid.
17. Ibid.
18. Nina Auerbach, *Communities of Women: An Idea in Fiction* (London: Harvard University Press, 1998), 77.
19. Katherine Byrne, "'Such a Fine, Close Weave': Gender, Community and the Body in Cranford," *Neo-Victorian Studies* 2, no. 2 (winter 2009/2010): 45, accessed 16 December 2013, http://www.neovictorianstudies.com/.

20. Nancy Armstrong, *Desire and Domestic Fiction* (Oxford: Oxford University Press, 1987), 7–10.

21. Kaja Silverman, "The Female Authorial Voice," in *Film and Authorship*, ed. Virginia Wright Wexman (New Brunswick, NJ: Rutgers University Press, 2003), 55.

22. Lucy Fischer, "Birth Traumas: Parturition and Horror in *Rosemary's Baby*," *Cinema Journal* 3, no. 3 (spring 1992): 7–8.

23. Ibid., 8.

24. David Hurley, "Historians as Demonologists: The Myth of the Midwife Witch," *Social History of Medicine* 3, no. 1 (1990): 1–26.

25. Imogen Tyler and Lisa Baraitser, "Private Views, Public Birth: Making Feminist Sense of the New Visual Culture of Childbirth," *Studies in the Maternal* 5, no. 2 (2013), accessed 15 December 2013, http://www.mamsie.bbk.ac.uk/.

26. Ibid., 1.

27. Ibid., 2.

28. Ibid., 10.

29. Diane Munday, Colin Francome, and Wendy Savage, "Twenty-One Years of Legal Abortion," *British Medical Journal* 28 (1989): 1233.

30. Jennifer Worth, *Call the Midwife: A True Story of the East End in the 1950s* (London: Merton Books, 2002), 265.

31. Ian Gordon and Tony Travers, *Race, Immigration and Community Relations in Contemporary London* (London: London School of Economics, 2006), 3–4.

32. Michael Pickering and Emily Keightley, "The Modalities of Nostalgia," *Current Sociology* 54, no. 6 (2006): 919–41, accessed 19 January 2014, http://csi.sagepub.com/; Nicholas Dames, *Amnesia Selves: Nostalgia, Forgetting and British Fiction 1810–1870* (Oxford: Oxford University Press, 2001).

33. Diane Negra, *What a Girl Wants? Fantasizing the Reclamation of Self in Postfeminism* (Abington, UK: Routledge, 2009).

Chapter Nineteen

Homosexual Lives

Representation and Reinterpretation in Upstairs, Downstairs *and* Downton Abbey

Lucy Brown

Homosexuality has gradually become more acceptable fodder for British literature and drama since the liberation movements and the decriminalization of homosexual acts that began with the Sexual Offences Act of 1967. Authors and scriptwriters alike have embraced the idea of "writing back" to the nineteenth and early twentieth centuries in order to illuminate previously hidden lives, homosexual and otherwise. In the context of costume dramas, both the original *Upstairs, Downstairs* (1971–1975) and *Downton Abbey* (2010–) include gay footmen. The treatment of them, however, is markedly different. Set between 1903 and 1930, with the homosexual subplot running until around 1912, *Upstairs, Downstairs* grapples with representing homosexuality, both within the confines of the 1970s and within the confines of the historical society it showcases. *Downton Abbey*, meanwhile, is a product of twenty-first-century Britain where homosexuality is generally incorporated into everyday life as standard. *Downton Abbey*, then, contends with the deviation between the era it is representing—the first four series of *Downton Abbey* are set between 1912 and 1923 when homosexuality was still a criminal offense—and the sensibilities of the milieu in which it was created. The date of production is a significant explanation for the differentiation between the two programs, yet even *Downton Abbey*'s treatment of homosexuality often borders on the conservative for a drama created in the twenty-first century.

A key moment that dispelled some of the willful ignorance in relation to homosexuality in the early twentieth century was, of course, the 1895 trials

of Oscar Wilde for sodomy. H. Montgomery Hyde describes this period: "The Wilde trials and their aftermath represented the high water mark of popular prejudice against homosexuality in Victorian England . . . and the anti-homosexual feeling was continued into the Edwardian and neo-Georgian period. A more humanitarian climate was slow in coming."[1] Against the backdrop of this climate, then, the characters of Alfred Harris and Thomas Barrow are introduced with vastly different story arcs. These contrasting story lines demonstrate the changing attitudes of the public and signify what was deemed appropriate for portrayal within a costume drama at two different periods in history.

UPSTAIRS, DOWNSTAIRS AND THE SPECTER OF RELIGION

Appearing in five episodes in series 1 of *Upstairs, Downstairs* and one further episode in series 3, Alfred Harris is a small character in the popular 1970s drama. However, the character's arc is striking due to his ultimate fate—execution as a direct result of his homosexuality. In the opening episode, "On Trial," Alfred is seen to be eccentric, sarcastic, and mischievous, hiding things from the lady's maid merely to annoy her. However, at the end of the episode, he ambushes new maid Sarah and deliberately scares her, bringing his biblical references scattered throughout the episode to the fore as he declares, "Beware the lusts of the flesh."[2] This sentence suggests how Alfred views himself, particularly when events from later episodes are taken into consideration. Alfred's religiosity is intrinsically linked to his character, with biblical references in almost every scene in which he appears. In a book published later in the 1970s, Jeffrey Weeks explains the impact faith could have on a homosexual's self-opinion:

> Inevitably, the concepts which emerged from the nineteenth century carried with them a weight of ideological baggage, much of it stemming from the intertwined Hebraic and Christian traditions, in which the taboo against homosexual behaviour is deeply rooted. No one who has lived in the West . . . can deny the dreadful feelings of guilt and sin that our culture still produces.[3]

This indicates the impact religious beliefs had on both homosexuals themselves and the wider public during the twentieth century, lasting well beyond the first transmission of *Upstairs, Downstairs* in 1971.

Certainly, Alfred's frequent recourse to the Bible in conversation with the other servants is not incidental. It frames him as a character uncomfortable with himself and concerned with a perceived higher power. It also serves to offer a definitive structure that can be used by Alfred and about him without direct reference to homosexuality. For instance, in his final episode, "Rose's Pigeon" in series 3, he describes the lover he has murdered as "like a serpent,

the lowest of the beasts." Alfred's reference to the Garden of Eden can easily be seen as regret that he is not himself an Adam. In addition, Alfred suffers from nightmares, both before his initial departure and in his return episode. Explaining these nightmares to Sarah in "On Trial," Rose describes him as "a bit touched." These nightmares can also be seen as a sign of Alfred's self-loathing.

It is Alfred's appointment as temporary valet to Baron von Rimmer in episode 1:5, "A Suitable Marriage," that prompts his departure from Eaton Place. He is noticeably enamored throughout the episode, and when the pair is alone the truth about their relationship begins to shine through. They are discovered by Rose righting their clothes, which she interprets as the aftermath of sexual activity. It is a subtle revelation, unsurprising since the first kiss between men in a relationship did not occur on British TV until an episode of *EastEnders* in 1987.[4] Indeed, much of the aftermath occurs off-screen: the viewer does not witness Rose's explanation to butler Hudson or his subsequent explanation to Richard Bellamy, head of the household. As Rose interprets what she has seen in the baron's room, the viewer is left to apply meaning to Rose and Hudson's coded language. This can be seen as a strategy by the writers to address 1970s sensibilities, cautiously bringing homosexual activity into the fray without naming it as such.

After helping the baron, a German spy, escape from the police, Alfred accompanies him to Germany. In his return episode, "Rose's Pigeon," he explains that the baron married and he was "found" a new position in England with a Lithuanian gentleman. Later statements suggest that he was "sold" or "given" to his new employer as a sexual plaything. Neither of Alfred's lovers is portrayed in a positive light: the baron is a spy searching for military secrets, while the Lithuanian man Alfred kills is unedifying at best. Alfred only mentions him in snippets, trailing off as he describes the "baron's friend. Baron's vile, disgust. . . ." By situating homosexuality in this world, *Upstairs, Downstairs* establishes it as "foreign." This is further enhanced by Hudson's pervading mistrust of all foreigners, something alluded to time and again in "A Suitable Marriage" and articulated by Lady Marjorie at the climax of the episode when she accuses the baron of "corrupting" their footman.

Ultimately, Alfred's fate is execution by hanging. His barbaric and premeditated murder of his Lithuanian lover with a meat ax is unforgivable, despite his motives. He explains to Rose, "People I lived with like here, decent people always here. I wanted to be decent. Wouldn't let me . . . pushing me to grovel . . . just wanted to get away back to this life, anything, wouldn't let me. Just laughed at me." Alfred's attack, then, is presented as a direct result of his homosexual lifestyle, a lifestyle of which he seems whole-heartedly to repent.

After the hanging, Rose says to the butler, "He was ill, Mr. Hudson. It wasn't his fault, what he done, it was other people made him. You can't hang a man what's not right in the head." Here, Rose equates his homosexuality with a mental illness, something not uncommon in the discourse of the period or, indeed, in the contemporary environment of the 1970s where homosexuality was not declassified as a mental illness in the United Kingdom until 1973. Hudson responds, "No matter why, he took away a human life and must pay with his own. That is the law of civilized man, and God's law too, if you read your Bible." This final word on Alfred's fate returns to the religiosity that has plagued him throughout his brief appearances in the program. This is both a comment on the Edwardian values the program is depicting and the environment in which *Upstairs, Downstairs* was created and first viewed. Jeffrey Weeks concluded in 1977 that "attitudes to homosexuality, at least on a formal level, are still shot through with medieval hangovers, both in phraseology and attitudes, which suggest that sex outside rigidly defined areas is at best something to be tolerated, and at worst dirty and sinful."[5] Viewing these episodes decades after their initial transmission reminds us that, despite the decriminalization of homosexuality, prejudices were slower to disappear.

DOWNTON ABBEY AND THE "GLASS CLOSET"

There are striking similarities between Alfred Harris and the character of Thomas Barrow, a regular in *Downton Abbey* from series 1 onward. The first is that they are both footmen who are out of kilter with most of their colleagues. The situation that reveals Thomas's sexuality to the viewer is also reminiscent of Alfred's revelation episode. In *Upstairs, Downstairs*, Alfred is drafted in to be temporary valet to Baron von Rimmer; in *Downton*, Thomas is drafted in to be temporary valet to the Duke of Crowborough, the difference between the two situations being that Thomas is already sexually involved with the duke. This is demonstrated to the viewer during a scene between the pair in the duke's bedroom where Thomas is removing the duke's boot. Similarly, Alfred Harris removes the baron's boot in a tense scene immediately prior to their discovery by Rose. The similarities between the characters are too evident to be ignored, although Thomas's longevity in the series contradicts Alfred's brief, and ultimately unhappy, tenure in *Upstairs, Downstairs*.

Like Alfred, Thomas is generally a destructive character. He is a vindictive, self-serving, and manipulative footman turned soldier turned valet, certainly, but he does not progress as far as murder. His intent throughout is to rise above other members of staff and be in a position of power within the household. However, his love affairs all display him in a sympathetic light,

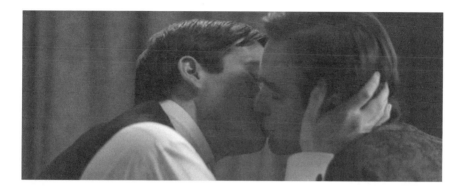

Figure 19.1.　Thomas and the Duke of Crowborough (*Downton Abbey*, episode 1:1)

quite unlike the malicious personality he cultivates more generally. It is true, too, that Thomas's sexuality is an open secret. Eve Kosofsky Sedgwick explains the climate of secrecy in *Epistemology of the Closet*:

> With a new public discourse concerning male homosexuality that was at the same time increasingly discriminant, increasingly punitive, and increasingly trivialising or marginalising, the recuperative rhetoric that emerged had an oddly oblique shape. I would describe it as the occluded intersection between a minority rhetoric of the "open secret" or glass closet and a subsumptive public rhetoric of the "empty secret."[6]

Unlike *Upstairs, Downstairs*, where Alfred's sexuality is hidden until it is forced into the open, this idea of a "glass closet" is applicable to Thomas's position in *Downton*. It becomes more important as his sexuality threatens his job and freedom in series 3.

While the viewer learns of Thomas's sexuality in the very first episode, the evidence that other members of the staff are aware of his sexuality comes in episode 1:4, when cook Mrs. Patmore attempts to dissuade kitchen maid Daisy from pursuing him. She tries four times to explain the situation without actually saying anything incriminating. She begins, "He's not the boy for you, and you're not the girl for him."[7] When this doesn't work, she adds, "Perhaps Thomas has seen and done more than is good for him." Getting exasperated, she continues, "He's not a ladies' man!" Finally, she tries, "Daisy, Thomas is a troubled soul." While her euphemisms go unheeded, this scene demonstrates that, among the older staff at least, Thomas's sexuality is common knowledge. He does indeed live in a "glass closet" where everybody sees but nobody comments openly.

While Thomas is a difficult character to sympathize with, his relationships with his lovers show him in a vulnerable light. In episode 1:1 he is betrayed by the Duke of Crowborough, who steals incriminating letters before abandoning him. After this altercation, Thomas is visibly upset rather than angry. Equally, in episode 2:2 he connects with a blinded soldier and opens up to him. Thomas's weeping over his suicide confirms that there was, at least in his mind, a romantic aspect to the relationship. Again, there is emotion attached to his sexuality, differentiating this aspect of his personality from the ambitious and selfish ones he proudly portrays at Downton. In series 3, when this emotion comes to the fore, Thomas's sexuality is thrown out into the open, and the repercussions demonstrate how twenty-first-century values have been imposed by the writers (to an extent) on early twentieth-century set historical fiction. While *Upstairs, Downstairs* depicts a harsh reality, a gay man being driven to murder his employer in Edwardian Britain, *Downton* seems to examine the past with modern, perhaps even rose-colored, sensibilities in mind.

Thomas's infatuation with Jimmy Kent, the new Downton footman, is partially the result of expert manipulation on the part of his former friend, lady's maid Miss O'Brien. It is crucial to note that Thomas only acts inappropriately toward Jimmy because he has been led to believe that his growing feelings are reciprocated. As he explains to Carson in episode 3:7, "When you're like me, Mr. Carson, you have to read the signs as best you can because no one dares speak out." Earlier in this episode, Thomas makes a move on Jimmy when a series of conversations confuse him and he misreads Jimmy's demeanor toward him. He goes first to his bedroom and then sneaks into Jimmy's room and into bed with him, awakening him with a kiss that the second footman, Alfred, walks in on. In this scene, Alfred functions much as Rose did in *Upstairs, Downstairs* as the bewildered and "good" servant. The similarity between these two discovery scenes is again striking, although *Downton*, written and filmed nearly forty years later, dares to show more on screen than does *Upstairs, Downstairs*. The conundrum there was deciphering what had happened: in *Downton* there is free rein to be more explicit.

Like Rose, Alfred brings the truth out into the open, but unlike *Upstairs, Downstairs*, this provokes more irritation than horror. The housekeeper, Mrs. Hughes, remarks in episode 3:8, "I think the point is that we didn't know officially. That's what Mr. Carson finds hard. He can't avoid the subject any longer, because it's lying there on the mat." Here, Mrs. Hughes shatters the illusion of the "glass closet," explaining that the tactics of avoidance rested on the assumption that everyone else would participate in the evasion. Alfred has broken this unspoken code, and the Downton residents are forced to confront the consequences.

Interestingly, the older members of the staff are generally the ones most at ease with Thomas's sexuality, with Mrs. Hughes asking Carson, "Do you

think Thomas is the first man of that sort I've ever come across?" Mr. Bates fails to understand the problem, pointing out, "It's not as if none of us knew," sentiments echoed by Lord Grantham before he utters the memorable line, "I mean, if I'd shouted blue murder every time someone tried to kiss me at Eton, I'd have gone hoarse in a month." Although this line is clearly played for laughs, it certainly does create the illusion that homosexuality was more tolerated than it was.

This deviation from *probable* lived reality depicts the older generation as more accepting. H. Montgomery Hyde, however, describes a more accurate situation in *The Other Love*: "In the decades between the two World Wars, homosexuality in England came to the surface of society for the first time, although what was visible was only a portion of what was still largely a submerged iceberg. With the older generation the subject was still taboo as a topic of conversation."[8]

To an extent, Mrs. Hughes, Mr. Bates, Mrs. Patmore, and Lord Grantham conspire with this taboo and do not speak about it until, as Mrs. Hughes says, it is "lying there on the mat." However, once the subject is approached, their attitudes are benevolent, with Mr. Bates blackmailing Miss O'Brien on Thomas's behalf in an ironic reversal of probable lived reality. Clause eleven of the Labouchere Amendment to the Criminal Law Amendment Act of 1885—under which Oscar Wilde was prosecuted—was dubbed the "blackmailer's charter" due to the extortion attempts homosexuals suffered under fear of being reported. *Downton Abbey* turns this on its head with Miss O'Brien being blackmailed to *keep* Thomas's "open secret" out of public view.

Thomas faces losing his liberty when Alfred calls the police to report him. They arrive at the cricket match at the climax of series 3, and it falls to Lord Grantham to persuade Alfred not to formally accuse Thomas of homosexuality, which under the Labouchere Amendment, could have subjected him to two years in prison, with hard labor. Lord Grantham says, "I'm not asking you to abandon your beliefs, Alfred. Just to introduce a little kindness into the equation." He continues, "Thomas does not choose to be the way he is, and what harm was done, really, that his life should be destroyed for it?" Lord Grantham's attitude here seems at odds with his implacably conservative outlook evident in earlier episodes. He condemns his daughter's "lesser" marriage to his chauffeur, reinforcing class division; he has criticized the women's suffrage movement and his daughters becoming involved in the labor market, reinforcing gender divisions. His support for Thomas in this episode can be traced back to his guilt at having to part with him as valet now that Mr. Bates has returned. It also marks a continuation of the benevolent employer facade that has permeated *Downton* from the first series including, for instance, the payment for Mrs. Patmore's cataract operation in episode 1:7. Occasionally, *Downton* seems to obstruct the reality of master-servant

relations in favor of showing the family as enlightened and kindhearted employers. His defense of Thomas is a direct continuation of this idealistic viewpoint but also stems from the desire of Lord Grantham to keep one of his best cricketers on the field. The fact that winning a game of cricket is more important to Lord Grantham than upholding the law and condemning "gross indecency" is a striking, if slightly unconvincing, representation of an early twentieth-century aristocrat.

The attitude that may have been expected of Lord Grantham is represented instead by Carson the butler. In episode 3:7, after being told of Thomas's attempted seduction of Jimmy, he prefaces his vitriol by saying, "I don't need to tell you this is a criminal offence," which serves to remind the twenty-first-century viewer of the comparatively recent decriminalization of homosexuality. By invoking the law, Carson roots his abhorrence in fact and is therefore given a respectable platform from which to speak. In the context of 1920s Britain, Carson is the accepted voice of condemnation.

His viewpoint is entirely in keeping with what Sean Brady describes in *Masculinity and Male Homosexuality in Britain, 1861–1913*: "This sexuality was inimical to masculinity as a social status in this country to such an extent that any public acknowledgement of its existence threatened society itself."[9] Carson asserts his own masculinity by opposing Thomas, but is Thomas really a threat to society? He is, perhaps, a threat to Downton's own insular society that Carson covets. As his attempt to seduce Jimmy has proven by this point, Thomas's sexuality has the potential to create discontent at Downton. Carson explains to Jimmy his own motives in trying to secure a peaceful departure for Thomas in episode 3:8: "I've never been called a liberal in my life, and I don't intend to start now! But I do not believe in scandal. Mr. Barrow will go, and when he does, I would like him to go quietly. For the sake of the house, the family, and for that matter, you." So, while Carson appears to relent by offering a positive reference, it is protection of Downton Abbey itself and not Thomas he is pursuing.

This attitude is again a repetition of what has already been seen in *Upstairs, Downstairs*. When Alfred Harris's return to Eaton Place in "Rose's Pigeon" is discovered by Hudson, his anger is rooted in household protection: "This man brought shame and disgrace on this house it took a long time to recover from." In a further twist, when Mr. Bellamy is discussing the ex-footman, he says, "Oh, yes, he had some trouble with a German baron, but that's all forgotten." As in *Downton Abbey*, it seems to be the butler who acts as the moral head of the household, essentially espousing the conservative arguments expected of his employer. In episode 3:8, Carson's vitriol is tempered by what appear to be more modern sensibilities: "I cannot hide that I find your situation revolting, but whether or not you believe me, I am not entirely unsympathetic. You have been twisted by nature into something foul, and even I can see that you did not ask for it." This seems out of kilter

with his previous comments but does serve to add a sheen of respectability and compassion to Carson's attitude: in essence, he may not be as enlightened as everyone else in the house, but he is not completely reprehensible to our modern eyes.

Unlike *Upstairs, Downstairs'* Alfred Harris, Thomas Barrow not only keeps his job but also finds himself promoted to underbutler as there is no other position for him. Furthermore, his infatuation with Jimmy develops into love. In the 2012 Christmas special, "A Journey to the Highlands," footman Alfred points out to Jimmy that the "funny thing with Mr. Barrow is he won't hear a bad word about you." This observation reiterates the emotional aspect of Thomas's attachment to Jimmy. It is not merely a physical attraction, something that is demonstrated later in the episode when Jimmy is attacked and Thomas rushes to help, taking a beating in the process. This fight is the catalyst for a reconciliation of sorts between the pair, which takes place when Jimmy visits the injured Thomas in his room and says, "You're brave, Mr. Barrow. Very brave. I feel badly. I . . . I shouldn't have run off," to which Thomas replies, "No, you should have. Otherwise, what was I bloody doing it for?" This exchange demonstrates the emotional aspect of Thomas's relationship with Jimmy. Despite being forcibly rejected—and almost losing his job—a year earlier, Thomas's attitude toward his colleague has not altered. The multiple episodes in which *Downton* explores Thomas's growing affection for Jimmy allows this facet of his character to be handled sympathetically: it is not a two-episode story line with a moral center as seen in *Upstairs, Downstairs.*

Jimmy's sexuality itself is considered unequivocal due to his overt interest in women. However, Thomas is certainly given the impression that Jimmy understands his overtures. While Jimmy appears ill at ease with these, even before Miss O'Brien's meddling, Mrs. Hughes sums up the situation perfectly to Mr. Carson in episode 3:8: "I think James may have led him on. . . . I don't mean deliberately. But he's a vain and silly flirt. He may have given Thomas the wrong impression without meaning to." However, some ambiguity over Jimmy's sexuality remains, particularly once he has agreed to be friends with Thomas.

Thomas Barrow is often portrayed as a snide and manipulative character. However, it is clear that some of this bravado is false, as he explains to his blinded soldier friend in episode 2:2: "All my life, they've pushed me around, just 'cause I'm different." This may explain Thomas's scornful attitude toward his colleagues that acts as a shield and allows him to mask his true self at Downton. This facade slips on several occasions, most notably following the death of Lady Sybil in episode 3:5. He has to leave the room after learning the news to cry in the corridor and explains to maid Anna Bates, "In my life, I can tell you, not many have been kind to me. She was one of the few." The fact of Thomas's "difference" may have, ironically,

helped to create one of the most unlikable men at Downton. But, in relation to the deaths of Lady Sybil and the blinded soldier and his true, self-sacrificing affection for Jimmy, Thomas Barrow emerges as a somewhat sympathetic character, alienated by his own difference. He explains to Carson in episode 3:8: "I am not foul, Mr Carson. I am not the same as you, but I am not foul."

HISTORICAL REPRESENTATION AND THE COSTUME DRAMA

Upstairs, Downstairs was one of the most popular programs of the 1970s, a surprise hit that captured the imaginations of millions of viewers. *Downton Abbey* is equally as popular, with the series 3 finale garnering twelve million viewers in the UK alone and captivating audiences around the world. Colin McArthur offers one explanation for the popularity of the costume drama during certain periods of upheaval: "It seems reasonable to suppose that a society going through a period of transition and finding it immensely painful and disorientating will therefore tend to recreate, in some at least of its art, images of more (apparently) settled times, especially times in which the self-image of the society as a whole was buoyant and optimistic."[10]

This proposition certainly applies to not only the economic and social upheaval of the 1970s but also the financial crash of 2008 and recession that predated *Downton*'s emergence. The idea of harkening back to more "settled times" is understandable when the fabric of society is under threat, and this may be partly responsible for the success of *Downton*. Other costume dramas have also emerged since the financial crash with similar success, such as ITV's *Mr. Selfridge* (2013–), whose first series regularly attracted over 7.5 million viewers, and *The Paradise* (2012–2014), the BBC's adaptation of an Émile Zola novel, which garnered over 5.5 million viewers in an earlier time slot. It may be significant that the 2010 revival of *Upstairs, Downstairs*, set in the years prior to the Second World War, suffered from low ratings and was consequently axed after two series. This may suggest that our renewed fascination with costume drama lies in an earlier period: as McArthur suggests, a period where the mood is more "optimistic" and positions within society more "settled."

One benefit of the costume drama is the ability writers have to explore positions that may be distasteful to modern viewers—for instance, the condemnation and secrecy of homosexuality when, today, it is far more accepted and acknowledged. In this way, the costume drama can act as an educational tool, but the entertainment value lies partially in the distance between "us," the modern, and "them," the older, more inferior version. For all the delight in watching a program where everyone knows their place, there is a certain satisfaction to be gained from the belief that "we" are better than "them" in

terms of our attitude toward homosexuality. This may explain the differing attitudes expressed by characters in *Upstairs, Downstairs* and *Downton Abbey* toward their homosexual colleagues or employees. *Downton* distinctly operates a "glass closet" where everybody knows and almost everybody is undaunted by it, but the wider society is seemingly more backward than the residents of the household. *Upstairs, Downstairs*—created in a culture that, despite the efforts of the British gay rights movement, was still more critical of homosexuality—allowed more realistic attitudes of both the early and late twentieth century to prevail.

There is a sense that *Downton*'s attempts to represent homosexuality as compatible with early twentieth-century values have failed, prioritizing the needs of a continuing drama over historical authenticity. The character of Thomas Barrow is one fans love to hate and has become a series staple: disposing of him at the end of series 3 seemed unlikely, so attitudes that would enable the character to stay had to be explored, but these ultimately oversimplified the contemporary prejudices. Forty years earlier, Alfred Harris was a short-term character with a predetermined arc that led to his initial dismissal from Eaton Place. His eventual death by execution offered no chance for rehabilitation and seemed almost inevitable to viewers at the time, as well as being historically accurate. *Upstairs, Downstairs*, then, allowed for homosexual prejudice to be shown unsentimentally in a way the sanitized *Downton* has perhaps not. It seems that in the twenty-first century we are as interested as ever in penetrating the mysteries of the past and rewriting them to accommodate more contemporary norms.

NOTES

1. H. Montgomery Hyde, *The Other Love: An Historical and Contemporary Survey of Homosexuality in Britain* (London: Heinemann, 1970), 2.
2. *Upstairs, Downstairs* (BBC One, 1971–1975).
3. Jeffrey Weeks, *Coming Out: Homosexual Politics in Britain from the Nineteenth Century to the Present* (London: Quartet Books, 1977), 4.
4. Tom Geoghegan, "It Started with a Kiss," *BBC News Magazine*, 26 June 2008, accessed 5 July 2014, http://news.bbc.co.uk/.
5. Weeks, *Coming Out*, 4.
6. Eve Kosofsky Sedgwick, *Epistemology of the Closet* (Hertfordshire, UK: Harvester Wheatsheaf, 1991), 164.
7. *Downton Abbey* (ITV, 2010–2012).
8. Hyde, *Other Love*, 197.
9. Sean Brady, *Masculinity and Male Homosexuality in Britain, 1861–1913* (Basingstoke, UK: Palgrave Macmillan, 2009), 83.
10. Colin McArthur, *Television and History* (London: British Film Institute, 1978), 40.

Chapter Twenty

Troubled by Violence

Transnational Complexity and the Critique of Masculinity in Ripper Street

Elke Weissmann

The title *Ripper Street* (2012–) creates associations with traditional images of gendered violence—women as sexualized victims, men as perpetrators and heroes.[1] The BBC–BBC America coproduced drama offers these images and at the same time complicates the associated pleasures by providing a critique that emphasizes the problem that is constituted by traditional, patriarchal masculinities. Set in the aftermath of the Ripper Murders, *Ripper Street* constantly plays with the images associated with sexualized violence, only to draw our attention to the failure to police such crimes. This chapter will provide an analysis of this, by unpeeling the layers of meaning that are produced in *Ripper Street* via a complex mix of genres that are drawn from the United States and the UK. I will argue that the drama, on the one hand, presents us with a return of the patriarch through traditional British genres such as period drama and crime drama. On the other hand, *Ripper Street* provides us with a critique of these nostalgic views of masculinities by drawing on the US quality dramas of *Hill Street Blues* (NBC, 1981–1987) and *Deadwood* (HBO, 2004–2006), both of which trouble their traditional genres of crime and Western respectively. *Ripper Street* uses such a transnational mix of genres as a result of its particular ontology as a coproduction between the BBC and BBC America, but also in order to complicate traditional notions of masculine heroisms. In particular, it investigates the trauma of violence on men and questions what place they can have in society. The chapter will first give an overview of masculinities in the new millennium before examining the genre complexity of *Ripper Street*.

MASCULINITY AT THE TURN OF THE NEW MILLENNIUM

The literature on the representation of masculinities has grown exponentially since the 1990s, although earlier work exists.[2] Most of these are focused on representations of masculinities in film, and more specifically Hollywood.[3] The work of Steven Cohan, Andrew Spicer, and Caroline Bainbridge and Candida Yates emphasizes that masculinities are, first of all, culturally and historically specific, and that they are in a constant process of renegotiation that is often perceived to be continuous with a sense of crisis.[4] In the case of *Ripper Street*, the instability of hegemonic patriarchal masculinity derives its sense of crisis from its situatedness in a particular time and a particular place.

Indeed, *Ripper Street* appeared on British and American screens at a time when the confidence of Britain and America as international economic powerhouses was severely shaken and the culture of hedonistic return to masculinities, which dominated British culture in the 1990s, came under scrutiny. In Britain, the economic crash of 2008 came at a time when the change in government seemed inevitable as New Labour, originally led by Tony Blair, had been in power for over ten years. The new Conservative government openly subscribed to the international mantra of austerity in order to see through a number of significant public-sector cuts. Under the Conservatives, the economy contracted for several quarters, leading to a wider sense of deprivation and crisis. The sense of crisis led to a wider reevaluation of the Blair years, including the availability of cheap credit, subprime mortgages, and an out-of-control financial market that had fueled a boom-and-bust economy. In America, the ultraconservative regime under George W. Bush was replaced by Barack Obama, the first African American president,[5] who had campaigned under the banner of hope and change but soon found his efforts hampered by the power of the Senate and Congress, which were largely held by Republicans.

The sense of crisis on both sides of the Atlantic also led to a distancing from the hedonistic, politically incorrect, and quite traditional form of masculinity that had been at the center of quite a few popular representations in film and television—and beyond—of the 1990s and early 2000s.[6] In the UK in particular, the "new lad" occupied the media during the 1990s and early 2000s.[7] This included, among others, celebrities such as Jamie Oliver and Liam Gallagher as well as fictional representations such as *Lock, Stock and Two Smoking Barrels* (Guy Ritchie, 1998) and *Coupling* (BBC, 2000–2004). As Imelda Whelehan points out, the new lad represents a deliberate rejection of both feminism and the "new man" who espouses political correctness.[8] More importantly, he celebrates and embraces the nostalgic construction of traditional masculinities,[9] even if he does this using an apparently knowing and humorous style.[10] Within this context, the new lad's deliberate misbehaving was often excused by pointing to his immaturity, with phrases that

emphasized his boyishness.[11] Thus, the return of misogyny and traditional masculine behavior could be excused as a passing phase. As Leon Hunt highlights, the men who participated in the creation of the new lad culture were usually middle class but were "in love with working-class masculinity," which further disguised the inherent power that the construction of the new lad actually facilitated.[12] In other words, the proposition that the new lad is both immature and affiliated with the working classes implies that he is inherently powerless, which suggests that his behavior is essentially harmless. In reality, the proponents of new laddism were everything but.

At first glance, *Ripper Street*'s narrative of a team of three men banding together in a society that reduces women to housewives or prostitutes seems to continue some of the themes established by new laddism. These are men who don't (yet) know better, who bend the law in a celebration of traditional masculinity. As such, *Ripper Street* shares some commonality with *Life on Mars* (BBC, 2006–2007), which engages knowingly and humorously with conventions of the British cop show. In particular, as James Chapman points out, "The characterization of the decidedly non-politically correct Gene Hunt . . . represents nothing if not a throw-back to the hard-drinking, straight-talking manner of Jack Regan [from *The Sweeney* (ITV, 1975–1978)]."[13] But *Ripper Street* differs significantly from *Life on Mars*, in that it rarely includes a humorous element. Thus, where *Life on Mars* celebrated the return of traditional masculinities, *Ripper Street* presents them at work, only, as I will show, to undermine them. It does that in a way that is unique to television and its long-form serialized narratives.[14] Such serialization has often been understood as evidence for a drama's attempt to engage a specific—highly educated, professional, middle-class—audience that values the narrative complexity and literariness of such apparently "quality" dramas.[15] As Jeffrey Sconce highlights, such a "cumulative" narrative allows for the development of "nuances of plot and character as a series matures over several seasons."[16] In *Ripper Street*, this goes beyond nuances but instead emphasizes that character needs to be gradually revealed in "moments of affect," as Robin Nelson proposes.[17] In these moments, the narrative of the episode slows down completely in order to reveal the complex emotional world of a character that becomes the focus point of the larger, serial narrative. In other words, in the "cumulative" of "serialized" series, the serial narrative is no longer linear but instead offers moments of intense emotional engagement—for the viewer as well as the characters on screen—that allow a patchwork of character knowledge to emerge. In the following I will show how this revelation of character and the connected critique of traditional masculinities are deeply embedded in the use of a multitude of genres in *Ripper Street*.

GENRE COMPLEXITY IN *RIPPER STREET*

As a coproduction made by Tiger Aspect for the BBC and BBC America, *Ripper Street* meshes a number of genres that appeal to audiences on both sides of the Atlantic. The period drama, for example, is perceived as quintessentially British and enjoys significant success in the United States because it provides an image of a unique Englishness that is bound up in the past.[18] Two channels have contributed to the success of period drama in the United States; namely PBS, which dedicates its regular, and prestigious, *Masterpiece Theatre* slot to it; and A&E, which in the 1990s in particular developed a unique brand that drew on British period drama.[19] In contrast to PBS and A&E, however, BBC America has focused on a more modern image of Britain, which celebrates the "Cool Britannia" of the Blair years.[20] As a result, *Ripper Street* betrays a knowingness about its own conventions and challenges some of these by using a scruffier aesthetic that is deliberately juxtaposed to the sumptuousness normally associated with period drama.[21] As John Ellis indicates, in part this is derived from its engagement with steampunk, which merges the nostalgia for the Victorian past with a deep-seated belief in scientific progress.[22] Thus, the London and the science that we see, though presented as progressive for its time, is also looked at through the lens of superior knowledge of the present. As a result, the Victorian age as a whole appears as backward and (relatively) primitive. In addition, the use of conventions from the Western,[23] and some from those of crime drama, contribute to the image looking decidedly less sumptuous than in other British exports on American screens.

As a period drama, *Ripper Street* at first sight seems to subscribe to a nostalgic view of the past.[24] Belen Vidal highlights, however, that neither period drama nor the heritage film is inherently nostalgic.[25] Rather, they might allow for a critique of understandings of past traditions, including gender roles. In order to offer such a critique, however, period drama needs to reconstruct traditional notions of gender. In the case of *Ripper Street*, this seems particularly apparent, since the Ripper Murders themselves represent gendered violence that relies on well-established dichotomies of femininity (as housewife, prostitute, or victim) on the one hand and the normalization of violent masculinity on the other.

Ripper Street goes further than that, however: it also establishes the traditional patriarch at the helm of his crew. Inspector Edmund Reid (Matthew Macfadyen), crucially, is haunted by his personal position as a father. In the first season this is revealed gradually to us as we come to understand that he and his daughter were caught up in a boat accident in which his daughter went missing. Reid clings to the thought that she might still be alive. The trauma of the event has left physical scars that we are shown twice in the first three episodes: In episode 1, "I Need Light," Reid changes his clothes at his

home while his wife watches. His body is covered in scar tissue that makes Reid visibly, but not audibly, wince as he takes off his shirt. That his wife observes this is no accident: it allows us to also see her emotions, which are a complex mix of empathy and sympathy. As Nelson highlights, such reactions from surrounding characters express the revelation of character: what we learn here about Reid is not just that he is scarred but also that he has learned to carry this pain that would overwhelm others.[26] As a result, Reid's character is marked by emotional and physical strengths, as well as integrity. In "The King Came Calling" (1:3), a similar scene shows us Reid with an inspector of the City Police at the river. Again, Reid takes off his shirt, this time without betraying any emotion, while the camera first catches the scar tissue in close-up and then the reaction of the other police officer who notices, is shocked, but then also hides his emotion. Such a sequence of shots and emotional reactions remind us of the fact that Victorian masculinity was supposedly marked by an (at least public) silencing of emotion,[27] a fact that at this point seems to inspire admiration rather than censure.

Ripper Street, then, presents us with a traumatized patriarch but one who is nevertheless, at least at first, presented as admirable. The casting of Matthew Macfadyen, who has in the past played primarily heroic, if troubled, and likable characters (*Spooks* [BBC, 2002–2011] and *Pride and Prejudice* [Joe Wright, 2005]), contributes to this. Increasingly, however, Reid is shown to not just fail but also be deeply fallible: he has affairs with two women, he makes use of heroin in order to get information from a suspect and by doing so jeopardizes several investigations, and he causes his wife's mental breakdown when he finally admits to the fact that his daughter must be dead. His relationships to women in particular reveal the flaws of his character. None of his relationships seem particularly warm, and our first visit to his house makes evident that he and his wife are practically estranged. His first affair with orphanage mistress Deborah Goren (Lucy Cohu) seems driven by his need for redemption from a maternal figure, rather than by lust or love. Finally, his moral corruption is revealed in his relationship to the first female councilor, Jane Cobden (Leanne Best), who acts as moral guide to the viewer throughout the second season. In the final episode of the second season ("Our Betrayal, Part 2"), Cobden is there to witness Reid's call for Sergeant Drake (Jerome Flynn) to kill his enemy in the boxing ring. Her shock and instant flight on hearing Reid scream "kill him" make visible that even in this "lawless town," murder by the police remains unacceptable. Unlike other dramas, such as *Breaking Bad* (AMC, 2008–2013), which suggests the gradual corruption of an essentially good man, *Ripper Street* seems to imply Reid's inherent moral corruption. It does this by revealing his character gradually through the moments of affect and by doing so offering more and more insight into his character. In that respect, too, the drama follows the

example of Victorian masculinity that presented a nondescript public persona while hiding personal emotions and turbulences from others.

The series achieves this complex depiction of masculinity also because it draws on a number of tropes from different subgenres of crime drama. On the one hand, the regular shots of police bobbies in their uniform draw attention to nostalgic images of a time when policing still seemed morally clear cut; particularly images of bobbies wearing their helmets draw on similarities with *Dixon of Dock Green* (BBC, 1955–1976). As Susan Sydney-Smith highlights, the image of Dixon walking the beat remains firmly embedded in the popular imagination as a myth that presents an example of the "'olden days', a mythical time during which everything seems—and in televisual terms, literally was—more black and white."[28] She indicates how this connects to relatively recent police scandals that had highlighted, among others, the institutional racism within the police. Within this context the past is evoked in order to present a counterpoint to a more troubled present. Thus, the play with the mythical past could be understood as retrogressive. However, the return of the bobby in *Ripper Street* functions precisely as a reminder of the fallacy of such a myth; it presents a comment on this nostalgic view as the image of the bobby in full uniform usually goes along with a representation of their struggle to actually keep order. Rather than presenting the British police as competent, therefore, they are shown fighting against superior forces, be that vigilante police in "In My Protection" (1:2) or a skilled kung fu fighter in "Pure as the Driven" (2:1).

The theme of the *problem* of policing is further developed by drawing on aesthetic tropes that are known from "quality" crime dramas such as *The*

Figure 20.1. The bobby defending the police against an excited and angry mob in "I Need Light" (*Ripper Street*, episode 1:1)

Wire (HBO, 2002–2008), *SouthLAnd* (NBC, 2009; TNT, 2010–2013), and *Hill Street Blues*. The latter has attracted some academic attention as the predecessor of the two former, but also as one of the first series to emphasize "(program) quality . . . over (viewer) quantity."[29] While Caren Deming focuses her discussion on the series' narrative complexity and the prevalence of melodrama in what she describes as essentially a "modernist text,"[30] she also draws attention to stylistic elements that contribute to the discourse of complexity. In particular, she stresses that "the density of the action is matched by the dense visual and aural texture and overall naturalism of style. The naturalism is achieved through harsh lighting, tightly-shot, crowded sets, handheld camera work, and thick, ambient sound."[31] It is these stylistic elements, rather than the complex narrative structure, that *Ripper Street* borrows from *Hill Street Blues.*[32]

Unlike *Hill Street Blues*, the BBC drama does not use handheld camera work, but its editing, particularly in moments focusing on violence in crowded places, is often rapid, giving the scenes a similar sense of immediacy. More importantly, the predominant use of sepia colors for costumes and to light nighttime scenes, when daytime scenes often use high-contrast lighting, creates a sense of realism as it reflects the limited color palette of Victorian photography and printing. In addition, the series uses an extremely complex aural design in which different sounds—from ambient ones of a city at work to a multitude of voices—overlap, making it sometimes difficult to follow the dialogue and creating again a sense of immediacy. As a result, *Ripper Street* presents policing as something that engages with a complex environment, in which what happens cannot always be assessed as the chaos of action and sound undermines the police's (and the viewers') ability to gain an overview. In that respect, it draws directly on the example of *Hill Street Blues*, which had similarly drawn attention to the difficulty that policing in an inner city presents.

While the discourse of the difficulty of policing dominates the narrative via the use of generic elements borrowed from both traditional British police series and American quality crime drama, the series nevertheless also offers a possible solution to this problem that it locates in science. In this respect, *Ripper Street* continues discourses well established in forensic science dramas on both sides of the Atlantic (e.g., *Silent Witness* [BBC, 1996–], *Bones* [Fox, 2005–], and *NCIS* [CBS, 2003–]). In particular, it draws on aesthetic elements of the most popular of these, namely, *CSI: Crime Scene Investigation* (CBS, 2000–).[33] In the first series, several episodes stage the autopsy and examination scenes in ways that are similar to those of *CSI*: in the "King Came Calling" (episode 3), for example, images of blood flowing into a bowl under the autopsy table, shots of a visibly disturbed rookie policeman, and detailed verbal explanation of what Captain Jackson will do to the body in the process of the autopsy emphasize the body gore that made *CSI* stand out

from its contemporaries. *Ripper Street* also makes use of extensive editing to condense the time that it takes to investigate evidence in the lab, perhaps most notably in "The Good of this City" (1:4), which adds an element of stylishness to the scene. Overall, *Ripper Street* betrays a stylistic awareness that is not dissimilar to *CSI* and connects to the postmodern pastiche of stylistic borrowing from different genres. Unlike the other stylistic borrowings that are clearly used to develop a self-reflexive critique of policing and masculinity, here the representation of rational science seems to suggest a way out of the problem of policing: it is in science that the answers lay.

Science itself is deeply intertwined with notions of masculinity, and forensic medicine even more so. Mary Jacobus and colleagues emphasize that science has since Francis Bacon's time become associated with the masculine while its object is presented as feminine.[34] In the context of nineteenth-century medical science, women's bodies were often used to teach and investigate aspects of life and death, while the male scientist was perceived as disembodied.[35] In that respect, nineteenth-century science mirrors the interest of Victorian art and literature in the female body. As Elisabeth Bronfen highlights, women's death in nineteenth-century literature functioned as a sacrifice to restabilize a society in crisis: "Over her dead body, cultural norms are reconfirmed or secured, whether because the sacrifice of the virtuous, innocent woman serves as a social critique and transformation or because a sacrifice of the dangerous woman re-establishes an order that was momentarily suspended due to her presence."[36] In addition, the female body can be used by male writers (and scientists) to grapple with the problem of their own mortality by displacing it on a body that is perceived as other.

Ripper Street complicates this by drawing deliberate attention to the body of its scientist. Captain Homer Jackson (Adam Rothenberg) is presented as the most dandyish of the three characters who indulges in sexual pleasures and attracts women easily. In addition, he is often seen using his own body as an object of study, particularly in order to test substances that he cannot identify through textbooks. Overall, he is shown to be the most flawed of the characters, with a potentially criminal past and living off his wife's brothel, which he also uses. More importantly, perhaps, his solution to problems is often to run or pull his revolver, which highlights his inability to offer more complex solutions. This becomes particularly apparent, again, in his relationship to a woman: his wife rejects him when, after a short honeymoon period in the second season, she realizes her inability to escape the patriarchal pressures of society. Jackson's attempts to rekindle her love for him all flounder, and he becomes the lovesick fool who populates the margins of the narrative. Thus, while *Ripper Street* does not necessarily question science itself, it does recognize that it might lie in deeply problematic hands. In the case of Jackson, the problem stems from his hedonistic, and at points misogynist, behavior that resembles that of the 1990s' lad. But science can more

generally become flawed when it is used by the wrong men. This is made explicit in the many stories that focus on science and that emphasize that science can be used for both good and evil (see, for example, "The Good of this City" [1:4] and "Dynamite and a Woman" [2:4]). As a result, the series introduces an element of doubt to the use of forensic science. What the inclusion of stylistic elements from *CSI* makes visible, then, is that the success of policing hinges on the quality of men who make use of it. We have already seen that the men who form the main investigative trio are perceived as deeply flawed. But *Ripper Street* goes beyond even the gradual revelation of apparently respectable characters as morally corrupt and hints at the problem that masculinity itself poses. It does that by using stylistic elements that it borrows from the post-9/11 Western, and more specifically the critically acclaimed *Deadwood.*

The sepia colors that pervade everything in *Ripper Street* also mark the color palette of the HBO Western. Moreover, it draws on a similar cluttered and claustrophobic imagery as *Deadwood* for its external scenes, while locating much of its action inside pubs or bars and brothels. While these stylistic elements clearly set the tone, the presence of Jackson, as lone gunslinger, further points to *Ripper Street*'s generic borrowing from the Western. *Deadwood* itself mixes a number of subgenres together, drawing on the stylistic devices of the classical Western and the spaghetti Western. As David Drysdale argues, this draws out elements of the different subgenres, which can, as a result, be critiqued within a larger critical examination of America's relationship to the "war on terror."[37] One such element is the exaggerated violence of the hero in the spaghetti Western (and indeed in *Deadwood*). *Ripper Street* too exaggerates the use of violence, casting Sergeant Drake primarily in the role of willing henchman who can beat a man to death if Reid wants him to. In most episodes, the use of violence seems to be celebrated as it restores the power of a deeply beleaguered police. But one episode, "The Weight of One Man" (1:5), makes it clear that violence is deeply troubling, and it does that by exploring the character of Drake.

Drake has experienced war and is famous as a result of fighting his way back to the British army when he was abandoned behind enemy lines. In the episode we see Drake gradually becoming more and more violent, including to his colleague and friend Captain Jackson. Standing next to each other in a pub as Jackson rambles on about a case of robberies, Drake suddenly breaks his whisky glass with one hand and then grabs Jackson by the throat and throws him against the wall. The camera then follows him outside, where the image of the gray outside world is slowed down and suddenly interrupted with fast-cut images of men being shot. These images appear and disappear so quickly that they can hardly be grasped by the viewer. However, they clearly visualize the suppressed trauma Drake deals with in this episode. The same trauma is played through again when Drake kills the band of robbers

and arrests their leader. This time, the episode reveals more to allow the viewer to more fully understand just how violent the experience was. Violence, then, as a key element of traditional, hegemonic masculinities, is presented as traumatizing and as such contributes to the problems men face.[38]

CONCLUSION

Overall, then, *Ripper Street* presents men whose specific form of masculinity contributes to their problems: Reid's role as patriarch places him in a position of traumatizing failure; Jackson's masculine body undermines the rational science of his profession; and Drake's connection to violence leaves him vulnerable and traumatized. Thus *Ripper Street* does not return men, over the body of women, into the disembodied space of traditional hegemonic masculinity and dominance, as the title seems to suggest. Rather, it constructs traditional masculinities in order to uncover their flaws and the problems that they cause. It achieves this critique of masculinity not just via the complex and transnational mix of genres and the foregrounding of the men's bodies; instead, *Ripper Street* achieves this through the gradual revelation of character in moments of affect. In addition, the series' continuous story lines allow for the juxtaposition of different conceptualizations of masculinities that enables *Ripper Street* to question if the crisis in society—its deep-seated sense of unhappiness—is not precisely derived from traditional gender roles.

NOTES

1. Karen Boyle, *Media and Violence: Gendering the Debates* (London: Sage, 2005).
2. See, for example, Donald Spoto, *Camerado: Hollywood and the American Man* (New York: New American Library, 1978); and Michael Malone, *Heroes of Eros: Male Sexuality in the Movies* (New York: Dutton, 1978).
3. Steven Cohan and Ina Rae Hark, eds., *Screening the Male: Exploring Masculinities in Hollywood Cinema* (New York: Routledge, 1993); Pat Kirkham and Janet Thumin, eds., *You Tarzan: Masculinity, Movies, and Men* (New York: St Martin's, 1993); Peter Lehman, ed., *Masculinity: Bodies, Movies, Culture* (New York: Routledge, 2001); Yvonne Tasker, *Spectacular Bodies: Gender, Genre and the Action Cinema* (New York: Routledge, 1993); Susan Jeffords, *Hard Bodies: Hollywood Masculinity in the Reagan Era* (New Brunswick, NJ: Rutgers University Press, 1994); Thomas Shary, ed., *Millenial Masculinity: Men in Contemporary American Cinema* (Detroit: Wayne State University Press, 2013).
4. Steven Cohan, *Masked Men: Masculinity and the Movies in the Fifties* (Bloomington: Indiana University Press, 1997); Andrew Spicer, *Typical Men: The Representation of Masculinity in Popular British Cinema* (London: Tauris, 2001); Caroline Bainbridge and Candida Yates, "Cinematic Symptoms of Masculinity in Transition: Memory, History and Mythology in Contemporary Film," *Psychoanalysis, Culture and Society* 10, no. 3 (2006): 299–318. Peter Lehman, adapting a psychoanalytical approach, indicates how this sense of crisis in film connects to representations of the male body as bearer of the penis-phallus, which for men presents both a source of empowerment and alienation from their own bodies. Such an approach, however, can too easily assume that the sense of crisis is disconnected from its historical place.

Peter Lehman, *Running Scared: Masculinity and the Representation of the Male Body* (Detroit: Wayne State University Press, 2007), 39.

 5. Thomas Shary, "Introduction," in Shary, *Millenial Masculinity*, 3.

 6. Spicer, *Typical Men*, 192; Aaron Taylor, "Adam Sandler, an Apologia: Anger, Arrested Adolescence, Amour Fou," in Shary, *Millenial Masculinity*, 19–51; Rebecca Feasey, *Masculinity and Popular Television* (Edinburgh, UK: Edinburgh University Press, 2008); Carlen Lavigne, "Two Men and a Moustache: Masculinity, Nostalgia and Bromance in The Good Guys," *Journal of Popular Television* 1, no. 1 (2013): 69–81.

 7. Joanne Hollows, "Oliver's Twist: Leisure, Labour and Domestic Masculinity in The Naked Chef," *International Journal of Cultural Studies* 6, no. 2 (2003): 229–48.

 8. Imelda Whelehan, *Overloaded: Popular Culture and the Future of Feminism* (London: Women's Press, 2000).

 9. Leon Hunt, *British Low Culture: From Safari Suits to Sexploitation* (Abingdon, UK: Routledge, 1998), 6.

 10. Hollows, "Oliver's Twist," 233.

 11. Hunt, *British Low Culture*, 8.

 12. Ibid., 7.

 13. James Chapman, "Not 'Another Bloody Cop Show': Life on Mars and British Television Drama," *Film International* 7, no. 2 (2009): 12–13. See also Elaine Swan, "'You Make Me Feel Like a Woman': Therapeutic Cultures and the Contagion of Femininity," *Gender, Work and Organization* 15, no. 1 (2008): 88–107.

 14. Jane Feuer, "Genre Study and Television," in *Channels of Discourse, Reassembled: Television and Contemporary Criticism*, ed. Robert C. Allan (London: Routledge, 1992), 154.

 15. Robert J. Thompson, *Television's Second Golden Age: From Hill Street Blues to ER* (New York: Continuum, 1996); Trisha Dunleavy, *Television Drama: Form, Agency, Innovation* (New York: Palgrave Macmillan, 2009).

 16. Jeffrey Sconce, "What If? Charting Television's New Textual Boundaries," in *Television after TV: Essays on a Medium in Transition*, ed. Lynn Spigel and Jan Olsson (Durham, NC: Duke University Press, 2004), 98.

 17. Robin Nelson, "The Emergence of Affect in Contemporary TV Drama" (paper presented at the Identity and Emotions in Contemporary TV Series conference, Navarra, Spain, October 2013). Nelson does not engage with the feminist understanding of affect that recognizes the phenomenological experience of emotion. See, among others, Laura Marks, *The Skin of Film: Intercultural Cinema, Embodiment, and the Senses* (Durham, NC: Duke University Press, 2000); Misha Kavka, *Reality Television, Affect and Intimacy: Reality Matters* (Basingstoke, UK: Palgrave Macmillan, 2008); Katharina Lindner, "Questions of Embodied Difference: Film and Queer Phenomenology," NECSUS, *European Journal of Media Studies* 1, no. 2 (2012), accessed 19 March 2014, http://www.necsus-ejms.org/.

 18. There is a tendency across the world to conflate Britishness and Englishness in regard to period drama. Period drama is perceived to be quintessentially British, despite the fact that it tends to focus on English, and largely southern English, upper-middle-class characters and their servants. See Elke Weissmann, *Transnational Television Drama: Special Relations and Mutual Influences between the US and the UK* (Abingdon, UK: Palgrave Macmillan), 57–62.

 19. The most successful drama that A&E coproduced with the BBC during that time was *Pride and Prejudice* (1995).

 20. Christine Becker, "From High Culture to Hip Culture: Transforming the BBC into BBC America," in *Anglo-American Media Interactions, 1850–2000*, ed. Joel H. Weiner and Mark Hampton (New York: Palgrave Macmillan, 2007), 275–94.

 21. Such sumptuousness is expressed clearly in the titles of dramas such as *Pride and Prejudice* and *Downton Abbey* (ITV, PBS, 2010–). Compare that to the collage style of *Ripper Street*, which uses a postmodern aesthetic and emphasizes how the world of Whitechapel is permeated by the makeshift.

 22. John Ellis, "BBC Goes Steampunk: Ripper Street, Peaky Blinders and the Memorialisation of History," CSTOnline, 15 November 2013, accessed 19 March 2014, http://cstonline.tv/.

 23. Showrunner Richard Warlow highlights that *Ripper Street* is also a Western in the DVD extras of series 1.

24. Andrew Higson, "Re-presenting the National Past: Nostalgia and Pastiche in the Heritage Film," in *Fires Were Started: British Cinema and Thatcherism*, ed. Lester D. Friedman (Minneapolis: University of Minnesota Press, UCL Press, 1993), 109–29.

25. Belen Vidal, "Labyrinths of Loss: The Letter as Figure of Desire and Deferral in the Literary Film," *Journal of European Studies* 36, no. 4 (2006): 418–36.

26. Nelson, "The Emergence of Affect."

27. Stephen Garton, "The Scales of Suffering: Love, Death and Victorian Masculinity," *Social History* 27, no. 1 (2002): 40–58.

28. Susan Sydney-Smith, *Beyond Dixon of Dock Green: Early British Police Series* (London: Tauris, 2002), 2.

29. Caren J. Deming, "Hill Street Blues as Narrative," *Critical Studies in Mass Communication* 2, no. 1 (1985): 2.

30. Ibid.

31. Ibid., 8. See also Thompson, *Television's Second Golden Age*.

32. Richard Warlow, "Ripper Street: Policing the Meanest Streets Possible," *BBC Blogs*, 4 January 2013, 20 January 2014, http://www.bbc.co.uk/.

33. One of BBC America's previews to *Ripper Street* was indeed titled "CSI: Victorian Style," YouTube, accessed 6 March 2014, http://www.youtube.com/.

34. Mary Jacobus, Evelyn Fox Keller, and Sally Shuttleworth, "Introduction," in *Body/ Politics: Women and the Discourses of Science*, ed. Mary Jacobus, Evelyn Fox Keller, and Sally Shuttleworth (New York: Routledge, 1990), 1–10.

35. Sue Thornham, "'A Good Body': The Case of/for Feminist Media Studies," *European Journal of Cultural Studies* 6, no. 1 (2003): 75–94.

36. Elisabeth Bronfen, *Over Her Dead Body: Death, Femininity and the Aesthetic* (Manchester, UK: Manchester University Press, 1992), 181.

37. David Drysdale, "'Laws and Every Other Damn Thing': Authority, Bad Faith, and the Unlikely Success of Deadwood," in *Reading Deadwood: A Western to Swear By*, ed. David Lavery (London: Tauris, 2006), 133–44.

38. Drake's story arc becomes even more complicated in series 2 in which we witness his descent into depression and subsequent rescue by a woman, Rose, a prostitute turned singer. Where Drake struggles with the legacy of violence and his exploitation first by the army and then by the police, Rose manages to transform herself, indicating yet again how traditional masculinities are shown to be helpless in the face of the status quo.

Index

Abraham, Cyril, 143, 147
Adventures of Robin Hood (1955–1959), 114; as social critique, 115
Adventures of Sir Lancelot (1956–1967), 114, 120
Allo Allo (1982–1992), 41
Arthur of the Britons (1972–1973), 121; nationalism in, 121
Atkins, Eileen, xvi, 18, 45, 97, 165
Au Bonheur des Dames (1883). *See* Zola, Émile
Austenland (2013), x

Bel Ami (1971), 16, 17
Bernstein, Michael Andre, 171
Blackadder (1983–1989), xxi, 41, 43, 44, 45, 49, 130, 135
Bleak House (2005), xi, xvii, 58, 59, 73, 193, 196, 200, 237; parody of, 46. *See also* Davies, Andrew
Bond, James, x
Borgias, The (2011–), 122
Brass (1983–1984), 41, 42
Brideshead Revisited (1981), ix, xvii, 14, 35n1, 41, 153, 164n9, 177, 188n1
Britishness, xi, xxiii, 278
The Buccaneers (1958–1960), 141

Cadfael (1994–1996), 120; ideology in, 120

Call the Midwife (2012–), xi, xvii, xxviii, 67, 68, 69, 70, 73, 249; abortion in, 256; birth in, 255; comparison to *Cranford*, 253; comparison to *Downton Abbey*, 113, 251, 257; comparison to *One Born Every Minute* (2010–), 254, 257; depiction of race in, 258, 259; depiction of working class in, 258, 259; as Feminist TV, xvii, 249, 250, 251, 252, 254, 257, 259; reception in US, 251; as soap opera, 67. *See also* Worth, Jennifer
Cameron, David, 4
Camelot (2011), 121
Cannadine, David, 168
Cardwell, Sarah, 6, 19n13, 198
Carolan, Victoria, 140, 149
Carry on Laughing (1975), 130
Chickens (2013), 49
Cooke, Lez, 113
Cooper, Glenda, 186
costume drama: authenticity of, 27; britishness, xi, xxiii, 278; class, 19; "cult of Sunday night," 17, 21n43; Dickens, influence of, 54, 55; Elizabeth I in, 125–135; Feminism, 18, 20n21; "Golden Age" of, 7, 20n19, 20n21; as heritage, x, xvii, xviii, xix, xx, xxii, xxiii, xxv, xxvi, 4, 5, 7, 14, 16, 23, 38, 41, 43, 45, 47, 80, 83, 142, 146, 148, 167, 177, 178, 181, 183, 187, 191, 192,

About the Editors and Contributors

James Leggott teaches film and television at Northumbria University, UK. He has published on various aspects of British film and television culture, such as contemporary cinema, popular comedy, and realist filmmaking. He also is the principal editor of the recently launched *Journal of Popular Television*.

Julie Anne Taddeo teaches history at the University of Maryland, where she specializes in Victorian and twentieth-century culture and gender studies. She is the author of *Lytton Strachey and the Search for Modern Sexual Identity* (2002), editor of *Catherine Cookson: On the Borders of Legitimacy, Fiction, and History* (2012), coeditor (with Ken Dvorak) of *The Tube Has Spoken: Reality TV and History* (2009), and coeditor (with Cynthia J. Miller) of *Steaming into a Victorian Future: A Steampunk Anthology* (2012). She also is an associate editor of the *Journal of Popular Television*.

* * *

Sabrina Alcorn Baron is visiting assistant professor of history at the University of Maryland and has published on censorship, book collectors, the book trade, and news writing, as well as the history of reading, the material culture of the book, and the culture of publication in seventeenth-century England. Baron coedited and authored (with Brendan Dooley) *The Politics of Information in Early Modern Europe* (2001) and *The Reader Revealed* (2001), and coedited (with Eleanor F. Shevlin and Eric N. Lindquist) *Agent of Change: Print Culture Studies after Elizabeth L. Eisenstein* (2007). She has published influential essays in other collections, as well as thirteen biographies in the online *Oxford Dictionary of National Biography* (2004), and

was an editor/researcher/author for *The History of Parliament: The House of Commons 1603–1629* (2011).

Giselle Bastin is senior lecturer in the department of English at Flinders University, South Australia. Her research interests include printed and cinematic biographies of the British royal family and representations of 1930s Britain in literature, film, and television. Indicative publications are "Filming the Ineffable: Biopics of the British Royal Family," in *a/b: Auto/Biography Studies* (2009); "There Were Three of Us in This Biography, So It Was a Bit Crowded: The Biographer as Suitor and the Rhetoric of Romance in *Diana: Her True Story*," in *Journal of Popular Romance Studies* (2010); and "Precursor Texts in the Novel and Film of *Atonement*," in *In the Shadow of the Precursor*, edited by Diana Glenn et al. (2012).

Tom Bragg is assistant professor of English at the University of South Carolina Salkehatchie. His most recent publications include essays on "Frederick Marryat" and "G. P. R. James," in *Blackwell Encyclopedia of Victorian Literature* (2015); "Further Readings," in *Short Story Criticism: Sherlock Holmes* (2014); and "Charles Reade," in *A Companion to Sensation Fiction* (2012).

Lucy Brown is a PhD candidate at the University of Sheffield, UK. Her research interests lie in the field of Victorian literature and culture, specifically the genre of sensation fiction. Her thesis is titled "Devotion and Identity in the Works of Wilkie Collins and Edmund Yates."

Katherine Byrne teaches nineteenth- and twentieth-century fiction and women's writing at the University of Ulster in Coleraine. She has published articles and book chapters on historical costume drama, particularly on the adaptation of Elizabeth Gaskell's work for the small screen, and on neo-Edwardian television, as well as on Victorian fiction and medicine. Her recent monograph, *Tuberculosis and the Victorian Literary Imagination*, was published in 2013.

Jerome de Groot teaches at the University of Manchester. He is the author of *Royalist Identities* (2004), *Consuming History: Historians and Heritage in Contemporary Popular Culture* (2008), and *The Historical Novel: The New Critical Idiom* (2009). He is working on a book titled *Remaking History* at present.

Andrew B. R. Elliott is a senior lecturer in media and cultural studies at the University of Lincoln, UK, where he teaches a range of courses in film, television, and cultural studies. His research focuses on the representation of

history on film and popular cinema, and the notions of authenticity and truth across the media. Elliott has published on a range of topics from accuracy and authenticity to Vikings and violence. His recent book, *Remaking the Middle Ages* (2010), analyzes the semiotic reconstruction of the medieval period. He is currently working on the use of history in popular films, historical epics, and video games, and the role of the audience in decoding them.

Louise FitzGerald is a senior lecturer in the school of Film and Screen Studies at the University of Brighton, UK. Her research interests focus on the relationship between the screen and identity politics, critical-race theory, mainstream cinema and television (UK and US), and feminism. Her recent publications include *Mamma Mia the Movie: Exploring a Cultural Phenomenon* (2013); "'Them over There': Motherhood and Marginality in Shane Meadows' Films," in *Shane Meadows: Critical Essays*, ed. Martin Fradley et al. (2013); and "'Let's Play Mummy': Simulacrum Babies and Reborn Mothers," in *European Journal of Cultural Studies* (2011).

Mark Fryers is an Arts and Humanities Research Council–funded PhD researcher at the University of East Anglia, UK, specializing in the historic study of British film and television. In particular, his work traces the symbols, mythology, and cultural dissemination of the maritime sphere and its links to representations of British national identity.

Stella Hockenhull is a reader in film and television studies and codirector of the Research Centre for Film and Media at the University of Wolverhampton, UK. Her main interests are British cinema and television. She has published two monographs on British cinema and landscape titled *Aesthetics and Neo-Romanticism in Film: Landscapes in Contemporary British Cinema* (2013) and *Neo-Romantic Landscapes: An Aesthetic Approach to the Films of Powell and Pressburger* (2008). She is the author of a number of journal articles and chapters in edited collections on film and television and is coeditor of a forthcoming collection of essays titled *Spaces of the Cinematic Home: Behind the Screen Door*.

Claire Monk is a lecturer in film and film culture at De Montfort University, UK, and a scholar of post-1970 British cinema. She is known especially for her contributions to the debates around the cultural, sexual, gender, and class politics of the "heritage film" and historical representation in period films and TV drama. Her most recent monograph, *Heritage Film Audiences: Period Films and Contemporary Audiences in the UK* (2011), and sequel article "Heritage Film Audiences 2.0" (*Participations*, 2011) engages with the audiences and transnational fans of British period/costume texts. Other publications include *British Historical Cinema*, coedited with Amy Sargeant (2002),

and many articles and chapters, including "Sexuality and Heritage" (1995, anthologized in *Film/Literature/Heritage*, ed. Ginette Vincendeau, 2001).

Ellen Moody is a lecturer in English and has been teaching in senior colleges for over thirty years. She was at George Mason University between 1989 and 2012 and is now teaching at the Osher Institute for Lifelong Learning at American University in Washington, DC. Her publications include *Trollope on the Net* (2003), e-text editions of French eighteenth-century novels, translated poetry from Italian, published essays on subjects in the long eighteenth and nineteenth centuries, and translation and film adaptations in (among others) *Studies in the Novel, Philological Quarterly, Renaissance Quarterly, Persuasions*, and the *Intelligencer*. Her most recent essay was published in *Adaptations: Teaching British Literature of the Nineteenth Century and Film*; she is now working on an edition of a novel by Charlotte Smith and her book project, *A Place of Refuge: The Jane Austen Film Canon.*

Marc Napolitano is assistant professor of English at the US Military Academy, West Point. He attained his PhD from the University of North Carolina at Chapel Hill. Napolitano's research interests include Dickens, Victorian literature, and children's literature. He has recently published articles on stage and film adaptations of Dickens's works in *Dickens Studies Annual, Ecumenica, English: The Journal of the English Association*, and *Neo-Victorian Studies.*

Benjamin Poore is lecturer in theater at the University of York, UK. His first monograph was titled *Heritage, Nostalgia and Modern British Theatre: Staging the Victorians* (2012), and he has recently published articles on modern screen adaptations of Sherlock Holmes.

Andrea Schmidt is a doctoral candidate in the comparative literature department at the University of Washington. She is currently writing her dissertation on the heritage film and the auteur.

Karen Beth Strovas is assistant professor of English at Wayland Baptist University, Texas, where she teaches undergraduate and graduate writing and literature, specializing in British literature. She is the associate editor of *Women's Studies: An Inter-Disciplinary Journal*, was the associate editor and project comanager of *All Things Dickinson: An Encyclopedia of Emily Dickinson's World* (2014), and has published articles and reviews on the topics of Victorian literature, sleep and sleeplessness in literature, and adaptation studies. Strovas received her PhD in English from Claremont Graduate University in Claremont, California, in 2011.

Scott M. Strovas is assistant professor of music history at Wayland Baptist University, Plainview, Texas, where he oversees the undergraduate music history sequence and teaches courses in the music theory curriculum. His publications include "Music in the First-Year Writing Classroom" (*The CEA Forum*, 2011) and entries on music and on nineteenth-century American foreign policy in All Things Emily Dickinson (ABC-CLIO, 2014). In addition to his publications, Strovas has presented scholarship on a range of subjects including film music, contemporary American music, jazz, and twentieth-century musical philosophy.

A. Bowdoin Van Riper is an independent scholar who specializes in depictions of science and technology in popular culture. He is currently Web coordinator for the Center for the Study of Film and History, and editor of Rowman & Littlefield's Science Fiction Television book series. He is author or editor of ten books, including *Imagining Flight: Aviation and Popular Culture* (2003), *1950s "Rocketman" TV Series and Their Fans: Cadets, Rangers, and Junior Space Men* (2012, coedited with Cynthia J. Miller), and *(Re)Locating the Frontier: International Western Films* (2013, coedited with Cynthia J. Miller).

Elke Weissmann is a lecturer in film and television, and program leader for television production management at Edge Hill University, UK. Her research interests focus on television, in particular aspects of transnational and convergent television, and feminism. She has recently published *Transnational Television Drama: Special Relations and Mutual Influences between the US and the UK* and is editor of *Renewing Feminisms: Radical Narratives, Fantasies and Futures in Media Studies* (with Helen Thornham). She is the vice chair of the television studies section of the European Communications Research and Education Association (ECREA) and member of the editorial team of *Critical Studies in Television*.

Andrea Wright is a senior lecturer in film studies at Edge Hill University, UK. Fantasy/fairytale cinema (particularly aesthetics, costume, set design, and location) and New Zealand cinema are central to her current research. Other research interests include film marketing and merchandising in the postclassical era and British cinema and television. Her most recent publications include work on production design in *The Company of Wolves* and *Legend* for the collection *Postmodern Reinterpretations of Fairy Tales: How Applying New Methods Generates New Meanings* (2011); the problematic representation of women and the female body in 1980s sword and sorcery cinema for the *Journal of Gender Studies*; Hercules, landscape, identity, and New Zealand for the *Australasian Journal of Popular Culture*; and adaptation, representation, and national identity in relation to *The Quiet Earth* for

the collection *Science Fiction across Media: Adaptation/Novelisation* (2013).